THE OXFORD HIST
OF ENGLISH ART

Edited by T. S. R. BOASE

THE OXFORD HISTORY OF ENGLISH ART

Edited by T. S. R. Boase
President of Magdalen College, Oxford

Plan of Volumes

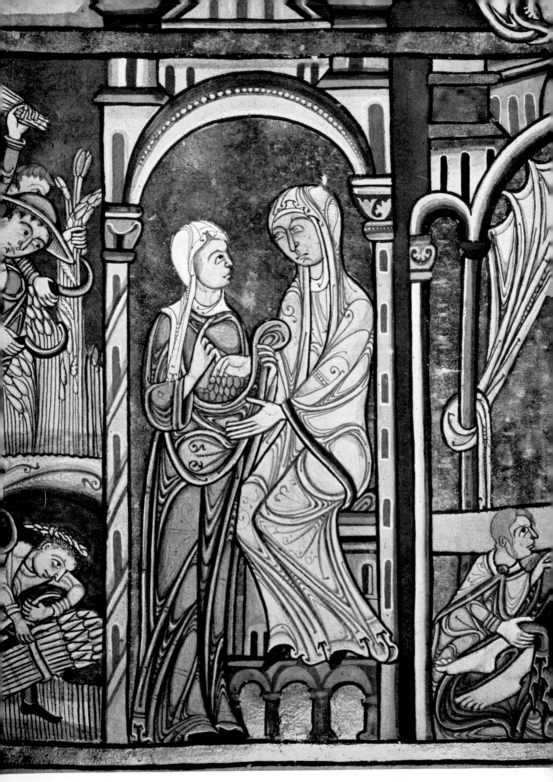

LAMBETH BIBLE: RUTH BRINGS THE CORN TO NAOMI

ENGLISH ART

1100–1216

T. S. R. BOASE

Oxford History of English Art.

OXFORD

AT THE CLARENDON PRESS

1953

Oxford University Press, Amen House, London E.C. 4
GLASGOW NEW YORK TORONTO MELBOURNE WELLINGTON
BOMBAY CALCUTTA MADRAS KARACHI CAPE TOWN IBADAN
Geoffrey Cumberlege, Publisher to the University

PRINTED IN GREAT BRITAIN
AT THE UNIVERSITY PRESS, OXFORD
BY CHARLES BATEY, PRINTER TO THE UNIVERSITY

PREFACE

THE greater part of this book was delivered as the Wayn-
flete lectures in the University of Oxford in the Hilary
term of 1950 at the invitation of the Fellows of Magdalen
College. I am deeply appreciative of that invitation and of their
permission to use the material for a volume in the *Oxford History
of English Art*.

The field of twelfth-century English art has been very unevenly
covered by the works of my predecessors in it. Architecture has
received notable and distinguished treatment and I must here
record, among many names that might well be mentioned, those
of R. Willis, J. Bilson, and A. W. Clapham. Anyone who has
worked on the history of our English cathedrals knows how well
the way has been cleared for him by Professor Willis's exact and
imaginative investigations. The writings of John Bilson are amongst
the most distinguished English contributions to architectural
history and have never received in this country their full due of
admiration, though long recognized in France as a landmark in
the subject. Sir Alfred Clapham's two volumes on Romanesque
architecture in England compress the significant and necessary
facts into a remarkably brief compass: using them constantly,
I have seldom failed to find in them the information sought.
Shortly before his death Sir Alfred summarized his latest views on
the subject in a pamphlet which showed how closely he was in
touch with all developments and discoveries and how his mind
was on the alert for any new aspect or line of approach. I had hoped
that this book might have benefited from his criticisms, always
most generously and frankly given: instead, it must appear under
the shadow of the recent loss of our greatest master in Romanesque
studies.

In sculpture the great tome of E. S. Prior and A. Gardner has
still no rival or successor. Their plates provide a corpus the like of
which few other countries possess in such convenient form. The
stylistic problems of contemporary art history were not those that

interested the authors, but their great knowledge and good sense have left their conclusions singularly unassailed.

In manuscript illumination the course of present studies has been redirected by Professor Francis Wormald in a series of brilliant and stimulating articles. But behind him and other workers in that field lie the minute, penetrating, and far-seeing labours of Dr. M. R. James, whose catalogues are the basis of all later research and whose achievement belongs in its extent to the age of giants.

These are the great classics of the subject. But the English twelfth century has at the moment many adherents: as I have been working on this century the ground as it were has been shifting under my feet. In architecture the articles and lectures of M. Jean Bony, whose generous advice and comments I most gratefully acknowledge, have given a change of emphasis in the selection of significant points. A thesis, as yet unpublished, by Dr. George Zarnecki has brought new order and shown new relationships over a large sphere of our Romanesque sculpture: I am greatly indebted to his work, to the collection of photographs formed by him for the Courtauld Institute, and above all to many talks with him on the problems involved. In illumination the wide knowledge and speculative ingenuity of Dr. Otto Pächt bring constant and startling increases in our understanding of this period. As yet his results have been made available only in one short article and in some lectures delivered in the universities of Oxford and London. I have learned much from him and almost every point in this book connected with illumination has been discussed with him, often, I fear, in the hallowed silence of Bodley's Selden End. I find it impossible to disentangle my own opinions from his and I should like to acknowledge most fully the great part he has played in all my treatment of the subject. His own book, when it appears, will establish many points that here are only hinted at. A striking contribution to the study of manuscripts of the Canterbury school has recently been made by Dr. C. R. Dodwell in a thesis for a doctorate in the University of Cambridge.

In the production of these volumes of the *Oxford History of English Art* illustration, of necessity highly selective, must always be a major problem, and each period requires a somewhat different

solution to it. In my plates architecture hardly receives an allotment comparable with its claims; neither Ely nor Peterborough for instance is represented; but our main buildings have been much photographed and illustrated books on them, either general works or individual monographs, are easily available. Illumination is much less freely reproduced and I have therefore given it something of a priority. Our Romanesque heritage is fortunately so rich, despite the inroads of iconoclasm and English weather on our sculpture and wall-paintings, that it would require a very lavish documentation to do it justice; and there are many works, monastic churches such as Wymondham or Chepstow, parish ones such as Melbourne or Elkstone, a carved font here, a tympanum there, the initials of a psalter or some ivory fragment, which cry out against me for lack, not only of illustration, but even of comment.

I have received much kindness and help from many librarians, sorely tried by my wish to see a large number of manuscripts, in which perhaps only one initial might be of interest to me. Acknowledgements are due to the following libraries and museums, whose authorities have generously given me permission to reproduce photographs of works in their possession or special facilities for using prints from their photographic collections: the British Museum; the Royal Library, Copenhagen; the Bibliothèque Nationale, Paris; the National Library of Scotland; the Vatican Library; the Victoria and Albert Museum; the University Library, Aberdeen; the Walters Art Gallery, Baltimore; the University Library, Cambridge; the Laurentian Library, Florence; the Hunterian Library, University of Glasgow; the Warburg Institute, University of London; the Kunstinstitut, Marburg; the Staatsbibliothek, Munich; the Pierpont Morgan Library, New York; the Bodleian Library, Oxford; the Museum of the Yorkshire Philosophical Society; and to the following individuals and governing bodies who have kindly given me similar permissions: the Most Reverend the Archbishop of Canterbury and the Church Commissioners; His Grace the Duke of Roxburghe; the Dean and Chapter of Durham Cathedral; the Dean and Chapter of Hereford Cathedral; the Dean and Chapter of Winchester Cathedral; the Dean and Students of Christ Church, Oxford; the Master and

Fellows of Corpus Christi College, Cambridge; the Master and Fellows of Pembroke College, Cambridge; the Master and Fellows of St. John's College, Cambridge; the Master and Fellows of Trinity College, Cambridge; the Master and Fellows of Trinity Hall, Cambridge; the Master and Fellows of University College, Oxford. In particular I owe much gratitude to the staffs of the Bodleian Library and the Manuscript room in the British Museum. The photographic collections of the National Buildings Record and the Courtauld Institute are essential to researches of this nature, and the latter body has photographed many manuscripts specially for my work on this book and co-operated in every way in its production.

Professor David Knowles, M. Jean Bony, Professor Peter Brieger, Dr. Otto Pächt, Mr. Lawrence Stone, Dr. Margaret Whinney, and Dr. George Zarnecki have read all or parts of my typescript and made many valuable corrections and suggestions. Miss R. M. Welsford has read the whole book in proof. I fully realize and appreciate the labour such acts of friendship involve.

T. S. R. B.

MAGDALEN COLLEGE

OXFORD

1952

CONTENTS

LIST OF PLATES

(The measurements of manuscripts are the size of the page unless otherwise stated)

Frontispiece: LAMBETH BIBLE: RUTH BRINGS THE CORN TO NAOMI. Lambeth MS. 3, f. 130, DETAIL (much enlarged). *Photograph by courtesy of the Warburg Institute.*

AT END

1. TEWKESBURY ABBEY: WEST FRONT.
Photograph by F. H. Crossley, Esq., F.S.A.

2. DURHAM CATHEDRAL: THE NAVE.
Photograph by Walter Scott, Bradford.

3 *a.* WALTHAM ABBEY: THE NAVE.

 b. DURHAM CATHEDRAL: VAULT IN NORTH AISLE OF CHOIR.
 Photographs by F. H. Crossley, Esq., F.S.A.

4 *a.* DETAIL OF INITIAL. Bayeux Capitular Library, MS. 57.
 [$19 \times 14\frac{1}{10}$ in.] *Photograph by courtesy of Bibliothèque Nationale, Paris.*

 b. INITIAL TO HABAKKUK FROM CARILEF BIBLE. Durham MS. A. II. 4.
 [$19\frac{1}{2} \times 12\frac{3}{10}$ in.]

 c. BEATUS INITIAL FROM CARILEF BIBLE. Durham MS. A. II. 4, f. 65.
 Photographs Victoria and Albert Museum, Crown copyright.

5 *a.* THE BURIAL OF PAULA: DETAIL OF INITIAL. Bodleian Library, MS. Bodley 717, f. 6v. [$14\frac{5}{8} \times 10\frac{1}{4}$ in.]

 b. INITIAL. Bodleian Library, MS. Bodley 301, f. 4. [15×11 in.]

 c. INITIAL. Bayeux Capitular Library, MS. 57. [$19 \times 14\frac{1}{10}$ in.]
 Photograph by courtesy of Bibliothèque Nationale, Paris.

6 *a.* A MEDICAL CONSULTATION. Durham, MS. Hunter 100, f. 119v.
 [$6\frac{3}{5} \times 4\frac{4}{5}$ in.] *Photograph Victoria and Albert Museum, Crown copyright.*

 b. INITIAL. ST. BENIGNE. British Museum, MS. Arundel 91, f. 186v.
 [13×9 in.]

 c. A MIRACLE OF ST. CUTHBERT. Oxford, University College, MS. 165, f. 132. [$7\frac{3}{5} \times 4\frac{7}{10}$ in.] *Photograph by courtesy of the Courtauld Institute of Art.*

7 *a.* INITIAL. Vatican, Rossiana MS. 500, f. 148. [$8\frac{4}{5} \times 6\frac{1}{5}$ in.]

 b. INITIAL. British Museum, MS. Royal 12 E. XX, f. 136. [$7 \times 4\frac{3}{4}$ in.]

 c. INITIAL. Cambridge, Trinity College, MS. O. 4. 7, f. 75. [$13\frac{1}{8} \times 9\frac{3}{8}$ in.]

8 *a*. CANTERBURY CATHEDRAL: THE CRYPT.
Photograph by courtesy of J. R. H. Weaver, Esq.

 b. CANTERBURY CATHEDRAL: ARCADE, NORTH TRANSEPT.
Photograph by National Buildings Record.

9 *a* and *b*. CANTERBURY CATHEDRAL: CAPITALS IN CRYPT.

 a. *Photograph by National Buildings Record.*

 b. *Photograph by courtesy of Dr. G. Zarnecki and the Courtauld Institute of Art.*

10 *a*. INITIAL: ST. DUNSTAN. British Museum, MS. Arundel 16, f. 2.
[$9\frac{3}{4} \times 6$ in.]

 b. INITIAL: CHRIST PREACHING REPENTANCE. Lincoln MS. A. 3. 17, f. 8ᵛ.
[$13\frac{1}{4} \times 8\frac{1}{2}$ in.]

 c. ST. WITHBURGA. Cambridge, Corpus Christi College, MS. 393, f. 59.
[$8\frac{4}{5} \times 6$ in.] *Photograph by courtesy of the Courtauld Institute of Art.*

11 *a*. INITIAL. Cambridge, Trinity College, MS. R. 3. 30, f. 9 (6).
[$8\frac{1}{2} \times 5\frac{3}{8}$ in.]

 b. DETAIL OF INITIAL. British Museum, MS. Harley 624, f. 137.
[$14\frac{3}{4} \times 9\frac{1}{4}$ in.]

 c. DETAIL OF FULL-PAGE DRAWING. Florence, Laurentian Library, MS.
Pluto XII. 17, f. 4. [$13\frac{3}{4} \times 9\frac{7}{8}$ in.]

12 *a*. INITIAL: CANTERBURY PROFESSIONS. British Museum, MS. Cotton
Cleopatra E. I, f. 38. [$12\frac{3}{4} \times 8\frac{3}{8}$ in.]

 b and *c*. INITIALS: JOSEPHUS. Cambridge, St. John's College, MS. A. 8,
ff. 91 and 136ᵛ. [$15 \times 11\frac{1}{5}$ in.] *Photographs by courtesy of the Courtauld
Institute of Art.*

13 *a*. INITIAL. British Museum, MS. Harley 624, f. 108ᵛ. [Initial: $3 \times 2\frac{1}{2}$ in.]

 b. DETAIL OF INITIAL. British Museum, MS. Cotton Claudius E. V, f. 49.
[$16 \times 12\frac{3}{8}$ in.]

14. CAPITALS. *a*. CANTERBURY CRYPT; *b*. HYDE ABBEY; *c*. ROMSEY ABBEY;
 d. HEREFORD CATHEDRAL: TRIFORIUM IN SOUTH TRANSEPT. *Photographs
a, c, and d by courtesy of Dr. G. Zarnecki and the Courtauld Institute of Art.
Photograph b by National Buildings Record.*

15 *a*. LEWES PRIORY: CAPITAL. THE MIRACULOUS DRAUGHT. British Museum.

 b. WINCHESTER CATHEDRAL: CAPITAL. THE CENTAUR.
Photographs by National Buildings Record.

16 *a* and *b*. WESTMINSTER ABBEY: CAPITAL. THE JUDGEMENT OF SOLOMON.
Photographs by courtesy of the Courtauld Institute of Art.

LIST OF FIGURES

ABBREVIATIONS

Antiq. Journ.	*Antiquaries Journal.*
Archaeol.	*Archaeologia.*
Arch. Journ.	*Archaeological Journal.*
B.M.	British Museum.
Bull. mon.	*Bulletin monumental.*
Burl. Mag.	*Burlington Magazine.*
E.H.R.	*English Historical Review.*
Journ. Brit. Arch. Ass.	*Journal of the British Archaeological Association.*
Migne, *P.L.*	J. P. Migne, *Patrologiae cursus completus. Series Latina.*
O.H.E.A.	*Oxford History of English Art.*
Pal. Soc.	Palaeographical Society, Facsimiles of manuscripts.
R.C.H.M.	*Royal Commission on Historical Monuments.*
R.S.	Rolls Series.
V.C.H.	*Victoria County History.*

I

DURHAM

THE accession of Henry I, which opened both a new reign and a new century, is a convenient point at which to survey the artistic achievement of the first period of Norman rule in England. The leading figures of the generation of the conquest were now, thirty-four years after Hastings, with few exceptions dead. Of the bishops who had known the period of diocesan reorganization in the early seventies only Osbern of Exeter was still living, and he had always been somewhat remote from the main movements of ecclesiastical policy: but the record of their energy and innovations was set out very visibly in the new cathedrals, which they had begun and in some cases completed, and in the rich furnishings with which they had equipped them. Here was to be seen the confident strength of a Church which looked both to the papacy of Hildebrand and the kingship of the Conqueror for its authority and establishment. Its architecture, in scale and style, reflected its sense of enlarged purpose and masterly dignity. Lanfranc had died in 1089, but his new cathedral, replacing its Saxon predecessor destroyed by a fire in 1067, had been built in the first decade of his archiepiscopate: 'You do not know', William of Malmesbury wrote, 'which to admire the more, the beauty or the speed.'[1]

At Winchester the aged Walkelin had lived till 1098 and his cathedral was far enough advanced to be consecrated in 1093. In any account of a building it is the consecration which is the date generally registered by the chroniclers and preserved in the tradition of the church. Unfortunately it is architecturally a somewhat ambiguous piece of information. The presbytery, transepts, and two eastern bays of the nave, which terminated the monastic choir, were normally the first stage of the building and were consecrated and brought into use on their completion. A further consecration took place when the nave had been built. But if the

[1] 'Ignores majore pulchritudine an velocitate', *Gesta pontificum*, R.S. lii (1870), 69.

Winchester consecration of 1093 may have marked the completion of the eastern arm only, the nave seems to have been carried on as a continuous piece of work. Lincoln was to have been consecrated in the early summer of 1092 and here the greater part of the building had been finished; but the death of its bishop, Remigius, caused a postponement. Worcester, rebuilt by its Saxon bishop and saint, Wulfstan, had been consecrated before 1092. St. Paul's, the cathedral of London, had been begun but was not yet far advanced. The ruined cathedral of York had been remodelled by Thomas of Bayeux (d. 1100) on the lines of Lanfranc's work at Canterbury. The Conqueror's chaplain, Herfast (d. c. 1085), had built his cathedral at Thetford, then the centre of the diocese that was to become that of Norwich. The cathedral of Old Sarum had been consecrated in 1092: it was a busy period for those involved in ecclesiastical ceremonies. Chichester was in course of building; at Chester and Bath churches were begun as centres for the sees that later were to have their seats at Lichfield and Wells; at Durham William of St. Carilef (d. 1096) began the new cathedral in 1093; Gundulf of Rochester, elected in 1077 and now, in 1100, with seven years more of activity before him, had already completed his cathedral: only at Exeter Osbern, the senior prelate at the opening of the new reign, had been content with the old Saxon building.

In the great abbeys also there had been much building activity. St. Augustine's, Canterbury, had been completed by 1099; the choir of Bury St. Edmunds was ready by 1095 for the translation of the relics of its patron saint; Abbot Serlo had begun his work at Gloucester in 1089; Abbot Simeon (1081–93) had begun the new church at Ely; above all, the abbey church of St. Albans had been largely completed by its magnificent abbot Paul before his death in 1093, and it remains today one of the most notable examples of the style of the time.

Largeness is the characteristic of these post-conquest English churches. The nave of Jumièges, the important Norman abbey at the mouth of the Seine, completed in 1067 and consecrated in that year in the presence of the Conqueror, measured 145 feet in length and 65 feet in width; that of St. Albans was 275 by 77. The cathedral of Rouen, built between 1030 and 1067, had, it is true, set a

pattern of greater size and seems, from its fragmentary remains, to have had a total length of 305 feet; but this had been surpassed by the 322 feet which was the internal length of the Confessor's church at Westminster, and it fell far short of the 318 feet which was the length of the nave alone at Winchester.[1] The severe, massive simplicity of their form can today best be judged in the interiors of some of the surviving buildings, in, for instance, the north transept of Winchester; externally, later additions and re-buildings, particularly the insertion into the west façades of great Decorated or Perpendicular windows, have much confused the outlines. The interior elevations have as their characteristic feature the large arches of the tribune[2] galleries opening above the ground arcade. These galleries provided additional space and also served to buttress the high wall of the nave while retaining the contrast of the low, vaulted aisles. The problem of raising the nave wall to the required height was also met by vertical buttresses rising the whole height of the interior of the nave in the form of semicircular half columns commencing from the composite piers of the nave arcade. In some cases, particularly after Durham had set the pattern, these buttresses are placed at every second bay and emphasize an alternation which was further marked by the contrast between compound piers and single, often circular columns. These wall shafts could serve also as the point from which diaphragm arches spanned the roof, dividing it into sections similar to those marked by the alternating shafts on the side walls. On the exterior, flat buttress strips supported the aisle walls and the high wall of the west façade. This type of shaft-buttressing was notably employed at the abbey church of Jumièges, the classic surviving example of the 'thin' wall rising to the considerable height of 82 feet. Here the tribune arch

[1] J. Bilson, 'Les Vestiges de la cathédrale de Rouen du XIe siècle', *Bull. mon.* lxxxvi (1927), 251. G. Lanfry, 'La cathédrale de Rouen au XIe siècle', extrait du *Bull. de la Soc. des amis des monuments rouennais, 1928–31* (Rouen, 1933). L. E. Tanner and A. W. Clapham, 'Recent Discoveries in the Nave of Westminster Abbey', *Archaeol.* lxxxiii (1933), 227.

[2] In England the term 'triforium' is usually applied to these galleries. The French practice, which I have used here, is to distinguish the tribune gallery, with an arch in each bay equalling the span of the ground arcade arch though sometimes subdivided, from the triforium passage, lit by a series of small arches.

is about half the height of the ground arcade, and is subdivided
into three small arches surmounted by a blank tympanum: above
the tribune story there is a blank wall face, unbroken even by a

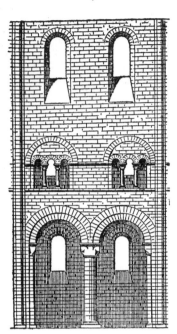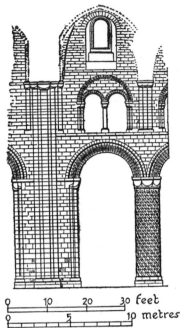

FIG. 1. *Jumièges and Durham: interior elevations of naves*

string course until the clerestory windows are reached (Fig. 1).
There is no passage at the clerestory level, except in the western
wall of the transepts, where an arcade passage runs below the
clerestory, forming a means of access from the corner staircase of
the transept to the central tower. At Jumièges this was a con-
venience. At the Conqueror's abbey of St. Étienne of Caen, the
Abbaye aux Hommes (*c.* 1073–81), so miraculously still standing
amongst the ruins of its city, the 'hollow' wall became a definite
technique (Fig. 2).[1] A clerestory passage ran partially behind a
colonnade of arches framing the window, partially in the thick-
ness of the wall, achieving in this way a form of internal buttress-

[1] The significance of the thin and hollow wall has been worked out in an important
article by J. Bony, *Bull. mon.* xcviii (1939), 153. See also A. Rolland in *Rev. belge
d'arch. et d'hist. de l'art*, x (1940), 169, and G. Webb, *Gothic Architecture in England*
(1951), 8. For the date of St. Étienne see E. Lambert, *Caen roman et gothique* (1935), 4.

ing; below, the tribune arcade—large, undivided openings almost equal in height to the ground arcade—is thickened on the gallery side by a further order to give support to the wide passage wall above:

the great composite piers, a regular series without alternation, are composed of applied columns, ten in all, answering to the increased depth of the arches, whereas at Jumièges the compound pier is a simple cruciform scheme with four engaged half columns. From the piers at St. Étienne the main shafts on the nave side still continue as buttresses, but on the exterior the flat pilaster strips have disappeared and are replaced by blind arcading. The height of the interior elevation is less than that of Jumièges, approximately 78 feet.

In England, the Confessor's church of Westminster, from what we know of its structure, followed the thin-

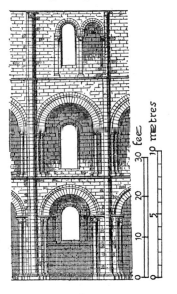

FIG. 2. *St. Étienne: interior elevation of nave*

wall pattern of Jumièges: but it was the hollow wall, which we find, for instance, at St. Albans and Winchester, in both of which the upper passage is already in use, that was to be the inspiration of Anglo-Norman building and the subject of some of its most striking experiments. Blyth priory, built in the last decade of the eleventh century, has a thin wall with no clerestory passage, a low tribune arch, and the simple cruciform piers of Jumièges, but there is little wall space between the tribune and the clerestory and therefore nothing of the sense of height given by Jumièges. The nave of Ely rises to the great height of 86 feet, Peterborough to 81 feet, but their naves are respectively 260 feet and 235 feet long, whereas Jumièges has a nave of only 140 feet. It was St. Étienne, with its hollow wall and somewhat lower elevation proportionate to its length, that became the normal pattern for England. The hollow wall encouraged the English liking for longitudinal emphasis.

There was, however, no uniformity in the scale of tribune openings. Sometimes it was the high arches of St. Étienne that were followed, sometimes the lower arch of Jumièges, though its blank wall spaces were avoided; even at Blyth there is a string course at clerestory level, and another at the base of the tribune which passes in horizontal continuity over the wall shafts instead of being cut by them as it is at both Jumièges and St. Étienne. These are visual, not structural matters, and this choice in interior proportions raises the question of the medieval aesthetic approach and the medieval formalization of aesthetic concepts.

Here we have to differentiate somewhat carefully between views current in informed circles and the vulgarization of these views which provides the vocabulary for expressions of aesthetic approval and in so doing both colours and reflects the general taste of the time.[1] The most influential textbook was the relevant passages of the *Etymologiae* of Isidore, the seventh-century bishop of Seville, a work that was represented in many English monastic libraries. In particular, Isidore's definitions and distinctions of meaning underlie medieval aesthetic terminology wherever it is used at all exactly in regard to the visual arts. The main headings are the following: *decor*, that which is *decens* or fitting,[2] where there is a harmony between form and use; *venustas*, that which ornaments, which is non-functional and exists only to give visual pleasure; *formosus*, that which is natural in its origin, comeliness; and *pulchritudo*, which has much the same general application that we give to beauty today. A detailed analysis of these categories is beyond the scope of this book, but it may be said that the main division between a functional and a decorative approach was recognized and that words and phrases existed to express it. In architecture, learned opinion was dominated by Vitruvius, since the revival of interest in him by Einhard at the court of Charlemagne, at whose behest the *De architectura* was, we know, copied at Fulda.

[1] See on this question E. de Bruyne, *Études d'esthétique médiévale*, 3 vols. (1946). He has summarized his conclusions in a one-volume work, *Esthétique du moyen âge* (Louvain, 1947).

[2] *Aptus et utilis* is the explanation of *decor* given by the author of the *Metrical Life of St. Hugh of Lincoln* (ed. J. Dimock, 1860, 34); he also uses the phrase *ordo venustus et geometricus*.

Various manuscripts of it were known in the middle ages; a Council of York in 926 had prescribed its use; Archbishop Rotrou in the twelfth century bequeathed a copy of it to the cathedral of Rouen,[1] and William of Malmesbury quotes from it in his anthology of 'pleasant and profitable reading', the *Polyhistor*.[2] Much in Vitruvius must have been very puzzling to the masons' yard of the early twelfth century, if it was ever passed on to them: it is uncertain how far his teaching affected medieval practice, though here and there the shape of a column, the form of a capital, may reflect the study of his maxims; but he remains the great transmitter of the classical theory of proportion. Vitruvius in discussing architecture constantly emphasizes *ordinatio*, the rules by which each part of a building must have a recognized proportion to the whole and also a relationship to ideal proportions: this did not always correspond to the haphazard growth of a medieval church, and it was a theory that did not come to full authority till Quattrocento Florence. The medieval theorist is more likely to have had in mind the Platonic harmonies, familiar to him in the much-read textbook, the *De musica* of Boethius: it would only be from some ecclesiastical supervisor that such subtleties would come, but in the varying elevations of church interiors and façades experiments in proportion, whatever their theoretic basis, were certainly being made.[3] The consciousness of this basic quality of architectural beauty appears in twelfth-century writers in their frequent use of the term *compositio*. Gregory the Englishman, in his account of the marvels of Rome,[4] writes of the *artificiosa compositio* of buildings such as the palace of Diocletian or the Colosseum. Baudri of Bourgueil in his account of the abbey of Fécamp writes of its *compositio decentissima*.[5] There is here a sense of the building as

[1] E. de Bruyne, *Études*, i, 243.

[2] See M. R. James, *Two Ancient English Scholars* (1931), 28.

[3] Though dealing with a later period, there is much suggestive comment in R. Wittkower's two articles, 'Principles of Palladio's Architecture', *Journ. of the Warburg and Courtauld Institutes*, vii (1944), 102, and viii (1945), 68. See also G. F. Webb in *Arch. Journ.* cvi (supplement, 1952), 117.

[4] M. R. James, 'Magister Gregorius *De mirabilibus urbis Romae*', *E.H.R.* xxxii (1917), 531. Both the period and the nationality of Gregory are uncertain, but the probabilities point to England in the twelfth century. James prints the text in full.

[5] V. Mortet, *Recueil de textes*, i (1911), 344.

a unified work of art, as possessing qualities that are distinct from its structural needs. Dangerously distinct they might prove to be, for at Beverley about 1200 the artificers 'cared rather for appearance (*decor*) than strength, for delectation rather than stability', and their work on the central tower soon brought it crashing in ruins.[1]

When we come to the more general comments of contemporary chroniclers we find a different tone. The classical approach to proportion and design has been abandoned for an overpowering interest in colour and light. It is the painted walls and ceilings, the gleam of the jewels and precious metals of the church furnishings that are admired, and we are at once aware that the cool, grey severity, which is our conception of the Norman style, was a thing unknown to its creators. Our tastes have been moulded by an unintended beauty that has been modified by time and history into something far different from its original form. In the twelfth century the noble lines of the architecture were broken by bands of painting giving a warmth of colour to walls and roof, and in the dimness, undissipated by the light from later Perpendicular windows, the eye was constantly caught by the glint of metal and the sparkle of jewels on altars, suspended crowns of lights, or the great Easter candlesticks; while during the high ceremonies men moving in rich vestments, also sewn with jewels, completed the varying richness of the scene. It is this glint of light, all the more vivid from the surrounding obscurity, that is the keyword. *Nitens*, gleaming, is the constantly recurrent term, as when, for instance, William of Malmesbury writes of the shining pavements of Canterbury's 'glorious choir'.[2] The most famous example of this joy in colour and the refraction of light is in the passage of Abbot Suger's *De administratione* in which he writes of how the loveliness of many coloured gems has called him away from external cares so that he seemed to be transported to 'some strange region, not yet heaven but above the earth';[3] and this fascination of the

[1] *Historians of the Church of York*, ed. J. Raine, i, R.S. lxxi (1) (1879), 345. See also L. F. Salzman, *Building in England* (1952), 26.

[2] *Gesta pontificum*, R.S. lii (1870), 138.

[3] E. Panofsky, *Abbot Suger* (Princeton, 1946), 63.

luminous is most completely summed up in a great passage of Hugh of St. Victor:

'There is little need for discourse about colours, since sight itself can prove how much the seemlier nature is, adorned with various hues. What is fairer than light, which not having colour in itself, yet by illuminating colours all things? What pleasanter sight is there than the serene heaven with its sapphire splendour . . . ? The sun blazes like gold, the moon shimmers among the jewel-like stars . . . Above all the green beauty of spring ravishes our souls when the seeds with new life push up young shoots towards the light, as though an image of death and resurrection. But why speak of the works of God? Even the work of man, deceiving our eyes with the adulterine talent of his painting, can fill us with wonder.'[1]

At one moment we are reminded of the theories of Impressionism, at another, in the term 'adulterine', of all iconoclastic fears of the art of representation. The twelfth century did not lack in subtleties of appreciation.

There has been much search for an explanation of why in the mid-eleventh century this new monumental style of architecture was developed in Normandy.[2] It was an age of architectural revival in the west. In Catalonia and along the Rhône the pre-Romanesque style, as it is called, spread from Italy with recognizably Lombardic features. Normandy reflects little of the characteristic elements of this movement. Its churches have a heavier masonry and a larger scale. The cathedral of Rouen, to which reference has already been made, was the earliest and most striking architectural example of that superabundant energy and initiative of the Normans, which in other spheres of activity carried them as conquerors throughout Europe and which were probably the most important factors in the creation of their buildings. Structurally this increase in size presented many problems. Romanesque churches, for all their schemes of buttressing, depended on their solidity rather than on

[1] Migne, P.L. clxxvi, 820. Hugh died 1141.

[2] V. Ruprich-Robert, L'Architecture normande aux XI^e et XII^e siècles en Normandie et en Angleterre, 2 vols. (1884), still remains extremely valuable. M. Anfray, L'Architecture normande (1939), is a more recent study. J. Vallery-Radot, Églises romanes (1931), is an able and stimulating summary. For England, A. W. Clapham, English Romanesque Architecture, 2 vols. (1930–4), is the essential guide.

any exact interplay of stresses and abutments. Foundations were very variously planned: some, as at Durham, were carried down to the rock; others were supported on sunk walls or set in frames of timber; some were much less thoroughly prepared, and subsidence followed by collapse was not uncommon. Stone vaulting was a problem that early exercised the minds of Norman builders, and at Bernay the abbey church begun in 1017 has groined vaults to the aisles though still a wooden roof to the nave. The experiments with different forms of support in the nave arcade are other instances of the search for stability. But it is probable that in the security of the building the quality of the mortar, both in the rubble core and the joints of the ashlar facing, played almost the most important part, and here, too, a steady development can be traced from the rough, thick jointings of the mid-eleventh century to the fine mortar and clean-cut edges of the mid-twelfth where the join is hardly apparent. The twelfth century saw also the growing use of the hammer and chisel or 'bolster' instead of the axe for the dressing of the stone, with a consequent increase in exactitude and in the range of ornamental carving.

In these activities, as carried out in England, the last ten years of the reign of Rufus seem to mark a break. With the removal in 1089 of the restraining authority of Lanfranc, the king had met some of his financial difficulties by exploitation of the Church. Bishoprics and abbeys were left vacant and their revenues seques-trated. At Ely Abbot Simeon, the brother of Walkelin of Win-chester and, as a former prior of the Old Minster in that town, acquainted with the buildings undertaken there, laid the founda-tions of the choir, though it seems unlikely that the walls had risen to any height before his death in 1093.[1] There followed a seven years' vacancy for the remainder of Rufus's reign and there can have been little funds for continuing the work. The new abbot Richard, a monk of Bec and son of Richard Clare, was appointed by Henry I on his coronation day, but in 1102, apparently owing to a quarrel between Henry and the Clare family, Richard was

[1] See D. J. Stewart, *Architectural History of Ely Cathedral* (1868), 35. Stewart also edited the *Liber eliensis* (1848). See also works of J. Bentham (1771), T. J. Atkinson (1933), G. Webb (1951).

deposed, journeyed to Rome with Anselm, and was not reinstated till 1105. It is therefore not surprising that it was only in 1106 that the eastern arm was completed and ready for the translation, on 17 October of that year, of the relics of St. Etheldreda. This disturbed period is sometimes thought to have left its mark on the south transept, where the capitals of the eastern wall are more elaborately worked than those on the western opposite them, but the evidence as to the building stages is obscure and uncertain and there is reason to think that, here and elsewhere, the eastern transept walls, included in the general view looking eastward to the high altar, received more careful treatment than the less observed western side. Anselm was eager that Ely should become the centre of an episcopal see, to reduce the cumbersome size of that of Lincoln, and in 1109 Richard's successor Hervey became the first bishop. No building is associated with his name and he was in fact more occupied with asserting that all responsibility for the fabric rested with the prior and convent. By English tradition and Lanfranc's constitutions the bishop was abbot also of the cathedral monastery, and the Norman prelates of the first generation were so in practice; but pressure of business and outside interests distracted the bishop abbot from the care of his house: the twelfth century saw the development and definition of the powers of the prior, though chroniclers continue to associate the bishop with any building carried out. At Ely Hervey seems to have forced on the separation of functions, but none the less the building of the great nave advanced steadily though slowly, following the St. Étienne pattern, already used in the transepts, of a tribune opening equal to that of the nave arcade, and a clerestory passage under a high arcade that recalls a similar design at Cerisy-la-Forêt. One of the building transitions is marked by the change from the early volute capitals to cushion or cubiform capitals, where the lower angles of the cube are rounded off towards the circular join with the shaft, leaving a flat face of roughly semicircular shape (Fig. 3);[1] these are used everywhere west of the crossing. The nave, 260 feet in length, had thirteen bays, whereas at Jumièges there are only eight; the choir consisted of four bays: excavations have suggested but not

[1] This type of capital as used at Durham can be seen in Pl. 2.

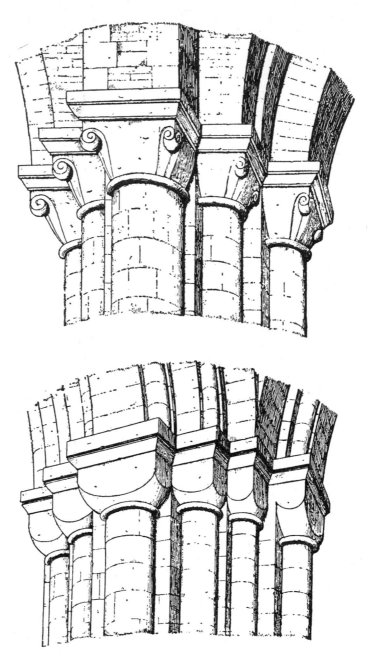

FIG. 3. *Capitals: Ely*

finally proved that for the original apsidal termination a square-ended one was early substituted.[1] The nave wall rises to a wooden ceiling so that the effect of its considerable height (86 feet) has full play, but the wall is only a framework for great arched openings. The floor space today is empty and there is little of later furnishings. The rhythms of the Norman scheme can be felt without distraction, more dominating than at the time of its creation, when painted decoration and screened choirs gave another emphasis, and immensely satisfactory in its austere survival.

The breaks and interruptions at Ely are characteristic of the period. At St. Albans there was a vacancy from 1093 to 1097, and though the abbey was already largely completed, it was not consecrated till 1115. At Bury St. Edmunds, following the death of Abbot Baldwin in 1097, there was a long pause and building was not resumed till Anselm of St. Sabas became abbot in 1119. In London Bishop Maurice before the Conqueror's death had pulled down the tower on the Fleet river to provide stone for his new cathedral, but by his death in 1107 the work is said to have advanced but little.

The same check is to be noticed in a greater building than any of these. In 1093 William of St. Carilef, bishop of Durham, who though he had held the see since 1081 had spent most of his time as an exile in France owing to his quarrel with Rufus, began a new cathedral to replace the old church built by Bishop Aldhun a century previously. Durham was a remote outpost, beyond the band of devastated territory driven through Yorkshire with which the Conqueror had limited his problems, but it still had a peculiar and compelling sanctity as the shrine of St. Cuthbert and round it were all the memories of the great days of Northumbria. William had carried out the ordinary Norman programme of substituting monks for secular clergy, a scheme which had cost his predecessor, Walcher, his life. Now, an ambitious but disappointed man, he seems to have determined to make his northern see once more a great cultural centre. He laid down that the building of the church should be at the charge of the bishop, the priory buildings at that of the monks. At his death in 1096 the work cannot have been far

[1] D. J. Stewart, *Ely* (1868), 24.

advanced, but the monks diverted their resources to carrying it on, preferring the church to their own quarters, during the three years' vacancy that preceded the election in 1099 of a new bishop, Ranulf Flambard, the notorious chancellor of William Rufus.[1] Imprisoned for a time by Henry I, he withdrew on his release to his diocese and seems to have interested himself, if somewhat spasmodically, in the building of the cathedral. We can follow the stages of the work in the contemporary writings of Symeon of Durham and his continuators; how Ranulf found it completed as far as the nave; how sometimes money was forthcoming from church dues, sometimes entirely lacking; how when Ranulf died in 1128 the nave was built as far as the roof, and how in the five years' vacancy before the appointment of his successor, Geoffrey Rufus (1133–40), the monks completed it, *navis monachis operi instantibus peracta est.*[2]

The plan of the cathedral was a nave of eight bays including two western towers; the transept arms had three bays with aisles on the eastern wall (Fig. 4). The eastern arm was composed of a choir[3] and aisles of four bays; the aisles ended in deep apses set in a rectangular outer wall; the apse of the choir, preceded by a rectangular compartment, seems, from excavations carried out in 1895, to have been semicircular both internally and externally. This appears to have been the type of eastern arm originally built at St. Étienne.[4] Rouen and Jumièges, on the other hand, had

[1] Symeon of Durham, *Opera,* R.S. lxxv (1) (1882), 128, 139.

[2] The authoritative account of the building of the cathedral is to be found in the two articles of J. Bilson, *Arch. Journ.* liii (1896), 1, and lxxix (1922), 101. See also R. W. Billings, *Durham* (1843); C. R. Peers in *V.C.H. Durham,* iii (1928), 93. There are well-illustrated short monographs by W. A. Pantin (1948) and G. H. Cook (1948). An important contribution to the subject has recently been made by J. Bony, 'Le projet premier de Durham', *Urbanisme et Architecture: en honneur de Pierre Lavedan* (Paris, 1953); he most generously allowed me to use his article in typescript.

[3] The term 'choir' is ordinarily applied to the eastern arm of the church beyond the crossing, and I have employed this familiar usage. It must, however, be borne in mind that the monks' choir extended beyond the crossing, including the first or second bay of the nave, at which point a stone screen separated it from the rest of the church; the space in the eastern arm between the choir stalls and the high altar formed the presbytery. The early tendency to elongate the eastern arm led to much shifting and change in the actual siting of the choir.

[4] E. Lambert, *Caen roman et gothique* (Caen, 1935), 36. Without excavation it is impossible to be certain whether St. Étienne had the four bays, rectangular compartment,

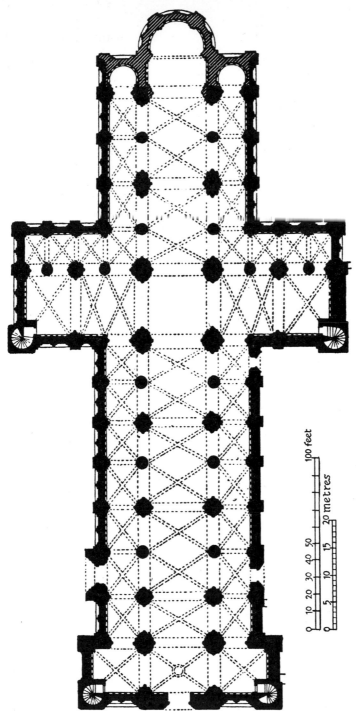

100 feet

20 metres

0 10 20 30 40 50

0 5 10 15 20

FIG. 4. *Plan of Durham cathedral*

continuous semicircular ambulatories with, at the former, three radiating chapels, a plan which was followed at Winchester, Bury St. Edmunds, Norwich, and many other Anglo-Norman churches. Canterbury and Lincoln, though the evidence in neither case is entirely clear, seem to have belonged to the type used at Durham. St. Albans had preceded Durham in the increase of the choir to four bays, in the insertion of a rectangular bay between the presbytery and the apse, and in the depth of its choir aisle apsidal chapels. Abbot Paul of St. Albans had been a monk at St. Étienne, and the affiliations of the Durham plan seem therefore to be through St. Albans with the Caen foundation. On the other hand, the elevation of the nave and choir has the proportions of Jumièges, not of St. Étienne. The arcade is composed of alternate columns and composite piers, and the tribune opening, divided into two by a small column, is only about half the height of the arched opening below (Pl. 2). The tribune galleries still retain their original round arched windows, and the majesty of Durham owes much to the fact that its play of light and shadow has not been dispelled by the intrusion of much larger windows at the tribune level. The clerestory of the nave is much more elaborate than that of its French prototype: the windows are set deeply in the wall and their arches are supported on either side by two free-standing columns, behind which a passage in the thickness of the wall runs the whole course of the clerestory range. In the choir, however, the wall, though of some thickness, is not 'hollow' and has no clerestory passage.[1] Raised on composite piers,[2] whose size can be seen on the plan to exceed that of the nave supports, it seems to have relied on its solidity rather

and apse as at Durham, or the two bays found at St. Nicolas, Caen (c. 1083), and at Canterbury. In each case the bays are counted from the eastern pillars of the crossing.

[1] J. Bilson in Arch. Journ. lxxix (1922), 127, n. 3.

[2] Pier or pillar is the term used for a free-standing block of masonry carrying an arch; a row of piers with the arches they support form an arcade. Piers may be (a) simple, in which case they are usually in English Romanesque either cylindrical or octagonal; (b) compound, that is, with columns or rectangular shafts bonded into (engaged, attached, applied) the main mass, answering to the various ribs and orders of the arch that the pier is required to carry. Where such piers, as in some Cistercian and transitional buildings, consist of a cylinder surrounded by attached columns, I have used the old-fashioned but expressive term of clustered columns. See F. Bond, Introduction to English Church Architecture, i (1913), 462.

than on any adjustments of thrust to carry the vault for which it was designed. The aisles of the choir have ribbed vaulting: the high vault, from the provision of shaft columns, seems to have been ribbed also; it was rebuilt in the thirteenth century and we cannot now be certain as to its nature. As soon, however, as the south transept was reached, a clerestory passage was introduced[1] and the supporting pillars are accordingly less substantial. This south transept has always been something of a problem. Bilson established from the relationship of the vaulting ribs to the clerestory windows that it was originally completed with a wooden roof. From this, and from the plainness of its western wall, he deduced that funds were failing and that the abandonment of the vault was necessitated by economy. This fits with some of the known facts of the cathedral priory's finances; but it has been argued by Bony that the relative plainness of the western wall is due to its invisibility in the eastern view of the church and that the natural explanation of the change from solid to hollow wall is that in the original intention the choir only was to be vaulted and the nave and transepts were to have wooden roofs, as was a common enough practice in church building of the time and one that probably had St. Albans, in this as in other matters, as a precedent.[2] As the walls of the north transept neared completion, the bold decision was taken to cover it with a vault, even though the hollow wall, with an elaborately colonnaded clerestory passage, had been employed: finally, the high vault of the nave was undertaken, though here, too, the hollow wall had been used, and the wooden covering of the south transept was replaced in stone. Only an advanced understanding of the possibilities of ribbed vaulting could have made such a scheme thinkable, and if acceptance of this view involves a later date for the planning of the Durham vaults, c. 1115, possibly even the twenties, it in no way diminishes the originality and enterprise of its builders, who advanced from the use of the ribbed vault in the choir aisles to the grand achievement of its finished nave. There has been controversy enough about it, for

[1] J. Bilson in *Arch. Journ.* lxxix (1922), 130, 132.
[2] For the groined vault of St. Albans choir see *R.C.H.M. Hertfordshire* (1910), 179.

these Durham vaults assail the primacy of France in the Gothic style somewhat as Constable threatens the French origin of impressionism; and they have to compete also with Sant' Ambrogio in Milan and a Lombardic building tradition. When so much evidence for the various claims has disappeared, such disputes are perhaps more fascinating than substantial. Durham remains the first example in north-west Europe of a major building roofed throughout with ribbed vaulting.

This revolution in structural design deserves some closer description. In the choir aisles the vault compartments are divided by transverse arches which spring from both the columns and the piers of the alternating arcades. Here, though with certain difficulties met by stilting the transverse ribs, it was still possible to retain the familiar round arch (Pl. 3 *b*). In the high vault of the nave, the transverse arches run only from the piers; the diagonal ribs are supported from corbels above the columns, so that each compartment between the piers contains two sets of diagonal ribs: in these oblong spaces it was impossible to use round diagonals springing from the same level as the transverse arch, if the latter was round in form. This problem was solved by the use of the pointed arch for the transverse ribs and the wall arches enclosing the clerestory. These pointed arches could be raised to any height, thereby preserving a level crown to the vault while still setting the height by the semicircle of the diagonals. Whereas the high choir vault was buttressed by semicircular arches built in the tribune gallery—a method which proved insufficient, for their point of abutment with the clerestory wall was not high enough—the nave vault was buttressed by quadrant arches which, equally concealed in the tribunes, found the right point of contact and have transferred the thrust to the aisle wall and so to ground level with considerable efficiency for over 800 years.

Much has been written of recent years to prove that the ribs of a vault were not structural but ornamental only, and that a groined vault was as strong without them. This thesis, which after a period of fashionable popularity seems now to be losing ground, is hard to reconcile with the efforts of the Durham builders.[1] No vault of

[1] See a summary of this controversy, with bibliographical references, in H. Focillon,

this scale without ribs was attempted in England, and the relation of the ribs to the supports and buttresses is clearly articulated and must be the result of calculated planning, quite apart from the question of the advantage of the stone web of ribs in the erection of the vault. A fuller knowledge of the interplay of stresses may invalidate some of their precautions: it has not undermined the stability of their building. Durham remains the product of an inventive and highly accomplished architect or master mason, bringing a tradition that had its origins in the east and an experimental stage in Lombardy to this splendid achievement in Northumbria, which once again appears as a leading centre in the art of the west.

These new methods were soon observed and imitated. In 1107 Walkelin's cathedral at Winchester met with disaster: the central tower collapsed, owing, the pious thought, to the burial of William Rufus beneath it, though William of Malmesbury attributes it more practically to faulty construction.[1] In the necessary rebuilding, the bays of the transept aisles nearest the crossing had to be re-vaulted, and here, instead of the groined vault of the earlier building stage, ribs are employed, with a semicircular curve and half-roll mouldings applied to the soffit as in the eastern arm at Durham. At Peterborough, following a fire in 1118, the abbot, John of Séez, began to rebuild the church, and here the choir-aisle vaulting is similarly treated; Romsey choir (c. 1125) and the churches of St. Mary and St. John at Devizes (c. 1130–40) are sufficiently close in the outline of the rib mouldings employed to suggest that they, too, looked to Durham for a pattern; there are remains also of early ribbed vaulting at Southwell, at Gloucester, where characteristically some variants are introduced, and in churches such as Lindisfarne and Selby, probably erected by the Durham masons' yard. It is in Normandy that the next developments took place. Some time after 1106, rib vaults appear in the

Art d'Occident (1947), 143, and Moyen âge survivances et réveils (Valiquette, 1943), 111. Dr. N. Pevsner has recently, but briefly, questioned the structural value of the Durham vaults, Outline of European Architecture (1945), 37. See also R. A. Cordingley, 'Norman Masoncraft in Durham Cathedral', Trans. of the Architectural and Arch. Soc. of Durham and Northumberland, vii (1934), 30.

[1] William of Malmesbury, Gesta regum, R.S. xc (2) (1889), 379.

chapter house of Jumièges, at Lessay, and the church of St. Paul in Rouen, but it is in the two great abbeys of Caen that the new experiment, the sexpartite division of the vault, was attempted between 1125 and 1140. In Matilda's foundation of La Trinité, as far as the original form of the vaults can now be reconstructed, it is merely a reinforcing rib without altering the segments of the groined vault, but at St. Étienne the six compartments of the vault are fully developed. England was not to use this system till it was brought from northern France in the last quarter of the century for the rebuilding of the choir at Canterbury.

The silhouette of Durham as it rises so majestically above the river Wear is very different from that of its twelfth-century form. The low Norman tower was struck by lightning in 1429, and the present great tower dates from the second half of the fifteenth century. It is a superb addition to the general group of the buildings, but it dwarfs the Norman west façade, whose proportions have been further masked by the Perpendicular additions to Bishop Hugh du Puiset's Galilee chapel. This façade was left uncompleted at the building of the nave and the towers are transitional work with alternating arcades of round and pointed arches which, though not clearly dated, must be work of the close of the century or the early years of the twelve hundreds. It retains, however, despite the insertion of the large Decorated west window, the main lines of a Norman west front such as that of St. Étienne, though the English examples seem, as far as we know them, to emphasize the horizontal lines rather than the soaring upward movement of the Caen abbey. At both Durham and Southwell, whose façades have many points in common, the string courses continue across the flat buttresses, whereas at St. Étienne the faces of the buttresses rise in an unbroken surface. This, however, is an unusual piece of majestic simplicity even in Normandy: at La Trinité the string courses are continuous and, as at Durham, the bases of the towers extend beyond the walls of the aisles, so that the façade is not, as at St. Étienne, logically related to the interior plan.[1] This tendency to make the west front an elaborate screen rather than a functional

[1] The façade of La Trinité may well be some fifty years later than that of St. Étienne, and the completion of the building shows many signs of English influence.

statement was to find much favour in twelfth-century England and to culminate in the thirteenth century with the splendid extravagance of Wells. Southwell façade, despite its large Perpendicular window, retains much of the simplicity of the early Norman style; its pyramidal spires, copied from drawings of the lead-covered wooden ones destroyed by fire in 1711, were restored in 1880, and its exterior thus gives a clearer picture of the original silhouette than any that we possess elsewhere, for the timber superstructures of our church towers in the eleventh and twelfth centuries are only known to us in contemporary representations as delineated on the Bayeux tapestry, monastic seals, illuminations or drawings such as the famous design for the Canterbury waterworks,[1] and, on a small scale, in a few village churches such as Blackmore in Essex, a stoneless county where several ancient wooden structures have been preserved.

On the exterior Durham is austere and unornamented, all the more so since nineteenth-century scraping of the stone has marred the projection of the mouldings. It recalls the severity of earlier buildings such as Winchester. Within, a change is at once apparent. Throughout the capitals are of the plain cushion type; on the single columns they are octagonal in form. In the building stages that extend to the easternmost bay of the nave, the soffits of the arches have rounded mouldings with a new softness of recession, and the great pillars have spiral decorations, possibly once inlaid with metal. In the other bays of the nave soffits and ribs take on a new elaboration: chevrons are freely used and the outer rim of the great arches has a single row of billet ornament; the columns are decorated with lozenges, chevrons, or fluting. A new sense of variety, a new surface play of light and shadow, stimulates the visual attention. Round the aisle walls stretches a band of arcading formed by interlocking arches, a method of ornament which was to enjoy immense popularity in England. It is a motif of Islamic origin, and its earliest European use seems to have been in Spain. Contemporaneously with its English popularity it formed part of the decorative schemes of southern Italy; it is found in Normandy, as, for instance, at Graville-Ste-Honorine, but used

[1] See below, p. 160.

sparingly. In England it becomes the most characteristic feature of the Romanesque style. It appears on a capital in the crypt of Lastingham built by Stephen of Whitby in 1078,[1] but its earliest arcaded use in England is probably in the choir aisles of Durham. In the first quarter of the twelfth century it is lavishly and widely employed and with ever-increasing elaboration remains in vogue throughout all the century.

There is no question but that the Durham masons' yard was much employed elsewhere. Our knowledge of the organization of such yards and of the method of their dispersion, whether men trained in them became master masons of other undertakings or whether groups of workers were seconded for special tasks, is very incomplete. Certainly the masons were itinerant rather than local, and the main quarries, where stone was partially faced before transport, may have been the chief training-grounds. Some workmen possibly came to Durham with the loads of building stone shipped from the Caen quarries. If their presence is to be deduced from the impress of the Durham style, their later journeys took some of them south to Essex, others as far north as Orkney. Lindisfarne priory was founded as a cell of Durham by William of St. Carilef. Reginald of Durham[2] gives us a full account of the building of a church, 'new from its foundations, finished of squared stone, of all elegance of workmanship'. He even compares, with an obvious technical interest, the stone brought from the mainland with that on the island, which sea air had made friable and which could only be used for the rubble. Reginald, mainly preoccupied with the miracles of St. Cuthbert, though his keen interest in all around him breaks through in his descriptions of a nesting eider duck or a hunted stag, does not give us any exact date for the building. A Durham monk, Ædward, *officialis frater* Reginald calls him, was charged with the work, though apparently in a managerial rather than technical capacity. The plan was composed of an aisled nave of six bays, transepts, and an apsidal choir, replaced later with a square end. The ruined aisles of the nave have fragments

[1] J. C. Wall in *The Reliquary*, xii (1906), 145.

[2] *Reginaldi Monachi Dunelmensis Libellus*, Surtees Soc. i (1835), 44. Reginald was writing after 1172. C. C. Hodges (*Builder*, 1895, 414) and A. H. Thompson (Ministry of Works Guide, 1949) differ on many points.

of ribbed vaulting: the nave clerestory had no wall passage and the external walls where they survive have external pilaster buttresses. The columns, which alternate with composite piers, have chevron and highly elaborate lozenge patterns. The west front, with lateral projection of the towers beyond the width of the aisles, similar to that at Durham, has an arcade of single arches and a doorway with chevron and billet ornament.

The abbey church of Selby was begun by its Norman abbot, Hugh de Lacy (1097–1123), who is described as *architectus* and was so devoted to the building enterprise that, wearing a labourer's smock, he joined in the carrying of stones and any other needful material. Here again the Durham plan and almost certainly Durham masons were employed. The eastern arm and transepts, where the details of mouldings are very similar to the later stage at Durham under Flambard, were probably completed during Hugh's lifetime; the nave was finished more gradually, but from the first the scheme seems to have included a stone quadripartite vault.[1]

The abbey of Holy Cross at Waltham had special ties with Durham. The creation of Harold and traditionally his burial place, it had been despoiled by William Rufus and many of its estates given to the bishopric of Durham. Under Henry I it enjoyed the patronage of his consort, Matilda, who doubtless had sympathies of her own for this Saxon centre, despite its connexion with the usurper. Of Harold's work nothing remains; probably only the east arm had been completed, which was remodelled and enlarged when in 1177 Henry II, as part of his expiation for Becket's murder, transformed this college of secular canons into a priory (in 1184 an abbey) of Augustinian regulars. This rebuilding has also left little trace and the parish church of today is mainly composed of the nave, built in the first half of the twelfth century. Here we have the proportions of the Durham elevation, with clerestory passage, alternate columns, and compound piers, with buttress shafts rising from the latter; the arches of the tribune arcade are fully open, but have side colonnettes which suggest

[1] J. T. Fowler, 'The Coucher Book of Selby' (with an architectural description of the church by C. C. Hodges), *Yorks. Arch. & Top. Ass. Record*, xiii (1893); for Abbot Hugh, see ibid. 22, from an anonymous chronicle written in 1184.

that dividing arches were intended. The aisles now rise to a wooden roof above the tribune arch, but originally there was a lower roof or vault forming a gallery. On the capitals, where Durham has a single curve on the cube face, Waltham has the face divided into two or more curved divisions carried down to the necking in a semi-cone, a form known as the scalloped or 'godron' capital. These scallops are, however, of an early type, and the billet ornament, the low relief of the chevrons on the outer courses of the arches, and the characteristic spiral and chevron decoration of the pillars all proclaim a date about 1120 and close association with Durham (Pl. 3 a).[1] There was in fact a constant interchange between the two houses. Laurence, poet, chronicler, and prior of Durham from 1149 till his death in 1154, came from Waltham, as did Richard, the sacrist at the same period. Laurence praises the beauty of his native church,[2] but provokingly the questioner in his dialogue form cuts him short: 'Pulchra sit: esto brevis'.

William of St. Carilef, whose praise as founder and enlightened benefactor lives in the pages of Symeon, is a puzzling character— a man undoubtedly over-ingenious in public affairs and sometimes caught in his own compromises.[3] From 1088 to 1093 he was in exile in Normandy: to Durham and the north the victim of plots and persecution; to Canterbury and the south a Judas who had betrayed his master. Having made his peace with Rufus he returned 'not empty handed', Symeon tells us, 'but sending to the church, before he came himself, many sacred vessels for the altar, and divers ornaments of gold and silver, as well as various books', or, as the later verse translator puts it, 'also many gude bokes That monkes hydir to on lokys'.[4] A list of the books bequeathed by William, nearly fifty in all, is inscribed on the fly-leaf of the second volume (the first has not survived) of his great bible. Of these certainly sixteen, possibly nineteen, still remain at Durham.[5] This

[1] R. C. Fowler, *V.C.H. Essex*, ii (1907), 166. *R.C.H.M. Essex*, ii (1921), 237.

[2] *Dialogi*, Surtees Soc. lxx (1880), 41.

[3] H. S. Offler, 'William of St. Calais, first Norman Bishop of Durham,' *Trans. of the Architectural and Arch. Soc. of Durham and Northumberland*, x (1950), 258.

[4] *The Life of St. Cuthbert in English Verse*, ed. J. T. Fowler, Surtees Soc. lxxxvii (1889), 233.

[5] C. H. Turner, 'The Earliest List of Durham MSS.', *Journ. of Theol. Studies*, xix

block of manuscripts, which can with some confidence be dated as written and illustrated before the bishop's death in 1096, is a rare boon in the problematic study of medieval illumination. There is, of course, no necessity that these manuscripts should be the product of a Durham scriptorium. Some of them were certainly among the 'gude bokes' brought back from Normandy and one, the third volume of St. Augustine's Commentary on the Psalter (B. II. 14), has a set of verses giving the name of the scribe and stating that it was written during the bishop's exile. The second volume of this work also survives and contains a portrait of the bishop signed by the painter, Robert Benjamin. William's reorganization of the scriptorium left its mark on the Durham calendar, where on 1 July, the feast of St. Carilef, first abbot of William's old monastery of St. Calais in Maine, was long included.[1]

The most elaborate decoration is found in the surviving volume of the bishop's bible. There are no full-page illustrations, but a series of initials, where human figures and monsters 'inhabit' great coils of knotted acanthus, and the bars and semicircles of the letters have cats' masks and sometimes end in interlace patterns. Much of this clearly descends from earlier Anglo-Saxon work, but it is closely paralleled by contemporary work in northern France.[2] These Norman scriptoria have as yet been but imperfectly studied. In the Bibliothèque Nationale and in the municipal libraries of Avranches, Évreux, and Rouen there are manuscripts from the various Norman centres, St. Michel, Fécamp, St. Évroult, Lyre, Jumièges, which date from around 1100 and stylistically form a

(1918), 124–33; R. A. B. Mynors, *Durham MSS.*, 32–45. Only three of the books have the bishop's name; but on stylistic grounds or through references in later catalogues there can be little doubt about most of the identifications. See below, pp. 42, 44.

[1] F. Wormald, *Benedictine Kalendars*, i (1939), 165.

[2] The problem of manuscript illustration in Normandy is still only partially explored. Dr. Otto Pächt's forthcoming book on twelfth-century English illumination will undoubtedly set the whole question in a new light, and show that between the conquest and the introduction of the new Albani style English work was closely linked with the contemporary Norman style. His article, 'Hugo Pictor', *Bodleian Library Record*, iii (1950), 96, is a brief but valuable introduction to the subject. I am much indebted for advice and information to him and to Professor Francis Wormald, whose articles (see bibliography) are the present basis for the study of twelfth-century English illumination.

connected group. Ordericus Vitalis has left us a vivid picture of the scriptorium at St. Evroult: it is calligraphy that he stresses and which he himself practised, but the drawing of William of Jumièges presenting his work to William the Conqueror at the opening of Rouen MS. 1174, which is written by Ordericus, may well be by him.[1] It seems clear that certain features—the inhabited scroll, the gymnastic initial, where climbing figures fill the bar of the letter,[2] and hatched shading, none of them completely absent in Anglo-Saxon work—were developed in northern France and from there came to England, though as features of a style that itself was English in origin. The Carilef Bible (Durham A. II. 4), the two volumes of St. Augustine's Commentary on the Psalter (B. II. 13 and 14), the Commentary of St. Jerome on the Minor Prophets (B. II. 9), and the *Moralia* of St. Gregory (B. III. 10) all belong markedly in their illuminations to this north French school, and some, perhaps all, were imports from it. In the capitular library of Bayeux cathedral, the cathedral of the arch-rebel Odo with whom Bishop William's relations had been so equivocal, there is a manuscript, another *Moralia*,[3] which might almost be by the same hand as much of the Carilef Bible. Their two great capital Bs (Pl. 4) have exactly similar foliage, dragons' heads, and interlace terminals, though in the Carilef letter the lower circle has the seated figure of David, while in the *Moralia* the coil is inhabited by a beast. The David, however, and other Carilef figure initials strikingly correspond with a figure initial at Bayeux: there is the same pose, the same emphasized bow for the line of the mouth and triangular treatment of the feet (Pl. 5 c). The Jerome Commentary has initials of a different type with fuller modelling and much use of dotted lines, but it, too, has many Norman parallels. Robert Benjamin's portrait of the bishop belongs to yet another group,[4] finer and more elegant in its conception: his drawing of himself and inscribing of his name are Norman rather than English

[1] For reproduction, see J. Lair, *Matériaux pour l'édition de Guillaume de Jumièges* (1910). [2] B.M. MS. Add. 17739 from Jumièges is a striking example.

[3] Bayeux, Capitular Library MS. 57-8. See H. Swarzenski, 'Der Stil der Bibel Carilefs von Durham', *Form und Inhalt: Festschrift für O. Schmitt* (Stuttgart, 1950), 89.

[4] Reproduced in *O.H.E.A.* ii (1951), Pl. 86, and in R. A. B. Mynors, *Durham MSS.*, Pl. 20.

practices. These formal portraits with no attempt at likeness (in fact William, though identified by the inscription, is shown with a halo as a saint) become a marked feature of the illustrative work of the period. An interesting comparison may be made between that of Bishop William and the figure of Bishop Ivo of Chartres, the friend of Adela of Blois, the Conqueror's daughter, carved on the ivory crook of his pastoral staff, now preserved in the Bargello.[1] Here also are to be found the dragon scrolls and cats' masks of Anglo-Norman decoration. Ivory and metal-work along with illumination were certainly media by which ornamental motives were distributed. The standing portrait, appropriate for a bishop in the act of blessing, was to find its commonest use on seals, an important means of tracing the change of types. The seal of Ranulf Flambard as bishop of Durham, with the fan-shape spread of his garments, is a close variant of Benjamin's portrait of Bishop William.[2]

These Norman influences must have been predominant as the Durham scriptorium was formed, but there are clear signs of other traditions also at work. MS. Hunter 100 is a collection of medical treatises, which from internal evidence can be dated with some certainty to Flambard's episcopate (1099–1128): it contains pen-drawings of the constellations and of medical treatments, some of which are clearly based on classical models and have taken from them a new naturalism of pose and outline (Pl. 6 a). The fine small script of this book is found again in a Bodleian manuscript of Bede's life of Cuthbert,[3] which has an initial of the author writing, tinted in green and red and close in style to the Hunter drawings. The figure is framed in acanthus foliage, but with none of the coiling confusion of the Carilef Bible. An initial to a life of St. Birinus in MS. Caligula A. VIII in the British Museum, a volume with Durham connexions, has a small horseman riding through it and is of similar workmanship. The same or an associated hand has

[1] A. Goldschmidt, *Die Elfenbeinskulpturen*, iv (1926), Pl. xii.

[2] C. H. Hunter Blair, 'Mediaeval Seals of the Bishops of Durham', *Archaeol.* lxxii (1922), 1; also H. Jenkinson, 'The Study of English Seals', *Journ. Brit. Arch. Ass.*, I, 3rd series (1937), 93.

[3] MS. Digby 20, f. 194. Reproduced *Bodleian Eng. Rom. Ill.* (1951), Pl. i.

drawn a miracle of St. Nicholas,[1] as initial to a life of the saint, and here the figures have achieved freedom of space within the letter, undisturbed by any luxuriant leafage. Greatest example of all this trend, where the old Anglo-Saxon sensitivity of line reappears strengthened by a revived study of classical examples, is a life of St. Cuthbert, which has a press-mark that is not a Durham one but which has close relationships with the Durham school, though its firmness of outline suggests a slightly later date than the other examples.[2] The small scenes, coloured in reds and greens with occasional gold ornament, are vividly imagined; the gestures are dramatic; the action, though with one exception unframed, admirably centralized by the balance of the design (Pl. 6 c). The artist has learnt something from the Romanesque style, his thin figures are defined in volume by circular strokes which were not used a hundred years earlier; but it is the return of the native graphic genius, and no parallels from Normandy need be in question. Here we have the hand of a master.

Elsewhere than Durham libraries were being compiled. In Exeter there was a tradition of book collecting that came from the episcopate of Leofric (1046–72), the learned and pious Lotharingian to whom Edward the Confessor had given the diocese.[3] Here again, as at Durham, we have the invaluable evidence of a contemporary list. These books, however, belonged to an earlier generation. Leofric's successor Osbern (1072–1103), a well-connected Norman, brother of the William Fitz-Osbern who under the Conqueror became earl of Hereford, had settled in England under the Confessor and was in his habits, William of Malmesbury tells us,[4] more of an Englishman than a Norman, and, indeed, he alone of the bishops made no attempt to rebuild his cathedral on the new Norman scale. The books, however, of his cathedral library tell a different story. They have survived in considerable numbers and much of their decoration is closely akin to that of the

[1] Durham MS. B. iv. 14, f. 170. Reproduced Mynors, *Durham MSS.*, Pl. 35.

[2] MS. University College, Oxford, 165. See *Bodleian Eng. Rom. Ill.* (1951), Pl. 6, and *New Pal. Soc.*, 2nd series (1915–30), Pl. 67.

[3] See *Exeter Book of Old English Poetry*, R. W. Chambers, M. Förster, and R. Flower (1933), 5, 10. If not born in Lorraine Leofric was, according to William of Malmesbury, trained there. [4] *Gesta pontificum*, R.S. lii (1870), 201.

Carilef volumes. Osbern's brother, Earl William, was the founder
of the abbey of Lyre in the diocese of Evreux,[1] and some manu-
scripts associated with this house have much similarity with those
of Exeter. There are also strong resemblances with the Bayeux
manuscript which I have already used as a parallel to the Carilef
Bible. An initial from the Bayeux *Moralia* and one from an Exeter
Commentary on St. John (MS. Bodley 301) may be compared on
Pl. 5. It is a similarity which cannot be gainsaid. These Exeter
books, several of which are in the Bodleian Library, have nor-
mally foliage and dragon initials with green, blue, and red as the
dominant colours. The most splendid example is a Commentary
of St. Jerome on Isaiah.[2] The artist has given us his name and
portrait, 'Hugo Pictor' at work with his stylus, his reed pen, and
his ink-horn fixed into the arm of his chair: '*Imago pictoris et
illuminatoris huius operis.*' He is a monk; his tonsure is plainly
visible and he has in fact left us another portrait of himself,
unmistakably by the same hand, in a fragment, an exultet page
bound in with various manuscripts from the library of St. Ger-
main-des-Prés (now Bibliothèque Nationale lat. 13765), where he
shows himself as a priest blessing the Pascal candle and where he
signs 'Hugo Levita'.[3] The Exeter manuscript, however, opens with
works more elaborate than the little stiff portrait, a seated figure of
Isaiah, based on some earlier evangelist type, and Jerome dictating,
a scene imagined with some freshness. Most striking of all is the
great initial of the opening page of text:[4] designed in swirling coils
the figure of the Virgin, carrying the 'Virga', Isaiah's 'shoot out
of the seed of Jesse', is enthroned between Jerome and Isaiah; a
little twisting dragon supports St. Jerome's desk and ink-horn;
at the bottom of the curve is the burial of Paula, to whose death
Jerome refers in his introduction, rendered with great delicacy of
line and considerable pathos (Pl. 5 a). The figures seated in the
coils are close to those in a British Museum manuscript (Add.
11850) which in its turn is stylistically linked to the Bayeux

[1] G. Oliver, *Lives of the Bishops of Exeter* (1861), 11.
[2] MS. Bodley 717, *New Pal. Soc.*, 2nd series (1913–20), Pls. 190–2.
[3] O. Pächt in *Bodleian Library Record*, iii (1950), Pl. 5.
[4] Reproduced in *Bodleian Eng. Rom. Ill.* (1951), Pl. 4.

Moralia; but its complex patterns can best be paralleled in a Beatus initial of an Evreux manuscript (No. 131), probably from the abbey of Lyre; a Rouen manuscript (No. 456), which came from St. Evroult, has the story of David somewhat similarly set in the foliage of a great B; while Rouen MS. 1408, from Jumièges, recalls in its drawings of the Virgin and of Christ in Majesty the style of Hugo's Isaiah and Jerome pages. Whether it was painted in Normandy or in England by a leading Norman artist who had followed this new expansion of his countrymen, the Exeter volume is a splendid example of the Anglo-Norman style of the turn of the century.

The monastery of Abingdon provides another striking instance of these interconnexions. Rouen MS. 32 is a volume of the gospels inscribed as presented by Reginald, abbot of Abingdon from 1087 to 1097, to Jumièges, where he had been a monk.[1] Its initials are drawn in red outlines: they include Christ blessing and some heads set in circles but are primarily concerned with men and beasts fighting in the coils. They are able work, but their hard, firm outlines suggest a Norman rather than an English hand. Abingdon was to become a great centre of the arts. Abbot Faricius (1100–17),[2] a great builder and donor of relics, imported additional scribes to write and doubtless also decorate his books, and some of these may well have come from Norman centres, carrying on a tradition of patronage that Reginald had begun.

[1] For Reginald see *Chronicon Monasterii de Abingdon*, ed. J. Stevenson, R.S. ii (2) (1858), 15.

[2] Ibid. 44 and 285. See D. Knowles, *Monastic Order* (1941), 181, 520.

II

CANTERBURY

WHILE in the north the masons of Durham were re-establishing the ancient glories of Northumbria, in the south, open to more varied and geographically closer influences, the greatest architectural event was the rebuilding of the choir of Christ Church cathedral, Canterbury. It was a lavish enterprise, for it entailed pulling down the work of Lanfranc, which in 1077, only some twenty years earlier, had seemed a pattern to the English Church. Gervase of Canterbury tells us[1] that Lanfranc had designed his monastery, whose walled enclosure was an innovation in England, for 150 monks, a number certainly not reached before the mid-twelfth century, so that pressure on space can hardly have been the reason for the new choir. But Lanfranc's church was not a large building by the new standards that were coming into use: its total length was 285 feet, shorter by 33 feet than the nave alone of Winchester, the largest of the Anglo-Norman buildings. The prior responsible for carrying out the new design was Ernulf, who had been chosen from the monks of Christ Church and appointed by Archbishop Anselm in 1096. The new archbishop had found his see impoverished by four years of vacancy when in 1093 he yielded to the king's insistence and accepted the primacy; till his death in 1109 he was to be in constant dispute with the Crown, which under both Rufus and Henry retaliated by confiscating the revenues of the see. It was an unpropitious time for the extension of his cathedral. Yet it is clear from the narrative of his chaplain, Eadmer,[2] that the new eastern arm was undertaken at his initiative and at least partially at his expense from the demesne revenues of the see. Anselm, though the appointment of the prior still lay with the archbishop, allowed him to conduct the affairs of the monastery without interference.[3]

[1] *Actus pontificum*, R.S. lxxiii (2) (1880), 368.
[2] *Eadmeri historia novorum in Anglia*, &c., R.S. lxxxi (1884), 13, 75, 219.
[3] For the organization of the monastery see R. A. L. Smith, *Canterbury Cathedral Priory* (1943); for the architectural history, R. Willis (1845).

William of Malmesbury and Gervase of Canterbury both confirm
that the work of rebuilding largely dated from the priorate of
Ernulf, which lasted till 1107, when he was promoted to be abbot
of Peterborough. Conrad, his successor, held the office for twenty
years and must have played a considerable part in completing the
'glorious choir'. It was finally consecrated by Archbishop William
of Corbeuil with a great assemblage of the bishops of England in
1130. William of Malmesbury writes of it in a famous passage too
significant to be dispensed with: 'Nothing like it could be seen
in England either for the light of its glass windows, the gleaming
of its marble pavements, or the many coloured paintings which led
the wondering eyes to the panelled ceiling above.'[1]

The probabilities suggest that the work, so impressive to con-
temporaries, was planned under Ernulf in his first year of office,
before Anselm's break with Rufus and departure to France; that it
was carried on intermittently throughout the disturbed episcopate
of Anselm and completed by Conrad in the more accommodating
period following 1114, when Ralph d'Escures was finally elected
archbishop, and on his death in 1122 under the rule of his suc-
cessor William of Corbeuil. The plan is from the time of Ernulf;
the elaboration of the ornament comes from that of Conrad.

Lanfranc's cathedral had a façade rising to a gable between two
towers, one of which survived Prior Chillenden's rebuilding of the
nave at the end of the fourteenth century and stood till 1834, 113
feet high, divided into five stories, severely plain in ornament,
with large arcades enclosing smaller twin openings—the common
system of tribune opening, and probably that used in the tribunes
within. The nave had eight bays: there were a central tower and
transepts, and beyond a raised choir and aisles of two bays ending
in apses. The proportions throughout show many similarities to
those of Lanfranc's former abbey of St. Étienne at Caen.[2] In the
new design the choir was pulled down and rebuilt, lengthened
to nine bays, with a second transept. The eastern end was peri-

[1] *Gesta pontificum*, R.S. lii (1870), 138. In MS. Magdalen College 172, f. 90, which is
probably autograph, this last clause 'which led the wondering eyes . . .' is crossed out,
possibly because the author had already used it to describe Lanfranc's cathedral:
ibid. 69. [2] For the choir of St. Étienne see above, p. 14.

apsidal, with a continuous ambulatory: opening off it were three rectangular radiating chapels, of which the western pair had apses (Fig. 5). The length of this enlarged eastern arm was 198 feet.

The ambulatory plan had obvious advantages for great processional services, particularly in a church such as the cathedral of Christ Church, rich in the relics of Anglo-Saxon saints. Here Dunstan and Alphege, if their cult was never so deeply embedded in popular affection, vied with the fame of Cuthbert in the north, and Anselm had been emphatic that no Norman prejudice should affect such saintly predecessors. The first example of the ambulatory plan in England seems to have been that of Battle abbey,[1] completed before the Conqueror's death and a near neighbour to Canterbury. The scheme had, however, already been employed at Canterbury in the second great church, that of St. Augustine's abbey, begun by Abbot Scotland between 1070–3 and fully completed under his successor Wido by 1099. Ernulf's work seems to have included the crypt and the lower stages of part of the walls of the choir, of the eastern transepts, and of the two radial chapels of St. Andrew and St. Anselm. His pier bases are easily distinguishable from later work and some of the arcades of the choir aisles have arches with no mouldings, decorated by a characteristic sharply pointed saw-tooth chevron which must be from the early building stage.

The great crypts, which are to be found in many Anglo-Norman churches, are not matched by any Norman examples with the possible exception of the crypt of the cathedral at Rouen. Rather was it Burgundy, with Tournus, Auxerre, and St. Bénigne, to which we must look for examples; and beyond Burgundy to Italy. In England small rectangular crypts were built in Anglo-Saxon times, and one of them, that at Repton, was vaulted on circular columns in the early eleventh century: before the century ended pillared ambulatory crypts, with chapels opening off them, were built at Winchester, St. Augustine's, Canterbury, Gloucester,

[1] For Battle, built by monks from Marmoutier and modelled on St. Martin of Tours, see Rose Graham, 'The Monastery of Battle', *Journ. Brit. Arch. Ass.* xxx (N.S.) (1924), 55; reprinted *Eng. Eccles. Studies* (1929), 188.

C.1071-78
C.1100-25
C.1174-84

0 10 20 3040 50 100 feet

0 5 10 15 20 metres

Fig. 5. *Plan of Canterbury cathedral*

Worcester, and Bury St. Edmunds, which last still lies unexcavated. The crypt at Worcester, with its closely spaced columns and stilted arches, is a building of unusual and memorable quality. Even at a smaller church such as Lastingham there was a rectangular crypt with pillared aisles, and the castle chapel at Oxford had an aisled apsidal crypt, the columns of which with their remarkable capitals, decorated with flat triangular groovings, still exist.[1] Romanesque St. Paul's in London was famous for the size of its crypt: *tanta criptae laxitas*, William of Malmesbury describes it.[2] Ernulf's two crypts, at Canterbury and later at Rochester, stand in this line of development. At Canterbury the crypt is 190 feet long (Pl. 8 *a*).[3] It has a remarkable series of carved capitals, intermixed with others where the cushion face is entirely plain and where any decoration that there was must have been painted. These capitals form something of a crux in the history of our Romanesque sculpture, and very various opinions have been expressed as to their date.[4] They are by no means of one style or of one workmanship, but their placing in the crypt does not correspond to their stylistic groups. For the most part free standing, on low columns within convenient reach, they were probably carved *in situ*. The columns forming the nave of the crypt are alternately plain and carved with various decorative motifs: if the column is plain, the capital is carved and vice versa: from the necking of some of these columns depend small sharply pointed saw-teeth similar to those on the early portion of the interior arcade of the choir. Ernulf's masons must have been among the first to employ this

[1] C. Lynam, 'The Crypts of the Churches of St. Peter in the East and of St. George within the Castle, Oxford', *Arch. Journ.* lxviii (1911), 209.

[2] William of Malmesbury, *Gesta pontificum*, R.S. lii (1870), 145.

[3] W. A. Scott Robertson, 'The Crypt of Canterbury Cathedral', *Archaeol. Cantiana*, xiii (1880), 17 and 500.

[4] The problems of Romanesque sculpture in southern England have been exhaustively studied by Dr. G. Zarnecki in a thesis for the University of London, *Regional Schools of English Sculpture in the Twelfth Century: the Southern School and the Herefordshire School*. This supersedes all earlier work on the subject. I am much indebted to it, to many conversations with Dr. Zarnecki and to his remarkable corpus of photographs (deposited at the Courtauld Institute, University of London) in this and the following chapter. Some of his conclusions are summarized in his *English Romanesque Sculpture 1066–1140* (1951), where a selection of the Canterbury capitals is reproduced, Pls. 47–57.

primitive type of the chevron that was to become so character-istic a feature of the Romanesque style in England. The column alternation is not, however, strictly followed, for the third pair of columns from the west have carved shafts but also carved capitals, one of which has been left unfinished as though the mistake had been realized: this unfinished capital is an indication that the carv-ing was done after the capitals had been put in position.

The stylistically earliest group of capitals has double rows of leaves with corner volutes, or volutes with between them a heavy T-shaped cross such as is found on the capitals of St. John's chapel in the Tower of London.[1] Some of these may be re-used material from Lanfranc's church, and it is likely enough that the bulk of the crypt capitals, all or almost all uncarved when originally put in position, came from the earlier building. Some of the uncarved capitals have abaci decorated with scale pattern or a version of the 'egg and dart', both of which suggest classical models. The north entrance to the crypt has similar volute capitals and also scale pattern, but the elaborate chevroning of the arch must be some-what later and the free-standing angle columns of Purbeck marble show that this doorway must have been much remade at the rebuilding following the fire of 1174. The diamond pattern on the walls of the stair leading down to it seems, however, early work and recurs on Ernulf's building at Rochester. Angle volutes, scale pattern, and double rows of leaves appear on the exterior arcade between the south-east transept and the southern ambulatory chapel (St. Anselm's). These capitals could much less readily have been carved *in situ*, fitting closely as they do against the wall in a blind arcade, and it is only reasonable to assume that they were prepared in the yard and put in position as required. As they are on the easterly portion of the choir, they must belong to a com-paratively early stage of the building. Moving westward along this southern wall of the choir (and also on three bays of the north-east transept) we find capitals which correspond to the second stylistic phase in the crypt. These arcades have also the system of carved and plain columns and above the arcade is a row of inter-

[1] See an interesting discussion of early Norman capitals by D. Roth in *Journ. of R.I.B.A.* xlii (1935), 867.

lacing arches. This is the motif we have already seen at Durham, but there the mouldings were rolls of a severely simple elegance; here the arches have a rich lozenge ornament with below it a roll moulding on which billets are set giving a sharp contrast of light and shade. With its carved columns, its deeply undercut capitals, and the rich surface of its arches, the arcade, even in its weathered state, has a brilliant liveliness and variety (Pl. 8 b). Finished as it must have been some little time before the ceremony of 1130, showing in its ornamental detail strong similarities with, but advances on, the carving of the crypt, it can be taken as dating these Canterbury sculptures to the twenty years preceding the completion and consecration of 'the glorious choir'.

It is to this second style of carving that the fame of the Canterbury capitals is mainly due. The leading master chose his subjects from the current repertory of the fabulous and the grotesque: music-playing beasts, winged griffins, two-headed monsters, jugglers, men fighting with lions. The face of the capital is treated as a unit with little regard for the curves of its surface: there is little use of foliage, though leaves sprout from the monsters' tails or terminate long coils twisting from the mouths or hair of masks. On one capital, where on one face the wolf of the bestiary story bites his leg, on two others a warrior rides his horse and on the fourth face a man wrestles with a lion, the statement is singularly direct and simple. The carving is in bold relief, cut with a precise certainty of touch and when coloured must indeed have been a vivid spectacle. The celebrated and popular capital that stands on the central pillar in the crypt chapel of St. Gabriel may be taken as a more typical example of the main style (Pl. 9 b). On two sides are scenes of beasts making music: a goat sitting on a dragon plays a recorder despite the fact that the dragon is biting his wrist: opposite, a winged creature, half ram, half woman, plays a viol: on an adjoining side it is a fox that plays the recorder[1] while a

[1] The goat plays an end-blown instrument: the fox appears to be playing a side-blown instrument, which should therefore perhaps be termed a flute. The holes and strings of these instruments are all marked with obvious care, a useful reminder that in the art of music also there were developments afoot and that Joannes Cotto's thesis, in which the new diaphonic trends are expounded, may well have been written in England near the time at which the capitals were being carved. Professor Knowles

griffin performs on the harp. These are the beasts that, despite their
long ears, make no sense of the music that they play, 'the ass and
the lyre' quoted by Boethius in his *Consolatio* and so made a
familiar phrase to medieval scholars.[1] On the other two faces of
the capital are a fawn-like creature seated between two dragons,
a motif that must have some eastern prototype, and two confront-
ing griffins springing from a mask. The different textures of skin,
hides, feather, scales, are all carefully rendered: the coils have a
beaded pattern. As pieces of decoration on a confined and difficult
space, they are immensely ingenious. On another capital the com-
bat of a dragon and a dog shows the feeling of tense energy that
the carver could impart to his stone (Pl. 9 *a*). On the external
arcades, the capitals are weathered and much of their quality lost:
there are one or two figure subjects; a horseman with a spear;
fighting dragons, their tails marked out in bead pattern; scenes
from the same repertory and of the same workmanship as those
in the crypt.

There remain three crypt capitals which are quite differently
treated and which have no parallels in those of the choir arcade.
In them the cushion form is carefully preserved and the semi-
circular line on each face is heavily moulded. The whole surface
within and below this line is closely carved with thick acanthus
foliage (in two cases animals, a dog and a dragon, fill the upper
space) clearly based on earlier designs of the 'Winchester' school.
The leaves are strongly articulated, with beading on the stems and
veins, and the tips turn over in a curling movement. It is a style
whose revived popularity can be seen in many manuscripts of
approximately the same date. Some fragments preserved at St.
Augustine's show that the same mason or group of masons worked
also at the neighbouring monastery. While the 'master of the
music-playing beasts' remains a distinctive, individual artist, this
new acanthus style was widely distributed: very similar, though
slightly coarser, work can be seen on a fragment at Westminster:

has suggested to me that the length of English churches enabled processional chants
to be carried out entirely indoors with considerable gain in musical effect.
 [1] E. Mâle, *L'Art religieux* (1924), 339; H. Adolf, 'The Ass and the Harp', *Speculum*,
xxv (Cambridge, Mass., 1950), 49.

its influence is apparent at Hyde abbey and at Reading: and at Romsey a series of capitals approximate so closely to the Canterbury examples as to suggest some actual interchange of masons (Pl. 14).

The sources of these designs, particularly those of the figure subjects in the second group, are not far to seek. They correspond so closely with illuminations of the Canterbury school that there can be little doubt that these served as models to the sculptor or that, more likely, sculptors and painters shared some common pattern book. The art of illumination at Canterbury centred in two scriptoria, that of Christ Church and that of St. Augustine's. Both monasteries had large libraries, and we are in the case of Christ Church unusually well informed, through medieval lists, about the books in its possession.[1] From what must have been a prolific output, many manuscripts still survive of which a considerable number are illuminated.[2] Though there are marked distinctions between the products of the two scriptoria, there are also many points of contact, and their artists, with those employed at or for Rochester, form the most accomplished and typical school of this first phase of Anglo-Norman book decoration. At St. Augustine's, despite the fact that its abbot, Scotland (1070–87), came from Mont St. Michel, there was a marked survival of Anglo-Saxon technique. The lines are light and broken: the highlights are brought out with contrasted flecks of white and black: there is a vivid sketchiness of drawing, a slim elegance of pose and gesture. The Martyrology, now MS. Vitellius C. XII in the British Museum, is a masterpiece in this manner. The Virgo in the KL (Kalends) initial for September is true Anglo-Saxon impressionism, though somewhat heavier in the deep purple colouring of its background.[3] Even here, however, the figure has lost something of the freedom of earlier days and is enmeshed in the foliage coils of the initial

[1] M. R. James, *Libraries of Canterbury and Dover* (1903). James's other catalogues, listed in the bibliography, are the prime source of information about English manuscripts. See also for Canterbury, C. E. Woodruff, *A Catalogue of the MS. Books in the Library of Christ Church, Canterbury* (1911).

[2] Dr. C. R. Dodwell in a Cambridge thesis, as yet unpublished, on *The Canterbury School of Illumination* has made an important contribution to the study of the subject.

[3] F. Wormald in *Journ. Brit. Arch. Ass.* viii (1943), 33.

(Pl. 30 *b*). Its pose is curiously echoed in an initial of the famous Stavelot Bible,[1] painted in the diocese of Liége *c.* 1097, but the drawing there has none of the nervous sensitivity of its English contemporary. For the March initial, MS. Vitellius C. XII has a scene of pruning, full of small figures hacking at the trees, while one carrying a large fish on a platter walks through the bar of the letter. Another St. Augustine's book, a Passionale (B.M. MS. Arundel 91) has the same purple backgrounds and flickering touch (Pl. 6 *b*), but hardening a little, and in some of its drawings it is fully adapted to the Anglo-Norman style practised in Canterbury in the first quarter of the twelfth century. Some of the initials have small narrative scenes set in roundels or panels telling the legend of St. Cesarius or St. Demetrius: one has a lion leaping through thin-stemmed tendrils while at the ends of the letters dragon heads clutch fish, a recurrent symbol in the work of the school: another, the letter I, has a naked climber and an archer shooting at a lion, men and beast alike hooking their limbs around the bars of the letter. These entwined gymnastic initials are a Norman rather than English convention, and their popularity in this phase of Canterbury work is a concession to the fashions of the Duchy. But the old 'Winchester' style died hard. In a somewhat later book, a Boethius *De arithmetica*,[2] there is the same nervous, broken line in an initial, which shows Christ and the Virgin between personifications of the sun and moon. Nor was it confined to the metropolitan centre: a manuscript of the *Historia Eliensis* (Corpus, Cambridge MS. 393) has a drawing of St. Withburga where, with cruder feeling, the same type of draughtsmanship appears (Pl. 10 *c*); and in a somewhat composite book of varied associations, B.M. MS. Caligula A. VIII, there is a very similar drawing of St. Margaret. At Lincoln there were miniaturists who drew slender figures with long narrow heads and garments spreading out into sharply frilled borders: it is a distinct and characteristic style, using the greens, blues, reds, and yellows of the Norman school, but with the agitated lines of the Anglo-Saxon tradition: the strange fantasy of Christ holding a bowl in one hand while

[1] B.M. Add. MS. 28106, f. 75.
[2] Cambridge University Library MS. Ii. III. 12.

from the other falls a scroll inscribed *penitentiam agite* is a characteristic example (Pl. 10 *b*) from a richly ornamented volume of St. Augustine's sermons,[1] which includes also a striking initial of the Trinity. A volume of Augustine's Commentary on the Psalter, which belonged to St. Paul's, London, and was presented by a Bishop Richard, who is probably Richard de Belmeis (1108–27), has an opening initial of a man in prayer before an altar with a flying angel above him, drawn with the familiar Anglo-Saxon conventions.[2]

The volume of Boethius mentioned above was a Christ Church not a St. Augustine's book. In the cathedral priory the artists show a more ready acceptance of Norman models. The outlines are firmer, the colours brighter, the subjects more irrelevant and grotesque, the scrolls and bars filled with an eternal battle between men and monsters. Lanfranc is known to have brought several monks from Bec and the script at Canterbury shows a sudden change under their influence. Of Bec as a school of illumination we know little, and little also of Lanfranc's other abbey of St. Étienne. We have at Canterbury no clear parallel such as that of Bayeux and Durham, no connecting link such as Hugo Pictor at Exeter. Nor are we at all certain about the exact organization of scriptoria. Certainly books were sent to scribes outside the monastery, even at times across the Channel. In Anselm's correspondence with Lanfranc there are several references to a volume of the *Moralia Job* which Lanfranc had sent to Bec to have copied. William, abbot of St. Étienne, and his prior Helgot found a scribe for it from Brionne but could not reach an agreement: the Bec scribes were rejected as unskilled or dilatory: the whole incident suggests a readiness to employ the best man, wherever he was found.[3] It is therefore not surprising at Christ Church to find strong Norman stylistic affinities, for it is probable that Normans were

[1] Lincoln MS. A. 3. 17: the Lincoln Bible (see below, p. 160) and a *Moralia* of St. Gregory (B. 3. 5) are other examples.

[2] Aberdeen University Library MS. 5, f. 1. A later Bishop Richard, and there were several of that name, may have given the book, but it is certainly early-twelfth-century work.

[3] F. S. Schmitt, *S. Anselmi Opera Omnia*, iii (Edinburgh, 1946), 130–4.

working there and that sometimes books were sent to the continent for further copies to be made.

Fortunately there are indications by which some of the Christ Church books can be approximately dated. One was among the books given by William of St. Carilef to Durham, that is before 1096. It contains the letters of St. Jerome (Durham MS. B. II. 10) in a Christ Church hand and it opens with a small beast leaping through the bar and the foliage coils of the letter.[1] The beast with its spotted hindquarters and rounded pads, the horned heads on the bar, the trefoil foliage and larger curled leaves, the bracelet-like bands holding the tendrils, all recur in another drawing in a copy of Osbern's Life of Dunstan,[2] where the opening initial shows the saint surrounded by a galaxy of grotesque animals, one playing a harp, while beside him a smaller figure swings a censer (Pl. 10 a). The Life was composed at Canterbury c. 1090, and this copy may well be approximately of that date. It has something of the crowded vivacious confusion of contemporary Norman work and the same bright colouring where reds and yellows predominate. Most unusually the initial appears to have been drawn before the text was written, as some of the script runs over a bar of the letter.

A firmer, more solid sense of design and a richer colouring can be found in a collection of decretals which is now B.M. MS. Claudius E. V. It is a notable book, based on a volume brought by Lanfranc from Bec, and is a product of his new legalistic policy.[3] Some documents added at the end conclude with two addressed to Ralph d'Escures, archbishop of Canterbury from 1114 to 1122, and its compilation must fall between these years. Set in a distinctive foliage of strongly veined trumpet-shaped leaves, the first half of the book has grotesque initials, of which 'the vintage', clearly based on some antique model, is a famous example. The

[1] Reproduced in R. A. B. Mynors, *Durham MSS.*, Pl. 26.

[2] B.M. MS. Arundel 16. It belonged to Dover priory but must have been, from script and decoration, produced at Christ Church. Osbern was precentor at Christ Church. His name is inscribed faintly in the upper circle of the R, but cannot apply to the censed figure. The manuscript has later corrections to bring it in line with Eadmer's version of the *Vita* and may well have been the original Christ Church copy. See W. Stubbs's introduction to *Memorials of St. Dunstan*, R.S. lxiii (1874), xxxi and lxii. [3] Z. N. Brooke, *English Church and Papacy* (1931), 85.

beast, for it is hard to specify it more exactly, playing the trumpet is a near parallel to the carvings of the crypt, and as there a dragon seized the goat's leg so here one bites the animal's foot, drawing a trickle of vividly coloured blood (Pl. 13 *b*). There is a constant sense of pain and horror running through these fantasies. Another datable book is B.M. MS. Cleopatra E. I., a collection of episcopal professions made to the archiepiscopal see. The first hand ends with the profession of David of Bangor in 1120.[1] Its one figure initial shows a bearded man, enmeshed in the tendrils, clutching a long-eared beast as it attempts to escape through the bar of the letter (Pl. 12 *a*). It is a splendid vigorous piece, in which something of the old impressionistic shading can still be found, very different from the strong outlines of the Decretals artist.

Such differences are frequent in the Canterbury school: the Decretals and the Professions are contemporary books within a few years of one another: they use the same convention of grotesque design: yet the individuality of the artists stands out clearly. This contemporaneity of stylistic differences within a highly productive period of approximately fifty years (for it seems reasonable to assign this phase of Canterbury art to the years 1090 to 1140) makes any exact chronological arrangement of the manuscripts an impossible task, nor can stylistic analysis be expected to produce any such answer when the career of a long-lived but conservative artist could so easily invalidate the conclusions produced by it. Yet it is possible to see a progressive development, however erratically used by individuals, in the type of foliage. The earlier books have small trefoil terminals or curling, half-folded leaves. The initial of the Professions shows a fuller leaf with a large central petal rising from two smaller ones and a smaller curved leaf below it. Soon, as in a Christ Church Martyrology, B.M. MS. Harley 624, the central leaf opens to show a blossom or fruit cone, the so-called 'Byzantine blossom' which, used before in the west, now becomes one of the chief motifs of Romanesque art. Gradually the central leaf throws out pronged shoots: its lower petals grow more luxuriant, to reach in the third quarter of the century a Baroque magnificence of elaborate formalization (Pl. 66 *a*). In figure drawing there is also

[1] *New Pal. Soc.* 1st series (1903–12), Pls. 60–62.

a distinguishable progress. The human beings of the same Martyro-
logy, still elongated and non-representational, have yet a new
roundness, achieved by the circular marking of the folds, clinging
to the body with an exacter definition of the forms beneath (Pl.
11 *b*).[1] In one of the most exuberantly imagined series of drawings,
those to a Boethius *De musica* (MS. Trinity Coll., Cambridge, R.
15. 22),[2] a Christ Church book that was marked 'de claustro', some
of the figures have a solidity and certainty which suggest that here
again some classical model must have been used, and the insetting
of cameo heads on the bar of the letter, which now becomes a
favourite practice, stresses the same classical influence on this
particular artist and his followers. A fine example of their skill can
be seen in an initial of St. Augustine writing while a dragon bites
his book in a Durham *De civitate dei* (B. II. 22):[3] lions and dragons
sprawl through the bar, which is decorated with two medallion
portraits. The Trinity Boethius is linked with another copy of the
same work, where one of the gymnastic initials is almost exactly
repeated save that, where MS. R. 15. 22 has a dragon biting its tail
in the central roundel, the other MS. (Cambridge University
Library Ii. III. 12) has an angel holding the host, a change which
says much for the pliability and probably the inconsequence of
these curiously irrelevant designs. The Trinity Boethius displays
also a marked type of man's profile, with protruding lips and
pointed chin, which becomes familiar in several works, notably a
collection of medical treatises (B.M. MS. Royal 12 E. XX) and
a volume of Priscian, now MS. 500 in the Rossiana Library in
Rome,[4] whose unusually finished paintings testify to the respect in
which grammatical studies were held. The former of these books has
a vigorous lion hunt, the latter a man with a performing bear:
almost certainly they are works by the same hand (Pl. 7). The
foliage initials in both books are more broadly treated than in most

[1] See F. Wormald in *Journ. Brit. Arch. Ass.* viii (1943), 34.

[2] To be distinguished from the other Boethius, Cambridge University Library,
Ii. III. 12, already mentioned. There seems to have been a convention that certain
works were particularly suitable for ornamentation.

[3] Generally identified with a Carilef copy, but the drawing suggests a later date.

[4] H. Tietze, *Die illuminierten Handschriften der Rossiana* (Leipzig, 1911), 56. The
manuscript has been renumbered since Tietze's publication.

Canterbury work, and the shading on the leaves, brushed in with washes of green, is close to a group of Rochester books, which will be considered later. The interconnexions of the Rochester and Christ Church scriptoria were exceedingly close, as is only to be expected, for the see of Rochester stood in a special mediate position to Canterbury.[1] A Rochester book, Jerome's Commentary on Genesis (MS. Trinity O. 4. 7), which is textually identical with a Christ Church copy of the same work (MS. Trinity B. 2. 34), has as its opening initial a man teaching a bear to say the alphabet, treated entirely in the style of the Canterbury artists (Pl. 7 c).

The various artists and their styles meet in the most sumptuous work that has come down to us from this phase of Canterbury activity, the two-volume Josephus which is now divided between St. John's College, Cambridge (MS. St. John's A. 8), and Cambridge University Library (MS. Dd. I. 4). Many hands worked on it, one of whom, responsible for the only historiated initial, gives a name, Samuel, which may be his own: another was almost certainly the Master of the Professions initial, whose broken strokes and flecked shading are easily recognizable: the medallion heads of the 'classicists' are freely used, the little figure in a Phrygian cap would be at home on any sarcophagus, and the two men struggling with serpents are clearly related to antique models (Pl. 12 b and c). It is a rich and varied book, whose drawings have the tingling energy and surprising conceits of the school at its best.

The genius of these artists lay in their handling of intricate closely knit patterns composed of unexpected violent conjunctions of motifs. For a time genuine narrative art seems to have been in abeyance and it is only by freeing the figures from the coils that it could be resumed. The Cambridge University Library Boethius already mentioned has two pages of seated figures, framed by inscriptions in square empty spaces. They are firmly drawn, and suggest some fairly direct contact with traditional models. A Worcester volume (Corpus Christi College, Cambridge, MS. 391), associated with St. Wulfstan (1062–95), has a figure of King David set in a foliage frame: the design is a familiar one, but the leaves and

[1] R. A. L. Smith, *Collected Papers* (1947), 88.

drapery already suggest twelfth-century mannerisms.[1] Far more decisive in its return to full-page narrative illustration are two puzzling books, both of them copies of Augustine's *De civitate dei*. One of these is MS. Laud Misc. 469 in the Bodleian Library. A folio volume, it opens with a full-page drawing where in the top register Christ sits between the twelve apostles under an arched building: the figures are drawn in red and green set against a purple background spangled with small triangles of red dots. Below against a vivid blue is Christ in limbo and the Virgin rescuing the soul of a dead man from the assault of a fire-breathing devil. The figures are drawn with curving drapery which outlines the bodies, while there are still traces of the frilled edges of the Anglo-Saxon tradition. The initials throughout the book have coiled dragons and in some cases figures of men: rich purple and blue are often used as a background: in others it is a patchwork of reds, yellows, blues, greens, and purple: in style they are not unlike Canterbury books such as the great Josephus. It must be work of approximately the same period, though there is no exact parallel to the lively accomplishment and imaginative iconography of its frontispiece. The other *De civitate dei* is in the Laurentian Library in Florence (MS. Pluto XII. 17).[2] Its script is not that of any twelfth-century Canterbury hand, but it is hard to place its drawings outside of the Canterbury school. Its four introductory folios show St. Augustine teaching; two groups of his followers debating his works; a strange page where angels weigh souls at the top while below are contrasted warfare and peace, the first typified by violent combats, the second by men ploughing; finally, the City of God, Christ in Majesty, with below the Church enthroned. The scenes of war and ploughing, strips across the page, are in an Anglo-Saxon convention: the frame of one of the pages is set with the familiar medallions and the figures show the curved markings and taut closeness of the drapery of Canterbury books such as the Martyrology MS. Harley 624 (Pl. 11): St. Augustine's large

[1] F. Wormald, *English Drawings* (1952), 56, 61.

[2] *New Pal. Soc.* 1st series (1903–12), Pls. 138–9; and G. Biagi, *Riproduzioni di Manoscritti miniati da Codici della R. Biblioteca Medicea Laurenziana* (Florence, 1914), Pls. x–xii. See also M. Schapiro in *Art Bulletin*, xxi (1937), 314.

figure, set against a purple background, shows the whorls at the shoulders and the flower-patterned stuff which we shall find in later Canterbury work (Pl. 52 *b*): the initials, figure scenes in roundels or coils, are so close to a group of historiated initials in a Canterbury Passionale (Canterbury Cathedral Library MS. E. 42) that they may well be by the same hand. This latter is a book that probably dates from the mid-thirties,[1] and this seems to me to be a reasonable date also for the Laurentian MS., which I believe, whatever the answer to the problem of its script, to be by a Canterbury draughtsman and to mark a return to an older tradition of full-page scenes. Its Christ in glory, seated in a mandorla, in pose, in fall of drapery and ornament, even in morphological details such as the shape of the ears, corresponds markedly with the great Christ painted on the ceiling of the chapel of St. Gabriel in the crypt at Canterbury,[2] and these wall paintings, a rare and precious relic of so much that is lost to us, must close this account of Canterbury graphic art in the first half of the century (Pl. 25).

The natural assumption would be that these frescoes formed part of the decorative scheme carried out by Prior Conrad before the consecration in 1130. The chapel, however, has clearly been reinforced by buttressing and supporting arches at a date not long after its completion, and the paintings may belong to this stage of the building. In the apse itself is the splendid Christ, surrounded by four supporting angels, poised in a rhythmic dancing movement, exquisite descendants of the 'Winchester' tradition. On the sides of the apse are narrative scenes, the missions of Gabriel, on the north side to Zacharias, with below the naming of John, on the south the Annunciation, the Visitation, and a destroyed subject

[1] C. E. Woodruff, *Catalogue of the MS. Books in the Library of Christ Church, Canterbury* (1911), 22. Another manuscript (Jesus College, Oxford, 93) has in its drawing of Abraham's Sacrifice figures which are strikingly similar to those of MS. Pluto XII. 17, but its foliage, with burgeoning fruit cones, is slightly more advanced in style. This fine book is of uncertain provenance.

[2] See E. W. Tristram, *Twelfth Century English Wall Painting* (1944), 102; and W. A. Scott Robertson in *Archaeol. Cantiana*, xiii (1880), 48. There are echoes of this Christ in the initial of a Canterbury manuscript of approximately 1130–40, MS. Bodley 271, f. 43ᵛ, and in a fine drawing bound in with some pages of twelfth-century script at the end of the Bosworth Psalter, a Christ Church book of the second half of the tenth century (B.M. Add. MS. 37517).

represented by Dart in the early eighteenth century as an Adoration.[1] On the soffits, vaults, and west wall there are further remains of painting, the seven churches, angels and seraphim, and decorative scroll-work. The wall frescoes are somewhat stiffer, less fluent work than the Christ and the angels, more solidly in the new Romanesque manner: with their large oval heads, curled hair, and fashion of dress, they have much in common with the revival of biblical illustration to be seen in the contemporary Rochester scriptorium of which more must be said in its due place.

If in painting, as the century advances, we find artists handling their figures more boldly, withdrawing their human beings from the encircling foliage to set them in historic scenes, in sculpture this is a process which advanced more hesitantly. Figure sculpture was not unknown in northern France. At Bayeux, associated with some foliage capitals with the leaves cut in double rows as in the early work of Canterbury crypt, there survive two historiated capitals which come from the pillars of the crossing in the cathedral dedicated in 1077 under Bishop Odo, the Conqueror's half-brother. One shows a seated Christ receiving a soul, the other the Incredulity of St. Thomas.[2] They are treated flatly with no attempt to mould or round the forms, as though the surface had been cut away to leave the silhouettes on which details of faces and drapery were then marked by incised lines. There are similar, slightly cruder but later carvings nearby in the church at Rucqueville. Yet the Saxon sculptural tradition was almost certainly a more developed one: Raoul of Caen, writing early in the twelfth century, talks of *sculptores Scottus et Anglus* as pre-eminent in the art.[3] Unfortunately there is much controversy as to what works can be assigned to the eleventh century in England and the proof of their greater plasticity must largely depend on the date attributed to the Romsey rood and the Chichester reliefs. My own view would place the former in the early eleventh century, a parallel in carving to the great Crucifixion page of MS. Harley 2904,

[1] J. Dart, *History and Antiquities of the Cathedral Church of Canterbury* (1726), 35.

[2] R. Fage in *Congrès arch.* lxxv (2) (1909), 632; J. Vallery-Radot, *La Cathédrale de Bayeux* (1915), 99.

[3] *Gesta Tancredi*, c. lxxvii, Recueil des historiens des croisades occidentales, iii (1866), 661.

though I admit that the stone drapery clings much more heavily to the body:[1] the latter, whose closest stylistic connexions seem to be with Germany, have sometimes been assigned to the end of the century, under some passing and premature influence from abroad which was also responsible for the wall paintings at Clayton and Hardham.[2] In style these splendid carvings of the appeal of Martha and Mary to Christ and the Resurrection of Lazarus, found in 1829 in the wall behind the cathedral stalls, remain isolated from all our twelfth-century sculpture and are certainly far removed from the timid carving of the Chichester choir capitals that precede the dedication in 1108. humanist in their dignity and strongly marked emotions, primitive in their variation of scale amongst the personages, their own evidence is full of conflicts. Their date, it seems to me, must fall somewhere between 1090 and 1140, but our surviving sculpture shows surprisingly little influence of such striking works on a phase that was a peculiarly receptive one.[3]

Of free standing sculpture we have no certain example. Above the pulpitum in Lanfranc's church at Canterbury there was a great cross with two cherubim and the figures (*imagines*) of Mary and St. John.[4] This 'crucifix' as it is termed in Lanfranc's constitutions, instead of the more usual term 'cross', with its supporting cherubim may owe something to Anglo-Saxon tradition, for it seems an innovation on continental custom. Probably it was made of wood or metal. The cross of bronze, silver, and gold set up at Beverley by Archbishop Ealdred of York was Teutonic work, *opere Theutonico fabricato*, but there is no word of accompanying figures: in metal-work clearly there was still some dependence on north-west Europe. At Winchester Archbishop Stigand had presented a gilded beam with a silver cross and two silver images of Mary and John.[5]

[1] See D. Talbot Rice, *O.H.E.A.* ii (1952), 98, Pls. 13 and 74 a.

[2] See A. Baker, 'Lewes Priory and the Early Group of Wall Paintings in Sussex', *Walpole Society*, xxxi, 1942-3 (publ. 1946): D. Talbot Rice, *O.H.E.A.* ii, 110, Pls. 20, 21.

[3] The recent discovery by Dr. H. Swarzenski and Dr. G. Zarnecki at Chichester of some fragments of other reliefs may throw further light on this problem. Another fragment exists at Toller Fratrum. [4] Gervase, *Opera*, R.S. lxxiii (1) (1879), 10.

[5] See P. Brieger, 'England's Contribution to the Origin and Development of the

In this puzzling matter of fragmentary hypotheses, the one established fact is that the great Norman buildings of the first two reigns of the new dynasty have few remaining signs of aptitude in figure sculpture. The capitals of the chapel in Durham castle, which show the early Norman volute and which must date from the work carried out there in 1072, have some human and animal figures of a ridiculous and crude inadequacy. The small church of St. Nicholas, Bramber, much of which is still the chapel built by William de Braose about 1075, has a capital where roughly carved birds and beasts are disposed in a disordered pattern.[1] It is not till the last decade of the century that figure work of any serious competence, apart always from the problematic Chichester pieces, is found in connexion with Norman building. A capital preserved at Westminster depicts the Judgement of Solomon: a second figure capital, found in 1807 built into one of the fifteenth-century gates of the precincts, bore figures set in niches inscribed as Abbot Gilbert and William II.[2] Gilbert Crispin was abbot from c. 1085 to 1117, and one would therefore presume the capital to be of that period, but the carved stone may commemorate some grant and be a later work than the lives of the king and bishop named. Its style suggests the latter view but is hard to assess from the drawings by its finder, William Capon, which are all that remain, for the capital, sold into private hands, has disappeared. Some capitals from Westminster Hall, now in the Victoria and Albert Museum, have figure carvings of men and beasts in fairly high relief, but these again are too battered for any close analysis. A fragment of carved acanthus is a coarser version of the carvings of the third hand in Canterbury crypt. But the evidence at Westminster remains tantalizingly inadequate. The Solomon capital is carved on all four sides, though on two of them the figures have been hacked back to make a flat surface. The

Triumphal Cross', *Mediaeval Studies*, iv (Toronto, 1942), 85; W. H. St. John Hope, 'Quire Screens in English Churches', *Archaeol.* lxviii (1917), 51.

[1] The Durham and Bramber capitals are reproduced in G. Zarnecki, *Eng. Rom. Sculpture* (1951), Pls. 3–12.

[2] W. R. Lethaby, *Westminster Abbey Re-examined* (1925), 34; J. Armitage Robinson, *Gilbert Crispin* (1911), 35; E. W. Brayley and J. Britton, *The Ancient Palace at Westminster* (1836), 416, 445, 446, Pl. xxxv.

scenes appear to represent various stages of the story of the two women and the child: they are cut in high relief with some attempt at roundness and the drapery folds marked by deeply incised strokes. Though still crude and heavy, they have a certain dramatic intensity (Pl. 16). Were they not at a centre such as Westminster, they might easily be taken as provincial work of *c.* 1150. A likely date seems to be *c.* 1110–20, for, though there is an ambitious roundness of the forms, the types are those found in drawings of the turn of the century. The face seen in profile, with large nose and receding chin, the hooked pointing finger are familiar in many Norman manuscripts, such as the B.M. MS. Add. 11850, which is probably a Bayeux product. They can be traced too in the later works of the 'Winchester' school and in the Canterbury manuscripts discussed earlier in this chapter. Above all they are characteristic features of another work associated with Bayeux, the great embroidered roll relating the progress of Harold's quarrel with William, known traditionally as the tapestry of Queen Matilda, though it is stitched not woven and Bishop Odo, from the prominence given to him, is more likely to have commissioned it than any of the royal Matildas.[1]

More flatly cut, with a linear sense of design that separates them in style from the Westminster example, are six historiated capitals on the eastern tower arch of the collegiate church (now the cathedral) of St. Mary of Southwell.[2] There is evidence to date the rebuilding of this church to the archiepiscopate of Thomas II of York (1109–14). The low Norman nave, only 50 feet high, was probably completed later, and the great cable mouldings of the arches of the crossing can hardly be as early as 1114: but it is noticeable that the cable work of the eastern arch does not fit exactly to the capitals, which are the carved capitals in question, though the latter appear, from the way the carving covers the surface, to be in their original position. The scenes depicted are somewhat curiously selected and their interpretation is uncertain. On the north side are the Last Supper; a priest at the altar and a

[1] D. Talbot Rice, *O.H.E.A.* ii (1952), 245.

[2] A. Dimock, *The Cathedral Church of Southwell* (1898); J. Romilly Allen, 'Sculptured Norman Capitals at Southwell Minster', *The Illustrated Archaeologist*, i (1893), 31.

kneeling figure before an angel (possibly Zacharias); the Virgin and Child; the Annunciation and a procession of figures; opposite on the south, the Entry into Jerusalem; the Agnus Dei, carved on a projecting rectangle between the volutes, a practice common in Normandy but less usual in England; the Washing of the Feet. The capitals, high above ground level and cut in low relief, can never have been clearly distinguishable except from the top of the screen and may have been associated with some particular liturgical use to which it was put. What foliage there is suggests Anglo-Saxon patterns and a re-used eleventh-century tympanum on the north doorway, a figure scene of Michael and the dragon, David and the lion, where the beasts dissolve into Viking ribbon pattern, proves that Southwell had an earlier sculptural tradition. The fine marking of folds and drapery on the capitals is in fact more Anglo-Saxon than Norman, and suggests, remote from movements in the south, some local continuity. Southwell in many ways stands apart: its choir was square-ended, a method to which English builders readily returned, and the horizontal lines of the nave arcade are unbroken by any shafts or alternation in its round columns.

To the south, in Northamptonshire, a group of carvings centres round the church of St. Kyneburga at Castor, a building dated by a surviving inscription and also by documentary evidence to 1124.[1] The foliage patterns have relations with the Reading school and will be discussed in the next chapter. At Castor itself there are figure subjects: men fighting with one another or struggling with beasts, a man gathering grapes: works which seem to belong to a stage of development not much later than that of Southwell. The same master seems to have worked at Wakerley near by.

At Canterbury itself some of the carvings, as for instance the capital of the wolf and the two horsemen, attempt to treat figures as ends in themselves rather than as elements of a decorative pattern, but there are no examples of genuine narrative pieces. And when

[1] J. R. Allen in *V.C.H. Northamptonshire*, ii (1906), 197; and C. S. Peers, ibid. 478. J. T. Irvine, 'Some Northamptonshire Churches of Norman Age', *Journ. Brit. Arch. Ass.* i (1895), 309. W. D. Sweeting, *Parish Churches in and around Peterborough* (1868), 15. See G. Zarnecki, *Eng. Rom. Sculpture* (1951), Pls. 39–42.

such are attempted, in buildings where Canterbury influences are
apparent, the crudity of the style shows the lack of any accom-
plished local models. In the south choir aisle of Romsey abbey
some of the capitals of the wall piers, with their thick foliage and
emphatic cushion lines, are close to the third group of Canterbury
crypt. Elsewhere in the abbey, however, there are capitals with
figure scenes: a man pulling a donkey by the tail (an incident
found also in a Canterbury MS., Arundel 91 f. 47v); a man fighting
a lion; two scenes of the months, February warming his hands and
August cutting corn; two others, placed on the eastern wall shafts
of the choir aisles, seem to chronicle some event of local signi-
ficance: on one is a crowned figure holding a scroll inscribed
Robertus me fecit; opposite him two further figures hold another scroll
whose inscription apart from the name Robertus is not satisfac-
torily decipherable: the second capital is a battle scene. This same
inscription, *Robertus me fecit*, appears on a fragment at St. Augus-
tine's, Canterbury, a grotesque of a man's head with two beasts
pulling at his beard, but this is a deeply cut work of high quality,
whereas the Romsey carvings are crude in modelling and their
forms mainly indicated by linear hatching. The carver seems to
have been experimenting with subjects for which he had neither
example nor practice.

Figure carving of a different type and quality was to be found
in another great church of the southern area. If the glorious choir
of Canterbury must be taken as the most important and influential
building of southern England, it had a near rival in the priory
church of Lewes,[1] founded in 1077 by William de Warenne and
his wife Gundrada. The whole account of its inception is given in
detail in the original charter: how William and his wife went on
pilgrimage to Rome, but owing to the disturbances of the Investi-
ture contest did not get farther than Cluny, and how there they
persuaded Abbot Hugh to send four monks to found a Cluniac

[1] F. Spurrell, 'Architectural Relics of Lewes Priory', *Sussex Arch. Soc. Coll.* vi (1853),
253; W. H. St. John Hope in *Arch. Journ.* xli (1884), 1, and *Sussex Arch. Soc. Coll.* xlix
(1906), 66. W. H. Godfrey, *St. Pancras at Lewes* (1927), and in *V.C.H. Sussex*, vii
(1940), 46. J. R. Allen, 'A Norman Capital from Lewes Priory', *Proc. of Soc. of Antiq.*
xv (1893–5), 199. B. M. Crook, 'General History of Lewes Priory in the 12th and 13th
Century', *Sussex Arch. Soc. Coll.* lxxxi (1940), 68.

priory in England. William gave them a small stone church near Lewes, where he and Gundrada were eventually buried in leaden coffins, found in 1845 when the railway from Lewes to Brighton was cut straight through the ancient site of the abbey. This small church did not long prove sufficient: under the thirty years priorate of Lanzo (1077–1107), a man widely respected for his piety, 'equal to any in sanctity' William of Malmesbury calls him, Lewes came to enjoy a high prestige. Henry I had a special devotion to Cluny, and the second prior of Lewes, Hugh, was chosen by him as abbot for his own foundation of Reading: at the close of the century, in 1186, another prior Hugh of Lewes became abbot of Reading and in 1199 the arch-abbot of the Order. To meet this growing repute and steadily increasing numbers a new church and some of the largest and most elaborate monastic buildings in England were erected. This church was dedicated between 1142 and 1147 by Theobald of Canterbury, Henry of Winchester, Ascelin of Rochester, and Robert of Wells. It was 405 feet in length, but seems to have been narrow for its size. The remains of an outer building suggest that it had a narthex as at Cluny or Vézelay: a nave and aisle there were of eight bays, an aisleless transept, a choir and aisles four bays long, an eastern transept and a great apse with ambulatory and five apsidal chapels (Fig. 6). It is the plan of the mother church of Cluny and must have been one of the earliest reproductions of it. Unfortunately only some foundations, sufficient in conjunction with earlier accounts to establish the ground plan, remain: the priory-church of St. Pancras is level with the ground, skilfully razed by Henry VIII's Italian engineer, John Portinari. Scattered fragments are all that are left of its decorative splendour, but these are suggestive enough. A capital in the British Museum shows a group of scenes, the Miraculous Draught of Fishes (Pl. 15 a), the Calling of Peter, the Grant of the Keys, and an architectural representation of the Church, a truly Cluniac subject, for the mother abbey was dedicated to St. Peter. Small in size, this capital, carved on all sides and therefore free standing, must come from the cloister or possibly the round lavabo adjoining it. But the style is even more striking than the subject: the figures, standing on the usual cable necking, are still somewhat

squat and expressionless, with heads too large for the bodies, but
they are deeply undercut and have a real sense of weight, which

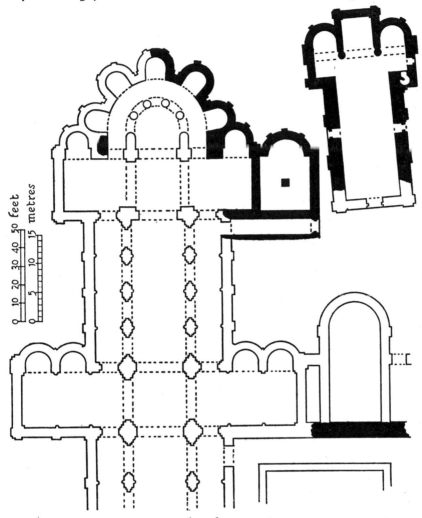

FIG. 6. *Plan of Lewes priory*

comes from the modelling of the forms, not from surface linear
drawing.[1] Amongst fragments in the Lewes Museum is a capital

[1] The font at St. Nicholas in Brighton might belong to this school of carvers: it
has scenes of the Last Supper, Baptism, and Legend of St. Nicholas. It is of Caen
stone, and restorations have made an exact stylistic assessment difficult. See Arch-
deacon Hannah, 'On the Church of St. Nicholas and its Font', *Journ. Brit. Arch. Ass.*
xiii (1886), 26.

on each side of which a dove is carved flying from out a concentric series of circles, as though from some rainbow glory:[1] a broken column has fluting similar to that in the Canterbury crypt with acanthus leaves, turning over at the tips, carved upon the base. Bold, strongly marked designs characterize this Lewes work as opposed to the more delicate fantastication of the Canterbury masons. It is difficult to date exactly: the capitals, which are not in local stone, might be an import from the Caen quarry. Certainly the famous tomb slab of Tournai marble, now in South-over church, traditionally that of the foundress, Gundrada, carved with interlacing coils, is foreign workmanship. Whatever the origin or exact dates of this Lewes carving, it is a new contribution to English art and one that was not without its effect.

Along the south coast other building enterprises were in progress. At Chichester the eastern arm of the cathedral was consecrated in 1108, but the final consecration of the church as a whole did not take place till 1184.[2] The modest resources of the diocese were reflected in a building comparatively small in scale and only slowly brought to completion. The eastern arm had an ambulatory and possibly radiating chapels. In the choir the capitals of the tribune have rows of upright leaves like the early capitals of Canterbury, and some halting attempts at interlace carving: in the nave the capitals have only some simple scallops and the main decorative feature is some diaper and scale work in the tympana of the tribune arcade. The cathedral masons seem to have been content with traditional styles. The stone employed was limestone from Quarr in the Isle of Wight and there does not seem to have been contact with any other quarries.

A more interesting building is that of the Benedictine nunnery at Romsey, whose carvings have already been discussed. Romsey enjoyed a certain prominence through its relations with the royal house.[3] Henry I's wife, Matilda, daughter of Margaret of Scotland

[1] Reproduced in G. Zarnecki, *Eng. Rom. Sculpture* (1951), Pl. 72.

[2] W. H. Godfrey and J. W. Bloe in *V.C.H. Sussex*, iii (1935), 105.

[3] R. Luce, *Pages from the History of Romsey Abbey* (Winchester, 1948). W. R. Corban, *The Story of Romsey Abbey* (Gloucester, 1947). C. R. Peers, 'Recent Discoveries in Romsey Abbey Church', *Archaeol.* lvii (1901), 317.

and descended from the ancient house of Wessex, had before her marriage lived there with her aunt Christina, who was a professed nun. Henry granted in all seven charters to the abbey and visited it on three occasions, but there is no indication that he in any way promoted or financed the rebuilding of the abbey church. Its history at this period is in fact singularly blank and not even the names of the abbesses are known: there is some evidence[1] to suggest that, while the higher posts in the house were filled by Normans, it remained a retreat where many Saxon ladies became nuns. Stylistically, however, the choir and transepts fall into the period c. 1125, and it is probable that the first stages of the building were contemporary with Conrad's completion of his choir at Canterbury; some of the carving, as has been said above, suggests that masons may have moved from one task to the other. The nature of its eastern chapel, entered through a double arch from the ambulatory, is uncertain: there are some indications that it was rectangular, as at Southwell.[2] The rest of the plan was normal: a choir of three bays, a retro choir, aisles with groined vaults ending in semicircular chapels, transepts with single apsidal chapels, and a nave of seven bays. The proportions of the tribune and the main arcade followed the model of St. Étienne and Winchester, not that of Jumièges and Durham. In its details, Romsey has some unusual features. The tribune openings of the choir are divided into two smaller arcades, but these are free standing without any tympanum filling the space above them. The first two bays of the nave, which closed the earliest and most elaborate of the building stages, are based on an alternate system of columns and composite piers, but the great columns on which the arches of the ground arcade are somewhat clumsily splayed rise right through the tribune level and their capitals support the tribune arches (Pl. 17 a): it is an unusual and not unimpressive scheme, but was abandoned later in the century when the nave was completed and composite piers were used throughout, though the tribune arches still

[1] See below, p. 66.

[2] Possibly at Ely, Rochester, and Chichester also: in England the square east end always remained popular; but the rebuilding of the eastern chapels has been so general as to leave only uncertain evidence.

project farther than the main arcade and their outer order is supported by an applied column which rises from the floor level.

Some of the Romsey masons, if one can judge from similarities in the foliage capitals, worked also at the neighbouring priory of Christchurch.[1] A new church had been begun there by Ranulf Flambard, c. 1093, but work seems to have been discontinued for a period on his appointment to Durham. Some of the capitals have volutes and rows of stiff, Lanfrancian palmettes. At Christchurch three small crypts were built, one under the east end and one under each of the transepts. The transepts were originally divided into two stories as was the case at Jumièges and Bayeux cathedral, but this fashion never pleased in England and here it was done away with in the course of the twelfth century. The Norman nave and transepts still remain: the exterior was decorated with interlacing arches as on the choir at Canterbury, and on the north transept and its circular turret there is an unusual display of scale pattern and diapering, recalling some of the ornament used at Rochester and Chichester. The foliage capitals, with their resemblances to Romsey, must be work of the thirties or forties, and the church was probably not completed before 1150.

This foliage style, with its rounded, carefully veined acanthus leaves, penetrated northwards to the small Oxfordshire church of Checkendon,[2] where Dr. Zarnecki has drawn attention to examples of the work of the Romsey–Christchurch carvers. Checkendon is only a few miles from Reading, and it is surprising to find here this imported south coast style, for by the mid-century Reading was a great centre dispersing stylistic influences of its own.

If Checkendon looks south, the carvers at Steyning, the traditional site where St. Cuthman halted his barrow, between Lewes and Chichester, had more in common with Reading than with the great churches round them.[3] The straight scroll-like stems curling over at the end and set in diagonal lines across one another are

[1] C. R. Peers in *V.C.H. Hampshire*, v (1912), 101.

[2] C. E. Keyser, 'Notes on the Churches of S. Stoke, N. Stoke, Ipsden and Checkendon, Oxon.', *Journ. Brit. Arch. Ass.* xxiv (1918), 24.

[3] P. M. Johnston, 'Steyning Church', *Sussex Arch. Collections*, lvii (Lewes, 1915), 150.

found at Reading and are the main Steyning motif. But the common bond is probably an Anglo-Saxon tradition rather than any actual interchange of craftsmen. Steyning was a dependency of the abbey of Fécamp,[1] and there are Norman elements also in its Romanesque capitals: but the interpretation is Anglo-Saxon and the eleventh-century sculptures which still exist near by at Sompting clearly influenced the designs. On a band of carving, most unusually cut as a rectangle on one of the respond columns of the south aisle arch, two figures are caught in the tendrils in attitudes curiously close to those that so often occur in manuscript illustration.

In Winchester itself, where we might well look for memories of the style to which its name has been given, the evidence is tantalizingly scanty. Walkelin's cathedral has to a most marked degree the unadorned severity of early Norman building, and ornamental carving is almost entirely absent. It is in the capitals from Hyde abbey, re-used or stored at the church of St. Bartholomew, that examples must be sought.[2] Carved on all four sides, about $10\frac{1}{2}$ to 11 inches square at the top, they must have belonged to the cloister colonnade. The birds and griffins recall Canterbury treatments of similar subjects, but are in high relief and more static in their poses. The circles in which some of the designs are set recall the capital at Lewes; the human heads set in the foliage terminals are in a convention much used by manuscript illuminators (Pl. 14 b). Hyde, the former New Minster abbey, moved to its new site on the outskirts of the town in 1111: the buildings were completely destroyed in the fighting of 1141, in which Winchester suffered heavily. It was not till some forty years later that serious rebuilding was undertaken. These capitals must fall between 1111 and 1141 and are most probably work of the thirties. Certainly they are amongst the most developed examples of this phase of our Romanesque

[1] *V.C.H. Sussex*, ii (1907), 122.

[2] C. J. P. Cave, 'Capitals from the Cloister of Hyde Abbey', *Antiq. Journ.* xxv (1945), 79. Some similar fragments are built into the wall of Holy Trinity, Winchester. Dr. Zarnecki was the first to call attention to the four capitals re-used in the south doorway at St. Bartholomew's and to the fragments at Holy Trinity. See his *Eng. Rom. Sculpture* (1951), Pl. 65, where he compares the medallion treatment with that on the font at St. Marychurch, Devon.

art. In the cathedral is a capital with a centaur fighting a dragon and another hunting a griffin, which is brilliantly cut and where the figures stand out against a plain background, freed at last from the coils (Pl. 15 *b*).

Before leaving this south coast carving of the first half of the century, we must return to the first patron of it, Ernulf of Canterbury. Promoted abbot of Peterborough in 1107, he busied himself with the monastic buildings there till in 1114, much to the grief of his monks and against his own will, he was made bishop of Rochester. Here he is reported to have built the chapter-house and cloister and he appears to have begun the rebuilding of the church, which, as at Canterbury, had only recently been completed under the great builder, Bishop Gundulf. Two bays of Ernulf's crypt survive, but the capitals are without ornament. Ernulf died in 1124 at the age of eighty-four, 'leaving', says William of Malmesbury, 'many monuments of his virtue'. He had given to his cathedral many manuscripts and embroidered vestments.[1] The new church was dedicated with considerable solemnity in 1130, the day following the consecration of the 'glorious choir' at Canterbury and with the same assemblage of eminent ecclesiastics. Everything about Rochester is puzzling. Twice subjected to fires and consequent rebuildings in the course of the century, it is full of curious conjunctions of differing styles.[2] On the chapter-house wall and on a pier of the central tower there is a diaper pattern like that on the side wall of the north entrance to Canterbury crypt. The tympana of the tribune arcade of the nave have scale and diaper ornament with chevron and billet decoration on the arches. There is structural evidence that on the south side of the nave the earliest Norman work has been encased by this newer more ornate style, whereas the north arcade and aisle were built from the start in the new manner, which may well mark the completion of Gundulf's church by Ernulf. The most curious feature of all, however, is the tribune story. The aisles are roofed above the tribune arcade and no gallery ever appears to have been built: it is an open tier of arches like a viaduct and the only means of circulation provided in the second

[1] H. Wharton, *Anglia Sacra*, i (1691), 342.
[2] W. H. St. John Hope, *Rochester Cathedral* (1900).

stage is a passage way pierced in the piers.[1] The west façade was much altered later in the century, but in its upper stories some of the carving recalls the crypt carvings of Canterbury, particularly a small tympanum of a beast, a near relative to the Canterbury wolf. Ernulf we are explicitly told built the chapter-house, dormitory, and refectory. We have seen already that his diaper pattern appears on the chapter-house wall. The rich carving of the chapter-house and dorter doorways seems, however, to belong to a later date. Much of the stonework here has suffered from fire, and Gervase of Canterbury expressly states that the monastic offices were destroyed in the conflagration of 1137,[2] but the present signs of calcination may be later damage, for which the history of Rochester provides ample opportunity. The heavy foliage, the elaborate grotesques of the voussoirs,[3] the small heads carved at the centres of the capitals, the confronting birds and dragons, have a fullness of modelling and range of motifs that suggest the second quarter of the century rather than work of Ernulf's lifetime. On the large tympanum of the dorter doorway is one of the saddest ruins of our medieval art, a great carving of Abraham's Sacrifice, the scene visible on the fast powdering surface but only as a shadow and a shadow that must soon disappear. Here in the mid-century a figure subject was attempted on a large scale and in the grand manner.

The Rochester scriptorium matches the individuality of the cathedral stone carvers. The library is particularly well documented, for we have a partial twelfth-century catalogue included in the *Textus Roffensis*, the great compilation of documents begun under Ernulf, and another from the year 1202.[4] Rochester books were inscribed at the foot of the first folio and a fourteenth-century librarian has given in many cases the names of the traditional donors. One group of illuminations comes close in its decoration to the cloister carvings and suggests some common pattern book,

[1] At Waltham abbey there is now no tribune gallery, but provision for vaulting the aisles shows that one existed or at least was intended, and there is no passage way in the arcade. [2] *Opera*, R.S. lxxiii (1) (1879), 100.

[3] To be seen in Thorpe's drawing: J. Thorpe, *Custumale Roffense* (1788), Pl. xxxviii.

[4] R. P. Coates, 'Catalogue of the Library of the Priory of St. Andrew, Rochester, from the Textus Roffensis', *Archaeol. Cantiana*, vi (1866), 120. W. B. Rye, 'Catalogue of the Priory of St. Andrew, Rochester, A.D. 1202', ibid. iii (1860), 47.

though in date there may easily be some considerable time lag between them. These thick, strongly marked dragons are to be found in two volumes of Augustine's Commentary on the Psalter, the first of which is inscribed in a fourteenth-century hand as the gift of Prior Arnulf, who held office from 1089–93, and the second as the gift of Bishop Ernulf himself.[1] This Rochester style is quite distinct from that of either Canterbury house: its colours are darker and richer, its monsters more fleshy, its foliage heavier; it is shaded with somewhat blurred strokes of colour and is more painterly than linear. The masterpiece is a *Moralia* of St. Gregory (MS. Royal 6 C. VI), ascribed to the gift of Archbishop Ralph (Ralph d'Escures, bishop of Rochester 1108–14, archbishop of Canterbury 1114–22). Its artist painted with deep reds and greens and his broadly sketched initials have a peculiarly rich effect. On the opening page Job's wife, in the circle of the letter, hands to her husband a glowing coal wherewith to cauterize his sores: on another a mounted warrior in chain mail recalls the Bayeux tapestry. A splendid eagle of St. John (Pl. 18 *b*) employs the whole range of the artist's colours.

There were, however, very different hands at work. The second volume of the Augustine Commentary (MS. Royal 5 D. II) begins in the painterly style, but is completed by an artist who uses a firm, clear line and paints in light, pale tones, quite distinct from the usual English range. His iconography also is uncommon, for he used figure scenes whose exact meaning is obscure but which are too particularized to be mere fancy and must contain some reference to the text; for Psalm cxlviii (cxlix) a boy maltreated by two men, for Psalm xcviii (cxix) a haloed youth clinging to an angel's garment. He employed also panels of continuous acanthus frieze in the bars of his letters, a practice which was much followed at Rochester.

[1] The two volumes are B.M. MSS. Royal 5 D. I and II. There may be some confusion between Arnulf and Ernulf and fourteenth-century ascriptions cannot be regarded as authoritative. Prior Arnulf occurs in a list in MS. Royal 5 B. XVI. The catalogue of the Royal manuscripts gives his dates without quoting an authority. In the catalogue of 1202 there is (No. 165) a verse Psychomachia by Prior Ernulf. Comparisons with some Carilef books make the 1090's a possible period for early examples of this Rochester style.

Most famous of Rochester manuscripts is the *Textus Roffensis*. Unfortunately it is a composite work of various dates. The ascription to Ernulf is in a fourteenth-century hand and the tradition behind it can only apply to the general scheme of the compilation.[1] The library list bound at the end includes the first part of the *Textus* in the items registered. There is good reason, however, to think that the first hand was working *c.* 1120 and it is to the opening of a group of charters from this period that the only elaborate initial belongs. It is painted in normal colours of green, red, and reddish purple, and shows Christ blessing, treading a dragon underfoot while somewhat incongruously a great winged dragon forms the other bar of the letter A.[2] Stylistically in its details of figure drawing and foliage it belongs to the group of manuscripts uncertainly divided between Rochester and Canterbury, which has already been discussed.[3] To this group another manuscript should be added, a copy of Lucan's *Pharsalia* (Trinity R. 3. 30), a beautiful small book whose initials recall the lion hunt of the medical treatises (MS. Royal 12 E. XX) and the gymnastic climbers of the Boethius (Trinity MS. R. 15. 22), but with the acanthus frieze of the Rochester Augustine set in the bars of its initial letter (Pl. 11 *a*).

Of quite a different significance is another Rochester problem. MS. Royal 5. D. III is the first volume of another set of Augustine's Commentary on the Psalter, that indispensable and much reproduced work. It is marked as *de Claustro* of Rochester, and the name of a prior has been erased. Its opening initial is a spirited rendering of lions, with long outstretched necks and with their muscular movements clearly articulated.[4] It is an individual hand and it is found with finer and much more profuse achievement in another book, a bible of which eight books exist in MS. Royal 1 C. VII and the New Testament in MS. 18 of the Walters Gallery in Baltimore. These two volumes have no indication of provenance and could from their script be either Canterbury or Rochester work. Some

[1] A. A. Arnold and F. Liebermann, 'Notes on the Textus Roffensis', *Archaeol. Cantiana*, xxiii (1898), 94.

[2] Reproduced in *Annual Report of the Friends of Rochester Cathedral*, i (1936).

[3] See above, p. 44.

[4] Reproduced in *Catalogue of Royal Collections* (1921), Pl. 41 *c*.

of the foliage, particularly where it coils round the bars of the letter, is very similar to the initial in the Canterbury Episcopal Professions, MS. Cleopatra E. 1 (Pls. 12 and 19). The circular bars, however, contain the same running pattern of acanthus leaves which we have seen used by the second hand of the Augustine Commentary and by the decorator of the Lucan. There seems strong stylistic evidence that this is a book produced for and probably at Rochester. The same acanthus panel and type of figure drawing are found in a volume of miscellaneous works by St. Ambrose, Ivo of Chartres, and Bruno of Asti (B.M. MS. Royal 6 B. VI), a volume which from its composite nature is unquestionably to be identified with No. 30 in the *Textus Roffensis* catalogue.[1]

Discussions of the biblical text, leading up to the great glosses, were to be one of the dominant interests of scholastic circles in the twelfth century. Lanfranc, as a teacher at Bec and as abbot of St. Étienne, had been one of the founders of this study, the revision of the biblical text, mainly directed towards a closer concordance with patristic commentaries. This revised text was brought by him to Canterbury and gave a new impetus to the production of copies of the scriptures.[2] The Bec tradition is reflected in the Carilef Bible and it is found also at Rochester in Gundulf's Bible, now in the Huntington Library in California.[3] The British Museum Octateuch and the Walters New Testament belong to this phase of bible-making but mark a new visual development. Not only have they admirable decoration, some of the finest coiled dragons of our English output, but in the Old Testament are historiated initials, which belong to an iconographical scheme that was to have most distinguished successors. The initial to Joshua shows Joshua receiving the book of the law, but the artist was puzzled how to adapt his scene to the letter space and his figures are drawn horizontally across the vertical line of the text. In Kings I he deals more happily with his material, and Elkanah between his wives, the opening subject of the book (A.V. Samuel I) which was to

[1] *Catalogue of Royal Collections* (1921), Pl. 45.

[2] H. H. Gluntz, *Vulgate in England* (1933), 158.

[3] H.M. 62: the opening initials of the various books are plain with no ornamentation, painted in a dull red pigment. I am indebted to the Curator, Mr. H. C. Schulz, for this information.

become a stock theme, is properly set on the page. For Kings IV the initial shows Elijah ascending in his chariot into a brilliantly coloured cloud on the far side of a Jordan full of fish (Pl. 18 a). This scene, which certainly has Byzantine prototypes, was later to be much elaborated, and the bar of the P to be used for Elisha seizing his master's falling cloak. Here the artist was not yet ready for such feats and the bar has an irrelevant huntsman, his hounds and a hare all compressed with fine disregard of relative positions into the long narrow space. The figures have the pointed faces and embroidered garments which are to be found in the frescoes of St. Gabriel's chapel and must be approximately contemporary work. These two volumes may well be the bible composed of items 113 to 116 in the Rochester catalogue of 1202, of which a note states that the Minor Prophets and Chronicles were lacking. Exact date and provenance must remain an open question. Whatever its origin, it is a work that marks a stage in the growth of English book illustration.

In any review of the first half of the twelfth century, a prime problem is this matter of assigning a date and place of origin to particular illuminated manuscripts. A psalter with its calendar of feasts and its litany or a martyrology with its selection of particular saints will provide some guidance: old library lists or library marks, as with the Durham or Rochester books, may give a book's early owners and therefore a presumptive indication of where it was produced: in addition to the style of the ornament, there is the script which, to the trained eye, will show individual traits associated with particular scriptoria: but scribes as well as painters may have moved from place to place and a liberal time lag has to be allowed for longevity either of individuals or fashions. Some of our most interesting illustrated manuscripts still lack any indication of provenance.[1] We have, however, for this period one remarkable document, where all the information as to date and place is fully provided. From the ninth century onwards, possibly earlier, it was the custom when an abbot died to send out to a wide circle of

[1] See on all these questions the introductions of V. Leroquais to his great catalogues of 'Les Bibliothèques publiques de France', *Sacramentaires et missels* (1924), *Psautiers* (1940–1), *Livres d'heures* (1927), *Bréviaires* (1934), *Pontificaux* (1937).

monasteries a request for prayers for the dead. This request took the
form of a roll, carried from monastery to monastery by a 'rotulifer',
a roll bearer. Each monastery as they received him inscribed on the
roll their prayers for the soul of the dead, adding a request for
prayers in return for their own members, sometimes giving the
names of those recently departed. Memorial verses were also
sometimes inscribed. Thus on the death, after a long reign, of

FIG. 7. *Titulus of Westminster abbey*

Matilda, the first abbess of La Trinité of Caen, her mortuary roll,
known unfortunately only in a partial transcription,[1] was sent
round the monasteries of northern France and England, being
taken westward to Exeter and north to York, in all to forty-eight
English houses. Twelve years later, on the death in 1122 of Vitalis,
abbot of Savigny, a similar procedure was followed, but here,
fortunately, the original manuscript survives.[2] It forms a com-
pendium of examples of the penmanship of all the abbeys con-
cerned. Here we can see in succession the firm thick lettering of
Christ Church, Canterbury, and the thinner, more rounded forms
of St. Augustine's. Immediately following is a scratchy uncertain
entry from St. Pancras of Lewes, where the surprisingly unskilled
scribe has left out *fidelium* and had to insert it above. The nuns of
Romsey write in an elaborate and very individual hand, and
request prayers for seven of their number, two prioresses, Petro-

[1] L. Delisle, *Rouleaux des Morts* (Paris, 1866), 177.
[2] *Rouleau mortuaire du B. Vital, Abbé de Savigni*, ed. L. Delisle (Paris, 1909): see also
A. W. Clapham, 'Three Bede-Rolls', *Arch. Journ.* cvi (supplement, 1952), 40.

nilla and Cecilia, and five nuns, Godiva, Gisla, Leoviva, Beatrice, and Gilburge. It is noticeable that the prioresses have Norman names, the nuns mainly Saxon. Few initials are elaborate: the monks of Corbigni, near Autun, have drawn a grotesque where a man with asses ears stands on a three-headed monster while two other human figures, in Phrygian caps and with tails, emerge from his mouth. It is hard to give any meaning to this and it seems a singularly unsuitable invention for its sombre context. The only other figure, on a much more modest scale, is a man carrying a dragon, from Thorney abbey in the Fens. Croyland is represented on the roll by a stylized foliage initial. Milton abbey in Dorsetshire uses a fine coiled dragon initial. Westminster has a splendid monogram, very boldly treated, without any foliage, dragons, or interlaces, a distinctive piece which must have been the work of a highly skilled craftsman (Fig. 7). But the interest of this book, which brings us at such close quarters to these monastic names, is endless. A sister of Argenteuil wrote an elegy on the roll so accomplished in its Latinity that it is hard not to attribute it to the convent's most gifted inmate at the time, and it is not least of the roll's claims to distinction that it may preserve for us an autograph poem by Héloise.

III

READING AND THE WEST COUNTRY

THE man who presided over the country, whose court however peripatetic set fashions in taste, Henry I, was not one who seems to have had much liking or understanding of the arts. His name of 'Beauclerk' was a fourteenth-century invention, and in his day he had the reputation of a practical rather than an intellectual man.[1] 'He never read openly', writes William of Malmesbury, 'nor displayed his attainments except sparingly, yet his learning, though obtained by snatches, assisted him much in the service of government.' He had little reputation as a church builder: William, writing shortly after 1120, says of him: 'Of laudable piety to God, he built monasteries in England and Normandy, but as he has not yet completed them, I in the meantime suspend my judgment.'[2] Reading abbey was, as William admits, the one exception. Robert of Torigni, the monk of Bec who became abbot of Mont St. Michel in 1154, tells us that Henry built the church of Notre-Dame des Prés at Rouen and Notre-Dame of Évreux: but the latter town had been destroyed by Henry in 1119 and the rebuilding, carried out by Bishop Audouin, brother of Thurstan of York, was in the nature of reparations: little now remains of Henry's work, but one bay of the nave triforium has a decoration of interlacing arches such as had been so freely employed at Durham and Canterbury. Robert was impressed, however, by Henry's liberality to men of religion, particularly by his presents to Bec and to the building fund of Cluny, where, he says, 'the greater part of the church was built at his cost'.[3] In England he

[1] V. H. Galbraith, 'Literacy of the English Medieval Kings', *Proc. of British Academy*, xxi (1935), 201: C. W. David, 'The Claim of Henry I to be called Learned', *Anniversary Essays in Medieval History by Students of C. H. Haskins* (1929), 45.

[2] *Gesta regum*, R.S. xc (2) (1889), 489.

[3] *Recueil des historiens de la France*, xii (1781), 580, or Migne, *P.L.* cxlix (1853), 901. For the question of Robert's re-editing of and additions to William of Jumièges, see *Recueil des historiens de la France*, xii (1781), xlvi, and J. Lair, *Matériaux pour l'édition de Guillaume de Jumièges* (1910), 29. For an estimate of Henry's patronage see J. C. Dickinson, *Origins of the Austin Canons* (1950), 125.

seems to have had a special regard for the Augustinian canons. But apart from Reading there is little indication of a personal interest in the buildings financed by him. Rufus, if no great patron, had done much for London, where he built a new bridge across the Thames, the hall of Westminster, and furthered the building of the priory of Bermondsey. This was a continuation of the work in the city initiated by his father, of which the Tower, completed by Rufus in 1097, was the most conspicuous feature.[1] Henry also is mainly known as a castle builder, and the prestige of the Tower, the greatest stone keep (107 × 118 ft.) yet built in western Europe, is the most fitting architectural memorial of the Conqueror and his sons.

The development of stone castles, replacing the earth mound and wooden palisade to which fortification had been reduced, is a feature of the second half of the eleventh century. The reign of Henry I saw a rapid increase in stone building and the chroniclers constantly stress his interest in fortification work. 'He guarded the castle of Domfront', Robert of Torigni writes, 'with such care that it continued in his possession as long as he lived': Gisors, erected by Rufus, Henry 'made impregnable by throwing round it a wall with lofty towers': 'the fortress of Arques he wonderfully strengthened with a wall and towers'.[2] Of his French strongholds, most have now disappeared or been transformed by later rebuilding: the keep he built in the vast fortress of Caen was destroyed by order of the Convention in 1793: at Gisors there are remains of some of the hollow rectangular towers with which he fortified his curtain wall and the lower stages of the central polygonal keep may be his work: but the great rectangle of Falaise is the main survival of his castle building, and with its ashlar, its flat external buttress strips, and its upper windows, divided by a colonette and with carved capitals, it is a typical example both of the strength and the amenities of the new castles. Today the medieval castle is usually discussed from the point of view of the science of its defence, but there is little doubt that to contemporaries it was also an object of splendid beauty. *Pulchra fortitudo* was the common epithet which they applied, and the great castles of the early

[1] I. M. Cooper, 'Westminster Hall', *Journ. Brit. Arch. Ass.* 3rd series, i (1937), 168.
[2] *Chronique*, ed. L. Delisle, i (1872), 165.

twelfth century, of that new epoch in stone craft, show in the careful working of their masonry, in their proportions which give full value to an imposing sense of height, and in the elaboration of their interiors a clear sense of their visual prestige.

In England Henry as a castle builder seems to have been less active. The much ruined keep at Canterbury may well date from the reign of Rufus: that of Norwich is undocumented but must come from the period 1120–40; certain resemblances to Falaise suggest that it is the work of Henry's masons; its unusually ornate exterior with elaborate arcading has been much restored, and was refaced in 1834 to an extent that makes it difficult to judge the original work.[1] The great keep at Colchester, 110 by 152 feet, was the work of Eudo Dapifer. Colchester was a royal castle, but Eudo seems to have supervised the building and probably saw its completion before his death in 1120. Its great size was partially due to the fact that it was built round the podium of the Roman temple, and its walls, which when rising to the full three stories (the third story was destroyed in 1683) were of vast proportions, rested on Roman vaults.[2] At Ludlow a considerable circuit of stone wall, with projecting rectangular or polygonal towers, was built by the Lacys at the close of the eleventh century.[3] The most perfect example of all, that of Rochester, was long attributed to Bishop Gundulf, who had played a leading part in the construction of the Tower of London and whose building activities can still be traced in various Kent churches. The keep, however, is not his work, but is the *egregia turris* built by William of Corbeuil between 1126 and his death in 1137.[4] Seventy feet square and 113 feet high, it was divided into three floors. Three of the corners have projecting rectangular towers, before one of which there is a forebuilding protecting the entrance: the fourth tower, as in London, is rounded.

[1] A. Hartshorne, 'Norwich Castle', *Arch. Journ.* xlvi (1889), 260; S. Woodward, *The History and Antiquities of Norwich Castle* (1847); A. B. Wittingham in *Arch. Journ.* cvi (1949), 77.

[2] D. W. Clark, *Colchester Castle* (Colchester, 1948); and *R.C.H.M. Essex*, iii (1922), 50. [3] W. H. St. John Hope, 'The Castle of Ludlow', *Archaeol.* lxi (1908), 257.

[4] G. M. Livett, 'Mediaeval Rochester', *Archaeol. Cantiana*, xxi (1895), 17, and 'Early Norman Churches in and near the Medway Valley', ibid. xx. 137, xxi. 260; C. H. Hartshorne, 'Rochester Castle', *Arch. Journ.* xx (1863), 205.

The sides are divided by flat pilaster strips. In sense of height combined with strength the effect is singularly successful (Pl. 20 *a*). Within, the arches of the great hall are carried on columns, faced with comparatively small ashlar blocks over a rubble core and supporting flat capitals with scalloped rims. The inner order of the arch and the arch of the fireplace have an unusual decorative motif of thick chevrons, indented deeply so as to stand out in relief from the voussoir.

On a smaller scale, the very completely preserved keep of Hedingham in Essex follows the main design of Rochester, but here the windows preserve their carved dripstones and the exterior retains as a result a certain elegance which Rochester has lost. The doorway has three rows of chevron ornament which are repeated on the interior arches and on the fireplace of the great hall. Probably built by the Veres, it must be placed close in date to Rochester—it has the same trick of a hollow angle where the two corner pilasters meet—but probably a few years later, about 1140. It marks the perfection of the style as practised in the first half of the century.

Reading was singled out by William of Malmesbury as the ecclesiastical foundation in which Henry took a real interest. Founded in 1121,[1] it was, as William tells us, strategically placed, 'in a spot well calculated for the reception of almost all who might have occasion to travel to the more populous cities of England'. Henry summoned seven monks from Cluny, to which house he had already shown very tangible devotion, to organize the community, and Hugh of Boves, prior of the Cluniac house of Lewes, was in 1123 appointed first abbot: but Reading remained an independent house modelled on, not under, Cluny. Abbot Hugh in 1130 became archbishop of Rouen and was to be a prominent and worthy figure till his death in 1164. The eastern arm of the abbey and probably some part of the nave were completed by Henry's death and he was buried there before the high altar. His gift to it in 1125 of the hand of St. James of Compostela, brought by Matilda from Germany, endowed it with a relic of major

[1] The authenticity of the foundation charter is questionable, but the date 1121 is probably correct.

attraction: the loss of his royal protection was shown by the fact that this precious treasure was appropriated in 1136 by Henry of Winchester and not restored till 1155. Possibly this may mark some decline in the abbey's fortunes: certainly its final consecration did not take place till 1164, when it was performed by Becket in the presence of Henry II.[1]

Four hundred and fifty feet long, with a width of 95 feet for nave and aisles, the plan was that of transepts with two apsidal chapels each, a choir and ambulatory with three radiating chapels opening off it. In this it followed the general lines of Battle abbey, the first Norman royal foundation, and those of Bury St. Edmunds and Norwich, of the latter of which the east end had recently been completed in 1119. In 1779 Sir Henry Englefield could still describe the abbey as situated on a small gravelly eminence, hanging over the river Kennet on the south, and to the north commanding a charming view of the Thames.[2] Now only the blackened rubble core of part of the walls remains, a gloomy adjunct to Reading's public park. But we are curiously rich in surviving fragments of its carved ornament: some are built into the archway leading to the ruins; others can be found in the adjoining nineteenth-century Roman Catholic church; an important series of capitals rescued from a rockery at Holme Park, Sonning, is now in Reading museum, as is also an elaborately carved column shaft; some pieces still form an ornamental arch in a private property at Shiplake; some are at Windsor, where a supply of stone was sent at the dissolution of the abbey; some, perhaps the most varied selection, were recently excavated in a garden at the village of Borough Marsh, near Twyford, built into the foundations of a wall, and are now in the Victoria and Albert Museum.[3] From these strange and haphazard

[1] J. B. Hurry, *Reading Abbey* (1901); J. C. Cox in *V.C.H. Berkshire*, ii (1907), 62; and H. Haynes, ibid. iii (1923), 339.

[2] 'On Reading Abbey', *Archaeol.* vi (1782), 61. For the demolition of the abbey and the systematic sale of its materials see A. E. Preston, 'The Demolition of Reading Abbey', *Berks. Arch. Journ.* xxxix (1935), 107.

[3] C. E. Keyser, 'Norman Capitals from Reading', *Proc. of Soc. of Ant.* xxviii (1915–16), 234. G. Zarnecki, 'The Coronation of the Virgin', *Journ. of Warburg and Courtauld Institutes*, xiii (1950), 1. The Borough Marsh excavation was carried out by the Courtauld Institute: the stones are deposited at the Victoria and Albert Museum on indefinite loan.

sources we can reconstruct the ornamental style of Henry's abbey.

Of these stones, some are springing stones and voussoirs and must come from an arcade: there is also a large corner-stone from which two arches sprang at right angles: many of the capitals are carved to be seen from all sides and from their size they too must belong to an arcade: it can be taken with some certainty that they represent the decoration, elaborate and very fully worked, of the Reading cloister. Unfortunately, there is no documentation for its building. Stylistically there are relations with Canterbury, but also many motifs not used there: some of these, the masks holding knots of thin stemmed foliage, the triangles filled with heavily veined leaves, are common to Reading and the masons' yard working round Castor in Northamptonshire, and it seems either that there was some interchange or some source in a common tradition. The cat's mask is familiar in manuscript initials; the triangles of leaves appear on the border of a robe in MS. Arundel 91 (Pl. 6 b). Castor, dated to 1124, certainly preceded Reading: elsewhere, similarities in carving are more likely borrowings from the great abbey, for it is natural to think of this royal foundation as a point of diffusion, not as a *retardataire* recipient of ornamental fashions. The work, even in the fragmentary state in which we have it, is from various periods. The nine capitals in Reading museum with trilobe markings on the cushion face and scallops below are distinct from the rest of the work and probably come from a later building stage (Pl. 21 a). They belong to a widely diffused type, which seems to have had its main popularity c. 1160. The bulk of the carving is earlier and should probably be dated between 1130 and 1140.

A wide range of patterns is employed. The winged confronting dragons on one capital recall closely the monsters of the Canterbury crypt, but where Canterbury has clear, strong designs and treats each capital face as a unit, the Reading masons spread their foliage in a network which in its clambering growth neglects and partially obscures the form of the capital, and is held together only by the cats' masks from which it springs. The leaves themselves become thinner and stringier. It is a return to a late Anglo-

Saxon style, and there is much at Reading which seems curiously English beside the more continental manners of Canterbury. And, if Anglo-Saxon motifs recur, there are also traces of Viking influence. Some of the knotted patterns, the curling shoots for instance which, on the corner-stone, pass beneath the pelican's wing and between its legs (Pl. 21 *b*), recall Scandinavian work. Even more characteristic, sharply separating it from Canterbury and the south coast churches, is the use of beak head ornament on the voussoirs of the arches. This English fashion, which was to spread to Normandy but never be fully acclimatized there, seems to date from the second quarter of the century. English masons delighted in these fantastic, sometimes repellent, heads and the use of them at Reading may have given the first great impetus to their popularity. Certainly Berkshire and Oxfordshire were one of the main and earliest centres of beak-head ornament.[1]

These northern motifs were, however, only one side of Reading art. Not all the foliage is thin leafed and wiry; some of it swells and burgeons into fruit; a pointed blossom springs from between the leaves and opens, showing a cone of seeds; it is an old classical and Byzantine motif, not unknown to Anglo-Saxon art, but now reviving in English carving as it had already done in English illumination.

The figure sculpture at Reading has also its own individuality. Some of the coils are inhabited by small naked figures, but here, unfortunately, weathering has destroyed the niceties of the work. On a voussoir there is a man fighting a dragon which must when less battered have been finely wrought. But on one face of a capital in Reading museum a characteristic figure style appears which belongs to a type that we shall find much used elsewhere. The cushion face is treated with little regard for the structural space: in fact two figures seated in mandorlas is as inconvenient a scheme for the semicircular shape of a cushion capital as could well be thought of. The figures are winged and haloed; one carries a staff, the other raises his hand in blessing: it is probable that some symbolism of the Father and Son is intended. These long-necked, goggle-eyed personages are crude and wooden; hair and drapery

[1] J. Salmon in *Yorks. Arch. Journ.* xxxvi (1947), 349; C. E. Keyser in *Berks., Bucks., and Oxon. Arch. Journ.* vi (1900), 13. For examples see Pls. 26 *a*, 70 and 71.

are marked by series of straight lines, like hatching; yet the sweep of the wings, cutting across the mandorlas, has a fine decorative effect. On the abacus is a beaded guilloche pattern of plaited strands, another feature not found in the Norman or the Canterbury repertory (Pl. 21 c). More deeply and more sensitively cut, but still with the folds drawn in straight lines, is a much damaged fragment lately found at Borough Marsh. It represents the scene of the Coronation of the Virgin and is the earliest known rendering in stone of that subject.

Near by, the parish church of Cholsey had been given to Reading abbey by Henry I.[1] Of the Norman carvings reset in the present structure, one of the capitals of the south door shows beaded interlace easily paralleled at Reading, the other the trilobe pattern of the later group of the museum capitals, here with a human head at the free angle: two capitals of the tower arch, elaborate versions of the trilobe scallop, show work of the same carver. The plan of the Norman church was an aisleless nave, transepts, each with an apsidal chapel, and an apsidal east end.

The other dependency of Reading, granted by its founder, was the priory of Leominster in Herefordshire.[2] It rapidly became a prosperous house. The altar of the Holy Cross in the easternmost bay of the nave was consecrated in 1130. This eastern arm no longer exists, but excavations have shown that it was on the Reading model with a round apse, ambulatory and three radiating chapels, and transepts with one apsidal chapel each (Fig. 8). The plan of the nave, which is now with the addition of two large Gothic aisles the parish church, seems to have undergone a change in alinement, possibly in connexion with the western tower. There is an uneven distribution of columns and large composite piers, and a triforium arcade, now blocked, in the Jumièges proportion. The west doorway has the unusual feature of a pointed arch, though its decorative detail cannot be much later than the mid-century. There is no tympanum, but the capitals, abaci, and imposts are richly carved (Pl. 22 c): two confronting doves emerging from interlaced coils; two men cutting corn, their tunics marked with the straight line

[1] F. J. Cole, *An Analysis of the Church of St. Mary, Cholsey, in the County of Oxford* (Oxford, 1911).　　　[2] *R.C.H.M. Herefordshire*, iii (1934), 111.

hatching of the Reading capital, their eyes large and protruding; an interlace of serpents; an unusual treatment of three rows of buds between opening leaves; two confronting lions; a foliage design

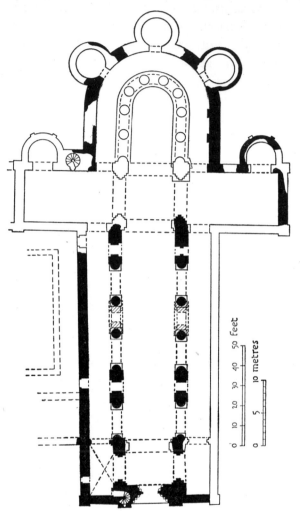

FIG. 8. *Plan of Leominster priory*

with the same patterning of the leaves repeated top and bottom. Inside the church the arch of the doorway has interlace capitals, two of them held by cats' masks at the angles. The decoration of the abaci makes much use of the pattern of leaves set in triangles, which was popular at Reading: stylistic coincidences are strong,

and it can hardly be doubted that some Reading masons worked at the abbey's Herefordshire dependency. The gap, however, in our knowledge is a large one. Nothing except foundations remains of the first building stage of the east end of Leominster. The west doorway owes something to Reading but much also to a local Herefordshire school, the most individual local school of stone carving that Romanesque art produced in England, and one which, if the opening of a yard at Leominster may have given the first impetus, had developed through its own experiences before the west front had been reached.

That it was at Leominster that this impetus came, in the building of its eastern arm, seems the more probable inasmuch as the cathedral of Hereford seems to have had little touch with the shire carvers who brought their work to such remarkable achievement. The cathedral's architectural history remains in fact curiously detached from its immediate surroundings. William of Malmesbury tells us that the Lorrainer bishop, Robert (1079–95), built a church at Hereford on the model of the minster at Aachen.[1] Various interpretations of this statement have been attempted, none completely satisfactory. The cathedral as we now have it seems to have been begun by Bishop Reinhelm (1107–15), and despite the series of brief episcopates which made the see proverbial, the work must have proceeded very steadily. The aisles of the choir terminated in apses and a tower rose over the eastern bay of each aisle, a unique instance in England. The eastern arch of the choir is still standing, though its capitals and much of its ornamented mouldings are restorations: the plan of the eastern chapel into which it led has not been established. The south transept still retains much of its Norman work. Here an elevation already used at St. Albans and possibly at Chester was carried at stage farther (Pl. 14 d).[2] Above a double row of blind arcading a small wall passage, a true triforium, with groups of three small arches, replaces the wider tribune openings of the choir, recreating an emphasis on flat wall

[1] *Gesta pontificum*, R.S. lii (1870), 300.

[2] J. Bony in *Bull. mon.* xcviii (1939), 180. See, for the general history of the cathedral, G. Marshall, *The Cathedral Church of Hereford* (1951); R.C.H.M. *Herefordshire*, i (1931), 90.

space which Anglo-Norman architecture had temporarily lost. The nave, of which the main arcade still stands under Wyatt's rebuilding of tribune and clerestory, has some rich chevron decoration, but has lost all the general proportions of its original design. The west tower fell in 1786 and destroyed most of the west front in falling. If any of the great Herefordshire carvers worked for the cathedral, their work has perished in the many vicissitudes which the building has undergone. A group of capitals, it is true, now deposited in the north transept, show some figure scenes, the Harrowing of Hell, Christ in Majesty, two facing figures that may be an Annunciation: they are crudely carved, though with some attempt at modelling, and are entirely distinct from the carvings of the Leominster group. A more notable work, the cathedral font, standing in a splendid Italianate manner on its four beasts, is later work of the second half of the century, and the carving of its bowl has links with works in the south-west, the stone font at Rendcombe or the lead fonts common in Gloucestershire.

Rather than in the cathedral, it is in a small country church that we find the most complete manifestation of the style and one that is fortunately fairly closely dated. The church of St. John at Shobdon was built by Oliver de Merlemond, steward of Hugh Mortimer. He went, shortly after the decision to build it, on a pilgrimage to Compostela, and the new ornateness of his small church may owe something to the splendours of Santiago and the thickly carved façades of Poitou. Merlemond invited to Shobdon a small group of canons from St. Victor, where he had stayed in Paris, and where he had been much impressed by all that he had seen. A later account of the foundation of Wigmore abbey, where eventually the Victorines settled, makes it clear that Merlemond, *quant sa eglise fut tote perfete*, asked Bishop Robert de Bethune of Hereford to consecrate it and that this took place before 1143.[1] His church seems to reflect observations made on foreign travels. Its decoration was

[1] MS. 224 in the University Library, Chicago. Printed in W. Dugdale, *Monasticon*, vi (1830), 345. Trans. in T. Wright, *History of Ludlow* (Ludlow, 1852), 102. Dr. Zarnecki has worked out the proof of this dating in great detail, *Later Eng. Rom. Sculpture* (1953), 9. See also J. C. Dickinson, 'English Regular Canons and the Continent', *Trans. of the Royal Historical Soc.* 5th series, i (1951), 74.

unusually lavish, possessing features for which it is hard to find English precedents. Unfortunately, it was pulled down in 1753 and rebuilt and furnished, most charmingly, in the style of Strawberry Hill Gothic. The chancel arch and the two doorways were re-erected as a 'Gothic' folly on a hill in the park. There, without any sheltering walls, they have steadily perished, and today, still exposed to all weathers, this great example of our native craftsmanship is in the final stages of decay. Fortunately there are some records to aid us in our interpretation of these mouldering remains. A plaster reconstruction was made for the Crystal Palace and though the relief was exaggerated it gave a fair rendering of what the carvings must have been. It in its turn was destroyed in the fire of 1936, but photographs exist of it. In 1852 George Lewis made detailed drawings of Shobdon in which, as so often, no amount of conscientious copying can disguise the tricks of contemporary style, but which are invaluable for identifying the various elements of the design.[1]

The chancel arch is of three orders of chevron decoration: they are supported by columns set in the angles of the jambs: imposts, capitals, columns, and bases are all elaborately carved (Pl. 26 *b*). One column shaft has rows of beaded rings enclosing birds, beasts, or interlace patterns joined together by cats' masks. The fragment of a similar shaft, where beasts are enclosed in linked circles, was found at Sonning with the Reading capitals. On another shaft, now hopelessly weathered, Lewis's drawing shows three figures in the upper coils of a scroll: one carrying the keys is clearly St. Peter, his companion presumably St. Paul; below, another figure carries some emblem, whose nature cannot be certainly distinguished. We shall find the same three figures repeated at Kilpeck. Another series of figures is better preserved: set in interlaces are five pairs of trousered warriors, their garments marked with the familiar 'hatching', their heads large and flatly cut. The arches of the two doors, now the side wings of the folly, have elaborate voussoirs carved, on the right doorway, with a confusion of themes in which the signs of the zodiac are mixed with small standing figures, and, on the left, with a row of beasts bending back their heads in a

[1] G. R. Lewis, *Shobdon* (1852); *R.C.H.M. Herefordshire*, iii (1934), 179. G. R. Lewis (1782–1871) had begun as a pupil of Fuseli.

regularly uniform pose, a convention rare in England but exactly
to be paralleled on the façade of Notre-Dame-la-Grande at Poitiers.
The capitals have groups of figures standing in rows, dragons,
interlaces, doves with the characteristic strongly marked wings
seen at Leominster: it is decoration used profusely with little sense
of its appropriateness and some of the figures are set on the cham-
fers of the abaci. The two tympana[1] show Christ in Majesty sup-
ported by four angels and the Harrowing of Hell. Something of the
vigour and noble spaciousness of the designs can still be perceived
through their battered state. The font, now replaced in the church
and somewhat better preserved, has four lions carved upon it,
larger versions of the lions on a capital at Leominster and un-
mistakably of the same workmanship.

So detailed is this Shobdon ornament, small village church
though it was, that several carvers must have been employed on it
and variations in handling and even considerable differences in
stylistic approach are in fact apparent: all the more apparent
because one of the sculptors was an artist of considerable merit.
His masterpieces, in present states of preservation, are two fonts,
one at Castle Frome and one at Eardisley. That at Castle Frome is an
elaborate and splendid piece of carving, in striking contrast with
the extreme simplicity of the little twelfth-century church in which
it stands and which, with its robust emphasis, it almost seems to
fill. On a round bowl, between two rows of plaited interlaces, are
shown the Baptism, the signs of the evangelists, and two doves
(Pl. 23); four crouching figures, now much mutilated, support it.
At Eardisley the font, of the same shape but without its original
base, has slightly larger figures, fine in themselves but not so finely
spaced as those of Castle Frome. It shows the Harrowing of Hell;
two men fighting with spears, brothers of the Shobdon warriors,
their garments strongly marked by the straight line shading; and
a great lion. At Chaddesley Corbett, across the border into Wor-
cestershire, another bowl font shows the same broad bands of
interlace and a lively design of four dragons. It is well cut, possibly
by the same hand, but lacks the vehement imagination of the two
Herefordshire examples, where every line seems to have a disturb-

[1] G. Marshall in *Trans. of Woolhope N.F.C. 1918–20* (Hereford, 1921), 54.

ing life of its own and the distorted figures, whatever limitations their crudity implies, exactly serve the master's expressionistic needs.

The small but very complete twelfth-century church of Kilpeck lies at some distance, south-west of Hereford city, but certainly the Shobdon master was responsible for its decoration.[1] Its carvings are in a remarkable state of preservation, so much so that it has often been thought that they were recut by Cottingham when he restored the church in 1846. The surface, however, does not suggest recutting: Cottingham's restorations, such as the top half of the tympanum, are perfectly clear and undisguised: the south doorway was long covered by a porch ('it being', as the ardent ecclesiologist Lewis wrote, 'in its whole appearance a public house porch') and must owe something of its present admirable state to that protection: the Herefordshire sandstone has some hard veins which are singularly lasting, and it is from one of those that this sharp-edged brilliant ornament has been cut. The doorway (Pl. 26 a) is of two orders: the inner jamb is plain and shorter than the outer; it supports the tympanum which thus comes below the capital of the shaft of the outer jamb; this shaft is as it were inserted into the main jamb and the ornament of its capital continues on to the flat surface of the main block. Column and jamb are alike carved; the left-hand column with two 'warriors' in a pattern of thin knotted coils, the right hand with foliage and confronting doves; the jambs are covered with twisting dragons; the tympanum has a foliage design, for which there are earlier local examples such as the tympana at Dymock and Kempley. The voussoirs are carved with beasts, a flying angel, and a variety of beak heads, the only use of this particular motif by this Hereford school. The label is composed of beaded rings enclosing doves and signs of the zodiac, joined by upturned masks. There is a curious sense of continuous movement around the frame of the door, in striking contrast to the firm, balanced repose of the design on the tympanum. So distinctive is its effect that explanations have been sought in Scandinavian or

[1] *R.C.H.M. Herefordshire*, i (1931), 156; G. R. Lewis, *Kilpeck* (1842); L. Cust, 'Kilpeck Church', *Walpole Society*, v (1917), 85; W. H. E. Clarke, 'The Church of St. David at Kilpeck', *Trans. of the Woolhope Natural Field Club, 1930–2* (1935), 7; S. Jónsdóttir, 'Kilpeck', *Art Bulletin*, xxxii (1930), 171.

Celtic influences: but Shobdon preserved would have been even more impressive and, though there is the individuality of genius in this group, these motives are from the Romanesque repertory, blending provincial crudities with the sophistication of Reading and almost certainly with memories or drawings of Aquitaine.

Inside Kilpeck there is as at Shobdon an elaborate chancel arch: on either side the shafts are carved with three figures, standing one above the other (Pl. 22 a). They include the same figures as appeared at Shobdon, St. Peter, St. Paul, and a figure with an un-certain emblem (probably an asperger, appropriate to the entry to the chancel): but at Shobdon the figures were still in the coils: here they are carved on the columns with no decorative background: they are in fact, though still in low relief, 'column figures' for which we know no English prototypes. The faces are strongly cut and the drooping moustaches, heavy cheek bones, and large eyes are those of the Baptist on the font at Castle Frome. Their draperies cling to the bodies and spread out fanwise at their feet. A drawing in a crudely illustrated manuscript (P. 4. iii) in Hereford cathedral library shows the same conventions and may be local work under the same inspiration (Pl. 22 b).[1]

One or two further examples must serve to indicate the rich survival of this Hereford school. At Rowlstone, close to Kilpeck, its work can be found on the doorway and the chancel arch. The tympanum is carried down, as at Kilpeck, below the capitals of the attached columns of the inner order. It is a copy of the Christ in Majesty of Shobdon, well preserved but less plastic in its execution, depending largely on fine closely cut linear patterns. The familiar doves perch on the capitals and on the responds of the chancel arch. In Hereford city there is another copy of the Majesty, now built into a wall of the cottages of St. Giles' hospital, but it is hopelessly weathered and no details can be traced on its crumbling surface. At the villages of Brinsop and Stretton Sugwas, close together to the west of Hereford, a sculptor carved two fine tympana, both now preserved within their respective churches.

[1] The drapery of the Shobdon school translated into graphic terms can also be seen in the curious English Psalter which is now MS. 1 of the Bibl. Municipale of Lunel, near Montpellier. See V. Leroquais, *Psautiers*, i (1941), 224, Pls. XXXIII–XXXV.

The Brinsop St. George is a vigorous, mounted warrior, with his cloak flying out behind him (Pl. 24 *b*). Some voussoirs reset in the church, carved with standing figures, signs of the zodiac and foliage, recall one of the Shobdon doorways. At Stretton Sugwas a long-haired Samson, in a tunic pleated in straight lines with long closely ringed sleeves, strangles a 'Shobdon' lion. Dr. Zarnecki has made the striking suggestion that these two tympana must be based on drawings of the 'Constantine' and 'Samson' figures on the façade at Parthenay-le-Vieux near Poitiers; and there is no doubt that there are striking points of resemblance supporting this further link between the Herefordshire school and western France. The Brinsop St. George is copied in a tympanum at Ruardean by a slightly later and much feebler artist. The Samson was copied in miniature on an abacus at Leominster. At Fownhope there is an even finer tympanum: it has the protruding ears, close ringed sleeves, and hatched garments which are common to the whole school, but the iconography raises some curious problems (Pl. 24 *a*). Amid interlacing tendrils, in which are set the eagle of St. John and the lion of St. Mark, are seated two figures, which appear from their pose to be the Virgin and Child; but the larger figure has a cruciform halo and behind the head the deeply lined veil seems more like wings; the Christ raising his hand in blessing is markedly unchildlike. The cruciform nimbus, the attribute of Christ, is often given also to God the Father, as for example in an Anglo-Saxon drawing of the Trinity (B.M. Harley MS. 603 f. 1) where the First Person is shown unbearded and embracing the Christ Child, but where the dove completes the meaning of the group.[1] In both the carving and the illumination Christ holds a long scroll. It is possible that some such reference underlies the inscrutable Fownhope figures: more probable that it was some confusion in the mind of the carver. As so often in this Herefordshire school, we are aware both of traditions and symbols forgotten or never known in the more cosmopolitan centres of the south, and also of misconceptions where the image is copied without grasp of its meaning.

[1] For MS. Harley 603 see E. H. Kantorowicz, 'The Quinity of Winchester', *Art Bulletin*, xxix (1947), 84. See also A. Krücke, 'Zwei Beiträge zur Ikonographie des frühen Mittelalters', *Marburger Jahrbuch*, x (1937), 29.

If there are latent problems in the iconography of recognized religious scenes, there are far wider uncertainties as to the meaning of these strange creatures which we have seen carved on lintels and capitals or sprawling over the pages of manuscripts: these entwined dragons, winged birds, battling manikins, all this outrageous paraphernalia of medieval visual imagery. I cannot hope to emulate George Lewis, who in the mid-nineteenth century wrote on Shobdon and Kilpeck with the intent 'to breathe into Ecclesiastical design the profitable breath of communicative intelligence':[1] but neither can I accept the view, sometimes put forward, that these intricate but whimsical designs are the mere doodling of the cloistered subconscious. No doubt there is in them a release of repressions, but these symbols have many sources. The northern barbaric mind was familiar with monstrous inhabitants of thick tanglewoods and dim overshadowed meres. It is not insignificant that one of the books about monsters, *De monstris et belluis*, almost certainly a version compiled in Anglo-Saxon England, contains a reference to King Hunglagus who ruled the Getes and who is in fact Hygelac, uncle of Beowulf. We can still see in the Bayeux tapestry the dragon standard which floated over Harold's last stand at Hastings.[2] To the monks of Laon touring England with their relics to raise money for their cathedral, destroyed by fire in 1112, it seemed that when their appeals were churlishly rebuffed at Christchurch a great fiery dragon descended on the town.[3] Geoffrey of Monmouth's History is full of strange beasts and is one of the great expressions of this twelfth-century cult. Once more at the end of the century a dragon was the ensign of Cœur de Lion. Then, defeated perhaps by the growing cult of St. George the dragon slayer, the winged monsters become less frequent. Classical models or much travelled Scythian motifs gave hints as to how these creatures might be represented, but the barbaric instinct for abstract pattern was strong and the dragons constantly dissolve into pattern and become hardly recognizable as beasts.

[1] The sub-title of his *Kilpeck* is 'An Essay on Ecclesiastical Design and a Descriptive Interpretation'.

[2] J. S. P. Tatlock, 'The Dragons of Wessex and Wales', *Speculum*, viii (1933), 223.

[3] J. S. P. Tatlock, 'The English Journey of the Laon Canons', ibid. 454.

Even in the early twelfth century this process was at work, as can be seen at Houghton-le-Spring near Durham, where the dragons hardly emerge from their ribbon design, though set in an early Norman chevron moulding. Then the animal forms once more appear, conditioned in their shapes by the geometric or foliage patterns out of which they come. The new solidity and vitality which the Anglo-Norman artists gave to their monsters is a step in a classicizing process that advanced steadily throughout the twelfth century, a stage also in the dialectic between pattern making and representationalism, which is the basic tension of the Romanesque style. The little beast with its foliage tail in a Mont St. Michel manuscript of the late eleventh century becomes the splendid prancing creature of *c.* 1160 (Pls. 5 *c* and 28 *c*).

Some of the sources for the repertory of images are known to us, even if we have to deduce the nature of the prototype from later versions. Ancient scientific books were eagerly scanned not only for their instruction but also to provide material which the Romanesque artist could copy and eventually interweave with his wild, decorative patterns. The influence of illustrated astronomical and medical treatises, such as that at Durham, has already been mentioned.[1] Late classical astronomical texts, of which the Hellenistic poems of Aratos, known as the *Aratea*, were the most popular,[2] provided models of the human figure showing the placing of the constellations: and as often when a classical model lies close at hand the copied figures have an unusual firmness and certainty of outline, even though they adapt themselves to the poses of Romanesque initials. The *Medicina de animalibus*, vaguely attributed to an author, Sixtus Placitus, of whom nothing is known, was another highly popular work of which we have two English eleventh-century copies, one in Anglo-Saxon (B.M. Vitellius C. III) admirably illustrated, the other in Latin (Bodl. MS. 130) from the library of Bury St. Edmunds, bound up with the Herbal of Apuleius. The Herbal also provides a series of illustrations, of which some have

[1] See above, p. 27.
[2] J. Seznec, *La Survivance des dieux antiques* (1940), 132; E. Panofsky and F. Saxl, *Metropolitan Museum Studies*, iii (1931), 231; F. Saxl and R. Wittkower, *British Art* (1947), 29.

human figures.[1] The twelfth century copied both the *Medicina* and the Herbal. The *Tractatus de diversis monstris quae sunt in mundo* (known sometimes as *Marvels of the East*), as its name suggests, was admirably fitted to the taste of the age: in B.M. MS. Tiberius B. V. we have a wonderful series of illustrations to it, some of the most imaginative and astonishing products of the Winchester school in its great early-eleventh-century period; the same prototype was used on a much smaller scale in MS. Bodl. 614 by a competent twelfth-century artist, but when the two are compared the later hand seems tight and over cautious. The twelfth-century miniaturists, particularly in the first half of the century, came under the spell of their great predecessors of a hundred years earlier. They sought for firmer outlines, but could not escape from these vivid broken lines and subtle curving strokes: they copied constantly, often debasing their model because its virtues lay counter to their own genius. Here too there was another tension, only gradually resolved. The Anglo-Saxon artist sets his scene of the giant goats (f. 78 *b*) in a real landscape, and his nervous strokes bring the movements to liveliness and throw an atmospheric shimmer over the page: his Anglo-Norman rival makes a correct pattern, but these are dummies, wooden models that have never been out of doors (Pl. 28).[2]

Half myth, half a fact of the forest, the wild huntsman and his horn were near to the minds of men to whom the chase was a burden or a favourite pastime. At Peterborough the misdoings of the abbot, Henry of St. Jean d'Angely (1127–32), brought a strange invasion of the woodlands: 'the hunters were black and huge and hideous, and they rode on black horses and black goats. This was seen in the very home park in the town of Peterborough, and in all the woods between that town and Stamford, and the monks heard the horn blown that they blew in the night.'[3] The

[1] There is a large literature on the herbals: see E. S. Rohde, *The Old English Herbals* (1922); C. Singer, 'The Herbal in Antiquity', *Journ. of Hellenic Studies*, xlvii (1927), 1; R. T. Gunther, *The Herbal of Apuleius*, Roxburghe Club (1925). Bodleian MS. Ashmole 1462 is a particularly fine example of an illustrated herbal of *c.* 1180.

[2] M. R. James, *Marvels of the East*, Roxburghe Club 177 (1929). A. Thomas, 'Un MS. mutilisé du liber Monstrorum', *Archivium Latinitatis Medii Aevi* (Bulletin Du Cange) i (1924), 232.

[3] See D. Knowles, *Monastic Order* (1941), 184, quoting from the Anglo-Saxon

Labours of the Months provided a homelier content for this hotch-potch of images (Pl. 31). Another theme with a classical origin, it was already familiar in English art.[1] Linked with the *De diversis monstris* they appear in the eleventh century as calendar illustrations in B.M. MS. Tiberius B. V, open-air scenes drawn as horizontal strips in the manner of the Utrecht Psalter: another finer and probably earlier version, by an excellent 'Winchester' hand, can be seen in B.M. MS. Julius A. VI, very vivid records of the actual scene. The lead font at Brookland, Kent, with its labourers posed under a colonnade and above the signs of the zodiac, must have been based fairly closely on some late classical model. By the end of the century these free-standing figures have been caught up in the coils of foliage, as in the initial of MS. Vitellius C. XII[2] or somewhat later in a calendar scene in MS. Bodl. 614.[3] Even in carving, though they strut solidly enough in a primitive work—its date is pure guesswork—such as the Burnham Deepdale font, they tend to merge into the ornament of capitals, or like the two men reaping on the door at Leominster to become detached motifs. Here and there other stock subjects provide opportunities for small genre scenes, David's musicians for instance: sometimes, but rarely, there are genuine studies of the contemporary scene, without any apparent symbolic or narrative context, as the bell-ringer crudely carved on a column at Stoke Dry in Rutlandshire.[4] Aesop's fables, or rather the collection which the middle ages attributed to Aesop, were another favourite quarry.[5] Some of them appear in the border of the Bayeux tapestry. Marie of France about 1170 translated the fables 'which folk call Esop' from English into French, which suggests that in England they enjoyed a particular popularity.[6] These ancient themes were gradually hallowed by an accretion of Christian association. Most curious and popular usage of all was

Chronicle, E. Text year 1127. The story is also given by Hugo Candidus, ed. W. T. Mellows (1949), 101.

[1] J. C. Webster, *The Labours of the Months* (1938). [2] See above, p. 40.

[3] Reproduced *Bodleian English Romanesque Illumination* (1951), Pl. 10.

[4] The Brookland and Burnham Deepdale fonts and the Stoke Dry column are reproduced in A. Gardner, *Med. Eng. Sculpture* (1951), Pls. 105, 107, 118.

[5] G. Thiele, *Der Illustrierte Lateinische Aesop*, Leiden (1905), 36.

[6] J. C. Cox, 'Marie de France', *E.H.R.* xxv (1910), 303.

the convention by which the four beasts of Ezekiel's vision had come to stand as symbols of the evangelists (Pl. 54 *b*). Here was scope not only for representing strange winged monsters, but even for a prime monstrosity, a man with a beast's head seated writing or even the tetramorph, a terrifying being with four heads.[1]

Finally, and in the end perhaps most potent, though its influence in England did not reach its full extent till the end of the century, was the Physiologus or Bestiary,[2] the Latin version of a Greek text known also in Syriac, Ethiopic, and Armenian translations. One example, but an eleventh-century one, is known of the Greek cycle of illustrations to it: these undoubtedly go back to earlier types. Of the western Latin type there is a ninth-century example at Berne (MS. 318) and a fine tenth- or eleventh-century manuscript (Brussels Bibl. Roy. 10074). In England our earliest copy is a manuscript in the Bodleian Library (Laud. Misc. 247), written in a Canterbury script of the first half of the twelfth century and illustrated with line drawings related to the Brussels example but omitting the various pictorial comparisons with the life of Christ that the latter manuscript had taken over from the Byzantine version. Certainly these accomplished drawings, which have all the ease of the 'Winchester' tradition and mark, with the Durham St. Cuthbert, a return to figure drawing in unconfined space on the old scale, can only be explained on the assumption that they were using some Anglo-Saxon model. The antelope caught in the bushes is an appropriate tanglewood tale (Pl. 51 *a*): the crocodile that devours a man and then weeps for him or the hyena plundering a grave (Pl. 92) are good horror stories: the caladrius, the white bird that cures jaundice, perches on the sick bed and foretells recovery by looking at the patient or death by averting its head: to each a moral application is applied, which increases the puzzling nature of visual references on capitals or in initials. Thus the lions

[1] Z. Ameisenowa, 'Animal-headed Gods, Evangelists, Saints and Righteous Men', *Journ. of the Warburg and Courtauld Institutes*, xii (1949), 21.

[2] M. R. James, *The Bestiary (Cambridge Univ. Lib. MS. Ii. 4. 26)*, Roxburghe Club, 1928. G. C. Druce, 'The Mediaeval Bestiaries and their influence on Ecclesiastical Art', *Journ. Brit. Arch. Ass.* xxv (1919), 41; H. Woodruff, 'The Physiologus of Bern', *Art Bulletin*, xii (1930), 226.

which pervade Canterbury manuscripts may be the devil roaring for his prey, the symbol of St. Mark, or, from the Bestiary, a type of the Resurrection because the lion cubs were said to be born dead and to come to life on the third day.

In this varied range of subjects there was much that stimulated a naturalistic approach similar to that of the classical models on which they were based and a new observation of the actual contemporary world of agricultural pursuits and familiar animals and birds. The lions and tigers, the phoenixes and unicorns, above all the dragon serpent, were, on the other hand, an invitation to fantasy: they were native inhabitants of the tanglewood and their ferocity and hunting are detailed in this popular art with a certain brutal and sadistic gusto. The snapping jaws are never far behind men's heels: puny man creeps about with his axe under overshadowing beasts: frail, naked humanity is for ever caught in the coils (Pl. 29). They are the images of an age hardened to unalleviated pain, to the wearing pangs of undiagnosed disease and its no less agonizing attempted cures, to wounds and blows, to the arrow that flieth by day and the pestilence that walketh in darkness. The devil himself and his attendants, the future gargoyles of Gothic art, are in the first half of the century mainly confined to set pieces of hell, scenes where they are depicted with a considerable variety of ingenuity, in which the Romanesque liking for the grotesque and the hideous has full play.[1] There is in fact a cult of the repulsive, of that which is far removed from any sensuous appeal. Hugh of St. Victor wrote[2] that to praise God through fair forms was to use earthly means: if He were praised in the ugly and misshapen (*per dissimilia*) then the mind instead of being drawn earthwards was turned away from the imperfections of this world to the true beauty that is in heaven. It was the subtle argument of a delicate thinker, but it reveals the inherent distrust which underlies and explains much of this early medieval art.

It was by no means only in painting and stone carving that these motifs were employed. Eastern embroideries and tapestries, patterned with formalized beasts, were an important source of visual

[1] A lurid example can be seen in MS. Nero C. IV, f. 38.
[2] The whole question is discussed fully in E. de Bruyne, *Études*, ii (1946), 215.

images, and the artists of the time reproduced them in the same medium: on the fragments of his robe found with the bones of William of St. Carilef, when his tomb was opened in 1795, griffins were worked;[1] the inventory of Ranulf Flambard's chapel lists copes with griffins and peacocks;[2] on Becket's stole, preserved in the treasury at Sens cathedral, are two sprawling dragons; the Sherborne cartulary of c. 1145 lists an alb 'apparelled with small lions and griffins' and another 'with goats and small birds'.[3] These textiles clearly made full use of the repertory.[4] But the straining coils in which man is entangled, while monstrous heads grasp at him, reached their fullest expression in the three dimensions of ivory or metal-work. On the carved tau cross head in the Victoria and Albert Museum or on the pierced ivory fragment found on the site of the monastic buildings of St. Albans (Pl. 30 c) the scrolls are inhabited by clambering figures.[5]

Gold and silver and polished bronze, inlaid with precious stones, are to the chroniclers the prime mediums of visual art, the shining metals that give forth light. But of this great activity, these altar fronts, hanging basins, crucifixes, reliquaries, hardly anything remains. Their preciousness was their destruction, and in the melting-pot they have been transformed to other uses. Among the most striking examples must have been the great seven-branched pascal candlesticks which stood at Easter before the high altars: at most of the cathedrals we have mention of them, and the great candlestick of Durham is fully described in the account, written in 1593, of the rites and customs as they were 'before the suppression':[6] the feet were four dragons and above them round the base were the four evangelists and it was all covered with 'curious antick worke as beasts and men uppon horsbacks with bucklers bowes and shafts, and knotts with broad leaues spred upon the knotts uery finely wrought'. There was another such candlestick given by Matilda the empress to Cluny: Winchester possessed one that had

[1] J. Raine, *Auckland Castle* (1852), 8.
[2] *Wills and Inventories*, ed. J. Raine, Surtees Soc. ii (1835), 2.
[3] B.M. MS. Add. 46487, ff. 67 and 67ᵛ. [4] For embroideries see below, p. 201.
[5] V. and A. 372-1871. See M. H. Longhurst, *Ivories* (1926), 27, 88.
[6] *Rites of Durham*, ed. Canon Fowler, Surtees Soc. cvii (1903), 10.

been given by Canute: at Canterbury the 'great brass candlestick
. . . called Jesse' formed part of the new equipment of the glorious
choir.[1] That at Ely is described as having scenes of the creation and
fall, and armed horsemen and dragons.[2] Some idea of the appear-
ance of such works can be learnt from the great candlestick in
the Duomo at Milan, which was presented by Archbishop Gian
Trivulzio in 1562 but is twelfth-century work and has sometimes
been thought to be English, salvaged from the Reformation.[3]
There is another in Brunswick, the gift of Henry the Lion, husband
of Matilda, daughter of Henry II. The gilt candlestick, 1 foot 11
inches high, in the Victoria and Albert Museum, which is inscribed
as given by Abbot Peter who ruled the abbey of Gloucester from
1104 to 1113, may be taken as a miniature comparison with these
great works. It may not be an English product: such an object was
portable and north-west Germany and the Low Countries were
undoubtedly the main centre of the craft; but it is in English taste,
and the ivory fragment found at St. Albans has much in common
with it. The feet are dragons' heads and from the base an endless
interlacing and burgeoning foliage coils round the pillar enmesh-
ing monkey-like little figures battling with beasts; but on the
central base are the signs of the four evangelists and round the
topmost rim the inscription, 'This light bearer is the work of
virtue, shining it preaches that man should not be darkened by
vice': *Fulgens ut vicio non tenebretur homo*[4] (Pl. 30 a).

Nothing could be more striking than the contrast between these
tortured imaginings and the confident achievement of contem-
porary architecture. If we move south from Herefordshire, at
Gloucester the church of Abbot Serlo had its first consecration, of
the eastern arm, in 1100, and the nave seems to have been partially

[1] Rose Graham, *Studies* (1929), 12, and 'The Monastery of Cluny 910–1155',
Archaeol. lxxx (1930), 161; W. Somner and N. Battely, *The Antiquities of Canterbury*,
ii (1703), 165.

[2] F. R. Chapman, *Sacrist Rolls of Ely*, i (1907), 96.

[3] O. Homburger, *Der Trivulzio-Kandelaber* (1949), contains a fine series of plates
showing details of the candelabra.

[4] J. H. Pollen, *Ancient and Modern Gold and Silver Smiths' Work in the South Kensington
Museum* (1878), 17. There is a striking passage on the candlestick in E. H. Gombrich,
The Story of Art (1949), 125.

built before a great fire in 1122 set back the work.[1] Of the first stage, Serlo's crypt, with some rudely carved human heads upon the capitals, remains little changed. His choir is covered by the famous Perpendicular facing which was one of the earliest manifestations of the style, but on the ambulatory side the Norman work is little altered; a groined vault with wide diaphragm arches springs from round, squat columns; above, the tribune has similar columns, but with applied colonnettes, and is almost as spacious, with chapels built as a second story above the radiating chapels of the ambulatory; with the crypt chapels there were in fact three stories, and choir and transepts at Gloucester provided in all fifteen chapels. The eastern arm thus presented an elevation where the low ground arcade was matched by a tribune opening of equal width and about three-quarters the height. Nothing could be a greater contrast than the elevation of the nave. Here the giant columns of the ground arcade, 6 feet in diameter, rise to a height of 30 feet: above them runs a broad string course of chevron decoration which serves as base for the small arcades of a genuine triforium passage with colonnaded openings in each bay. The clerestory windows follow immediately above the triforium and they too have a wall passage (Pl. 27 a). Much of the effect of this Gloucester elevation is destroyed by the later vaulting, whose ribs now rise from triple Purbeck colonnettes set at the triforium level, but it still preserves a dramatic and unique effectiveness. Many of its features were found at the two neighbouring churches of Tewkesbury and Pershore, but in them the scheme is more logically worked out. Pershore, rebuilt after a fire in 1102,[2] had the giant order in its nave, now almost entirely destroyed, and in the walled-up bays of its south transept can be seen an elevation of four stages which is found also, better preserved, in the transepts at Tewkesbury: ground arcade, tribune opening, triforium passage, and clerestory windows. In the great nave of Tewkesbury with its giant columns 28 feet high (Pl. 27 b) this triforium passage is con-

[1] Rose Graham in *V.C.H. Gloucestershire*, ii (1907), 53. There are important articles on this group of churches by J. Bony in *Bull. mon.* xcvi (Paris, 1937), 281; and by A. W. Clapham in *Arch. Journ.* cvi (supplement, 1952), 10.

[2] A. W. Clapham in *V.C.H. Worcs.* iv (1924), 159.

tinued at the same level. Both choirs have been rebuilt, but in that of Tewkesbury it seems probable that there, too, the giant order was employed, with, however, a tribune stage set back from the main face and supported by an arch splayed from a point about half-way up the great columns, so that ground and tribune arcades were both included in one greater arch, an original and strange design which was not to be without influence in England.[1] Tewkesbury was founded in 1087 by Robert Fitz-Hamon, and in 1102 was sufficiently advanced to become the centre of a monastic community hitherto living at the abbey of Cranborne, which from that date took a subordinate place. The church was consecrated in 1123. Many of its details seem more primitive than those of Gloucester, such as the setting of the triforium openings to the side of, not at the crown of the arch; and the mouldings are much less ornate. On the exterior, however, Tewkesbury does not lack in elaboration. Fitz-Hamon's heiress Mabel married Robert of Gloucester, Matilda's half-brother, a great patron and church builder, and the abbey's external felicities may owe something to their wealth and enlightenment. The central tower is one of the finest that remain to us, while the western arch (Pl. 1), 60 feet high and 30 feet wide, echoing the giant order within in its lofty applied columns, is one of the most dramatic of all our Norman architectural achievements, dramatic and unique, though the Romanesque abbey church of Bath, a great gap in our knowledge for Bishop John of Tours (1088–1122) built on a large and splendid scale, may have had a similar western façade.[2] Tewkesbury's façade may well have been designed for western towers, not its present turrets: if so, it is a happy accident that its unfamiliar beauty was not transformed into some more normal pattern. The great Perpendicular window, dating in its present form from 1686, is also singularly at one with its Norman setting. This Avon valley style has been the subject of considerable speculation. The cathedral

[1] Clapham (in *Arch. Journ.* cvi, supplement 10) suggests that Evesham may have had a similar design. Other instances of the giant order are Romsey (above, p. 57), Jedburgh (below, p. 152), Oxford (p. 215), Dunstable (p. 215), Glastonbury (p. 221), Waterford (p. 222).

[2] R. A. L. Smith, *Collected Papers* (1947), 79, and *Bath* (1944), 24.

of Tournai has a four-storied elevation, though none such was
known in Normandy. It was known also in some German churches.
It is noteworthy that the south-west was a region to which Lor-
raine had supplied several bishops during the eleventh century.
Probably, however, it is wiser to see in it a local style worked out
by a group of ingenious and enterprising builders.

At Exeter William Warelwast, the opponent but eventual friend
of Anselm, became bishop in 1107 and held the see till 1137.
Early in his episcopate he began to replace the old Saxon cathedral
with a building in the new style, a nave of seven bays, transepts
with single apsidal chapels, and a choir ending in a polygonal
apse with aisles leading to smaller apses, without an ambulatory.
The striking feature of the building was the transept towers.
Exeter has never had provision for a central tower, so that the vista
of nave and choir is unblocked by any supporting pillars. Possibly
employed somewhat earlier at Old Sarum, these transept towers
are not known in Normandy and seem another practice peculiar
to south-west England. The building had advanced far enough for
consecration by 1133, and the south tower, the earlier and better
preserved of the two, must date from the following years. Its
severe, slender arcading, with no interlock of the arches, and
the strongly marked circular sound holes that divide the second
from the third story, seem quite distinct from the more or less
contemporary work on the tower of Tewkesbury.[1]

The royal example in founding Reading abbey was followed by
at least one of Henry's courtiers. The *Liber fundacionis ecclesie Sancti
Bartholomei Londoniarum* (MS. Vespasian B. IX), which though
extant in a fifteenth-century copy claims to be a transcript of a
twelfth-century text, gives us many and somewhat hagiographical
details of the life of its founder Rahere. Gay and subservient,
'attending spectacles, banquets, jests and the rest of the trifles of the
court', he followed the fashion, when the disaster of the White Ship
changed the old gaiety into something more severe and sombre,
and went on pilgrimage to Rome. On his return he obtained from
Henry in 1123 the grant of a piece of land in Smithfield and

[1] H. E. Bishop and E. K. Prideaux, *Building of Cathedral Church of Exeter* (1922),
20–29; F. Rose-Troup, *The Consecration of the Norman Minster at Exeter, 1133* (1933).

founded here a priory and hospital of Augustinian canons, an order enjoying at the time an increasing popularity and having already a nearby house in Aldgate, Holy Trinity, founded by Henry's queen, Matilda, in 1107. Rahere became the first prior at his house of St. Bartholomew and it is clear by another charter from Henry in 1133 that the priory was by then sufficiently built for use. Architecturally the church, of which only the choir and transepts now remain, presents many problems. The plan of the east end was similar to that of Reading, an ambulatory, round apse, and three radiating chapels. The building appears to have been held up before the choir was completed and the crossing shows certain changes in style and plan. It probably dates from the middle years of the century. The choir tribune has a broad arched opening, but the bays are subdivided by three columns, which from their adjustment to the imposts of the main arch are clearly a later addition. Some of them have the scallop capital with the flat trefoil facing found at Bermondsey and Reading.[1]

Rahere's church, in the groined vaults of its aisles and the detail of some of the mouldings, is a more primitive building than would be expected from its date. It has, however, something in common with what we know of the greatest of London churches, the cathedral church of St. Paul. Begun by Bishop Maurice (1086–1107) and carried on by his successor, Richard de Belmeis (1108–27), the work seems to have been conducted in a somewhat leisurely manner. William of Malmesbury[2] said that it was worthy to be numbered amongst famous buildings, but adds that Maurice left most of the work to posterity and that Richard, though he assigned the revenues of his see to the purposes of the building, achieved almost nothing. Henry of Huntingdon says that it was unfinished, and he was writing between 1135 and 1140.[3] In 1137, it had, as Dugdale puts it, 'great hurt by a dreadful fire'. The final translation of the body of St. Erkenwald did not take place till 1148, a date which presumably marks the completion of the eastern arm. Hollar's print of 1658, in Dugdale's account of the church,[4]

[1] E. A. Webb, *St. Bartholomew's Priory*, ii (1921), 3.
[2] *Gesta pontificum*, R.S. lii (1870), 145. [3] *Historia anglorum*, R.S. lxxiv (1879), 208.
[4] *St. Paul's Cathedral* (1st ed. 1658; 2nd and revised ed. 1716). See also W. R.

shows a Romanesque nave with a low tribune opening of the Jumièges proportions, its arch undivided, and above a clerestory modified when the nave was vaulted. The main arcade is composed of composite piers from which wall shafts in the form of triple applied columns rise to the clerestory level: the arch is of two orders with rounded mouldings and a small billet decoration on the outer course: the cushion capitals are uncarved: the bases of the pillars are rectangular.[1] In these respects the arcade closely resembles that of the choir of St. Bartholomew's, which has the same billet decoration and square bases; but there the capitals are scalloped, not plain. St. Paul's, as far as we can rely on the plate, is early-twelfth-century work, but we know that as late as 1174 the work 'which has been so prolonged' still demanded 'such heavy charges' that without liberal help there was no hope of seeing it completed. Such was the gist of an appeal issued by Bishop Gilbert Foliot, commended by Pope Alexander III and promulgated in the diocese of Winchester, possibly in others also, as well as in that of London.[2] Foliot, always a shrewd and practical man, based his appeal on the formation of a confraternity of regular subscribers for whom masses would be said, the first instance in England of such an organization that has come down to us. This strongly suggests that work on the west end at least was still in progress. Of the Norman choir, rebuilt in the first half of the thirteenth century, we know nothing: Wren thought, when he investigated the remains, that the eastern end was curved,[3] which suggests that it had the ambulatory plan. But if Reading survives as dismembered fragments, Norman St. Paul's exists only as a drawing. Some of its books, now by a strange migration in Aberdeen, show initials of a Canterbury type, of no great inventiveness, though one, a *Moralia*, has some fine foliage on a deep blue background, spangled with white dots; work of *c.* 1130–40.[4]

Lethaby, 'Old St. Paul's', *Builder*, cxxxviii (1930), 862, 1091; cxxxix (1930), 1088; W. Benham, *Old St. Paul's Cathedral* (1902).

[1] A capital and some carved fragments are preserved in the present building.

[2] R. Graham, 'An Appeal about 1175 for the Building Fund of St. Paul's Cathedral Church', *Journ. Brit. Arch. Ass.* x (1945–7), 73.

[3] S. Wren, *Parentalia* (1750), 272.

[4] Aberdeen University Library MS. 1: cf. also MS. 4.

IV

ST. ALBANS AND THE EASTERN
. COUNTIES

MATILDA, to whom her father left an uneasy and disputed succession, was in 1135 a woman of thirty-three years of age who had seen much of the world. When only eight years old she had been sent to Germany to be educated as the bride of the emperor, Henry V, to whom four years later she was married. She accompanied him on his Italian journey and was with him in Utrecht at his death in 1125. Despite the fact that, now twenty-three, she had borne no heir, she enjoyed great popularity in Germany, and the return of the empress to England, to a father embittered by the loss of his only son in 1120 in the wreck of the White Ship, was something of an exile from the land of her breeding. In 1128 she was married, an essentially political marriage, to Geoffrey of Anjou, ten years her junior, and, though a son, the future Henry II, was born in 1133, the marriage was an unhappy one. Strong willed, used to the subservience of the Imperial court, familiar with the main centres of Europe, with interests far outside insular preoccupations, she was singularly ill fitted to consolidate her uncertain island inheritance. Her continental outlook is reflected in the gifts which she gave freely to the monasteries of her choice. Robert of Torigni tells us:

The church of Bec was nearer her heart than any other of the numerous monasteries of Normandy; for she gave it many gifts, most precious alike from their material and workmanship, which she had obtained, at a great cost, from Constantinople, and which shall continue throughout all ages as proofs and tokens of the love and esteem in which that church was regarded by this august empress, ever imprinting on the hearts of those who dwell there the memory of this illustrious lady. It is needless therefore to describe them severally, or to specify them by name. The sight of them is a pleasure to the guests, however great, who come thither, even those who are familiar with the treasures

possessed by the most wealthy foundations. The traveller, be he Greek or Arabian, who passes thither, is equally delighted.[1]

Unfortunately none of these gifts has survived and their contemporary fame, as Robert states, rendered their specification unnecessary. Some probably were articles she had secured in Germany: we have already seen that she brought from there the famous relic of St. James's hand. One of Matilda's surviving donations, presented later in her life to the monastery of Grandmont, where the church was being built between 1139 and 1163, is a dalmatic preserved in the parish church of Ambazac, a typical piece of Byzantine stuff, tangible evidence of the import of eastern works of art.[2] In the marked change in taste which becomes apparent in England in the thirties, Matilda's patronage and connexions must be counted as one of the factors that built up the new complex of visual conventions.

In illumination this change is most closely associated with St. Albans, a scriptorium which as yet had produced no series of manuscripts, to judge from surviving examples, as characteristic as those of Canterbury. We have, however, a few books which belong to or reflect its early stages, works in the old tradition, unaffected by new fashions. Of these MS. Bodley 569, Lanfranc's treatise on the Sacrament, is a typical example. Its first folio has a portrait of the bishop, a coarse piece of drawing in a reddish brown ink; behind his feet spreads out a frond of flat acanthus, the normal decoration of this group. Its initials throughout are rough and vigorous, using a distinctive colour scheme of brown outlines on a red, purple, or dull green background. A Christ Church (Oxford) manuscript (115) of Bede's *Expositio de tabernaculo* uses a more refined version of the same type of initials, though here the foliage swells into blossoms and fruit cones, a burgeoning that belongs to the second quarter of the century. Similar ornament and traces also of the earlier style appear in a splendid two-volume St. Albans Josephus, now in the British Museum (MSS. Royal 13 D. VII and VIII). The popularity of this Jewish historian is a marked feature of twelfth-century book

[1] Migne, *P.L.* cxlix (1853), 896; cf. ibid. 1267. [2] R. Graham, *Eccles. Stud.* (1929), 215.

production, particularly in England and northern France, and has a significant place in the biblical studies of the time and the new emphasis on the historical approach. His *Antiquities* and *History of the Jews* were among the works constantly selected for elaborate ornamentation. At Christ Church, Canterbury, the Josephus was one of their finest manuscripts: at Durham, York, and Lincoln, and in the Hunterian Library at Glasgow,[1] there are fine copies from varying dates in the twelfth century. Trinity Hall, Cambridge, has an example (MS. 4) that comes from the alien priory of Monkland in Herefordshire and seems to be work of the second quarter of the century, with bold, somewhat coarsely drawn beasts and foliage and as opening to the fourth book an elongated nimbed figure (Pl. 32 *a*). The cathedral library at Valencia has an example with striking grotesque initials, which are more likely to be north French or Flemish than English work.[2] The same is true of the early-twelfth-century copy in the Laurentian Library in Florence (MS. Pluto 66. 5), which amongst its other initials has a series of scenes of the Creation set in a bar of seven roundels.[3] This reappears in the St. Albans Josephus and was to become a popular element of bible illustration in the second half of the century. Historiated initials are, however, rare in the Josephus ornament. The two Royal manuscripts have coiled foliage, inhabited by beasts, birds, and nude figures, brightly coloured with much use of a distinctive orange pink. The opening initial, more thickly painted than the rest, has two spread-eagled pink lions, whose small size reflects a tendency to reduce the leonine inhabitants of scrolls to a minor and subdued decorative feature.

Before leaving this phase of St. Albans work, another Christ Church manuscript (95), the epistles with the *glossa ordinaria* of Anselm of Laon, deserves mention. Of no documented provenance, in date from its gloss *c.* 1140–50, it has some striking outline

[1] Durham cathedral B. II. 1, York minster XVI. A. 7, Lincoln cathedral C. 1. 6 (145), Hunterian S. I. 4. The Lincoln volume is sadly mutilated and only one small initial remains, foliage on burnished gold. The Hunterian copy has striking and unusual foliage initials on dark purple backgrounds.

[2] MS. 29. E. Olmos y Canaldas, *Códices de la catedral de Valencia* (Madrid, 1943).

[3] A. M. Alari, 'Codici miniati in editi dei secoli XI e XII della Biblioteca Laurenziana', *La Bibliofilia*, xxxix (Florence, 1937), 98.

initials which in their strongly marked designs and foliage recall the St. Albans style, though they have a delicacy of execution and ingenuity of invention which are their own. This artist's master-piece, the initial to Ephesians, is one of the most engaging of our Romanesque initials (Pl. 33 a). The tall, elegant figure, holding with surrealist nonchalance the little victory who spears the dragon, is a wonderful invention, though hard to connect appropriately with the opening passage of the epistle. Its intense, nervous style finds a parallel in another distinguished work of art, an ivory crozier head in the Victoria and Albert Museum,[1] which in its confined space depicts most movingly the beginning and close of Christ's life: on the end of the staff an angel appears to the shepherd and in two separate scenes the Virgin cradles the Child and shows him to St. Joseph; at the top of the bend of the crook there is a group sometimes interpreted as an angelic visit to the three holy women to rouse them to go to the tomb, and on the end of the curve the Virgin lowers the body of Christ to the outstretched arms of St. John; the scheme is completed by the ingenious carving of the inner curl of the crook which shows on one side the Christ Child asleep, on another an angel supporting the Agnus Dei.[2] This lovely work has been claimed as eleventh century and some interesting parallels demonstrated with late 'Winchester' manu-scripts, but here on the Ephesians page the parallels are even closer: the same elongated figure, the snood falling back from the head, the round folds over the abdomen, the strongly articulated feet, the emphatic line of the chin. This ivory seems to me one of the most beautiful products of the period 1125 to 1150.[3]

Abbot Paul of St. Albans had laid the foundations of a great library by a gift of twenty-eight fine volumes:[4] Lanfranc is said to

[1] No. 218–1865. Height 4⅜ inches.

[2] The episode of the three women is not based on scripture and seems an improbable interpretation. An alternative interpretation is shortly to be published.

[3] A. Goldschmidt, *Die Elfenbeinskulpturen*, iv (1926), 15, assigns it to the twelfth century. H. P. Mitchell, 'Flotsam of Later Saxon Art', *Burl. Mag.* xlii (1923), 162, argues very fully the case for dating it in the second half of the eleventh. See also M. H. Longhurst, *Ivories* (1926), 18, 80; T. D. Kendrick, *Late Saxon Art* (1949), 45; D. Talbot Rice, *O.H.E.A.* ii (1952), Pl. 41, also accepts it as Anglo-Saxon.

[4] *Gesta abbatum*, R.S. xxviii (4 a) (1867), 58. For St. Albans see L. F. R. Williams, *St. Albans* (1917).

have given them a hundred books. There is some evidence that St. Albans had in its possession older illustrated books which transmitted a classical tradition. One such must have been followed in the volume of Prudentius (B.M. Titus D. XVI) which comes from the abbey and seems most likely to be work of the first half of the twelfth century. Behind it lies a long series of illustrated texts, popularized in several Anglo-Saxon versions. The *Psychomachia*, where armed virtues battle with vices, is yet another important element of the Romanesque repertory and one much used in carving as well as in painting. The little figure piercing the dragon in the Ephesians initial is an example of motifs borrowed from this popular subject. The St. Albans version follows an established iconography, but the figures have a new poise and solidity: the nervous fluttering drapery of the 'Winchester' school[1] is replaced by close-fitting garments, which mould themselves to the limbs below. The curious flying hair of the earlier drawings, the flame-like hair appropriate to vice and villainy, is here treated with thicker strokes which give the curious appearance of a Red Indian head-dress, a convention which was to remain a feature of English twelfth-century work (Pl. 34 a).

It was not, however, from such classical prototypes that the decisive influence was to come. The missal given by Abbot Richard (d. 1119), in which he was painted kneeling at the feet of Christ,[2] must have been a more elaborate book than any that has come down to us from the first two decades of the century, but the subject illustrated was one for which the Anglo-Saxon tradition provided examples. It is, on the other hand, some Byzantine or Ottonian model that lies behind the remarkable psalter, now the possession of St. Godehard's church in Hildesheim,[3] which is the most complete and magnificent expression of a new movement in

[1] Cf. B.M. Cotton MS. Cleopatra C. VIII, and Cambridge, Corpus Christi College, 23 (a book which belonged to Malmesbury). E. M. Thompson, *Eng. Ill. MSS.*, 19–21, considered the St. Albans volume to be continental work, but it has stylistic features perfectly in keeping with an English origin. See R. Stettiner, *Die Illustrierten Prudentius-handschriften* (Berlin, 1895–1905); A. Katzenellenbogen, *Virtues and Vices* (1939).

[2] *Gesta abbatum S. Albani*, R.S. xxviii (4 a) (1867), 70.

[3] It came into the possession of the German Benedictine monastery of Lamspringe in the sixteenth century, when an English colony of monks settled there.

English taste. The book is of such importance that it requires a somewhat detailed description. It is composed of three gatherings. The first contains ferial tables and a calendar, the second forty full-page ($11 \times 7\frac{1}{2}$ in.) paintings starting with the Fall and going down to Pentecost, and including a page with two scenes from the life of St. Martin; then, in the same gathering, follows a poem in Norman French on the life of St. Alexis; an extract from the letter of Pope Gregory I on the use of images; three paintings devoted to the story of the journey to Emmaus and the Beatus page of the psalter with a large initial of David playing the harp. The third gathering contains the psalter, canticles, creed, and litany with 209 initials, mainly figure subjects, followed by two full-page scenes, the Martyrdom of St. Alban and David and his musicians.

The calendar is that of a Benedictine house with special prominence given to the feasts of St. Martin and St. Alban. There is no obvious explanation of the emphasis on the former saint: the latter is undoubtedly the patron saint of the house, as is further established in the calendar by the obit of Abbot Geoffrey, abbot of St. Albans from 1119 to 1146. The various other obits have been examined in much detail by Adolph Goldschmidt in his account of the psalter, which is a classic in the history of the study of manuscripts.[1] From his analysis the following inferences were reached. The first and third gatherings (the calendar, psalter, and concluding two illustrations) are the work of the same scribe and illustrator: the second gathering with the Song of Alexis and the forty full-page scenes is by another hand: the writer of this added to the calendar the obit of 'the hermit Roger, monk of St. Albans, in whose possession was this psalter'. This entry has been corrected in the spelling of monachus by another hand, which has entered also the obits of Abbot Geoffrey, Christina the anchoress and several members of her family, and the mother of Michael the cantor: this Michael may well have been responsible for all these entries. The hermit Roger was the director of Christina, a lady much consulted by Abbot Geoffrey, who founded a cell for her, and the psalter was presumably produced for these anchorites: the Song of Alexis commemorated a saint to whom a chapel had been

[1] A. Goldschmidt, Der Albanipsalter in Hildesheim (1895).

erected by Geoffrey's predecessor, Abbot Richard (1097–1119), and dedicated by Ranulf, bishop of Durham (d. 1128). The St. Albans associations are therefore very fully established: as to date, the joint work of the two scribes and the illustrators working with them was completed during Geoffrey's lifetime, and the first part, the calendar and psalter, during the lifetime of the hermit Roger, who predeceased the abbot but by how long is not known.

This group of St. Albans characters to which the obits introduce us is a striking one. Roger the hermit enjoyed some reputation, particularly for foretelling the death of Robert Bloet, bishop of Lincoln, an event which occurred in 1123.[1] The fourteenth-century St. Albans Life of Christina places his death four years after the release of Christina from her marriage vows by Archbishop Thurstan of York. Thurstan's long episcopate (1119–40) does not give much assistance with the dating: Christina, however, also appealed to Archbishop Ralph d'Escures of Canterbury (d. 1122) and the indications all suggest a date in the early twenties.[2] It seems reasonable to place Roger's death on the evidence of the St. Albans tradition at c. 1125. His tomb was long preserved in the abbey as a shrine of some importance.[3] Christina was a notable seamstress, whose embroidery was deemed worthy of presentation to the pope.[4] Geoffrey of Maine had come to England to take charge of the abbey school, but had been relegated to the school of the dependent priory at Dunstable. While there he had borrowed some copes from the abbey for use in a miracle play of the life of St. Catherine, an interesting indication of the growth of such plays with all their implications for the visual arts. Unhappily the school caught fire and the copes were destroyed. Geoffrey, overcome by this disaster, abandoned teaching and became a monk at the abbey, eventually being chosen abbot in 1119. His long rule is described as a great period in the history of St. Albans.[5] Amongst other activities he reorganized the scriptorium, relieving the three scribes

[1] Wm. of Malmesbury, *Gesta*, R.S. lii (1870), xvi. See also *Gesta Abbatum*, R.S. xxviii (4 *a*) (1867), 97.

[2] *Nova legenda Anglie*, ed. C. Horstman (Oxford, 1901), i. ix; ii. 532.

[3] *Chronica monasterii S. Albani*, R.S. xxviii (5 *a*) (1870), 433, and (5 *b*) (1871), 302.

[4] See below, p. 202.

[5] *Gesta Abbatum*, R.S. xxviii (4 *a*) (1867), 73–106.

who composed it of administrative work. We are told of a 'most costly psalter' as being amongst its products. In the arts the most notable figure was a monk, Anketil, a great worker in metal, who had been employed in Denmark and who now undertook the great shrine for the relics of St. Alban. The account in the monastic chronicle gives us a vivid picture of how such a work was carried out: how the plate and gems of the abbey were devoted to it and then in an emergency diverted to other purposes: how the work advanced in stages and Anketil's crest to it could not be completed through lack of the precious materials in which to carry it out. It is tempting to think that it was through this master craftsman's work that new continental influences made themselves felt. There is in the Copenhagen Museum a bronze Virgin, a figure from some altar or reliquary, whose heavy, linear folds and strange, remote expression strikingly recall the art of the Hildesheim Psalter: but in Denmark it is a unique piece and too tenuous evidence for any serious hypothesis.[1] The production of the Albani Psalter, to give it its familiar German name, must have been spread over several years, and from what we know of its influence, coupled with the history to be gleaned from its obits, the decade 1125 to 1135 seems to me the most probable period of its creation, though the certain terminal date is that of Geoffrey's death in 1146.

With regard to the illustrations, Goldschmidt's divisions, now that the book can be studied at leisure in adequate photographs,[2] seem too rigid, though this does not invalidate his main argument as it was a common practice for blank spaces to be left for the artist and to be filled in quite inconsecutively. Certainly the calendar scenes of the months, in each case a seated figure holding some appropriate emblem (Pl. 31 a), are in some cases by the artist of the full-page gospel scenes, though the psalter hand pre-

[1] The suggestion is made by P. Nørlund in *Gyldne Altre* (1926), 71.

[2] The manuscript was photographed in full in 1949 by Mr. O. Fein of the Warburg Institute: it is probably the finest set of photographs available for any English illuminated manuscript. The manuscript will be published in detail for the Institute by Dr. C. R. Dodwell, working in collaboration with Professor F. Wormald and Dr. O. Pächt, a publication in which without doubt many problems will be solved. I am most grateful to the Warburg Institute for permission to reproduce some folios of the manuscript from their photographs despite their own forthcoming publication.

dominates. Even in the initials to the psalms there are various hands employed, and some of the drawing is again close to that of the full-page scenes. The artist of these scenes is the dominant personality of the book and a man of remarkable gifts, though much of his work, painted in rich but sombre colours, olive green, dark brown, greyish blue, and a somewhat livid purple, is of a harsh and forbidding nature. At first sight it might seem strange to acclaim the opening page, the scene of the Fall, as a major document of an aesthetic revolution. These gaunt, over-anatomized nudes have an archaic, retrograde appearance. But this very attempt to display the structure of the body is an advance in humanism. The tree beneath which they sit is a formalized, impossible piece of growth, but it stands solidly in the centre of a carefully balanced design which is firmly contained within the frame (Pl. 36 a). Gone are the exuberant curlings of 'Winchester' pattern, escaping always from the centre, refusing all limitations of clearly marked borders. Here the space is determined and defined. The eerie inventiveness which pervades the book is already shown in the curious incident of Satan spewing out the serpent. The first page, as though a manifesto, is an exactly centralized design, as balanced as any Renaissance theorist could have wished. In the Expulsion there are three parallel divisions and the elongation of the figures to stress the vertical line becomes emphatically apparent, as also the powerfully expressionist use the artist can make of his strange conventions. Sometimes, as in the scene of the Shepherds, he divides his framed space by strongly stressed diagonals (Pl. 36 b), and in one of his most remarkable pieces, the Ascension, he marks by a series of short, parallel diagonal lines the upward movement of his theme, while retaining the parallel verticals of the standing figures. In the Deposition he creates a feeling of despair and confusion by breaking up his design by short lines for once running counter to one another and not in a parallel movement. The Magdalen anointing Christ's feet is one of his masterpieces (Pl. 35). The strong curving line sweeps upward connecting the two main participants: for once a figure steps across the frame, only to emphasize the enclosed space by doing so. The Beatus page, where David sits in a large B while the Spirit inspires him in the form of

a bird, is also by his hand. Above the fully painted B is an outline drawing of two mounted knights fighting. It is noteworthy that the psalter contains, following the Song of Alexis, the letter of St. Gregory justifying the use of 'picturae' for the instruction of the unlearned, which is given first in Latin, then in a French translation. On the Beatus page there is a further commentary, in which the two warriors are explained as an example of spiritual warfare: 'It behoves us to use in the spirit all the arts which these two warriors use in the flesh': and further the details of the representation of David, his position in the letter, his harp, and his book, are described with relation to their spiritual significance. Here then there is no question of ornamental fancy; the artist attaches meaning and importance to every feature he depicts, and, though the hand changes, this is true also of all the vast body of historiated initials which accompany the psalms.

In them the relation of the painting to the text is singularly direct and literal, a kind of picture writing for actual phrases and verses. This was a system which had been used in the Utrecht Psalter and its derivatives, but there the themes of the psalm were combined into one drawing, filled with small figures. Another Carolingian version, as represented in the tenth-century Stuttgart Psalter,[1] had given one scene with larger figures to selected phrases of the psalms. The Rochester Commentary of St. Augustine on the psalms has traces of a cycle based on similar principles.[2] No exact model has, however, as yet been found for the Albani illustrations, and their bizarre but concentrated renderings have an individuality which seems the mark of a curiously independent genius. It is only by following out the whole sequence of pictures that the full impression can be gained—here as with a roll of Chinese paintings we have constantly to remember that it is a book designed for leisured perusal—but in default of that one or two examples must serve to illustrate the method. For Psalm xxi (A.V. xxii) a naked man is seen springing above a row of horned cattle; 'Many oxen are come about me: fat bulls of Basan close me in on every side': Psalm xlii (xliii), the figure of God points to his

[1] E. T. De Wald, *The Stuttgart Psalter* (Princeton, 1930).
[2] MS. Royal 5 D. II: see above, p. 62.

eye, holding a book in his other hand; below three men gaze on it, 'O send out thy light and thy truth': Psalm cxxxvi (cxxxvii), a strange fantasy, with its flat fishes and its crockets of mourning figures following the bend of the S; 'by the waters of Babylon' (Pl. 34). To us the splendid words, echoing with the strains of noble music, are so charged with associations that these somewhat grotesque images are jarringly inadequate, but they have a fierce intensity of their own. As with the full-page drawings, they have a space inside the curves of the letter, untrammelled by any intruding foliage: they are strictly narrative in form and their interpretative method is completely at variance with the obscure significance of the inhabitants of Canterbury scrolls; and in keeping with this the figures, however crudely drawn, have firm outlines, unmasked by patterned folds. The main artist of the initials seems to have been responsible also for the two full-page paintings that conclude the book, the Martyrdom of St. Alban and David with his musicians. The twisted pose of the executioner in the former becomes an easily recognized feature of later works (Pl. 38 b): the latter, though set within a frame, has no spatial sense and is a return to pattern making, a return which does not fit altogether easily with the new conventions.

We know of one other work by the hand of the master of the full-page scenes, a volume of the Meditations of St. Anselm, now MS. 70 in the library at Verdun. This manuscript has no certain provenance and unfortunately is much mutilated. Only one full-page painting remains, Christ giving the keys to St. Peter.[1] The subjects of the other scenes may be guessed at from another copy of the same text[2] where the initials, jewel-like compositions of light reds, greens, and blues on a gold background, owe much to the Albani style. The Charge to Peter, a small initial as opposed to a full-page painting, is differently designed from that in the Verdun manuscript, but the faces, the grouping of the small figures in the bend of the S, the long-haired sheep, are all part of the mannerisms of the same school (Pl. 50 b).

[1] f. 68ᵛ. Reproduced in H. Swarzenski, *The Berthold Missal* (New York, 1943), 46, where the connexion between the two manuscripts is pointed out.

[2] Bodleian MS. Auct. D. 2. 6.

The popularity of the new style seems to have been instantaneous. At St. Albans itself, in a volume of Bede on the Canticles (King's College, MS. 19), among foliage initials in some cases inhabited by lions which recall the more finished work in the St. Albans Josephus, there suddenly appears a drawing of the bride and bridegroom, unmistakably in the Albani manner. Its influence was not, however, confined to the mother house. A psalter made for the nuns of Shaftesbury,[1] the great foundation of whose twelfth-century splendour only a partial ground plan and some fragments of carving remain, is in some of its pages so close to the Albani model as to suggest that it must have been directly based on it, but already the austerity of the new school is modified by the reassertion of the older tradition, and the edges of the garments, albeit a little stiffly, resume some of their former frilled shapes. The Marys at the Sepulchre seems a copy of the St. Albans page (Pl. 37), but the tension is relaxed, the poses easier, the clothes slightly fluttering, and the guards have been extruded beyond the enclosing frame. The eight full-page miniatures have an unusual range of subjects: the Almighty sending out the angel Gabriel;[2] the Marys at the Sepulchre; the Ascension; Pentecost; Christ in Majesty with a female suppliant; the Tree of Jesse; the Virgin and Child with a female suppliant; St. Michael holding the souls of the blessed in a fold of his garment with Christ in a circle above: in this emphasis on angelic messengers, the Ascension, and Pentecost there seems to be some mystical trend of thought which separates the illustration of this book from the more narrative content of other contemporary work. Initials, historiated with scenes of the life of David, mark the main divisions only of the psalter: here there is no dependence on the Albani model, nor in the small calendar scenes: the Albani Psalter has a fine series of roundels where the labours of the months are represented by seated figures, though occupations such as pig killing are not easily performed as sedentary pursuits: in the Shaftesbury Psalter groups of small

[1] B.M. MS. Lansdowne 383. See E. G. Millar, *Eng. Ill. MSS.* (1926), Pls. 32, 33; G. F. Warner, *Ill. MSS. in the British Museum* (1903), Pl. 13.

[2] This rare subject occurs also in the St. Swithun's Psalter, MS. Cottonian Nero C. IV (for which see below, p. 172).

figures, only partially framed in the initial letter, carry out a series of country scenes which was to become the normal pattern for English calendar illustration and which, in tasks such as its June weeding and December log-carrying, reflects the conditioned practices of English agriculture (Pl. 31).[1] A St. Albans calendar,[2] now unfortunately detached from its psalter, has a series of single figures, many of them seated as in the Albani version though not here set in roundels, beautifully drawn with easy, curvilinear patterns, using a somewhat different cycle of labours, in June sheep-shearing and in December feasting. The Easter tables date this work to the period 1140–58.

Elsewhere the Albani influences appear in manuscripts with less lavish pretensions. A volume of Boethius in the Bodleian Library (MS. Auct. F. 6. 5) has a picture of the writer's vision, a scene of which we have other versions[3] and which must go back to some classical original, though here the chained Boethius, turning from the trumpet-blowing muses to the elongated figure of philosophy, is a piece of true Romanesque imagination. The drawing has similarities with the Albani style, but a gentler quality of inspiration lies behind it. A manuscript of St. John Chrysostom in Hereford cathedral uses the new types with a fine sense of proportion in an outline drawing of Christ in Majesty, with the saint between two cherubim appearing in a vision to two of his followers: the drawing here might almost be by the same hand as that of the Shaftesbury Psalter.[4] In some scattered pages from a psalter, where incidents from the Old and New Testaments are shown in small scenes twenty to a page, the new style links up with a Canterbury tradition, for these pages look back to the great Italian gospel-book brought to St. Augustine's in the seventh century (Corpus Christi,

[1] Another and possibly earlier example of this series is a volume of Isidore's Homilies (St. John's, Cambridge, MS. B. 20), where a single page shows the Labours and the signs of the Zodiac in linked roundels.

[2] Bodleian MS. Auct. D. 2. 6. This is the same volume as that containing the *Meditations of St. Anselm* mentioned above, but it is a composite book in which three manuscripts of different origins have been bound together at a later date.

[3] Compare Cambridge University Library MS. Dd. VI. 6, f. 3ᵛ. For MS. Auct. F. 6. 5 see F. Saxl and R. Wittkower, *British Art* (1949), Pl. 29; and M. A. Farley and F. Wormald in *Art Bulletin*, xxii (1940), 157.

[4] MS. O. 5. xi. *Burlington Fine Art Club Catalogue* (1908), Pl. 26.

Cambridge, MS. 286) and forward to a later psalter that also has strong Canterbury associations.[1] The figures are very close to those in the Albani initials, and the scene of the Deposition is based on the full-page Albani painting. In a Bodleian manuscript (Bodley 269) there is a page with a seated Virgin, close in many details to the same scene as rendered on a page of the Shaftesbury Psalter, but set in a great double circle which recalls Ottonian rather than English models, though the mandorla in which Christ sits in the much ruined mid-century frescoes at Kempley church may be compared with it.[2] These seated Virgins, presenting the Child to the congregation, immobile and inhuman, typify all the solemn, hieratic side of Romanesque art. In pose and gesture they can be compared with the great seal of Matilda, made for her in Germany, and curiously opposite to the light, sketchy, traditional model followed in that of her rival Stephen.

The cult of the Virgin was at that time the subject of some debate in England, centring round the feast of the Conception on 8 December. Eadmer had written his tract defending the doctrine of the immaculate conception, a tract which was long attributed to St. Anselm, and gained for that saint in sixteenth-century art a prominent position as one of Our Lady's chief advocates. In fact it was the other Anselm, his nephew, elected abbot of Bury in 1121, who seems to have been the chief promoter of the feast in this English early acceptance of it. As abbot of St. Sabas, he had been in touch with the Greek monasteries of south Italy, where the doctrine was much honoured. At Bury he established a fund for a daily mass for Henry I and the worthy celebration of the feasts of the Conception and St. Sabas.[3] Already in the previous century, before Anselm's proselytizing, this festival had appeared in several English calendars. Now it came to an open dispute; on the one side, Anselm of Bury, Osbert of Clare, prior of Westminster, Hugh of Reading, and Gilbert 'the Universal', the scholar from Lyons,

[1] B.M. MS. Add. 37472 (1). V. and A. MS. 661. Pierpont Morgan MSS. 521 and 724. See M. R. James, 'Four Leaves of an English Psalter', *Walpole Society*, xxv (1937); H. Swarzenski in *Walters Art Journal*, i (Baltimore, 1938), 67. See below, p. 289.

[2] F. Wormald in *Antiq. Journ.* xxii (1942), 17.

[3] D. C. Douglas, *Feudal Documents from the Abbey of Bury St. Edmunds* (1932), 112.

another centre of the doctrine, newly appointed to the see of London; on the other, Roger of Salisbury and Bernard, the first Norman bishop of the see of St. David's. It was a dispute between theologians and administrators and the theologians won: in a council at London in 1129 in the presence of the papal legate, John of Crema, the celebration of the feast was solemnly confirmed. It was a step as yet not taken in any other country of western Christendom, and in eight years' time Bernard of Clairvaux was to launch his attack upon the doctrine, carrying France with him. In England, however, Bernard's arguments were repulsed: Peter de Celle, talking with Prior Nicolas of St. Albans, might say that English mists begot vapourish imaginings, but the feast was still celebrated. We have already seen at Reading one of the earliest if not actually the first renderings in stone of the Coronation of the Virgin: we shall see later further traces in the visual arts of English devotion to Our Lady.[1] 'It is by your assiduity that the feast of the Conception is now celebrated in many places', wrote Osbert of Clare to Anselm of Bury, and added many laudatory comparisons of his virtues to those of great classical figures such as Augustus and Cicero.[2] The younger Anselm is in fact a splendid and controversial figure in the history of the English church in his day: twice holding special legatine commissions, at least once journeying back to Rome, proposed as bishop of London and when not finally elected given as abbot episcopal standing, founding the church of St. James at Bury because his monks persuaded him not to go to Compostela, he had a position of much influence and one also that had many European interests. It is not surprising to find that under him Bury was readily responsive to the new style. Possibly even it may have originated there, for the two books now to be considered, the Pembroke Gospels (MS. 120) and the Pier-

[1] E. Bishop, *Liturgica historica* (1918), 238; A. W. Burridge, 'L'Immaculée Conception dans la théologie de l'Angleterre médiévale, *Revue d'histoire ecclésiastique*, xxxii (1936), 570; D. Knowles, *Monastic Order* (1941), 509.

[2] E. W. Williamson, *Letters of Osbert of Clare* (1929), 65. Osbert, the promoter of Edward the Confessor's canonization and the critic of Norman monasticism, may have regarded the feast of the Conception as an English usage. Hugh of Reading seems to have played a less active part in the controversy, but the feast was celebrated at Reading abbey.

pont Morgan Life of St. Edmund, have no exact dating, and the
Albani Psalter is only given priority because its whole-hearted
acceptance of the style suggests a very direct contact with the
source. Nor are the Bury books of very certain provenance. The
Gospels were presented to the abbey library by the sacrist in the
early fourteenth century: the Life is assigned on the strength of its
subject matter. Stylistically the Pembroke Gospels are in fact a
compromise. The figures might be by the hand of the St. Albans
master, but instead of his heavy, sombre colouring they are here
rendered in the Anglo-Saxon tradition of outline drawings with
light washes, arranged in bands across the page. The page is framed,
but only a narrow line divides its component scenes. They are
works of lovely quality: the figure of the rejected Christ has a
dignity and pathos that exploit to the full the new resources of
this humanistic approach (Pl. 39 a): the story of the Good Samaritan
shows a dramatic range of violence, satire in the characterization of
the passers-by, and pity for the naked, wounded traveller.[1] The
man without the wedding garment has the tufted Red-Indian like
hair of the figures in the St. Albans *Psychomachia*:[2] the Incredulity
of St. Thomas, the Betrayal, the Unjust Steward, the Raising of
Lazarus, are scenes where a great artist working in a curiously
restricted convention has found patterns which draw out the whole
dramatic feeling of the scene: the initials, with the possible excep-
tion of that to St. Matthew, are I think by the same hand (compare
the treatment of feet and fingers) but lose in painting much of their
imaginative subtlety; though the lion-headed St. Mark cutting off
his thumb, a reference to the tradition that he mutilated himself
to avoid becoming a bishop, is a fine forceful design. The foliage
is mainly a three-leaved acanthus, with curling edges and a pointed
centre leaf, not yet breaking into fruit or blossom. It is entirely
distinct from the heavy leaves of the St. Albans Psalter, and is
nearer but by no means exactly similar to that of the next manu-

[1] There are six full pages ($16\frac{3}{10} \times 10\frac{7}{10}$ in.) of drawings dealing with the later stages of
the ministry, some of the parables, the passion, resurrection, and last judgement.
See M. R. James, *Catalogue of MSS. Pembroke College* (1905).

[2] f. 1ᵛ of the *Psychomachia* (Titus D. XVI), which has the scene of the Sacrifice
of Isaac, provides another close comparison with the Pembroke Gospels.

script to be discussed, the Pierpont Morgan Passion and Miracles of St. Edmund. Here the foliage has a curious pointed pattern on the back of the leaves: elaborate patterns also decorate the neck and wings of the monsters. The convention of the figure scenes is stiffer and derivative. The framed space, rich colouring, strongly vertical poses, profile heads, are used with a certain imitative clumsiness. The large heads and bulging eyes suggest the Albani types of the psalter master rather than those of the gospel master, and some of the figures are so close to those in the former artist's Execution of St. Alban as to suggest direct borrowing. In the strange macabre rendering of the hanging of the thieves who had attempted to plunder St. Edmund's shrine, the vertical emphasis, noted in the St. Albans work, has found a theme which gives it the fullest play (Pl. 38 a).[1]

Reflections of this change of taste in works of a large scale are few and uncertain. The problems of the Chichester reliefs and of the wall paintings at Hardham and Clayton have already been mentioned. Both the carvings and the paintings have certain features, the tall bodies, straight falling drapery, and rounded bend of the shoulders, which would not be inappropriate to the Albani school. But the stylistic evidence remains inconclusive. Decay and restoration have so blurred the outlines of most of our wall-paintings that it is singularly difficult to set them in relationship with the unimpaired sharpness of our manuscript pictures.

In small-scale carving the morse ivory king from an Adoration found near Dorchester and now in the Dorset County museum shows the facial type and flat, curving folds of the Shaftesbury Psalter.[2] The Virgin and Child in the Victoria and Albert Museum (A. 25–1933) may well be another fragment of the same group.

While the developments mentioned above were taking place in the scriptorium of Bury, the great church and the monastic buildings were being completed. The eastern arm seems to have been built under Abbot Baldwin (1065–97), the nave under

[1] *New Pal. Soc.* 1st series (1903–12), Pls. 113–15. There is some internal evidence for dating it before 1135; the list of pittances on the opening pages appears to be written while Henry I was still alive. There are also included two letters to Abbot Anselm, one from Henry I and one from Prior Talebot.

[2] See E. Maclagan in *Antiq. Journ.* iv (1924), 209.

Anselm: the latter was composed of twelve bays and was 300 feet long: it ended in a western transept about 250 feet wide, of which the rubble core, defaced of its ashlar, still partially stands. It must have been, when completed towards the close of the century, as imposing a façade as any in England. The west doorway was provided with bronze doors, worked by a certain Master Hugo, an Italian fashion that doubtless owed something to Anselm. The same artist made a crucifix with the Virgin and St. John for the rood screen, and there is ample documentary evidence that Bury was well furnished with paintings, carvings, and goldsmiths' work.[1] Today all that remains in any completeness is the gatehouse tower, a wide arch under a diapered gable, surmounted by three carefully planned stories, of which the middle one has on its exterior face a triforium gallery with three windows above, gallery and windows being set under one arch, supported on giant half-columns. The capitals of the arch are carved with beasts and foliage of a distinctive type, which doubtless was more elaborately developed in the church and cloister. For the rest, the facing and details of the tower have been much restored in 1846–7 by Cottingham, and two curious gargoyles, found at Kilpeck and identified by Druce as the crocodile devouring the hydrus,[2] recur here and are almost certainly in this instance a fantasy of the restorer, for they do not appear in earlier prints.

Besides Bury there was much building activity throughout the eastern counties. Next to Durham the most strikingly preserved cathedral of the first half of the twelfth century is that of Norwich. The Conqueror had appointed his own chaplain, Herfast, to the see of Elmham. A restless, intriguing man, Herfast had attempted to secure the abbey church of Bury St. Edmunds as the centre of his diocese, but having failed in this had built a cathedral church at Thetford, of which nothing remains and little is known. In 1091 Herbert Losinga, a priest of Fécamp who was then abbot of Ramsey, was appointed to the see. He secured the bishopric by simoniacal bargains with the Crown so gross as to rouse public

[1] M. R. James, 'On the Abbey Church of S. Edmund at Bury', *Cambridge Antiquarian Soc.* No. xxviii (1895), 115.
[2] G. C. Druce in *Arch. Journ.* lxvi (1909), 325.

protest. He himself seems to have repented of his act or to have been alarmed by its notoriety. In defiance of Rufus, he appealed for absolution to Urban II and eventually made his peace with both parties. In 1096 he began the building of a great church at Norwich, which replaced that at Thetford as his cathedral. By his death in 1119 the choir, transepts, and first bays of the nave had been built and the nave was completed by his successor, Everard of Montgomery (1121–45). The story of Losinga's sin and repentance is depicted in some medallions on the soffit of an arch in the south aisle, work which seems to belong to the second half of the century but is hard to date in its much damaged condition.

In plan the cathedral, which is of unusual length, has fourteen bays, crossing and transepts, a choir of four bays surrounded by an ambulatory with three radiating chapels.[1] The tribune openings are almost equal to those of the ground arcade and are not divided. The arcade is supported by composite piers, with the exception of the sixth bay from the crossing, where on either side there is a circular column, decorated with spirals as in the choir at Durham. In the north and south walls of the transepts a new development of the hollow wall technique was brought to perfection. The continuity of the tribune stage across the end walls of the transept had always presented a problem, and had been solved, as in the south transept at Ely, by building out a platform: now at Norwich the middle range of windows is given a wall passage, similar to that of the clerestory but continuing the tribune range of the side walls (Pl. 42).[2] In the apse also the tribune still remains and possibly there was originally a clerestory stage rising to a wooden roof as at Peterborough, but later rebuilding has left this uncertain. The plain cushion capitals have little or no decoration: those on the tall engaged columns which support the central tower have stiff leaves with curling volutes, an early example of this form, but there were many accidents to the tower and consequent modifications of its details. Some fragments of more ornamental carving are preserved in the cathedral museum: a series of small capitals which may have come from the cloister, for some of them appear to be pairs, an

[1] D. J. Stewart and R. Willis, 'Notes on Norwich Cathedral', *Arch. Journ.* xxxii (1875), 16. [2] J. Bony in *Bul. mon.* xcviii (1939), 181.

ornate capital paired with a plain one, as was sometimes done on the inner and outer columns of a cloister arcade. There are some fine, deeply cut inhabited interlaces, which cover the whole surface of the capital: a capital with two men fighting and a man attacked by a lion: a curious piece with men fighting and a figure with an asperger. They are distinct from both the Reading and the Canterbury schools, but the remains are insufficient for any clear assessment of the work of the Norwich carvers.

Losinga is a type of the courtier bishop. In the affairs of the kingdom, the most important ecclesiastic was Roger, bishop of Sarum from 1107 to 1139. A poor priest of Caen, who is said to have pleased Henry by the speed with which he said mass, who combined the office of chief justiciar with that of bishop and who strengthened his hold by securing the see of Lincoln for one nephew, Alexander (1123–48), and that of Ely for another, Nigel (1133–69), Roger was the essential type of a secular prelate. As such it was a matter of prestige that he should dignify his cathedral, and in the case of Sarum it was also a strongly fortified site where he had his chief castle. The latter was probably his main interest: on the great earthwork he erected a courtyard keep, a rectangle of buildings round an open space, similar to that at Sherborne, which was also built by him and of which some part is still standing.[1] The neighbouring cathedral, of which the ground plan has been established by excavation, had been built by his predecessor, the saintly but business-like Osmund (1078–99), possibly on the foundations of Bishop Herman, laid when the see was transferred from Sherborne to Sarum in 1075. Osmund's cathedral was composed of a nave of seven bays, transepts with apsidal chapels, an apsed choir whose aisles also ended in apses. Its peculiarity lay in the absence of a central tower: the thickness of the walls suggests the possibility of transeptal towers, that form unknown in Normandy but found at Exeter, for which Sarum would then be the model. Roger immensely extended it: the choir became the crossing: aisles were added to the transepts and the new choir and its aisles ended in unusually deep apsidal chapels, embedded in a square east end (Fig. 9). Roger also added a crypt, possibly under

[1] H. Brakspear in *Arch. Journ.* lxxxvii (1930), 422. *R.C.H.M. Dorset*, i (1952), 64.

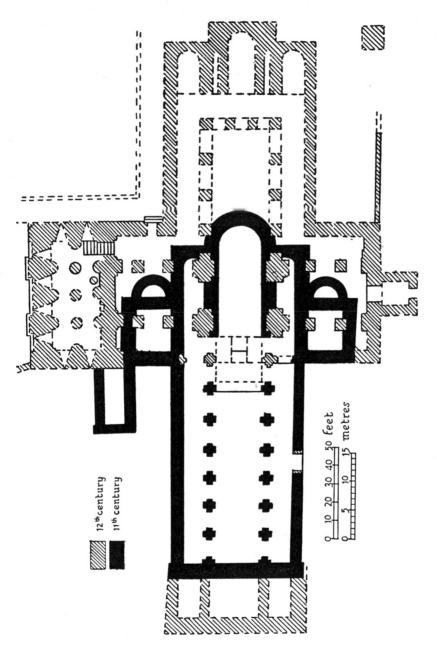

FIG. 9. *Old Sarum cathedral*

a chapter-house, and a cloister.[1] 'He built anew', wrote William of Malmesbury, 'the church of Salisbury, and beautified it in such a manner that it yields to none in England . . . the courses of stone were so correctly laid, that the joining line escapes the eye, so that it seems the whole wall is composed of a single block.'[2] The building was splendidly furnished: much of the paving of white Chilmark and green Hurdcote stone still survives, and in the museum at Salisbury there is a blue marble capital from the Sarum site, admirably carved with an elaboration of cutting unknown in English work of the period and probably an import from abroad (Pl. 43 *b*). These, with some corbel masks and a tomb slab, perhaps his own, are all that survive of Roger's magnificence, though in the chevroned ribs and interlacing arcades of the church of St. John at Devizes we may have an example of the work of his masons.[3]

The death of Henry and the civil war brought troubles for Roger and his kin. He sided with Stephen but incurred his suspicion: Sarum was seized and the castle garrisoned by the Crown: Alexander of Lincoln (1123–48) was besieged in Devizes and deprived for a time of his temporalities. He, too, was a great builder. His main castle was at Newark, again in the form of a fortified courtyard, with the gate tower as its chief strong point. At Lincoln the castle had been built by order of the Conqueror and it is not known if Alexander did much to alter it. In his cathedral, a fire shortly before 1146 destroyed the roof and Alexander covered it with stone vaults.[4] He also considerably modified the west front, the most original feature of Remigius's building.[5] The portals, within the earlier great arches, were enlarged and ornamented with carved columns (Pl. 40 *a*). Two on either side have coiling

[1] For the castle and the cathedral see D. H. Montgomerie, 'Old Sarum', *Arch. Journ.* civ (1947), 129.　　　　　　　　　[2] *Gesta Regum*, R.S. xc (2) (1889), 484.

[3] E. Kite, 'The Churches of Devizes', *Wilts. Arch. and Natural Hist. Magazine*, ii (1855), 213.

[4] Giraldus Cambrensis, *Vita S. Remigii*, R.S. xxi (7) (1877), 33, 198. See also Henry of Huntingdon, R.S. lxxiv (1879), 278. The fire in many older books is dated 1124, but it seems clear that in the conflagration of that year the cathedral received no damage. See J. W. E. Hill, *Medieval Lincoln* (1948), 109. It may have taken place during the siege of 1141.

[5] F. Saxl, 'Lincoln Cathedral: The Eleventh-century Design for the West Front', *Arch. Journ.* ciii (1946), 105.

foliage forming ovals inhabited by men and beasts: two have diaper pattern: one with its confronting birds and beasts recalls the patterns of eastern woven fabrics: the capitals are of the scallop type with richly scrolled abaci and imposts: the voussoirs are composed of chevrons and beak-head masks, some of them strikingly close to those of Salisbury: the outer circle of the arch is covered with a key pattern. The central arch was altered in the thirteenth century, when the façade was heightened and extended on either side, but above the two side arches there is a row of interlacing arcades, which probably formed a main feature of Alexander's design. The column carvings and some of the panels were largely restored by J. C. Buckler in the mid-nineteenth century, but some of the original fragments are preserved in the cathedral cloister. The naked figures clambering in the trellis work or drawing back the string of their bows are cut with a conviction which is noticeably lacking in their modern substitutes. Stretching across the Norman façade, at the level of the side niches and the impost of the main door, is a series of carved panels. These sculptures provide a curious group of problems. They have been described as Saxon or as from the building of Remigius: their subjects have been very variously interpreted.[1] They fall into two halves, divided by the main doorway: to the south is the story of the Fall and the Flood with, inset in a frame of the same style as the dripstone moulding, Daniel in the Lion's Den. One of the series, the Deluge, is now enclosed in the chapel created by the thirteenth-century additions, so that their present position is not due to that phase of alterations but is either their original place or a rearrangement of Alexander's time.[2] It has often been stated that the slabs are out of order and clearly reset. This view seems to be due to misinterpretation of the subjects: allowing for one or two blanks, where from the masonry it is clear that a slab has been removed, their order is iconographically logical enough. Of the

[1] A. F. Kendrick, *The Cathedral Church of Lincoln* (*1898*); J. R. Allen in *Journ. Brit. Arch. Ass.* xlviii (1892), 292; M. R. James in *Camb. Antiq. Soc. Proceedings*, x (1901–4), 148; G. Zarnecki, *Later Eng. Rom. Sculpture* (1953), 20.

[2] The Deluge panel includes a side figure out of the main rectangular alinement, but this appears to be part of the original design.

Fall story, we have the Expulsion, Adam and Cain at work, while the hand of God appears in the top of the panel, holding a bag, the promised earnings: Eve suckling Abel (formerly interpreted as Hannah, Samuel, and Eli, and the meaning of the lower half of the panel, probably again Adam and Cain, is still somewhat obscure): there follow two gaps, probably the deaths of Abel and Cain, then God speaking to Noah and Noah building the Ark. It is here that Daniel is inserted: one of the most usual examples taken from the liturgy for the salvation of the soul, this may be a statement of the general theme of salvation from sin, of which the ark is another type: the last panels on the south are Noah leaving the Ark and the Covenant with Jehovah, a long continuous piece; a walled-up blank; and the scene of men perishing in the Deluge, which is now inside the south-west chapel. There are certain inconsistencies here: the Flood should precede the Exit from the Ark, but on the whole it is a possible sequence. Stylistically the figures, solidly cut but with comparatively little articulation, suggest a group of connected carvers rather than one hand. In the strongly marked eyelids and curled hair they have links with the figures inhabiting the interlaces of the pillars and also with the masks on the voussoirs. To the north there are more gaps: two at the beginning and three at the end. Starting from the centre, the first preserved is Dives at table:[1] the figure of Lazarus at which he is pointing has been destroyed though the dogs' heads are still visible: then follow the Death of Lazarus and Dives in Hell; Lazarus in Abraham's Bosom; the Souls of the Blessed (?); the Harrowing of Hell; the Torments of the Damned. Again it is a fairly consistent and connected statement on the theme of salvation and damnation, a far more reasoned statement than anything we have yet seen in English sculpture. Stylistically there is a change from the group on the southern side: the heads, unfortunately, are mainly mutilated: in those preserved, Dives and his two table companions, the type is similar to that of Noah and Adam but with more expression: the much damaged figure of Abraham wears a shirt whose opening is similar to

[1] E. Trollope, 'The Norman Sculpture of Lincoln Cathedral', *Arch. Journ.* xxv (1868), 1, interprets Dives' feast as the Supper at Emmaus, and the dogs' heads at the side as finials of a chair.

examples in the Noah sequence, but the seated figures of the elect and the Harrowing of Hell show far finer drapery with thin folds. The Torments of the Damned, much battered in its details, has a fine coiling rhythm, very distinct from the stiffness of the nude figures in the Expulsion, but which may be aided by the possibilities of the subject. This thin drapery reminiscent of the Burgundian school is found again in two fragments preserved inside the cathedral: the seated headless figure of Christ (part of his cross-marked nimbus survives, above which there is a nimbed dove), probably the centre of a large Majesty; and a tall, standing figure of an apostle holding a book, carved in relief in a cross-legged posture with drapery of the greatest refinement. On the same panel is the rim of a circle of quatrefoil petals, with an eagle at the top (curiously reminiscent of the Leominster doves) and at the foot a winged lion's head, two of the signs of the evangelists. These must have been part of a great central tympanum of the highest quality, which would well agree with the account of Alexander's splendid undertakings. If so this is a new stage in English sculptural achievement, in which the smaller panels show a local band of carvers developing the traditional stiff heavy style, but influenced by new examples from a man or men familiar with the best French work and possibly coming from beyond the Channel (Pls. 41, 43 a).

At Ely, Nigel, Roger of Salisbury's other nephew and Alexander of Lincoln's brother, had a longer reign, not dying till 1169, though his last years were those of a sick and ineffective man. He had shown little care for his cathedral church, plundering the shrine of St. Etheldreda to provide money for the financial difficulties occasioned by his political reverses. Work, however, was steadily advancing on the nave, and some additions to the fabric date from the middle years of the century and suggest some contact with the masons' yard of Lincoln, even if they may well be due to the zeal of Prior Salomon, who is known as a patron of gold-smiths' work, rather than to Bishop Nigel.[1] These additions are two doorways on the south side of the nave, both leading into the cloisters and known respectively as the monks' door and the

[1] J. Bentham, *Ely*, i (1812), 137–41. Salomon may have been related to the abbey goldsmith of the same name. *V.C.H. Cambridge*, ii (1948), 204.

prior's door. Both have elaborately carved jambs, and display on voussoirs and capitals a sprawling acanthus pattern such as is found in the spandrels of the doorway at Lincoln. The former, the monks' door, seems to be the earlier work, and its most striking feature is its trefoil arch with two crouching figures in the spandrels and, above, two interlacing dragons. The second, the prior's door, has on its innermost jamb a band of acanthus leaves; on the middle one an inhabited scroll in spiral divisions; on its outermost circular medallions of human figures (dancers, musicians, a man drawing wine from a cask, two men rowing) and a selection of fabulous beasts. The tympanum, supported on two corbels of human heads, has a Majesty, Christ in a mandorla supported by an angel on either side. It is hard and contorted work: the grotesque pose of the angels is one of the most emphatic in our Romanesque art, but there is a sense of force behind it and the elongations and disproportions are used with a certain mastery of this essentially non-naturalistic style.

The finest piece of figure carving at Ely is, however, to be found on a tomb slab, now placed behind the high altar. Its inscription, asking for the prayers of St. Michael, gives no indication as to the man commemorated, though the name of Bishop Nigel is often put forward. His tomb is known to have been before the altar of the Holy Cross set in the great pulpitum which was probably erected in his episcopate and which survived till 1770. Carved in a bluish marble, like the 'black' fonts imported from Tournai or the capital from Old Sarum, the tomb slab is probably foreign work. The subject is St. Michael holding the soul of the deceased in his lap, and it is cut with great delicacy: hollowed out from the slab, not raised on it, it is linear in concept and, despite the mutilated head of the archangel, is a work of distinguished quality. In Salisbury cathedral, one of three tombs moved from Old Sarum in 1226, is a slab of similar dark stone, showing a bishop surrounded by coiling foliage with a submissive dragon at his feet. Tradition assigns it to Bishop Roger, which seems probable enough,[1] and in the absence of examples in native stone we may

[1] Sir Alfred Clapham has suggested (*Arch. Journ.* civ, 1947, 145) that it is more likely to be the tomb slab of Bishop Jocelin (1142–84), but the argument for this is far from convincing.

take it that these princely bishops ordered their memorials abroad before the fashion for them was well established in England. At Westminster the tomb slab of Abbot Crispin is also of this foreign stone, as is the decorative panel known as the 'Gundrada' slab at Lewes and, in quite another style, a stone panel carved with beasts at Bridlington. English stone figure-slabs such as the rough 'Herbert' at Norwich, now set in the exterior wall of the north transept, are much inferior in quality, but another of the Sarum tombs, identifiable by an inscription as that of Bishop Osmund (1078–99), has a recumbent figure in Purbeck marble, more rounded in its modelling than that of the 'Tournai' slabs. Certainly somewhat later than the date of the saintly bishop's death, it suggests that by the mid-twelfth century the Purbeck quarries were beginning to supply tomb effigies, and this is borne out by examples at Westminster, Abbotsbury, Exeter, and Peterborough.[1]

The abbey church of Peterborough, refounded by St. Ethelwold in the tenth century as one of the key positions in the conversion of the Danelaw, had not been rebuilt in the first period of Norman architectural undertakings. That great builder, Ernulf of Canterbury, was abbot from 1107–14, but his activities, as later at Rochester, are described by the chronicler as concentrated on the monastic buildings, the dorter, rere-dorter, and chapter-house: three blocked and battered doorways in the west wall of the cloister are all that can now be assigned to his abbacy, though his new buildings escaped the disaster which befell the church in 1116, when through the carelessness of a servant—and also, Hugo Candidus the chronicler tells us, because the abbot in a fit of anger had cursed the monastery—the buildings caught fire and the whole church was burned. The fire lasted in the tower for nine days, scattering, when the wind rose, fresh showers of red hot ashes on the remaining buildings: 'That day was indeed one of sadness and grief.'[2] The rebuilding was undertaken by the abbot, John of Séez, in 1118, but interrupted by his death in 1125, which was followed

[1] For Osmund's tomb see F. J. E. Raby in *Arch. Journ.* civ (1947; publ. 1948), 146. For the tombs in general and for reproductions see E. S. Prior and A. Gardner, *Medieval Sculpture in England* (1912), 568.

[2] *The Chronicle of Hugh Candidus*, ed. W. T. Mellows (1949), 97.

by three years' vacancy, ending in the appointment of Henry of St. Jean d'Angely, an ambitious courtier priest whose intrigues led to his banishment in 1132. It was only with Abbot Martin of Bec (1133–55) that the building was resumed, and in 1143 (or 1140, the date is variously given) the eastern arm was sufficiently advanced for consecration. Pauses in the building programme are marked by changes in the details of sections and mouldings. By Martin's death in 1155 it is reasonably certain that the transepts and eastern bays of the nave were, if not completed, partially built, but it was not till the abbacy (1177–94) of Benedict, Becket's friend and biographer, that 'the whole of the nave of the church in stone and wood from the tower of the choir up to the front' was carried out, in a style that continued, after a possible experiment in vaulting, that which had been established in the choir and transepts.

The ribbed vaults of the choir aisles of Peterborough have already been mentioned as successors to the experiments at Durham, but it is rather in the absence of vaulting that Peterborough holds its own particular place in our Romanesque building. The nave and transepts retain their original boarded ceilings, and in the former case the decoration, though much restored, still displays its late-twelfth-century design, a medley of saints, kings, bishops, liberal arts, signs of the zodiac, music-playing beasts, and varied monsters, set in lozenges framed in a key pattern.[1] In the choir and apse the ceilings are of fourteenth-century date. Whether or not the apse was ever vaulted is uncertain: it has undergone much alteration and its original scheme can only be conjecturally established. If, however, a vault was ever tried, there were good reasons for its failure, for the apsidal elevation of Peterborough rises to three stories and shows the final triumph of the hollow wall.[2] At Norwich the end walls of the transepts continue the proportions of the arcades of the side walls and join them with a window passage: this was repeated in the Peterborough transepts with an

[1] C. J. P. Cave and T. Borenius, 'The Painted Ceiling in the Nave of Peterborough Cathedral', *Archaeol.* lxxxvii (1937), 297.

[2] Ely may have preceded it, but the form of the twelfth-century apse there is most uncertain. See J. Bony, *Bul. mon.* xcviii (1939), 178. For Norwich see above, p. 115.

effect of unusually classical and balanced harmony. Now the apse was also brought into the same single scheme. In general the Norman apse was vaulted by a semi-dome at a lower level than the high vault of the choir, leaving it a two-storied elevation in which the clerestory passage could have no continuity. By foregoing a vault, the builders of Peterborough could continue round the apse the proportions of arcade, tribune, and clerestory openings that had been used in the choir and could also establish, even with a semicircular or polygonal ending, that equivalence of height throughout the whole building to which the English were always partial. Alas, fourteenth-century insertions have destroyed the harmony of Peterborough's east end. The characteristic features of the choir, the three arches of the clerestory, the twin bays and chequered tympana of the tribunes, the intersecting arches of the wall arcade, have gone from the apse to make way for larger windows, but even stripped of its unifying detail the framework still sets out one of the most satisfying of our Norman designs.

V

THE CISTERCIANS

IN the religious life of England between the conquest and the
close of the century the most marked feature had been the
growth of monasticism. The increase in numbers in the old
Anglo-Saxon foundations is, wherever it can be checked, very
marked, Worcester, for instance, increasing from twelve to fifty,
Gloucester from ten to a hundred, Abingdon under Faricius from
twenty-six to eighty. Important new foundations were made such
as the abbeys of Battle (1067), Selby (*c.* 1069), Shrewsbury (1083–
90), Chester (1093), Colchester (1095), St. Mary's, York (*c.* 1095),
and Tewkesbury (1102). Lanfranc found four cathedral mon-
asteries in England when he became archbishop: Canterbury,
Winchester, Worcester, Sherborne. The last of these ceased to be
a cathedral monastery on the transfer in 1075 of the see to Sarum,
where Bishop Osmund (1078–99) organized a body of secular
canons, giving them a constitution which was to become a model
for other cathedrals. By 1133, out of seventeen bishoprics, eight
had monastic centres, the additions being Durham, Rochester,
Bath, Coventry and Lichfield (where the centre of the see was
being constantly shifted), and Ely. Carlisle, created in that year,
was a foundation of Augustinian canons. A strong impulse in this
development was the new life from abroad: from Cluny or Cluniac
houses with their priories of Lewes (1077), Wenlock (*c.* 1080), Ber-
mondsey (1089), Castle Acre (1089), Pontefract (*c.* 1090), Monta-
cute (*c.* 1102): from Bec and Mont St. Michel whence came so
many abbots to English monasteries, from Marmoutiers, from
St. Ouen, and from St. Étienne of Caen. The monasticism of
Normandy may well have been weakened by the drafting of many
of its ablest leaders to England, and the opening years of the
century saw there a stirring of discontent, a demand for a new
strictness of conformity, and the secession of individuals and groups
in search of new rigours of piety. The wild country between Maine
and Brittany was their resort, and from there came two leaders,

Bernard, who founded in 1109 a community at Tiron near Nogent-le-Rotrou, and Vitalis, the founder of the abbey of Savigny near Avranches in 1112. Bernard of Tiron had been strongly supported by Ivo, bishop of Chartres, and through him this new order must have been well known to Adela of Blois and her sons. Vitalis had visited England, and his successor in 1122, Geoffrey, is described by his biographer as well known to Henry I. It was not long before these new orders crossed the Channel. Robert Fitz-Martin settled a group of monks from Tiron in Cardiganshire and built for them the small abbey of St. Dogmael. This Robert's father may have come from Tiron, for a sixteenth-century manu-script history calls him Martin Tironensis.[1] Certainly his son, the founder, visited Bernard in France. Only fragmentary ruins remain of this abbey, most of them from the Gothic period. Savigny received more distinguished patronage from Stephen, son of Adela of Blois, and his wife Matilda, daughter of Eustace of Boulogne and Mary, the sister of Matilda, Henry I's queen. In 1124 this pair, both of royal stock, both of crusading families noted for their piety, made a grant of land in Lancashire to Savigny. This small colony was moved in 1127 to Furness and we know that in the course of the next twenty years considerable building was carried out.[2] The plan of the church was an unusual one, a square-ended presbytery with, in the east wall of each transept, two apsidal chapels, those nearer the crossing being larger and more deeply projecting as though arranged in echelon. Nothing remains or is known of the plan of the parent house at Savigny, but the abbey of Les Vaux-de-Cernay, begun c. 1135, one of the leading Savignac houses in northern France, had a similar ground-plan. Furness, built contemporaneously with it, must share some common Savignac scheme. The order enjoyed much popularity in England: twelve houses were founded in the thirties, of which the latest, Coggeshall, was another foundation by Stephen and his wife. Their last monastery, the abbey of St. Saviour at Faversham,[3]

[1] E. M. Pritchard, *The History of St. Dogmael's Abbey* (1907), 23.

[2] W. H. St. John Hope in *Trans. of Cumberland and Westmorland Arch. Soc.* xvi (1900), 221.

[3] R. C. Fowler in *V.C.H. Kent*, ii (1926), 137.

endowed by Matilda with a piece of the True Cross sent by Godfrey of Bouillon, designed as their burial-place, was, however, colonized from the Cluniac priory of Bermondsey and its organization modelled on that of Reading abbey. But by 1148, the year of Faversham's foundation, the order of Savigny had ended and had been merged in that of a greater revival, the order of Cîteaux, illuminated by the prestige of Bernard of Clairvaux. Of Stephen's buildings at Coggeshall or Faversham nothing remains, or of his tomb in the latter church, which was destroyed at the dissolution 'for the trifling gain of the lead' in which the body was lapped.

Of this fervour of the time the most enduring manifestation was the foundation of the Cistercian order. Begun in 1098, the formative period was under the abbacy of the Englishman, Stephen Harding, from 1109 to 1133, but its early years had little contact with England. The first Cistercians came there in 1128 and the first English house, Waverley, founded the following year by monks from L'Aumône, is generally considered as thirty-sixth in the chronological expansion of the order.[1] The patron of Waverley was the bishop of Winchester, William Giffard, a man of humble and saintly life, who had gone into exile during the investiture dispute and who now in the closing years of his life had taken the monastic vows in his cathedral monastery. He died in 1129 and Waverley was thus his latest interest. But the new order did not lack for friends: Stephen interested himself in Waverley, Matilda and Stephen competed in patronizing one of its daughter houses, Bordesley. Five houses were founded from this first settlement, though Waverley itself remained a comparatively small house, only numbering seventy in 1187. It was the second Cistercian mission, sent out by Bernard himself in 1131, that gave the real impetus to the spread of the order in England, and it was not till 1147, when the Savignac order, of which there were then thirteen houses in England, was absorbed in that of Cîteaux, that it became without rival the leading community of English monastic reform.

The Cistercians had based their reform on a new and stricter

[1] A. M. Cooke, 'Cistercians in England', *E.H.R.* viii (1893), 640; J. Bilson, 'Architecture of the Cistercians', *Arch. Journ.* lxvi (1909), 185; E. Sharpe, *Architectural Parallels* (1848).

asceticism. Their statutes, compiled between 1134 and 1152, prohibited painting and sculpture, the use of colour or precious metals or fine fabrics within the churches, and the erection of bell towers without. This renunciation of visual beauty receives an almost lyric quality in the writings of St. Bernard. Nowhere else is there so vivid a contemporary description of Romanesque art, and, well known as it is, it must once more be quoted. He writes in the twelfth chapter of his *Apologia*[1] of the curious carvings and lavish ornaments which distract the mind of those who seek to pray:

'There are hung in the churches great wheels—I cannot call them crowns—garnished with lights, but shining more with precious stones. as candelabras, great trees of massive bronze are raised carved with infinite art, where the tiers of candles throw less light than the jewels. *O vanitas vanitatum, sed non vanior quam insanior.* Sacred images form the pavement that we walk on: here one spits on the face of an angel, there the features of a saint are effaced by the feet of the passers by.... In the cloisters, to what purpose are these ridiculous monsters, this deformed beauty and beautiful deformity? To what purpose these obscene monkeys, these raging lions, these monstrous centaurs, these half men, these spotted tigers, these battling warriors, these horn-blowing hunters? Here several bodies grow under one head, there several heads on one body—it is more agreeable to read these astonishing vanities on the marble than to study in books, to wonder at them than to meditate on the law of God.'

At last it has come, the protest against this wild erratic symbolism, but half emancipated from the barbarian world. Bernard is writing a polemic, but the sincerity of his distaste is beyond question. Yet he sets a limit to his criticism: to the ignorant some concession, some easy appeal to the senses, may be necessary; these farouche fancies may sometimes be justifiable; it is the monk, the athlete of God, who needs them not, to whose higher, spiritualized thoughts they are an outrage. It is as a distraction from godly meditation that the statutes forbid them.[2] Cîteaux in its starkness

[1] 'Apologia ad Guillelmum Sancti-Theoderici Abbatem', Migne, *P.L.* clxxxii. 895. Excerpts in V. Mortet, *Recueil de textes*, i. 366. See E. Vacandard, *Vie de St. Bernard* (Paris, 1895), i. 107, and V. Mortet, 'Huge de Fouilloi, Pierre le Chantre, Alexandre Neckham' in *Mélanges offerts à M. Charles Bémont* (Paris, 1913), 105; De Bruyne, *Études*, ii. 133. [2] *Nomasticon Cisterciense* (1892), 217.

proclaimed a new concentration on the inward life. The author of the *Pictor in Carmine*, possibly Adam of Abbey Dore (fl. 1200),[1] admits that in 'some churches painting may be permitted, but this painting must be instructive not bizarre'. 'Struck with grief that in the sanctuary of God there should be foolish representations, rather misshapen monstrosities than ornaments', he drew up a list of biblical scenes, those of the Old Testament typifying those of the New, for the guidance of painters, so that men should not contemplate 'the intrigues of the fox and the cock, monkeys playing the pipe and Boethius's ass and lyre', but rather 'the deeds of the Patriarchs, the rite of the Law, the deliverances wrought by the Judges, the symbolic acts of the Kings, the conflicts of the Prophets, the victories of the Maccabees, the works of the Lord the Saviour, and the revealed mysteries of the Gospel in its first splendour'. Others, such as the Augustinian Hugh of Fouilloi, raised a further question, that of cost. 'Adam and Eve', he writes, 'are clothed on the walls, but the poor crouch in their nudity in the cold embrace of winter.'[2] It is both vain curiosity and superfluous expense that are called in question.

To us today the Cistercian abbeys, many of them ruins, toned by the weather, ornamented by the destructive growth of intruding plants, have none of the shock of contrast that must have come from their white simplicity as opposed to the glowing colours of the painted walls and carvings of the other churches of the time. But as St. Bernard's rebukes and exhortations themselves fall into some of the most refined cadences and choice language of medieval Latin, so the bareness of the churches served to emphasize the purity of their architectural lines, and the soundness of the building was all the more apparent for its lack of detail, all the more exacting from the absence of any means by which botches could be disguised. The plan most commonly used, though there were notable variants and exceptions, can still be seen in the church of Fontenay (Fig. 10), built (1139–47) largely by a grant of money from

[1] M. R. James, 'Pictor in Carmine', *Archaeol.* xciv (1951), 141. (This important article was written in 1932 and published posthumously.)

[2] *De Claustro animae*, Migne, *P.L.* clxxvi. 1053. Hugh was prior of St. Laurent d'Heilly in 1153 and died after 1173.

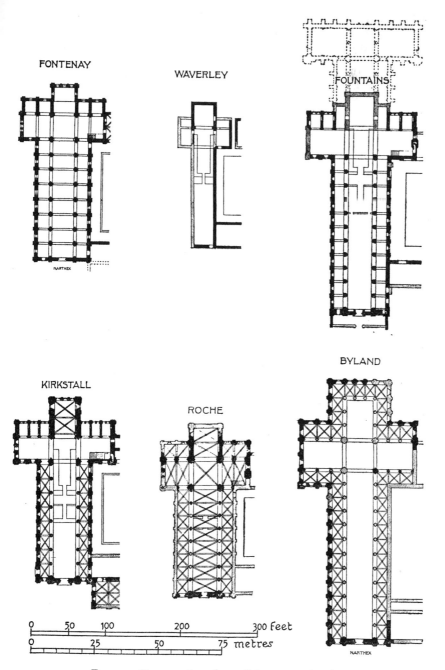

FONTENAY

WAVERLEY

FOUNTAINS

NARTHEX

KIRKSTALL

ROCHE

BYLAND

| 0 | | 50 | 100 | | 200 | | 300 feet |
| 0 | | 25 | | 50 | | | 75 metres |

NARTHEX

FIG. 10. *Comparative plans of Cistercian churches*

Everard, bishop of Norwich, who retired to end his days in the abbey where his inscribed tombstone still survives, but purely French in design and probably closely similar to the slightly earlier church at Clairvaux.[1] Its most marked features are a square apse and wide transepts with two chapels made in their eastern aisles. The aisled nave had eight bays. Throughout the church was vaulted by a pointed barrel vault: the nave vault was abutted by transverse vaulting in the aisles at right angles to it and the transept chapels had similar transverse vaults. The arches of the arcades are pointed, those of the windows round. The latter had no mouldings or columns except in the central window of the west façade, but both in the façade and the chevet, where five windows were pierced in the gable of the nave rising above the choir, the effect of their placing is one of great symmetry and taste. Fontenay may be taken as representing the general forms of the churches of Cîteaux and Clairvaux as they existed in the mid-twelfth century: at Clairvaux a circular apse with ambulatory and radiating chapels was substituted in an extension begun in 1154.

In the earliest known English church, that of Waverley, where the ground plan has been recovered by excavation, the building was small in scale and extremely simple, an aisleless nave, shallow transepts with only one eastern chapel each, and a small square-ended presbytery.[2] There are indications that Tintern, founded in 1131, was of a similar type.[3] But it was neither in Surrey, though Waverley had five daughter houses, nor in the Welsh border that English Cistercianism was to find its full development. Built in a deep valley of the river Rye in the North Riding, Rievaulx was founded in 1132 by Walter Espec and colonized directly from Clairvaux.[4] The plan of the church (Fig. 11) was close to that of Fontenay, a square-ended presbytery, transepts with three eastern chapels and a crossing surmounted by a low belfry; for in England the prohibition against stone bell towers, not formally issued till

[1] M. Aubert, *L'Architecture cistercienne*, i (1947), 234.

[2] H. Brakspear, *Waverley Abbey* (1905), and in *V.C.H. Surrey*, ii (1905), 620.

[3] H. Brakspear, *Tintern Abbey* (1921).

[4] W. H. St. John Hope in *V.C.H. North Riding*, i (1914), 494; C. Peers, *Rievaulx Abbey* (Office of Works Guide, 1932).

the General Chapter of 1157, was never strictly observed, and English builders continued to raise a tower over the high arches

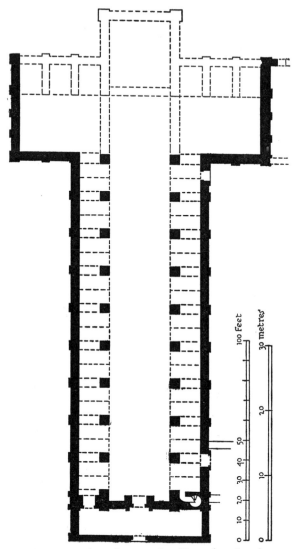

FIG. 11. *Plan of Rievaulx abbey: first church*

of the crossing whether it were a Cistercian house or not. The aisled nave had nine bays of which now the foundations only are standing: the choir and upper parts of the transepts are part of the thirteenth-century rebuilding. The nave, as in other Cistercian

churches, was divided by stone screens, and also screened between the piers from the aisles, which were narrower than in most churches and were in their turn sometimes divided into chapels by screens placed across them: the pulpitum or rood screen, between the second pair of piers westward from the crossing, was the entrance to the monks' choir: then there was a bay, open to the aisles and used largely as a passage way, and another screen, across the nave and between nave and aisles, enclosed the choir of the lay brothers or *conversi*. The long vistas of our ancient monuments were unknown to their builders, except when they raised their eyes to the upper stories of the building.

The building of Fountains, founded in 1132 by a secession from the abbey of St. Mary at York, was probably commenced after the dean of York, bringing his wealth with him, joined the community in 1135.[1] In the course of the dispute between the abbot, Henry Murdac, and William, archbishop of York, ending in the deposition of the latter, the abbey was sacked and burned (1146–7). The chronicle of Hugo of Kirkstall, based on information obtained from Serlo, one of the first monks,[2] tells us that the buildings were reduced to ashes. This may well be an over-simplified lamentation, but certainly much rebuilding had to be carried out, and there seems from entries in the chronicle to have been continuous work in progress till the death of Abbot Robert in 1180. The plan (Fig. 10) consisted in an aisleless presbytery of three bays, north and south transepts each with three eastern chapels, and a nave and aisles of the unusual length of eleven bays with a western narthex. It was a typical Cistercian plan with one peculiarity, that the two innermost transept chapels flanking the presbytery were 11½ feet longer than the others and thus gave an echelon formation, as at Furness, to the eastern arm. In their deep and still secluded valley, the buildings both of church and monastery largely survive, one of the noblest of ruins and in its unspoiled setting as romantic as any that England possesses. The nave has a pointed arcade with a simple chamfered moulding of three orders, supported on round columns

[1] J. A. Reeve, *Fountains* (1892); W. H. St. John Hope in *Yorkshire Arch. Journ.* xv, 1900, 269.

[2] *Memorials of the Abbey of St. Mary of Fountains*, Surtees Soc. xlii (1863), 101.

with scalloped capitals, their bases resting on square plinths. Above, as was usual in cloudy England, though not found at Fontenay,[1] is a clerestory of round arched windows. There is, however, no clerestory passage, and the 'hollow' wall is abandoned in these early Cistercian buildings. Above the roof of the aisles flat pilaster strips support the outside of the clerestory wall. Inside, the only wall ornament is a strongly marked string course running below the clerestory, with another joining the springing point of the windows and continued round them as a hood-mould. The nave was roofed with wood. The aisles were vaulted with transverse barrel vaults, as at Fontenay, divided by round arches and supported by corbels on the outer wall, on the inner by a corbel on the column of the arcade. The single order of the arcade on the aisle side is supported by three-quarter round shafts attached to the main columns, so as to surmount the difficulty of the aisle arcade having one order as opposed to the three orders on the nave side; on the latter the capitals form half of an octagon. There is thus a curiously different effect provided by the nave and aisle vistas (Pl. 44 a). The west front had three round-headed windows and, above, a plain circular opening. The whole with its excellent stonework must have been a building of splendid dignity and severity, and around it, centring on the great cloister, 125 feet square, the monastic buildings, whose ruins still include much twelfth-century work, completed the picture.

Two other Cistercian churches of this first period require mention because of their comparatively complete survival: Kirkstall, now on the outskirts of Leeds and sadly blackened since the days when Girtin delighted to paint it; and Buildwas in Shropshire. In 1147 a convent was founded from Fountains by Henry de Lacy at Barnoldswick and Serlo the chronicler was one of the men sent out to colonize it. This proved an unsuitable site and in 1152 they moved to Kirkstall. Henry de Lacy laid the foundation stone of the new building and largely financed its erection. The plan was the normal Cistercian one, with a nave of seven

[1] M. Bony has pointed out to me that there may well have been a 'premier art cistercien' in northern France much closer to English examples than dependence on the chance survival of Fontenay suggests.

bays.[1] As compared with Fountains, the interesting features of Kirk-
stall are the ribbed vaults, still intact, of the choir and the aisles of the
nave. These are split into bays by transverse pointed ribs, stilted
some 8 or 9 inches, that is, pointed at a much more acute angle than
the somewhat timid pointing of the arches in the nave of Durham.
The use in Cistercian buildings of pointed arches and arcad-
ing is probably borrowed from French examples: in 1153–4, that
is almost exactly contemporaneously with work at Kirkstall, the
rebuilding of the choir was begun at Clairvaux and ribbed vaults
were employed: it would be hard to establish an exact prece-
dence between them. Apart from its vaults, Kirkstall has also
a certain ornateness in detail not found in the earliest building.
Instead of the round columns of Fountains, with applied half
columns on the aisle side only, Kirkstall has composite piers with
twelve engaged columns, in varying proportions, answering to
the various orders of its arcade (Fig. 12 a). The capitals show a con-
siderable range of scallop patterns: here and there are examples of
interlacing designs, in one instance spreading unusually over the
base of a pillar in the nave arcade:[2] in the north transept there are
some foliage capitals with thin pointed leaves and interlacing
stems: on capitals from the cloister arcade, the smooth flat leaves
curve inwards at the angles of the abacus, the so-called 'water-leaf',
a type found also in the later twelfth-century work at Fountains,
where there is a particularly fine example on the corbel of the
reading desk in the refectory, and in most of the Cistercian abbeys
of the last quarter of the century, when it becomes a common
feature of the transitional style.[3] The profile of the capital becomes
concave, the 'hollow bell' style, instead of convex as in the cushion
capital, so universal in earlier work. These are forms that were
contemporaneously appearing in northern France, and here they
may well be borrowings from an area where the order had so many
affiliations. Kirkstall, however, uses also several motifs popular
with the Anglo-Norman builders. The west front has a round-

[1] W. H. St. John Hope in *Thoresby Society*, xvi (1907), 1, and J. Bilson, ibid. 73.

[2] J. T. Irvine, 'Notes on Specimens of Interlacing Ornament which occur at Kirk-
stall Abbey', *Journ. Brit. Arch. Ass.* xlviii (1892), 26.

[3] For examples see Pl. 47 b.

headed doorway of five orders, the third of which has deeply cut chevrons: the porch is set in a gable and above, between the top of the arch and the point of the gable, is a blind arcade of four inter-secting arches, a very modest tribute to this pre-eminently English

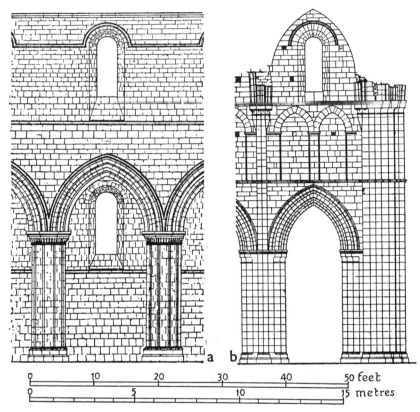

FIG. 12. a. *Kirkstall abbey, nave: interior elevation*
b. *Roche abbey: north transept elevation*

design (Pl. 46). The north doorway also has chevrons, with its outer moulding formed into an unusual Greek key pattern, a design which was gaining popularity. These decorative motifs appear again in later Cistercian churches, and Kirkstall seems to mark a less stringent stage in the use of carving.

Buildwas, on the Severn near Shrewsbury, first founded in 1135 as a Savignac house, though on a smaller scale follows the same general pattern as Fountains and Rievaulx, round columns

supporting a pointed arcade with, above, a round-arched clerestory (Fig. 13).[1] The presbytery had ribbed vaulting, as also the chapter house, where it still exists, though this latter may be thirteenth-century work. Succeeding abbeys mark a change in design. Roche abbey, the house of St. Mary of the Rock, on the south-east border of Yorkshire, was founded from Newminster, the first daughter house of Fountains, in 1147. Its site and some of its actual remains were in the eighteenth century subjected to the ministrations of Capability Brown and form the text for an interesting discussion by William Gilpin on the appropriate setting for a ruin.[2] The character of the scene, he thought, Mr. Brown had mistaken: 'in a ruin the reigning ideas are *solitude, neglect* and *desolation*'.

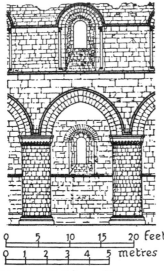

FIG. 13. *Buildwas abbey, nave: interior elevation*

Roche only gradually attracted patrons and endowments and it is probable that the building of the church advanced but little before the accession of the third abbot, Roger of Tickhill, in 1171. His successor Osmund (1184–1213) was an able, business-like man, who secured from the Pope and Richard I confirmation charters of all the monastic possessions and privileges, and in addition, from the king, remission of a debt of 1,300 marks borrowed from the Jews. He seems a character likely to have brought the building to an early completion. Certainly it must be later work than that at Kirkstall. Today only the eastern walls of the transepts and parts of the choir are standing (Fig. 12 *b*). The arcade as at Kirkstall is raised on clustered columns, but a blind triforium arcade of pointed

[1] R. W. Paul, 'Buildwas Abbey', *Builder*, lxxix (1900), 292. Buildwas is very fully illustrated in J. Potter, *Remains of Ancient Monastic Architecture in England* (1847).

[2] Quoted in J. D. Aveling, *The History of Roche Abbey* (1870), 164, from W. Gilpin, *Observations relative chiefly to Picturesque Beauty made in the Year 1776 on several parts of Great Britain, particularly the Highlands of Scotland* (1789), 24.

arches intervenes between it and the clerestory, where the windows are still round-arched. Water-leaf capitals are much used. The transepts and presumably the choir also appear to have been vaulted.

The three great abbeys that mark the final stage of twelfth-century building, Byland, Furness, and Jervaulx, were, like Build-was, Savignac foundations. The early history of Furness has already been dealt with. Much rebuilt, it is now in ruins and its architectural development is little documented and obscure. Certainly in the second half of the century the choir and transepts were altered to a more normal Cistercian form, the apsidal chapels being replaced by an eastern aisle. The east wall of the north transept still stands, a pointed arcade supported on clustered columns with water-leaf capitals and, above, a round-arched triforium divided by twin trefoil arches. The doorway to the north transept was also altered: the plinth was cut away to introduce an elaborate work of four orders carried on jamb columns with water-leaf capitals and on the outer order an elaborate billet moulding with some dog-tooth beading, a lavish scheme quite out of keeping with the early Cistercian tradition. There are also some fine round-headed arches with dog-tooth ornament opening from the cloisters into the chapter house. Byland abbey had been founded from Furness, but the original colony, first at Calder then at Hood, had had a period of disturbed migrations, which did not end even when Roger de Mowbray gave them a site at Byland, for this proved to be too close to Rievaulx (the two houses were disturbed in a most un-Cistercian manner by one another's bells) and in 1147 they had to move farther westward, but took the name Byland with them. Their second abbot, Roger, ruled from 1142 to 1196, and was succeeded by Philip, who 'for that human memory, through the disobedience of our first parents is so darkened and clouded', wrote down an account as it had been told him by Roger and others, of the early days of the abbey: how they cleared a dry site in marshy ground and there built 'their fair and great church' to replace the smaller one they had originally set up.[1] They moved to this final site in 1177, and by then the church was probably begun. It was 330 feet long and 140 feet across the transepts: the cloister, 145 feet

[1] W. Dugdale, *Monasticon*, v (1825), 353.

square, was larger than that of Fountains.[1] The pointed arch was employed throughout. While the normal square-ended presbytery was retained, there was an ambulatory round the choir, with five chapels against the east wall: the transepts had western as well as eastern aisles (Fig. 10): as at Roche there was, as can be seen from the remaining fragment of the south transept, a triforium arcade of narrow pointed arches; and in the nave clerestory the wall passage reappeared. The west facade, which must date from the early years of the thirteenth century, had an elaborate trefoil doorway and a great circular window above a group of three lancets. The detail of the vaulting and the masonry is highly finished, and the capitals of the great piers, many of which were recovered during excavation, show the curly edged water-leaf and concave bell of the transitional period (Fig. 14) and even some graceful acanthus volutes. The church was paved with green and red glazed tiles in a geometric pattern: the white-washed walls were marked out with a red masonry pattern, and some of the details of the carving were also picked out in red. Byland, set in a level plain at the foot of a low range of hills, has none of the perfect relationship of building to site which makes Rievaulx and Fountains memorable among all the monastic buildings of western Christendom: its stone also has darkened to a somewhat livid hue: but nothing can impair the beauty of its west front, and the half circle of its broken window, in itself such a striking silhouette, is strangely evocative of the splendid proportions that must have been apparent in the days of its completeness (Pl. 45 a). A building original in its ground plan, it was in its details and elevations an example of the ready Cistercian reaction to the new Gothic style which their architecture did so much to foster. It marks also the passing of Cistercian building from its austere isolation into the full current of the contemporary architectural movement. Jervaulx, founded originally at Fors, became a daughter house of Byland and in 1156 moved to Earl Witton on the Ure, a site which came to be known as Jervaulx. The church is much ruined, but it is clear that it repeated the plan of Byland and much of the detail of the work.

[1] C. R. Peers, *Byland Abbey* (Ministry of Works Guide, 1952).

If Yorkshire was pre-eminently the great centre of Cistercianism, Wales and the Welsh border experienced from it a remarkable development of the monastic life, particularly in the second half

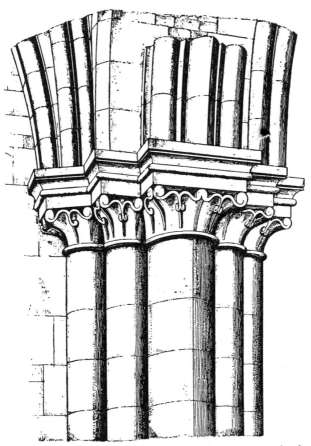

FIG. 14. *Capital of respond pier, south transept, Byland*

of the century. As early as 1131 the monks of L'Aumône had planted a sister house to Waverley at Tintern in the Wye valley, but Tintern's only daughter house had lain eastwards in Gloucestershire at Kingswood. The Savignacs had two outposts, one in the south at Neath, not far from Swansea (founded in 1130), and one at Basingwerk in Flint overlooking the sea near Holywell, founded by Ranulf of Chester, of which some pieces of the nave are still standing, plain, rough work. The main impetus came from a

mission from Clairvaux which arrived in 1140 and settled finally in 1151 at Whitland in Carmarthenshire. Whitland, of which today nothing but the traces of a normal Cistercian ground plan remains, was essentially a Welsh house, and from it came three houses: Cwmhir (1143), Strata Florida (1164), and Strata Marcella (1180). Strata Florida was founded by Robert FitzStephen but soon seized by Rhys ap Griffith of south Wales, Strata Marcella by Owen Kyveiliog, the poet prince of Powys. Strata Florida still has a remarkable round-arched doorway whose orders are continuous, broken by no capitals or imposts but crossed at regular intervals by transverse bands of moulding. Between aisles and nave there were screen walls 5 feet high on which stood the short pillars of the arcade, another most unusual feature. At both abbeys fragments have been found of water-leaf and other transitional decoration. They must have been important and striking monuments of this phase of Welsh resurgence.[1] From Strata Florida was founded in 1186 the abbey of Aberconway by Llewelyn the Great, and in 1201 from Strata Marcella, Valle Crucis, one of the best preserved of these Welsh abbeys, with a striking arrangement of lancet windows in the east end, finely effective even if it may represent a compromise between two building stages.[2] Margam, the other Welsh house colonized directly from Clairvaux, was founded by Robert of Gloucester in 1147 and never enjoyed the same influence in Wales as the abbey of Whitland. Abbey Dore in Herefordshire was founded in the same year (1147) by Robert Ewyas, but, as with most of these Welsh and border churches, the surviving building is from the close of the century, and the presbytery is a notable example of the Early English style. These Cistercian houses came to Wales at a time when monasticism was hardly established there and when in the Celtic districts comparatively small and simple churches only had been built in the Romanesque style: they brought not only Latin as opposed to Celtic monasticism but also architecture, and the example of their pointed

[1] See C. A. R. Radford, *Strata Florida Abbey* (Ministry of Works Guide, 1949); S. W. Williams, *The Cistercian Abbey of Strata Florida* (1889), and 'The Cistercian Abbey of Strata Marcella', *Archaeol. Cambrensis*, 5th series, ix (1892), 1.

[2] E. W. Lovegrove, 'Valle Crucis Abbey', ibid. xci (1936), 1.

arches and rib vaults made Wales a centre of the transitional style.[1]

Three other orders require brief notice. The Augustinian Canons were the most widely spread order in England. By 1215 there were 173 independent houses, but of these only twenty-five were abbeys, and the priories were not large in scale.[2] The priory of St. Botolph at Colchester, which has some claim to be considered the oldest of them all, had been founded before 1100, when a group of secular priests sent their leader, Ainulf, to Normandy to study the Augustinian rule and adopted it on his return. These Augustinian houses were small communities, not always reaching the mystical number of thirteen, a number of which Christ and the apostles were the type and which was regarded as the minimum by Benedictine houses. It is not therefore surprising that the buildings at St. Botolph's, made of flint rubble dressed and banded with Roman brick and plastered over, advanced slowly. Its ruins, curiously impressive with their red brick and grey flint, show an arcade carried on round columns and a lofty tribune arch, above which ran a clerestory with a wall passage (Pl. 45 b): the west end is decorated with interlacing arches and has an elaborate doorway of five orders; here the chevron, voussoirs, and capitals with entwined foliage are carved in stone and must be of mid-century date.[3] The priory of Holy Trinity, Aldgate, founded in 1107 by Queen Matilda as a daughter house to St. Botolph's, seems to have been on a larger scale and with its royal patronage was one of the most influential Augustinian houses in the kingdom,[4] only rivalled by the priory of Merton, founded in 1114 by Gilbert the Sheriff, whom the queen took as her 'god-son' and who seems to have

[1] For 'The Cistercian Order in Ireland' see A. H. Thompson, A. W. Clapham, and H. G. Leask in *Arch. Journ.* lxxxviii (1931), 1.

[2] See on all the paragraph that follows J. C. Dickinson, *The Origins of the Austin Canons* (1950). Of the twenty-five abbeys, eleven were Arrouaisian or Victorine houses which seem to have been *ipso facto* abbeys, as was the case with Cistercian houses.

[3] C. R. Peers, *St. Botolph's Priory* (Office of Works Guide, 1917), and *R.C.H.M. Essex*, iii (1922), 48.

[4] W. R. Lethaby, 'The Priory Church of Holy Trinity, Aldgate', *The Home Counties Magazine*, ii (1900), 45.

been a character of outstanding integrity. The buildings of Aldgate were destroyed by a fire in 1132 and little is known of them at any stage of their history: those of Merton at the Dissolution were pulled down to provide material for the palace of Nonsuch. The chief architectural monuments of the order's first fifty years in England are the eastern arm of St. Bartholomew's, Smithfield, another foundation from court circles, and the two surviving bays of the nave and south aisle of Carlisle cathedral, whose scallop capitals and chevron ornament suggest a date in the twenties, between its foundation as an Augustinian priory by the royal chaplain Walter, supported by charters from the king, and the creation in 1133 of the see of Carlisle of which it became the cathedral church.[1]

The Praemonstratensian order did not develop rapidly in England till the last quarter of the century, though Newhouse in Lincolnshire was founded c. 1143–6. The buildings that remain are largely thirteenth-century work.[2] The most representative surviving church on the continent, St. Martin of Laon, built c. 1150–60, was of a normal Cistercian plan and this seems to have been the type followed in England.

The Gilbertine order,[3] primarily organized for nuns and lay sisters, under the devout and shrewd guidance of Gilbert of Sempringham, hardly merits mention architecturally, for its houses were built simply and generally in connexion with some existing church: that at Watton in the East Riding of Yorkshire was built for the order and excavation in 1893 revealed something of its ground plan, with the striking feature of a wall dividing it from east to west, the larger part on the north for the sisters and the smaller on the south for the canons and lay brothers. Near by at Old Malton much of the priory church still survives with transitional period work of good quality and a beak-head door from an earlier building stage.[4] At Gilbert's parish church of St. Andrew

[1] C. G. Bulman, 'The Norman Priory Church at Carlisle', *Trans. of Cumberland and Westmorland Antiquarian and Arch. Soc.* xxxvii (1937), 56.

[2] A. W. Clapham in *Archaeol.* lxxiii (1924), 117.

[3] Rose Graham, *St. Gilbert of Sempringham and the Gilbertines* (1903).

[4] Ada Russell in *V.C.H. Yorkshire North Riding*, i (1914), 538.

at Sempringham there are considerable remains, and the south doorway retains its original iron scroll-work, a pleasant link with the founder of this purely English order.

Nowhere can the intellectual life and general civilities of the time be more clearly traced than in the intercourse between the leaders of the new Cistercian movement and the court of Scotland. Ailred, son of a priest of Hexham, almost hereditary priest of Hexham for the married state of the clergy had still in the north retained its respectability, was brought up under David I's patronage as a close companion of his son, Henry, and his stepson, Waldef, and eventually held the office of steward of the household 'The King loved him exceedingly and every day was more and more considering how to advance him, so much so, indeed, that if he had not unexpectedly entered the Cistercian order he would have honoured him with the first bishopric of the land.'[1] Ailred himself writes of his admiration for the young prince and his father, 'whom I may leave in body, but never in mind or affection'.[2]

The first break in the group of friends was caused by Waldef's departure about 1130 to the Augustinian priory of Nostell, a house well known in Scotland, for from it had come Robert, prior of Scone and then in 1123 bishop of St. Andrews. Some four years later Ailred joined the new community at Rievaulx, founded by Walter Espec in 1132. About the same period Waldef became prior of Kirkham, an Augustinian priory founded in 1122 by the same Walter. The new prior joined with Abbot William of Rievaulx in strong opposition to another William, whose election to the archbishopric of York was challenged as simoniacal and who was to be replaced by Henry Murdac, abbot of Fountains, though in the end William was to return to York and win canonization as a miracle worker. Then, to the alarm of the Augustinians, Waldef laid down his priorate to become a novice at Rievaulx. In 1147 Ailred became abbot of Rievaulx and the following year Waldef was made abbot of his step-father's new foundation of Melrose,

[1] Walter Daniel, *Vita Ailredi*, ed. F. M. Powicke (1950), 3. There is an admirable introduction by the editor: I have made much use also of the article by Dom David Knowles, 'The Humanism of the Twelfth Century', *Studies* (1941), 43.

[2] 'Genealogia regum anglorum', Migne, *P.L.* cxcv. 736–7.

colonized by Rievaulx monks. Ailred, through his own writings and his biography by Walter Daniel, is a figure whom we can know with some intimacy. No professional scholar, untrained in the schools, he was yet well read in the classics. His reading of the *De amicitia* of Cicero had been a turning-point in his life, and in later years there are constant echoes in his writings of the *Confessions* of St. Augustine, a book at that time little read but of which Ailred seems to have had an intensely sympathetic understanding. His own writings range from the *Speculum caritatis*, an analysis of the religious life written at the express order of St. Bernard, to his account of the Battle of the Standard. They reveal in their details, for the inner spiritual life is always the main theme, very varied preoccupations: the hard life of the Cistercian with its manual labour, which even Waldef's enthusiasm found discouraging; the constant ailments, misunderstood and unalleviated; the proscription of works of art, of that 'superfluous beauty, which the eyes love in various forms, in shining and pleasant colours', and of the elaborations of monastic singing of which Ailred gives a vigorously humorous account;[1] the conflict of loyalties when David invaded England, bringing an army of marauding Galwegians, who pillaged, murdered, and desecrated churches, and were finally driven back, not far from Rievaulx, in the Battle of the Standard by Walter Espec, the monastery's founder. *Quis Apuliam, Siciliam, Calabriam, nisi vester Normannus edomuit?* It is with such words that Ailred makes Walter exhort his followers: opposed is David, fighting on behalf of Matilda, the two heirs of the royal house of Wessex.[2] But the abbot's narrative is a document of tolerance: he can enter into the outlook of both sides, and can find eventually in the accession of Henry II the reconciliation of the two traditions, 'the corner stone of the Norman and English peoples'. The canonization of Edward the Confessor, which was granted by Alexander III in 1161, is another step in this union of the two royal houses: Ailred wrote his Life of Edward for the occasion of the translation of the relics in 1163, and prepared a sermon on the text, 'No man

[1] *Speculum caritatis*, ii. 23, 24; Migne, *P.L.* cxcv (1855), 571–2.
[2] *Relatio de Standardo* in *Chronicles of the reign of Stephen, Henry II, and Richard I*, R.S. lxxxii (3) (1886), 186.

lights a candle'. Here is the gradual ending of a long debate, the fusion which lies behind the artistic expression of the times as well as behind its political and constitutional problems. In Ailred's writings and character, lit by his warm affections and disciplined charity, we can be drawn into understanding of it by a personality whose attractiveness overcomes all differences in times and customs.

The ecclesiastical reorganization of Scotland was begun by David's brother, Alexander I, who ruled from 1107–24. New sees were founded at Moray and Dunkeld, and Augustinian houses, colonized from England, were established at Scone and Inchcolm. The see of St. Andrews had been vacant since 1093. In 1109 Alexander obtained the appointment to it, as first Roman as opposed to Culdee bishop, of Turgot, his mother's confessor and biographer, then prior of Durham. Turgot, however, maintained the supremacy of York over St. Andrews, while Alexander favoured the more remote control of Canterbury. A quarrel broke out, and Turgot retired to Durham, where he died in 1115. Alexander now sought the promotion of another great literary figure, Eadmer, the biographer of St. Anselm. Eadmer stood for Canterbury but also for the strictest observance of the Investiture decree. New disputes arose, and Eadmer also withdrew, returning to his beloved Canterbury, where the works of Prior Conrad, which he chronicles, were daily increasing the glories of the building. On Eadmer's death Alexander, shortly before his own end, appointed Robert, the prior of his new foundation at Scone.

Bishop Robert ended the Culdee domination of the Scottish see. Augustinian canons were installed and a new cathedral built, the church of St. Rule or St. Regulus. This was the first important building of David's reign, and it is one with curious architectural associations. St. Rule's today consists of a square tower, a nave, and the arch leading to the chancel, which last now no longer exists. The mark of a roof on the west side of the tower shows that there was also a western nave (when the scheme would then be nave, tower, chancel, sanctuary) but this nave was probably a later addition as the corbel table of the tower is continued on the western side. This type of church—tower chamber, nave, and chancel—is a common form for smaller churches in northern England. In particular

there are two Yorkshire examples of it, Weaverthorpe and Wharram-le-Street, which can be securely dated to the first quarter of the twelfth century. The thin walls and absence of any pilaster buttresses are an archaic feature, and the type is probably an Anglo-Saxon one. Weaverthorpe, however, has a carved dial-stone (in itself a Saxon rather than Norman feature) stating that the 'Monasterium' was made by Herbert of Winchester. This Herbert was chamberlain of Henry I and the identification is confirmed by a charter of Thomas II, archbishop of York (1109–14), and by another charter confirming the grant of Weaverthorpe to the Augustinian canons of Nostell by Herbert's son William, the future St. William of York. Wharram-le-Street also belonged to Nostell. Similar in plan, it has details, such as the Norman volutes of its chancel capitals, which suggest a slightly later date. Plan and workmanship are strikingly repeated in the church of St. Rule, so closely in fact as to suggest that the same masons were employed. This is likely enough, for Bishop Robert came from Nostell, where also David's stepson, Waldef, went about this time for his novitiate.[1]

David meanwhile continued his brother's policy of organizing new sees. Already as count of Strathclyde and Lothian, ruling almost independently over southern Scotland, he had been responsible for the creation of the see of Glasgow. As king in 1128 he founded the bishoprics of Ross and Caithness, in 1136 that of Aberdeen, and at the end of his reign, in 1150, those of Brechin and Dunblane. Little remains to show the form taken by the new cathedrals: at Dunblane there is a square tower, now attached to the thirteenth-century church but out of alinement with it, which must be part of the twelfth-century building, though considerably altered and restored; possibly it was at one time free standing, possibly the tower of a church on the St. Rule's model. The round tower at Brechin, with its curious carving, seems to be eleventh-century work, a rare relic of an earlier phase of Scottish building.

The central church of the Scottish kingdom was in many ways

[1] J. Bilson, 'Weaverthorpe Church and its Builder', *Archaeol.* lxxii (1922), 51, and 'Wharram-le-Street Church, Yorkshire, and St. Rule's Church, St. Andrews', ibid. xxiii (1923), 55.

that of Dunfermline.[1] It had been founded by Queen Margaret
and dedicated in 1074 to the Holy Trinity. The church was her
burial place, where her sons had carried her corpse as the Celtic
reaction burst into flame on the news
of her death. In 1128 David brought
there as abbot of a new foundation
Geoffrey, prior of Canterbury, who
had but recently succeeded the great
builder, Conrad. Geoffrey followed
the same tradition of a more spacious
building, replacing the church of St.
Margaret with a church in the new
Anglo-Norman style. Dunfermline
has often been compared with Dur-
ham. The octagonal scalloped capitals
and the chevron markings of its
columns are points of similarity, suffi-
cient to suggest some masonic con-
nexion. But the scheme of the build-
ing is quite different. Dunfermline

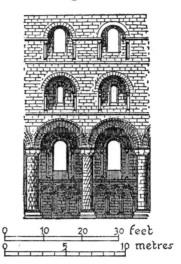

FIG. 15. *Dunfermline abbey:
interior elevation of nave*

has a continuous row of round columns: no wall shafts rise from
them and the openings of the tribune and the clerestory are both
severely plain: the only decoration of the former, a central order
to the arch supported on half columns, is so deeply recessed as to
be hardly noticeable, and the arch of the clerestory passage is a
single opening with two colonnettes, free standing, but set closely
to the wall (Fig. 15). Blank wall-space is in fact once more a pre-
dominating feature, and along with it goes a liking for unbroken
horizontal alinement which we have already seen at Southwell and
which is a marked feature of Scottish twelfth-century churches.
Dunfermline, apparently the completed church, was consecrated
in 1150.

It is not only the larger churches which recall English styles. At
Leuchars, near St. Andrews, a Romanesque apse and chancel
survive, admirable and elaborate work with an arcade of inter-

[1] *R.C.H.M. Fife, etc.* 106. See also for Dunfermline and other Scottish churches
D. MacGibbon and T. Ross, *The Ecclesiastical Architecture of Scotland*, i (1896).

lacing arches running round the exterior of the apse (Pl. 48 *b*). At Dalmeny the highly ornamented south porch also employs this motif, while the varied subjects on the voussoirs remind one of the Herefordshire school or of some of the Yorkshire churches. The church of Duddingston in Midlothian has a Romanesque doorway, where the pillars copy the Durham patterns of chevrons and lozenges, though interspersed with some rough and archaic figure carvings which suggest provincial workmen.[1]

In 1137 another major church had been begun, whose ground plan, interior elevations, wall arcade of interlacing arches, and many details of proportions and masonry proclaim a close association with the Durham masons' yard. This is the cathedral of St. Magnus at Kirkwall in the Orkneys. Remote in distance, the circumstances of its origin are as remote from the enlightened civilization of David's court. It is a wild story of the northern twilights, handed down to us in the *Orkneyinga Saga*, written in Iceland in the early thirteenth century but partially based on an earlier Latin life of St. Magnus. This pious martyr was an earl of Orkney murdered by Haakon Paalson in 1115. His murderer did penance by a pilgrimage to Jerusalem for the deed, which was condoned by the dominant character in Orkney, Bishop William the Old, whose long episcopate began in 1102 and ended in 1168. William had been appointed to the see as dependent on that of Trondhjem, but there was a rival claimant, Bishop Rodulf, consecrated by the archbishop of York. He was supported by Magnus's nephew, Rognvald Kolson, who was preparing in Norway an expedition to avenge his uncle, and who was in close touch with David of Scotland. Bishop William decided on a volte-face: in 1135 he proclaimed Magnus a saint and dedicated in his honour a church at Egilsay on the site of his murder, a Celtic church with aisleless nave and round west tower. On Rognvald's conquest of the island in the following year, this northern vicar of Bray maintained his position, was accepted by York, and he and Rognvald celebrated this new allegiance by building a cathedral on the English model.

[1] For all these churches see the Reports of the *R.C.H.M.*; for Leuchars, *Fife and Clackmannan* (1933), 190, and for Dalmeny and Duddingston, *Midlothian and West Lothian* (1929), 201 and 66.

By 1155–8 part of the new church was in use, though there had been many difficulties over funds, and by William's death in 1168 the choir transepts and first bay of the nave had probably been completed. The remainder of the nave was carried out in the Gothic style after Earl Rognvald had in his turn been canonized in 1192. The Romanesque work, faced with a local freestone in some parts banded with red ashlar, is of excellent quality, and the mastery of the style, in a country where the previous churches, such as that built by Bishop William at Egilsay, are typical Celtic buildings, implies visiting masons, who must have come via David's court.[1]

Of David's own buildings, it is the monastic ruins which today represent his achievement most clearly. As prince of Strathclyde he had brought over in 1113 thirteen monks from Tiron and settled them at Selkirk. As king in 1128 he moved them to Kelso, near his royal castle of Roxburghe, to form a college of chaplains. It was a community rich in eminent men. The Scottish chroniclers claim that Ralph, abbot of Selkirk, became abbot of Tiron in 1117, and that his successor at Selkirk, William, was also his successor at the mother abbey. Herbert, abbot of Selkirk and Kelso, became bishop of Glasgow in 1147: the next abbot, Arnald, became bishop of St. Andrews in 1160.[2] By that date much of the building of the abbey must have been completed, for in 1152 the king's son, Henry, had been buried there. In 1165, Abbot John (d. 1180) obtained from Rome the precedency of a mitred abbot. Kelso, the parent house in 1178 of the abbey of Arbroath, was the greatest monastery of Scotland. Today only the west front and a fragment of the south wall of the nave remain. Its eastern arm is now built

[1] There is a considerable literature on Kirkwall: see H. E. L. Dryden, *St. Magnus Cathedral and the Bishop's Palace* (Kirkwall, 1878); J. Mooney, *The Cathedral and Royal Burgh of Kirkwall* (Kirkwall, 1947); L. Dietrichson and J. Meyer, *Monumenta Orcadica* (Oslo, 1906); A. B. Taylor, *The Orkneyinga Saga* (Edinburgh, 1938). Mooney argues for architectural influences coming via Norway and points out resemblances with Stavanger cathedral, whose first bishop came from Winchester. Stavanger cathedral was dedicated to St. Swithun.

[2] C. Innes, *Liber S. Marie de Calchou*, Bannatyne Club (Edinburgh, 1846). For the architecture of the abbey see J. Ferguson, 'Notes on the Abbey of Kelso', *History of the Berwickshire Naturalists' Club*, xxiv (Edinburgh, 1923), 296, and J. W. Kennedy, 'Kelso Abbey', *Hawick Archaeological Society Trans.* (Hawick, 1930), 8.

over and has never been excavated, but we know from an account of the church, strangely preserved in a consistorial process of 1517 in the Vatican archives,[1] that it had double transepts, an aisled nave, a wooden roof, and a central and western tower: from the applied half column on the aisle side of the grand arcade the aisles appear to have been vaulted. The interior elevation is an unusual one: the second stage consists of a continuous arcade of small round-headed arches supported on single columns, a row along which the eye travels with a new sense of speed; above, the arches of the clerestory passage correspond approximately in size but are supported by twin colonnettes. Here as at Dunfermline there are no wall shafts and the horizontal lines are unbroken. The western transept in its proportions, its central tower, and side turrets recalls that of Ely and must be work contemporaneous with it. The crossing of the western transept has high pointed arches: the projecting narthex or porch had a highly ornamented doorway of five orders, now only a ruined fragment. The north-west transept also had an elaborate doorway, topped by a gable covered with diaper pattern, and with a group of interlacing arches like those at Kirkstall.[2] The ornament throughout consists of chevrons, cables, interlacing arches, where the arches them-selves form involved chevron patterns, scallop and water-leaf capitals, and a curious form used in the arch mouldings of a round tube passing through rings or clasps. It is a developed style of high Romanesque for which it is difficult to find an exact parallel.

Jedburgh, founded before 1139 for some Augustinian canons from Beauvais, was made an abbey in 1147, and it was probably shortly after that date that the original choir and transepts, parts of which still remain, were built.[3] The elevation is composed of arcade and large tribune openings, divided by a column into two compartments: giant columns run through both stories, ending in

[1] A. Theiner, *Vetera monumenta Hibernorum et Scotorum historiam illustrantia* (Rome, 1864), 527.

[2] There is another of these diapered gables at the remarkable church of Streetley in Derbyshire, which in its small compass is a meeting-place of many Romanesque styles. See G. Le Blanc Smith, 'Streetley Chapel', *The Reliquary*, xii (1906), 73.

[3] J. Ferguson, 'Notes on Jedburgh Abbey', *Hist. of the Berwick Nat. Club*, xxiv (Edinburgh, 1923), 217.

scalloped capitals from which spring the tribune arches (Pl. 48 *a*). The clerestory is later, with a wall passage under pointed arches supported on colonnettes, and it seems clear that the east arm was enlarged and partially rebuilt at the close of the century. This feature of the continuous column we have already seen at Romsey, and it is to Romsey that Jedburgh approximates rather than to any variants of the giant column employed by the Severn valley churches. Romsey was the abbey of David's aunt, Christina, and contacts with it can easily be imagined. The west and south doorways of Jedburgh, still round-arched, are richly ornamented with the latest variants of chevron and zigzag ornament. Dog-tooth enrichments are to be found on the doorways of Dryburgh abbey, David's Praemonstratensian house, founded in 1150, but in its existing ruins dating from the close of the century. At Melrose, the most famous name among David's foundations, a colony from Rievaulx of which the king's stepson, Waldef, became abbot, the celebrated ruins are all work of considerably later periods. Enough still stands of the transepts and cloister buildings of Cistercian Dundrennan to show two stages of work, round-arched and pointed; and the abbey of Arbroath, founded by William the Lion on his release from captivity in 1174 and dedicated in 1178 to St. Thomas, one of the earliest dedications to the martyred archbishop, has some round-arched arcading amongst its transitional and early English detail: the eastern arm was certainly completed by 1214, when the founder was buried before the high altar.[1] There remains for mention David's royal foundation of Holyrood for Augustinian canons: here again the surviving work is mainly of later centuries, but the south doorway has fine chevron ornament, and in the north aisle there is an arcade of interlacing arches, where mouldings as well as arches intersect, the last elaborate variant of this familiar ornament. These Holyrood arches may be taken as closing the Romanesque period in Scotland, but one other great work had been initiated in the style: the commencement of the new cathedral of St. Andrews, by Arnald, bishop from 1160–2 and formerly abbot of Kelso. Here again some interlacing arches

[1] K. C. Corsar, 'Arbroath Abbey', *National Ancient Monuments Review*, ii (1928), 275 and 352.

remain in the south transept and the shell of its square, turreted east end still stands magnificently on its windswept promontory.

Of the arts as practised in these northern houses little is known. The Scottish reformation vented its thoroughness of destruction on a heritage that can never have equalled the great possessions of the southern kingdom. One document, however, survives to show us something of the painting of the time: the charter granted by Malcolm IV in 1159 to Kelso abbey has a fine initial M showing David and Malcolm, the former a bearded figure, closely modelled on that on the royal seal attached to the charter, while Malcolm, his legs crossed, his sword lying on his knees, is a youthful and strongly contrasted figure. Between them is a pillar formed of two interlacing serpents. Circular lines pattern the drapery and the style is that of the mid-century in England. Not only does this initial provide us with our first Scottish royal portraits, but also with an exactly dated and admirable specimen of Romanesque art[1] (Pl. 50 a).

The Kelso charter may serve as an example of figure drawing of the mid-century. In the Cistercian scriptoria the prohibition against ornament in architecture was extended to illumination and the statutes laid down that initials should be of one colour and not decorated (depictae).[2] We find therefore in the twelfth century in England no important Cistercian historiated miniatures, though many books have fine monochrome initials whose bold simple outlines have a virtue of their own, a virtue that matches on its smaller scale the purity of Cistercian architectural lines. A manuscript from Buildwas[3] has admirable specimens of this type of work and is a book that deserves a particular commendation, for along the top of the first page the scribe has written: Liber sancte Marie de bildewas scriptus anno mclxvii. Would that others had followed so excellent a practice!

From Fountains there is a volume of Hugh of St. Victor (Bodl.

[1] The charter is reproduced in facsimile in the edition edited by C. Innes of the Liber S. Marie de Calchou (1846). The charter itself is now deposited by the duke of Roxburghe in the National Library of Scotland, Edinburgh.

[2] 'Instituta Generalis Capituli LXX', Nomasticon Cisterciense (1892), 230. The statutes were not completed till 1152.

[3] Now MS. Lat. 88, Christ Church, Oxford.

MS. Laud. Misc. 310) where the fine bold initials preserve the limitation to one colour save for very minor touches. In one of the Roche books,[1] however, we find as in architecture a slackening of the old rules. The initials are still only ornamental letters, with no gilding or historiation, but several colours are employed and a large H on f. 5, with its red, green, and violet-blue, is as gay a piece, almost perhaps in its somewhat muddled motifs as vulgar a piece, as could be desired.

These restrictions had not, however, been in force in the early days of the order; indeed the position had been much the reverse. The library at Dijon has a collection of books coming from Cîteaux itself. Amongst them is a great four-volume bible which at the end of the second volume contains a letter of Stephen Harding, the second abbot (1109–33), dated 1109 and dealing with the steps he had taken to secure a reliable text: it refers to the work of writing the bible as completed, but this need only be taken as applying to the first two volumes, and the decorative work in volumes iii and iv, which contain many figure scenes, may well be later.[2] On the other hand, the main artist of volumes iii and iv worked also on a copy of the *Moralia* of St. Gregory (Dijon MS. 168), the writing of which is stated in a colophon to have been completed in 1111. The decoration might have been carried out at some interval of time, but is unlikely to have been appreciably delayed. There is strong evidence for giving these impressive books an early date. We shall find that they or works of a similar type had considerable influence in England, and these volumes, produced under the patronage of an Englishman, stand at the beginning of the greatest pictorial development of the century, the illustrating of the large folio bibles.

[1] Bodl. MS. Laud. Misc. 308.
[2] See on all these questions C. Oursel, *La Miniature du XII^e siècle à l'Abbaye de Cîteaux* (Dijon, 1926): his views as to dating have been much questioned.

THE GREAT BIBLES

THE rigid vertical lines of the Albani style had been a reaction against the feathery, curving fluency of Anglo-Saxon art, but it was too harsh a contrast to create a form in which the new humanistic tendencies could permanently adapt themselves to English taste. In the same scriptorium of St. Albans other styles were being tried out, and in their library was a manuscript of Terence[1] which appears to be work of the mid-century, most probably done at the monastery. Here, as earlier in their Prudentius, classical models were being closely copied, probably through the media of Carolingian and Anglo-Saxon versions: one of the former, which belonged to Fleury and is a close prototype of the St. Albans drawings, is still extant.[2] At least four artists were employed on the St. Albans book: one drew with a firm outline, marking the shapes of his figures with short, circular strokes and placing them on scalloped ground lines; it is a characteristic hand, whose work, or that of some follower, reappears in other manuscripts.[3] Another, with lighter lines, had a trick of flying scarves emphasizing the movement of his figures, whose arms he liked to show bent at sharp right-angled turns (Pl. 63 *b*). All the artists achieve something of a classical rotundity for their figures and a new naturalism of movement. The faces of the dramatis personae are covered with masks, so that here naturalism stops, but these large caricatured heads were also not without their influence. The opening page shows rows of these masks fixed on a rack, and this arrangement inspired some later designs, such as one in the Dover Bible.

The older traditions, however, did not give way easily. A curious document of transition is provided by a drawing of the Crucifixion

[1] Now Bodleian MS. Auct. F. 2. 13.

[2] MS. Bibl. Nat. lat. 7899. See L. Webber Jones and C. R. Morey, *The Miniatures of the MSS. of Terence* (Princeton U.P., 1931). *New Pal. Soc.* 1st series (1903–12), Pl. 63.

[3] W. Oakeshott, *Sequence* (1950), 19, and *Winchester Bible* (1945), 18.

in a copy of the Chronicle of Florence of Worcester in the library of Corpus Christi College, Oxford.[1] Here a normal 'Winchester' design has been followed and the artist shows complete ease in his use of the style, but he has given a new firmness to the outlines, and the treatment of the hair and beard and the curling folds of St. John's mantle show familiarity with the methods of the Terence illustrators. A gospels from St. Augustine's, Canterbury,[2] has a brilliant series of outline initials, showing gymnastic bars with interlaces and foliage tails to the letters closely knotted in a manner that had been popular in the tenth century: other initials copy those in the Passionale, MS. Arundel 91.[3] These copies are drawn firmly with a hard line, but in some of the ornament, where a many-petalled acanthus appears, the lines are much finer and more sensitive: it seems to be a mid-century work with strong archaizing tendencies. Another psalter which must have had some Anglo-Saxon model for its evangelist portraits is the Winchcombe Psalter, now MS. 53 of Trinity College, Dublin. Its initials have rich acanthus foliage not unlike that of the St. Albans Josephus, and its Beatus initial, with David and his musicians set in roundels against a background of coils inhabited by the familiar lions and monsters, is one of the most intricate pieces of the century; but its drawings of the evangelists, of whom one only is fully painted, with an elaborate pageant of Christ's ancestors in the border, look back to earlier types, though the handling is that of a Romanesque artist (Pl. 49 b). Most extraordinary of all is the Mostyn Gospels, now No. 777 in the Pierpont Morgan Library: script and initials, where a somewhat sketchily drawn acanthus branches out into thin fruit cones, suggest a mid-century date: the four evangelist pages, where the figures are grotesquely seated on their emblematic beasts, are clearly copies of a Carolingian original and are wonderful pieces of colouring: St. Mark in a light blue cloak with hair of the same colour sits on a pink lion against a deep blue background framed in brick red.[4]

[1] C.C.C. MS. 157. See F. Wormald, 'Anglo-Saxon Illumination', *Proc. of British Academy* (1944), 141. *New Pal. Soc.* 2nd series (1913–20), Pl. 87.

[2] B.M. MS. Royal 1 B XI. [3] See above, p. 40.

[4] E. G. Millar, *The Library of A. Chester Beatty*, i (1927), 72. D. Tselos, in *Art Bulletin*, xxxiv (1952), 257.

The most famous instance, however, of continuity comes from the scriptorium of Christ Church, Canterbury. Here a psalter was written by a monk named Eadwine, and the illustrator, whether Eadwine or another, used as his model the famous Utrecht Psalter, a ninth-century product of the Rheims school, which was at one time in Sir Robert Cotton's library as Claudius C. VII and then passed in 1718 to its present home, the library of Utrecht university. An English copy had already been made in the great days of the 'Winchester' school at the beginning of the eleventh century, though worked on also by a later and probably twelfth-century hand. This copy, now MS. Harley 603 in the British Museum, is incomplete: some of the spaces for illustrations are blank; others diverge from the Utrecht pattern. These blanks and divergencies do not occur in the Eadwine Psalter, so that the artist must have used the original, not the Anglo-Saxon copy, though that also may well have been known to him. We thus have three most instructive versions of the same theme.[1] In the first, the Utrecht, the small figures, drawn with broken, impressionistic touches, are set in a landscape, subtly suggested by the shaded contours of the ground and by thinly sketched trees, and revealing some of that mastery of atmospheric depth familiar in the surviving examples of classical art. In the second, the eleventh-century psalter, much of this vivid, nervous quality is retained, though the defects of a copy are shown in a loss of rhythm and an occasional hardening of the line. With Eadwine's book a complete change has taken place. Instead of being drawn on the open page, the scenes are now framed in an ornamental border: the figures have the straight, strong lines of the Albani Psalter, and the agitated variety of the original groups is replaced by a regular use of confronting profiles: the vaguely suggested trees have become formalized patterns: the shaded contours have turned into the familiar Norman scalloped foothold: the colours—blues, reds, and greens—have a Romanesque range and brilliance.

The new treatment has its own merit: the designs are less fluent but more balanced: the statement has less passion and greater

[1] E. T. De Wald, *The Utrecht Psalter* (1932). The Canterbury Psalter is now Trinity Coll. Cambridge MS. R. 17. 1. See M. R. James, *The Canterbury Psalter* (1935).

clarity. The text is a parallel triple version of the psalms, the three versions of St. Jerome known as the Hebrew, Roman, and Gallican, the first with a French, the second with an Anglo-Saxon translation: there are interlinear and marginal glosses. In the history of the psalter and its translations this text has an important place:[1] it also provides an early example of the elaborate lay-out of a glossed page. The small initials are mainly foliage with three-petalled acanthus, but there are one or two figure scenes with men and beasts: all are held firmly framed within the bars of the letter. Several hands worked on the main drawings. The figures in them are reminiscent of those in the scattered gospel pages already described.[2] The drawing to Psalm xv (xvi) shows the method of illustration (Pl. 94 a). Christ draws Adam and Eve from the pit (v. 11, 'Thou shalt not leave my soul in hell'); above stands the Psalmist holding a cup and a cord (vv. 6 and 7, 'The Lord himself is the portion of mine inheritance, and of my cup . . . the lot [vulgate *funes*, cords] is fallen unto me in a fair ground'); in the centre are the three women at the tomb (v. 11, 'Thou shalt not suffer thy Holy One to see corruption'); on the right the 'saints on earth' (v. 3) and three men on couches (v. 10, 'my flesh also shall rest in hope').[3]

Besides the psalter illustrations, Eadwine placed at the end of the book a full-page portrait of himself writing, surrounded by a somewhat naïve inscription to the effect that the book would rightly procure him eternal fame, a statement which, if restricted to somewhat specialized circles, has been entirely justified. The claim is as 'scriptor', but he may well have been an illustrator also: certainly he is to be regarded as supervising the production of the book. The portrait is of a tonsured bearded man, but there is no attempt at realism: the hair is blue, the shading on the face is green, as it is throughout the drapery of his white robe; the head is somewhat too large for the body and its clumsy weightiness is

[1] F. Michel, 'Le Livre des Psaumes', *Documents inédits sur l'histoire de France* (Paris, 1876); G. Berger, *La Bible française au moyen âge* (Paris, 1884), 1.

[2] See above, p. 109.

[3] For the same scene as treated in the Utrecht Psalter and in MS. Harley 603 see D. Talbot Rice, *O.H.E.A.* ii (1952), 205 and Pl. 65.

enhanced by the cowl slipping from it; shoulders, elbows, thighs, and knees are outlined by great curving folds; a faint pattern is traced on the stuff of the robe; the background is a deep lapis lazuli blue (Pl. 52 a). Whatever the archaism of the pictures to the psalms, this portrait page is a work employing all the mannerisms of the fully developed Romanesque style as practised in the third quarter of the century. There is unfortunately little by which to date this psalter at all exactly. On the margin of folio 10 is drawn a comet with a note in Anglo-Saxon, and this is sometimes connected with a recorded appearance of Halley's comet in 1145: this is a possible date, but the evidence cannot be considered conclusive. At the end of the book two pages are bound in, containing a celebrated plan of the waterworks of the abbey, topographically of great interest and generally associated with schemes of c. 1165, but the pages have been trimmed and are almost certainly additions to the book.

The Eadwine Psalter follows an old and known iconographic tradition. The books now to be considered, the great bibles of the mid-century, have a less clear descent. Of the early Anglo-Norman bibles, the Gundulf Bible[1] has plain single-coloured initials. The fragmentary bible, which is now MS. 184 in the library of Salisbury cathedral, seems from its script a product of the late eleventh or early twelfth century: the few initials surviving from the mutilations it has undergone have human heads in sparse foliage terminals. The great bible of Lincoln, given to the cathedral by Archdeacon Nicholas, probably the first archdeacon of Huntingdon, who died c. 1109, has dragon or figure initials to each book of the one volume that remains.[2] The drawing is that of the Lincoln artists of the beginning of the century, but the rich blue employed seems to be a colour of a special quality. Only the Joshua initial, however, where Moses gives the tables of the law to Joshua, is in any sense narrative in its content. In the bible of Rochester or Canterbury provenance (MS. Royal 1 C. VII, Walters MS. 18)[3] we have seen a more elaborate example of historiated initials. They have no

[1] See above, p. 64.
[2] Lincoln MS. A. I. 2. See Giraldus Cambrensis, *Opera*, R.S. xxi (7) (1877), 165.
[3] See above, p. 63.

relation to the Albani cycle: some other series of biblical scenes was current, a series which selected its subject-matter in a very straightforward way from the content of the opening chapter of the book. It is perhaps reasonable to see in this trend a connexion with one line of development that was marked in biblical studies, the investigation of the historical meaning of the text as opposed to its theological implications. At certain centres, particularly at St. Victor's in Paris, a singularly objective approach was followed. Hugh of St. Victor, while urging that the meaning of a text should be 'that which appears to have been certainly intended by the author', gave concrete form to his discussions by drawing the figure of Christ or plans of the ark of Noah. His *De archa Noe* was certainly known in England, for it exists in a manuscript (Trinity College, Cambridge, B. I. 25) in a twelfth-century Canterbury hand. Richard, prior of St. Victor from 1162 to his death in 1173, was a Scot by birth: his contemporary, Andrew (d. 1175), was probably English and resided for much of his working life in this country as abbot of Wigmore, the Herefordshire daughter house of St. Victor originally founded at Shobdon. Andrew was a passionate and devoted scholar, wrestling with the difficulties of the prophetical books, consulting with learned Jews as to possible meanings, always insisting that the whole context must be studied: *Exponenda est totius littere series.* It is against this background of vigorous and enthusiastic studies and the keen arguments that they aroused that the great illustrated bibles of the twelfth century must be considered.[1]

Of these pride of place must go to the bible of Bury St. Edmunds. We have already discussed the probable influence there of the Albani Psalter school. The continuance of this style is shown in books from the Bury library such as the manuscripts which are now Nos. 16 and 78 in the library of Pembroke College, Cambridge. The former is a splendid book, with foliage and dragon initials, mainly coloured green and gold on red or ochre grounds, but also with historiated scenes of the Adoration (Pl. 49 *a*), Christ

[1] See on the whole question of biblical studies, B. Smalley, *The Bible in the Middle Ages* (revised ed., 1952), and 'Andrew of Wigmore', *Recherches de Théologie ancienne et médiévale*, x (1938), 358.

teaching, Samson and the Lion, where the figures have Albani profiles and considerable roundness of form. Its developed acanthus and frieze patterns suggest a mid-century date. The great bible, now MS. C. 2 of Corpus Christi College, Cambridge, retains the framed space of the Albani Psalter, but modifies its rigid lines with a new and naturalistic suppleness. It has the press-mark of Bury St. Edmunds abbey, B. 1,[1] that is the first of its bibles, and is generally identified with the bible whose cost was paid for by Herveus, sacristan under Abbot Anselm (1121–48), a bible which was incomparably painted by 'Master Hugo', a craftsman who also carved the doors of the abbey church and made a crucifix for the choir. The *Gesta sacristarum*[2] which tells us of Herveus's gift, adds that Hugo could not obtain fine enough vellum for his paintings and therefore sent to Ireland for it, and in fact the paintings of the Corpus book are mainly done on separate vellum sheets pasted on to the main page. This is a practice of which we have other examples, but it is sufficiently rare, coupled with the high merit of the paintings, to make it a reasonable assumption that one volume of Hugo's book has come down to us. This would date it in the second quarter of the century. Herveus was the second sacristan of Anselm's period and was apparently succeeded in Anselm's later years by Ralph:[3] his gift, therefore, must precede 1148 by some years, though he may have commissioned the work without seeing its actual completion. Stylistically the so-called 'damp fold', the drapery moulded in circular patterns to the body, is employed,

[1] M. R. James, *Catalogue of Corpus Christi College, Cambridge* (1912), i. 3, and 'The Abbey of St. Edmund at Bury', *Cambridge Antiquarian Society, Octavo Publications*, xxviii (1895). For reproductions see *New Pal. Soc.* 2nd series (1913–30), Pls. 172–4; E. G. Millar, *Ill. MSS.* (1926), Pls. 37–40; and O. E. Saunders, *Eng. Ill.* i (1928), Pls. 41–42.

[2] *Memorials of St. Edmund's Abbey*, R.S. xcvi (2) (1892), 289.

[3] See witnesses to charters in D. C. Douglas, *Feudal Documents from Bury* (1932). The *Gesta sacristarum*, in its present form a late-thirteenth-century compilation, gives 'Ralph and Herveus' as sacrists in the time of Abbot Anselm and states that the latter was succeeded by Helyas, who was sacrist under and nephew to Abbot Ording (1148–56): but this may only mean that compared to Herveus's period of office, a time of great patronage of the arts, that of Ralph was less significant, for there is evidence that Ralph witnessed charters later than those attested by Herveus, and he signs with prior William, who survived Anselm, never with prior Talebot, who was the brother of Herveus and the most prominent figure of Anselm's abbacy.

but with a real sense of the forms underneath, never degenerating into mere surface pattern-making.[1] The figures also stand with a new certainty and, though only the most conventionalized scenic properties are provided, they exist in space. This is chiefly contrived by the device of setting in the centre of the background a large rectangle painted in another colour from that of the main ground: this gives a curious and striking feeling of depth to the design. The colours have none of the vivid brilliance which we usually associate with illumination. Gold is employed as edging, but the main effect is of sombre richness, olive greens, russet browns, and deep blues and purples, a colour scheme certainly influenced by the Albani model but treated here with a quite different suavity. The initials use a large, fleshy acanthus leaf, curling back to reveal cones of rounded seeds (Pl. 55 a), far removed from the wiry, nervous coils of the Canterbury school or the Anglo-Norman work at Durham and Exeter. When figures occur in the initials, they have a defined space of their own, undisturbed by whirling tendrils (Pl. 54 b), and when the grotesque style is used as in the initial to Jerome's prologue on folio 1, the mermaid, the rabbit chase, and the centaur are confined to their own roundels; there are it is true two 'gymnastic' figures and a few bearded heads emerging from acanthus fronds, but the coils of the design are firmly controlled into a balanced pattern. Of the subject pieces that of Elkanah distributing clothes to his wives, Hannah and Peninah, is perhaps the most monumental in its effect (Pl. 54 a), but the seated figures of Moses and Aaron (Pl. 59) have a grave and tactile dignity that had hardly been seen in England since the carving of the Ruthwell cross. Of the Bury Bible we possess only the first part, down to the Book of Job, and this unfortunately in a most incomplete state. The use of separate sheets of vellum has made it fatally easy to strip off the paintings, and five whole or nearly whole-page illustrations have been lost in this way. Had all this bible, this *bibliotheca* or collection of volumes, survived, we should have had a body of illustrative work to which contempo-

[1] The term 'damp fold' was, I believe, coined by Dr. Wilhelm Koehler in a lecture on 'Byzantine Art in the West', published in *Dumbarton Oaks Inaugural Lectures Nov. 2–3, 1940* (Harvard University Press, 1941), 63.

rary Europe could show no parallel. These great visual conceptions are only equalled by one other painting of the twelfth century and that is not on miniature scale. In the chapel of St. Anselm at Canterbury, the south chapel of Conrad's choir, known then as the chapel of St. Peter and St. Paul, there is a fresco of St. Paul plucking the viper from the fire. It has the same inner panel, here of deep blue, set in the background, the same variegated clouds, the same tracery patterns on the folds, even the remains of the same acanthus pattern, as in the Bury Bible: but these are mannerisms to be found elsewhere. It is the certain ease of the movement, the expressiveness of the features, the solidity of the forms that link it with Hugo's work. We know that there was considerable activity at Canterbury during the priorate of Wibert (1151–67), whose waterworks have already been mentioned in connexion with the plans at the end of Eadwine's psalter: on stylistic grounds the fresco could well fall within that period. It is certain that it was carried out before the rebuilding of the choir in 1175, for part of it is covered over by the alterations of that date. Its bold design of the bending figure had some Byzantine prototype, and the same pose is similarly treated in the St. Paul mosaics of the Capella Palatina in Palermo (c. 1160):[1] bible and fresco alike witness to a powerful influence from some centre of Byzantine art.

The marked treatment of the drapery, clinging to the shapes of the limbs in set curving folds, of which the Bury Bible is the supreme example, though known in Byzantium became one of the most marked of Romanesque conventions. In the Albani Psalter, though the garments fall in long straight lines, circular whirls mark the knees and shoulders. Gradually the straight hatching and frilled edges of the earlier manner, still predominant in the Rochester Joshua to Kings volume, is completely replaced by this new custom. It can be seen very fully developed in two striking evangelist portraits included in a Sherborne cartulary,[2] which was compiled shortly after 1145, an admirable volume, still retaining its original cover with, fixed on it, a small enamel of an angel, part

[1] F. Saxl and R. Wittkower, *British Art and the Mediterranean* (1948), 26.

[2] B.M. MS. Add. 46487. See note by F. Wormald in *Annual Report of the Pilgrim Trust*, xviii (1948), 7, where the painting of St. Mark is reproduced.

probably of a crucifixion scene. Its two paintings are expert work of much dignity: the standing St. John, a rare posture for evangelist portraits, is set within a green border; his cloak is a rich blue lined with green, his robe purple; the bend of his hip is marked by the wavy line familiar in the Terence illustrations and other works of the mid-century; the folds form curious heart-shaped panels, with small arrow-head hatchings to mark the recessions (Pl. 56 a). These elaborate formulas soon broadened into the more sweeping circles and long ovoid panels, so familiar in the miniatures of the last phase of the Romanesque style. In a gospel book in Hereford cathedral library this stage is clearly evident,[1] as also in Eadwine's self portrait in the Canterbury Psalter: the same process can be seen at work in some interesting drawings of a series of visions of Henry I in the Corpus Christi volume of Florence of Worcester already referred to.[2] These can with some confidence be dated between 1140 and 1154. Before, however, this transition was completed several artists were to exploit to the full the decorative possibilities of the 'damp fold' manner. Of these in his fantastic inventiveness the Master of the Lambeth Bible takes first place. This great manuscript, one volume of which is now in the Lambeth library (MS. 3), the other much mutilated in the Maidstone library, has no documentary indication of date or provenance.[3] The only evidence lies in the fact that the Maidstone volume passed at the time of the Dissolution into the possession of the family of Colyar of Lenham, and that the Lenham estates were held from St. Augustine's, Canterbury; further, the Lambeth Bible is now paired with the second half of a bible which, while clearly from its script and foliage initials a different piece of book production from later in the century, completes the text and has a Canterbury press-mark. These circumstantial hints seem some basis for attributing this highly original and individual work to the Canterbury scriptorium

[1] Hereford MS. O. 1. viii. See *Burlington Fine Arts Club Catalogue* (1908), 9 and Pl. 24.

[2] C.C.C. 157. The drawings are reproduced in J. H. R. Weaver, 'Chronicle of John of Worcester', *Anecdota Oxoniensia*, xiii (Oxford, 1908). See above, p. 157.

[3] E. G. Millar, 'Les principaux MSS. à peintures du Lambeth Palace à Londres', *Bull. de la Société française de Reproductions de MSS. à peintures* (1924), Pls. II–XI: M. Kershaw, 'On MSS. and Rare Books in the Maidstone Museum', *Archaeol. Cantiana*, xi (1878), 189.

of St. Augustine's. The master's hand is not certainly recognizable in any other English work, but has strikingly close similarities to the illustrations in two volumes of the gospels made at the abbey of Liessies in the diocese of Cambrai under Abbot Wédric (1124–47).[1] One of these, which was unfortunately lost in the destruction of the Metz library in 1944, was dated 1146. Of the other, two evangelist portraits survive in the possession of the Société Archéologique d'Avesnes: the panelling of the drapery, the outward whirl of the hem of the skirt, the articulation of toes and fingers, the U-shaped junction of nose and eyebrows, all recall the Lambeth Bible to a marked degree. If they are not all the work of the same hand, they are certainly the product of some closely connected group of craftsmen.

In general conception the Lambeth Bible is a more primitive work than that of Bury, but it is a sophisticated primitiveness, an elaborate pattern-making that is the end rather than the beginning of the movement. The draperies are cut up into emphatic folds, outlined by a thick double line, but their geometric forms, often running in parallel movements throughout the whole scene, are flat and hardly pretend to any relationship with the forms of the figures. The closeness to metal-work is strongly marked, and in fact the Masters plaque, an enamel showing the Last Judgement with a linear vehemence that seems to establish its English origin, is the nearest parallel.[2] There are several full or three-quarter-full pages of illustration, where the scenes are arranged in bands, which in turn are split up by pillars into smaller incidents. The story of Nebuchadnezzar, for instance, ranges from the King's Dream, through the intervention of Daniel to the excited scene of the Worship of the Golden Image and the Three Children in the Fiery Furnace. In the scene of Jacob's Ladder, with, above, Abraham and the Angels, the design is more unified, though it includes beside the

[1] Published with reproductions by A. Boinet, 'L'atelier de miniaturistes de Liessies au XIIe siècle', La Bibliofilia, l (Florence, 1948), 149, and in Bull. de la Soc. nat. des antiquaires de France (1919), 215. Dr. Dodwell in his as yet unpublished thesis has independently reached the same conclusion as to the interrelationship of these manuscripts.

[2] Now in the Victoria and Albert Museum: Masters is the name of a former owner. See H. P. Mitchell, 'English Enamels', Burl. Mag. xlvii (1925), 163.

vision Jacob anointing the stones and the Sacrifice of Isaac (Pl. 58). The famous page of the Tree of Jesse[1] shows a tall, stiff figure of the Virgin, her face fixed and expressionless, holding in her outstretched hands medallions where are represented the Church and Synagogue: below is shown the harmony of the virtues, 'Mercy and Truth meeting, Justice and Peace kissing one another': in the third roundel are prophets, one of whom holds a scroll with the prophecy of Isaiah, *Egredietur Virga*, and it is to the Book of Isaiah that the picture serves as opening. The swaying rhythm of the figures in the roundels serves only to emphasize the hieratic rigidity of the central column figure. Ruth and Naomi from another page may be taken as an example of the tenderness which the artist could infuse into his metallic, patterned style (Frontispiece). The initials, in which the co-operation of other hands is evident, include elaborate arabesques of inhabited scrolls, medallion scenes, such as the opening series of the Seven Days of Creation, and seated contorted figures of prophets. The Creation scenes follow the same type as that used in the St. Albans Josephus. The Death of Saul, where the spears and even the falling body burst from the picture space, is an astonishing example of dramatic composition (Pl. 62), and the grisly Martyrdom of Isaiah, with its judge perched on the bar of the letter, is another instance of this artist's eager disregard of the theories of defined space which underlie the Albani Psalter and the Bury Bible. The colouring throughout is in high, clear tones of blue, light green, purple, and red, far removed from the sombre magnificence of the Bury artist. The Jesse page is predominantly blue, in the background of all the medallions except the two centre ones, which are gilt, and in the Virgin's robe; the background of the corner roundels is green.

Another great bible has Canterbury associations: now MSS. 3 and 4 in the library of Corpus Christi College, Cambridge, it originally belonged to Dover priory, a dependency of Christ Church founded in 1139. This house had a considerable artistic tradition, though one probably very dependent on Canterbury. The refectory, now incorporated in Dover College, retains on its

[1] See A. Watson, *The Tree of Jesse* (1934), 99. The page is reproduced also in E. G. Millar, *Eng. Ill. MSS.* (1926), Pl. 41, and O. E. Saunders, *Eng. Ill.* i (1928), Pl. 40.

wall the shadow, it is little more, of a large twelfth-century painting of the Last Supper. The bible contains a wide range of styles and must have been the product of several hands and produced over a comparatively long period. The foliage is closely knit coils of full-leaved and thick-stemmed acanthus: there are still some monsters leaping through it and there are some unusual patterns, including a black design on gold (f. 96ᵛ), a fine bar of key pattern drawn in high relief (f. 183), and an ingenious wheel design on folio 240. The second epistle of St. Peter has in its initial the fables of the fox and the cock and the wolf and the crane ('For we did not follow cunningly devised fables, when we made known unto you the power and coming of our Lord Jesus Christ', i. 16). The figure drawings belong to two distinct schools. A Romanesque artist or group of artists used many of the Lambeth mannerisms, the strange postures and patterned draperies, the twisting fingers and toes, but the drawing is softer and more flowing, and the curves are full and rounded, at times as in the curious sacrifice of a calf in the initial to St. Luke almost grotesquely so. At its best, it reaches a high level: the strangely formalized head of the Baptist, with the curiously misshapen ears that characterize much Canterbury work and are found also in the Bury Bible; the initial to Wisdom, 'Love righteousness, ye that judge the earth', with its moving contrast between the slight figure of the prisoner, naked, bound, blind-folded, and the harsh visages and claw-like hands of the judges (Pl. 57 b), and the evangelist initial to St. Matthew, one of our finest Romanesque author portraits (Pl. 56 c), a mature and beautiful work in the main tradition. In the Old Testament, however, an artist was at work who had experienced the new wave of Byzantine influence. Elijah's chariot still rises in a cloud of flame as in the earlier bible of the Canterbury school, but here it is driven by the Almighty, who reaches out his hand to the prophet and whose dark-haired, large-eyed head has the gravity of the Christ of Cefalù or Monreale: below in the foot of the bar Elisha's pose and garments have a fluency and ease that come from a fresh inspiration (Pl. 60 a). This artist illustrated also the twelve minor prophets (always treated as a section by itself), and with these light stepping figures, gesticulating with a slightly affected elegance, a new

civility breaks across the hieratic formalism of our Romanesque style (Pl. 57 a).

A hand not unlike that of some of the earlier Dover work, though its thick leaves and striped shading are distinctive, is found in the fragment, Genesis to Ruth, of the Walsingham Bible (Chester Beatty MS. 22).[1] Genesis has a bar initial with scenes of the Creation, but based on some different scheme from that of Lambeth and ending with the Temptation by the Serpent: the Book of Joshua has Moses and Aaron set across the page as in the same initial of MS. Royal 1. C. VII: Exodus and Numbers have curious parallel initials, in both of which Moses stands removing his shoes, holding the serpent rod and surrounded by sheep: in the Exodus initial, God appears in the flames of the burning bush, but in the Numbers initial his place is taken by a monkey playing a harp, one of the strangest vagaries of this iconographically eccentric time.

Durham, Exeter, Canterbury, St. Albans, Bury St. Edmunds, have been the scriptoria which so far have demanded our attention. Winchester, the leading name of the great Anglo-Saxon period, had taken little part in the early Anglo-Norman achievement. But in the mid-century the bishop of Winchester was a splendid patron, and it is not surprising to find from this period Winchester illumination once more taking a central place. Henry of Blois is the last of the grandchildren of the Conqueror with whom we shall have to deal.[2] Brought up in the cultured atmosphere of the court of his mother, Adela of Blois, of whose civilized surroundings Baudri of Bourgueil has left us such a highly coloured picture, he was for a time at Cluny, and in 1126 while still a young man was appointed abbot of Glastonbury, a post which he continued to hold in plurality when three years later he became bishop of Winchester. A man of great administrative ability, he seems particularly to have concentrated on the management of the estates of his diocese and abbey, but he was also a great collector, though a man who himself, at least in his later years, lived austerely and with little luxury. His splendid gifts are the subject of constant comment by the chroniclers. 'Most earnest in the beautifying of

[1] E. G. Millar, *Library of A. Chester Beatty*, i (1927), 84.
[2] See L. Voss, *Heinrich von Blois* (Berlin, 1932).

churches', says the Winchester annalist.[1] In the *Historia pontificalis*, generally attributed to John of Salisbury, there is an account of his stay in Rome in 1151:[2] how he bought ancient statues there, which he sent back to Winchester, and how the Roman crowd was amazed to see this reverend long-bearded man buying idols in the market place. The phrase *veteres statuas* might stand for any representational works of art, but the whole account suggests that these were actual pieces of ancient sculpture which Henry had shipped to England. John of Salisbury writes that a clerk standing by, likely enough the writer himself, quoted a tag from the satires of Horace, *Insanit veteres statuas Damasippus emendo*, and goes on to add that it was perhaps as well that Henry removed their ancient idols as the Romans were not far from idolatry. Doubtless Henry made many other purchases, for the lists of his gifts to Winchester[3] and to Glastonbury[4] are full of items that must have come from the continent, ornate reliquaries, cameos, two stoles from Germany, a carpet of Saracen work.

Of the smaller more precious objects, one has come down to us that can be associated with Henry with some certainty. In its present form, it consists of two semicircular copper plaques, enamelled in champlevé, and showing, the one a kneeling figure inscribed *Henricus Episcopus*, the other two censing angels: the former is surrounded by an inscription, saying that Henry is equal to the Muses in intellect (*Mente parem musis*) and greater in eloquence than Cicero (*Marco voce priorem*), the latter by a prayer that an angel may carry the giver up to heaven, but that England, whose peace depends on him, must not hasten this event. These invocations can only refer to Henry of Blois. In the design he carries what seems to be a reliquary box, perhaps the 'scrinium aureum' of his inventory, and it is tempting to see in these plaques the remains of the 'tabula' covered with enamels that he gave to

[1] *Annales Wintonienses*, R.S. xxxvi (2) (1865), 60.

[2] *Historia pontificalis*, ed. R. L. Poole (Oxford, 1927), 81. See C. C. J. Webb, *John of Salisbury* (1932), 135.

[3] E. Bishop, 'Gifts of Bishop Henry of Blois to Winchester Cathedral', *Downside Review*, iii (1884), 41 (reprinted in *Liturgica historica*, 392).

[4] Adam de Domerham, *De rebus gestis Glastoniensibus*, ed. T. Hearne (Oxford, 1727), 316.

his cathedral. Stylistically the work is associated with the manner of Godefroid de Claire, the famous goldsmith of Huy in Belgium, though not I think by his hand. A group of five enamels, divided between an English and a French private collection, come close to them and might well be ornaments of the same composition as that from which the plaques come: they show Alexander carried to heaven, a centaur, men battling with beasts, and a camel.[1] The large ovoid folds of these works belong to the style that was rapidly dominating England and northern France in the mid-century and was much influenced by enamelling technique.

We know, however, little of Henry's more substantial achievements. Of his buildings, his castle of Wolvesey has the remains of a fine hall, but insufficient to give us any certain idea of the detail of its work.[2] It was from the castle that Henry's troops showered missiles on Hyde abbey in the wars of 1141, finally destroying and pillaging it. This act was to involve the bishop in constant litigation, for the monks of Hyde appealed against him to Rome and won the support of no less an advocate than St. Bernard. As part of the reparations Henry provided a copy of the famous golden cross of Canute, which had perished in the fire. It is this act of destruction rather than his buildings which has left the most abiding memory in his episcopal city, though his foundation of St. Cross must be reserved for later comment. At the cathedral there still exist iron grills, closing the entrance to the south aisle of the choir, which are splendid pieces of iron tracery work, curiously like the contemporary grills which the crusaders placed round the Rock of the Temple. These may well date from Henry's time, as may also the font of black Tournai stone, carved with scenes of the life of St. Nicholas and with doves and a lion in circular medallions, the most elaborate of the group of seven such Tournai fonts still to be found in England.[3] Two much battered

[1] H. P. Mitchell, 'Some Enamels of the School of Godefroid de Claire', *Burl. Mag.* xxxv (1919), 92, 217. Three of them are now lent to the Victoria and Albert Museum by the trustees of the late Lord Lanattock.

[2] N. C. Nisbett in *Hants Field Club*, iii (1894–7), 207. There are some twelfth-century remains at Henry's other palace of Bishop's Waltham, 9 miles south of Winchester, but the ruin is mainly of fifteenth-century work.

[3] C. H. Eden, *Tournai Fonts* (1909), 12. The other fonts are at St. Michael's,

capitals in the museum, one with a row of seated figures, the other with figured scenes of which only the Sacrifice of Abraham can be distinguished, suggest work of high quality from the middle years of the century, but their place of provenance is not securely established.

Henry, as was to be expected, interested himself also in the production of manuscripts. Adam of Domerham gives a long list of Glastonbury books which were transcribed at Henry's orders,[1] a normal list of the usual commentaries and histories. None of these books can now be accurately identified nor can Adam's list, written a century later, be considered necessarily reliable. But it is clear that this was a subject in which Henry took much interest, and the great days of the Winchester scriptorium cannot be separated from his stimulus and inspiration; though there is no decisive authority for the name, 'The Psalter of Henry of Blois', sometimes given to one of its finest products.

Stylistically between the classicism of the Bury Bible and the schematizing of the Lambeth, this psalter, now in the British Museum (MS. Cottonian Nero C. IV),[2] is perhaps the most characteristic work of the High Romanesque phase of English art. It contains thirty-eight pages illustrating the Old and New Testaments and ending with stirring scenes of the Last Judgement. Many pages are divided into two compartments but framed as a unit in borders, closely similar to those used in the Bury Bible. The scenes were originally set against a deep blue background, but this blue is much worn or may even have been scraped off, so that as we have them the works approximate to tinted drawings rather than to full paintings. It is likely enough that the delicacy and inventiveness of the work is more apparent and to us more readily appreciable than it would have been in its finished state. The calendar is a Winchester one and a prayer addressed to St. Swithun refers to 'his house',[3] hence its other name of the Psalter

Southampton, East Meon, St. Mary Bourne, Lincoln Minster, Thornton Curtis, St. Peter's, Ipswich. See also J. Romilly Allen, *V.C.H. Hampshire*, ii (1903), 241, and G. C. Dunning in *Antiq. Journ.* xxiv (1944), 66.

[1] *De gestis*, 317.

[2] The psalter is parallel Latin and Norman French: see E. M. Thompson, *Eng. Ill. MSS.* (1895), 29–33. [3] f. 136.

of St. Swithun's, but the book later belonged to the nuns of Shaftesbury, where the Abbess Mary (c. 1181–1216) was a half sister of the king.[1] The feast of St. Hugh of Cluny may be included on account of Henry's early connexion with that abbey and as there is no entry for the feast of Edward the Confessor the book probably precedes his canonization in 1161, a canonization which Henry had actively promoted. Certainly it must come from the long period of Henry's episcopate, and there are two pages in it which suggest some closer identification with the great bishop's tastes. These are representations of the death and glorification of the Virgin and seem to be direct copies of a Byzantine model, so close that it has sometimes been argued that they must be actual Byzantine works.[2] Undoubtedly the artist had before him two Byzantine paintings, which he rendered faithfully, though the colouring was in the English style and here and there a fold of the drapery recalls English draughtsmanship. The main drawings of the book are characterized by a strong linear sense, which breaks up the monumental spaciousness of the Bury Bible into a more flowing, closely knit rhythm, filling the scene with figures and movement and closing it in upon them with elaborate architectural canopies. There is a liking for excessive expression, verging on caricature, and the men are sometimes weighed down by heads large out of all proportion to their bodies, a common idiosyncrasy of Romanesque art, here used very tellingly (Pl. 64 b). The scenes of the Passion have an intensity of emotion that is at times almost painful: every line tells in the violent agitated pattern: the emaciated Christ, swaying under the blows, is sharply contrasted with the grinning, robust tormentors.[3] Had we any knowledge of passion plays performed at so early a date, it would be natural to discern here the influence of theatrical performances. But the artist or artists—for it is not all one hand, though a similar convention is adhered to—could be decoratively formal as well, and David posed on one side of a highly conventionalized tree admires

[1] See J. C. Cox, 'Mary, Abbess of Shaftesbury', E.H.R. xxv (1910), 303, and xxvi (1911), 317.

[2] Pal. Soc. (1873–83), Pl. 124, and B.M. Reproductions, iii (1925), Pl. ix.

[3] Reproduced O. E. Saunders, Eng. Ill. (1928), Pl. 38.

the heraldic attitude of his goats, while on the other he forces a lion to disgorge a pigmy lamb and also to fit into the space left by the coiling branches.[1] The Tree of Jesse, with its coiling branches between the figures of Abraham and Moses and its half-length Virgin, owes nothing to Lambeth but is based on the same scheme as that of the psalter, MS. Lansdowne 383, another book with Shaftesbury connexions,[2] and one where another St. Swithun's scene, the Almighty dispatching the angel Gabriel, is also found. The Crucifixion is most strangely set: it includes, unusually, the two crosses of the thieves; Mary and John stand close to, in fact partially behind, the side frame, and are large in proportion to the figures of Christ and the lance and sponge bearers, as though in an attempt to create a sense of recession; the thieves shown in the background are yet smaller; behind Mary and John a crowd, shown by heads in profile, rises to the top border of the frame (Pl. 64 a). It is by no means a satisfactory piece and it is by one of the lesser artists of the book, but it is an intriguingly experimental venture. The same crowd of profiles is used by the same hand for the blessed in paradise and a sadly dull business is made of it. Hell, on the other hand, is treated with much vigour and an unusual realism in its horrors. The foliage in the initials is a highly decorative pronged acanthus. Characteristic as is the style of this book, it is difficult to find certain examples of it elsewhere. In a Bodley MS. (Bodley 297), another Florence of Worcester, there is a fine but unfinished Crucifixion, where the figure of Christ comes strangely close to the passion scenes of the psalter (Pl. 65), and which in its turn may be compared to the small ivory torso of the crucified Christ now in the Guildhall museum.[3] But if works of this quality are rare, there are frequent traces of the artist's manner in lesser products, and there is little doubt that the book sums up and admirably displays a style that was very generally acceptable.

The great bible, now bound in three volumes, in the library of Winchester cathedral and always known by the name of 'The Winchester Bible', is a work by many hands engaged on it over

[1] Reproduced in colour G. F. Warner, *Ill. MSS. in B.M.* (1903).
[2] Reproduced *B.M. Schools of Ill.* i (1914), Pt. II, Pl. 2.
[3] M. H. Longhurst, *Ivories* (1926), 86, Pls. 5 and 26.

a long period, and presents a compendium of the development of English painting in the second half of the twelfth century. It was we know in the cathedral library in the mid-seventeenth century, when Cromwell for a time transferred it to the college, and it is a reasonable assumption that it was for the cathedral that it was made. Nothing certain is known of its earlier history. The very strongly characterized initials of the Winchester cartulary[1] of c. 1150, whose foliage encloses human heads in its finely drawn coils, have in their leaves and general pattern connexions with the bible as also with the Beatus initial of MS. Nero C. IV, but there is no clear interchange of hands, and the bible's motifs and types have a varied repertory behind them. It is tempting to think of it, at least in the work of the earlier hands, as the product of a team of artists drawn to Winchester from various centres by the wide ecclesiastical authority and splendid patronage of Henry of Blois. It is tempting also, as with the Bury Bible, to associate that of Winchester with a reference in a chronicle. When Henry II induced Hugh of Avalon in 1175 to leave the Grande Chartreuse to become prior of his new foundation at Witham, the energetic and forceful saint persuaded the king, among other benefits, to assist in the provision of a library. The *Magna Vita* of St. Hugh[2] tells us how the king heard 'that the monks of St. Swithun had completed with new and seemly work a splendid Bible', which was to be used for reading at meals. Henry, with many promises of recompense, persuaded the monks to send their bible to Witham, where it was received with much gratification, not only because of the elegance of the style and the beauty of the whole work, but because the text had been carefully emended. St. Hugh later returned the book to Winchester on hearing that they had only surrendered it under pressure from the king. Now the Winchester Bible has been accented for reading aloud and the text has been considerably emended. It therefore fits the description given and there is no doubt that it must in its day have been a work of considerable celebrity. Its illustration could certainly not have been completed before 1186, when St. Hugh left Witham for Lincoln, but illustration followed script in book production and in fact in

[1] B.M. MS. Add. 15350. [2] R.S. xxxvii (1864), 92.

this case was never entirely carried through. Mr. Walter Oakeshott in his remarkable study of the various hands has invented names for the painters who at different times worked on the book, and his nomenclature is gradually passing into general use.[1] The Master of the Leaping Figures is one of the outstanding artists of the mid-century even though we only know his work in this miniature scale. He used the 'damp fold' convention, but here there is none of the surface pattern making of the Lambeth Bible. Every movement and curve of the body is articulated to emphasize the dramatic tension and energy of these vehement figures. In the round arc of the great P of folio 120ᵛ the messengers of Ahaziah bend to fill the curve, but their pliancy has dramatic as well as ornamental fitness, a withdrawal before the menace of the grim, hawk-like pose of Elijah: the bar of the letter contains the car of Elijah and ends in the bounding figure of Elisha, who seems to rise upwards with every thrust of his limbs, propelled by the flying line of his cloak (Pl. 61). The figure of Doeg the Edomite slaying the priests of Nob[2] is a stern, youthful being in the long garment split from the waist which is common in this artist's representations. The calling of Jeremiah is another strange fantasy set in coils of acanthus and inscribed scrolls. The Master worked also on the New Testament, but his initials for the epistles of St. James and of St. Paul to Philemon are drawings only and have never been completed by painting. The latter, the 'prisoner of Christ Jesus', caught in the tendrils of the vine, might stand as the great climax of the inhabited scroll, which has reached its final intensity and found a theme to fit its convulsed design. There are several initials, based on his designs, which have been finished by another artist, but in which the Master's original drawing can be clearly distinguished when held before a strong light. The later hand, working in a different technique, painted out the tubular folds, substituting a more flowing and yet on the whole less expressive form of drapery. Other initials show similar dual authorship. Here in fact we have a direct insight into the creation of these great books. From their

[1] *The Artists of the Winchester Bible* (1945).
[2] This was an accepted subject for illustrating Psalm li (lii), of which the rubric gives this as the occasion.

inception various hands were set to work on them, not apparently by any allotment of quires or any particular limitation to sections of the book: visitors to the scriptorium might add their share: drawing was not always immediately followed by painting, and some spaces can only have been filled in when the book had long been in production. In the foliage initials are curling, frilled acanthus leaves with closely intertwined stems and many fruit cones. In one of them takes place the fiercest contest of men and beasts that the period produced. The latest hand of the Winchester Bible, the Master of the Gothic Majesty, belongs to the world of a new classical revival, infinitely removed from the great Romanesque master of its early stages. In between, the Byzantine impulse, responsible for the Dover prophets, had exerted its influence. The figures are set against a burnished gold background: their faces are carefully shaded with white and green lines: there is a naturalistic approach in gesture and attitude and the picture space is more clearly defined: the scenes chosen are quieter and more humane. Some of this later work is of outstanding quality and the so-called Master of the Genesis Initial is a considerable artist; but it is in another purely Romanesque hand, that of the Master of the Apocrypha Drawings, that the Master of the Leaping Figures has his most serious rival. The Apocrypha is illustrated in two full pages of drawings. The rounded contours, smooth curves, upward flying draperies, and treatment of the hair all recall the ablest of the St. Albans artists of the Terence cycle. This in itself is not surprising: great miniaturists were known outside any single scriptorium, and may even have been travelling laymen. Certainly they circulated amongst the main centres, creating a fusion of styles. Whether a scene such as the poignant burial of Judas Maccabaeus (Pl. 63 a) was an earlier work than the Terence pages cannot be established, but it is tempting to think that the accomplishment of the Winchester work was matured in the schooling at St. Albans in an old classical tradition.

A final problem in the analysis of this bible's paintings is created by the existence of what seems to be an alternative sheet for the opening of the first Book of Kings. In the Pierpont Morgan collection (MS. 619) there is a folio where the text begins at the

identical point as on the corresponding page of the Winchester Bible. Begins, but does not end, for half the page in the single leaf is devoted to a series of scenes of the story of Samuel's childhood, far more elaborate than that in the bible. The verso has a full page of illustrations in three tiers of the life of David. The Samuel cycle seems to have been drawn by the Master of the Apocrypha and painted by a later hand: the verso is by an artist using some early Gothic mannerisms not current till the last fifteen years of the century. It is a magnificent but puzzling page, iconographically going back to a tradition that had been used in the bible of Stephen Harding, a tradition which underlies also the full page of Maccabean drawings. Certainly the Master of the Apocrypha worked on this sheet, possibly leaving it so incomplete that it was discarded, to be finished later by an artist who appreciated its merits while adapting the design to his own conventions.[1]

Prolonged undertakings such as the illustrations of these great bibles clearly attracted the leading artists of their time. They must have been men who had already become renowned through other works. In the chance survival of existing manuscripts it is difficult to feel certain of particular hands, but the widespread influences of the various styles is clearly apparent. An example of work close to that of the Master of the St. Swithun's Psalter has already been quoted. In the two pages from a psalter bound into MS. 2 of Corpus Christi College, Oxford, we can see in the unfinished paintings of the Marys at the Tomb and the Deposition a more suave and elegant version of the Lambeth style. On a surface of dull gold, the ground paint of blues, greens, and reds has been laid on in thin washes that do nothing to obscure the keen tension of the drawing. These pages, shadowy as they are, must rank among our twelfth-century masterpieces: the script of the map of Palestine drawn on the back of one of them points to St. Albans as a probable place of origin; and their iconography is that of the St. Albans Psalter. An epistles of St. Paul (MS. Auct.

[1] See Oakeshott, *Winchester Bible*, 18. I am indebted also to a lecture by Dr. Pächt. The volume of Zacharias Chrysopolitanus, formerly MS. 28 in the Chester Beatty collection, appears from photographs to be associated with some of the Winchester Bible hands, see E. G. Millar, *Chester Beatty Catalogue*, i. 99, Pls. LXXV–LXXVII.

D. I. 13 in the Bodleian Library) has a long initial with St. Paul preaching, then in the bar of the letter lowered in a basket, and finally his martyrdom, a drawing strongly reminiscent of the narrative letters of the Winchester Bible, though the large head of the executioner recalls the St. Swithun's Psalter types.[1]

The decorative features of the period are finely summed up in a great two-volume bible, which survives complete in the Bodleian Library (MS. Auct. E. Infra 1 and 2). Several hands worked on its profuse ornament, but, with the exception of the Beatus initial[2] which opens the second volume and which must be by one of the latest hands (c. 1180–90), there are no historiated initials. Human figures clamber among the foliage and pursue fantastic monsters of a nightmare size: bearded heads emerge from the terminals of branches (Pl. 29):[3] immensely elongated in drapery of curling folds, a strange being, standing on the pinnacle of a church which in turn rises from a twisting-tailed dragon, supports the head of Christ in the *In principio* initial (Pl. 76 *b*). This is a great repertory, perhaps the greatest, of Romanesque ornament. Many of the initials are coloured outlines only, but done with a baroque sweep of movement: where gold is used it is brightly burnished, a technique that belongs to the second half of the century: the acanthus leaf swells into a heavy star-shaped pattern, its leaves bending over with their own weight (Pl. 66 *a*). No inscription gives any clue to the date or provenance of these splendid books. One of the hands, the Master, we might call him, of the Entangled Figures, is recognizable in a psalter (Bodley MS. Auct. D. 2. 4) whose calendar, despite the inclusion of some Norman saints, is unmistakably that of Winchester; and very similar foliage and nudes, of the same school if not actually by the same artist, are found in another psalter (MS. Auct. D. 2. 6),[4] whose calendar is missing but which contains Winchester offices. Here once again a nude man struggles in a series of circling coils: the anatomy is

[1] Reproduced Bodleian *Eng. Rom. Ill.* (1951), Pl. 16.

[2] Ibid., Pl. 12.

[3] For a provincial use of these motifs compare Jesus College, Oxford, MS. 62, f. 4ᵛ, a book that belonged to St. Mary's abbey, Cirencester.

[4] This is the third manuscript of the volume that contains the St. Albans calendar and the Anselm meditations already mentioned.

not as clearly articulated as in the bible examples and as in the opening letter of MS. Auct. D. 2. 6, but all three manuscripts come from the same group of craftsmen and the great bible as well as the psalters must have Winchester connexions.[1] It is to be noted, moreover, that the bible was given to the Bodleian Library by George Ryves, Warden of New College (1599–1613) who was also a canon of Winchester, and that its outline foliage initials seem to be by the same hand as decorated a volume of Cassiodorus on the Psalms still in Winchester cathedral library and marked with the St. Swithun's anathema. If these artists, men of outstanding ability, were working at Winchester contemporaneously with the production of the great bible of the cathedral library, whose masters are entirely distinct from them, then Henry of Blois had indeed formed a scriptorium of unrivalled excellence.

Two groups of manuscripts which show new developments are associated respectively with St. Albans and Canterbury. The former group is marked out by the St. Albans anathema and an inscription that they were made for Abbot Simon. This bibliophil, who ruled the abbey from 1167 to 1183, was a notable scribe himself and took a close interest in the scriptorium:[2] he was busied in completing and expanding the library and a letter is extant in which he asks Richard of St. Victor for permission to copy the works of Hugh of St. Victor:[3] a special case was set aside for his collection 'opposite the tomb of the hermit Roger', an appropriate spot, for this Roger is the first owner of the Albani Psalter; and the scriptorium was endowed so that the abbot could always employ a special scribe, presumably from outside the monastery.[4] Amongst the books written for him, the *Gesta* tells

[1] Dr. Otto Pächt is responsible for relating these manuscripts together and his forthcoming publication of them will undoubtedly set the whole problem of the Winchester scriptorium in a new light.

[2] *Gesta abbatum*, R.S. xxviii (4 *a*) (1867), 183. L. F. R. Williams, *Abbey of St. Albans* (1917), 79.

[3] 'Opera Richardi S. Victoris', Migne, *P.L.* cxcvi. 1228.

[4] An interesting group of manuscripts written at the Augustinian house of St. Mary of Cirencester between 1131 and 1176 are inscribed with the names of the scriptors, nearly all religious, Fulco, canon afterwards prior, Gilbert the cantor, &c., but on two of the finest manuscripts (Jesus College, Oxford, 52 and 63) Ralph of Pulleham was employed and is given no religious designation.

us, were glossed copies of the Old and New Testament. His interest in the arts was shown also by his patronage of the goldsmiths, John and Baldwin: the former made the great reliquary for the high altar, with its frontal scene of the beheading of St. Alban, his life story on the side pieces, and, above, an icon of the Virgin framed in jewels with, on the reverse side, an icon of the Crucifixion. Unfortunately, on Simon's death the monastery had so run into debt that Aaron the Jew was able to say that it was he who had presented the shrine.

It is not surprising with his foreign contacts that Abbot Simon's illuminated works show a new closeness to foreign models. The third quarter of the century found many gifted painters at work in the monasteries of north-east France. In particular the abbeys of St. Sauveur of Anchin, St. Amand near Valenciennes, and St. Bertin of St. Omer were producing books of considerable quality. At Anchin, under the long abbacy of Gossuin (1131–65), there seem to have been several Englishmen employed, amongst them one Helias, whose English origin is stated in a poem in a manuscript now in Boulogne (MS. 115) which he wrote and probably also decorated. Another fine Anchin book (Douai MS. 914) is the *Speculum caritatis* of Ailred of Rievaulx, where Ailred is shown opposite the initial portrait of the abbot, possibly St. Bernard himself, for whom the book was written. These Anchin manuscripts have the usual repertory of coiling foliage, beasts and Phrygians, but there is a new element of the grotesque (one artist is particularly addicted to men with wooden legs): the Ailred manuscript shows the broader, circular folds which from now on characterize illumination on both sides of the Channel.[1]

Helias the Englishman, though working at Anchin, was a monk of St. Bertin. Here, amongst many notable manuscripts, the great bible, now MSS. lat. 16743–6 in the Bibliothèque Nationale, takes pride of place. This work, which must have required many years to complete and whose latest hands may well belong to the early thirteenth century, has many points of contact with English work. Its Tree of Jesse, with prophets in roundels, is a staider

[1] See E. A. Escallier, *L'Abbaye d'Anchin* (Lille, 1852), 112; E. de Moreau, *L'Église en Belgique*, ii (1945), 341.

version of the Lambeth design. Amongst the earlier hands there is one that is recognizable again in a psalter[1] whose calendar shows that it was made for St. Bertin. Later entries indicate that by the first quarter of the thirteenth century it had come to the nunnery of Wherwell in Hampshire; it has also many English feasts entered in the original hand, including on 4 May the obit of *Matilda Anglorum Regina*, that is Matilda of Boulogne, the wife of Stephen, who died in 1152; as the festival of Becket is not included the book can reasonably be dated between 1152 and 1173.[2] Its initial, where Doeg crouches in the tail observing Ahimelech and David, shows the large-headed tradition of Nero C. IV, but a new suppleness in the fall of the drapery (Pl. 39 *c*). Another work, stylistically close, is a volume of St. Gregory's Homilies in the library of Stonyhurst, which bears Abbot Simon's inscription and therefore links him with this group of Anglo-French manuscripts. If the initial of St. Gregory from the Stonyhurst book is compared with the Christ from the Wherwell Psalter, it can be seen that the curious oval of the letter, the mottled book cover, the triangular folds of drapery, the curled fringe of the beard, the hands and the ears are exactly similar. Yet another of Simon's books, a volume of Radulphus Flaviacensis on Leviticus in the library of Trinity Hall, Cambridge (MS. 2), has an introductory initial of a similar style, though not by the same hand. It has also a grotesque initial, where the bar of the P is formed by a long pink dog with its legs stretched out, somewhat as though hanging in a butcher's shop, an odd, unattractive convention which, however, enjoyed great popularity. Similar initials of extended beasts or nude human figures occur in the St. Bertin Bible and the Wherwell Psalter. There is a remarkable gallery of them in a manuscript of Laon library (No. 103) which comes from the chartreuse of Val St. Pierre.[3]

Simon's successor as abbot, Warin (1183–95), appointed his brother Mathias as prior. A bible (now MS. 26 of Eton College library) was presented by him. This in itself is not an elaborately

[1] St. John's College, Cambridge, MS. C. 18.

[2] Matilda's death is given in the Lincoln obituary as 3 May; that of Henry I's wife, another Matilda, as 2 May: see Giraldus Cambrensis, *Opera*, R.S. xxi (7) (1877), 157.

[3] E. Fleury, *Les MSS. à miniatures de la Bibliothèque de Laon* (Laon, 1863).

decorated work, but in its small script (it is a one-volume bible), arrangement, and size ($13\frac{3}{8} \times 9$ in.) it is close to another bible (Corpus Christi College, Cambridge, MS. 48, $13\frac{7}{10} \times 8\frac{3}{10}$ in.), from which the top margin of folio 1, where would be the presentation note, has been removed. This book has fine initials, with some figure subjects and one of the pink beast initials as in the Trinity Hall Leviticus. A bible at Trinity College, Dublin (MS. A. 2. 2), has very similar ornament and layout. Whether or not all these books were written in the St. Albans scriptorium, they form a notable connected group, exemplifying a new fashion in scale and format, and some of them were owned by St. Albans and were produced under the stimulating patronage of Abbot Simon and his successor.[1]

No purpose would be served by any attempt to assess the priority of these developments as between northern France and England: this is once again a Channel style, though one that runs curiously counter to political divisions, for, with all the extent of the Angevin empire to choose from, the marked affinities of English work are with the books produced in the Capetian areas of Ponthieu, Vermandois, Flanders, and Paris. It is perhaps a tribute to the growing supremacy of Paris as a cultural centre and our views might well be clarified if we knew more of the art of painting as patronized by the abbey of St. Victor, in the centre of the activity of the Parisian schools. One Victorine manuscript at least, a volume of Peter Lombard's Commentary on the Psalms, bequeathed by Nicholas, monk of St. Victor, to the Abbot Guerin (d. 1192),[2] is ornamented with small foliage initials on a gilt background and corresponds closely to the English manuscripts which form the second group that we have now to discuss: this presumably is a book produced in Paris, but it is a style, whether France or England has precedence in originating it, that was magnificently handled by English artists.[3]

[1] See M. R. James, *Catalogue of MSS. in Corpus Christi College, Cambridge* (1912), 97.
[2] Bibl. Nat. MS. lat. 11565. A. Haseloff in Michel, *Histoire de l'art*, ii. 1 (Paris, 1906), 308.
[3] For the close relations between England and St. Victor's see J. C. Dickinson, 'English Regular Canons and the Continent in the Twelfth Century', *Trans. of the Royal Hist. Soc.* 5th series, i (1951), 71.

The books in question—and many examples of them have survived—are characterized by a profuse ornament of foliage with thin, finely modelled stems, set in bars and square frames on a burnished gold background: small grotesque figures occasionally appear but there are few historiated initials: in some cases figures, not necessarily grotesques, are shown in medallions or drawn in the margins with no frame or background, but even here it is unusual for any incident to be represented. Small pink, white, or blue lions, pigmy successors of earlier monsters, inhabit the scrolls, and extended beasts and elongated nudes provide the uprights of the letters. The most particular and characteristic feature is, however, the layout of the page. These books, as is that from St. Victor's already instanced, are mainly glosses: they reflect in the arrangement of the page a stage in biblical study, the acceptance of the *Magna Glosatura* of Peter Lombard (completed 1143) and the growth of notes and *quaestiones* upon it, so that the whole apparatus of commentary has become extremely complex and varied. In earlier glossed manuscripts the gloss had been crammed in smaller script into the margins or between the lines of text. Now the whole page is designed to give full weight to comparative material and to create an aesthetic effect out of variations in size of lettering and width of spacing. The ornament, elements of which, apart from long marginal bands, are small in size, is arranged to lead the eye from point to point on the page and to create irregular frameworks to provide the requisite emphasis. It is a highly formalized, elaborate style, and its use of gold and bright colours gives it a marvellously rich appearance, but there is something over finished and calculated about it: it lacks the spontaneous exuberance of the first half of the century. It has trivialities which a rougher method had never employed.

The development of biblical studies between the *Glossa Ordinaria* of Anselm of Laon and the Great Glosses of Peter the Lombard on the psalms and epistles is too complex a subject to be summarized here.[1] The latter's attempt to compare discordant authorities is a significant step in that work of biblical commentary which

[1] See H. Glunz, *History of the Vulgate in England* (1933), and B. Smalley, *The Study of the Bible in the Middle Ages* (1952).

is so pronounced a feature of twelfth-century intellectual life. In the introduction of these new studies to England a large part was played by Becket in his years of exile. Himself no scholar, he seems to have entrusted to Herbert of Bosham the task of producing for Canterbury not only an edition of the Lombard Great Gloss but a complete set of glosses as then used in the learned circles of France. The archbishop referred on his return to England in 1170 to the *bibliotheca* which he had had compiled.[1] Bibliotheca is an ambiguous word: it was the common term for a bible,[2] but also was used for a collection of books other than those of the vulgate. If Prior Eastry's catalogue, which dates from the early fourteenth century, can be relied on, the *Libri Sancti Thome* included a complete set of glossed books of the bible as well as various other volumes.[3] Several of these books have been identified with considerable probability, if not with absolute certainty. There survive, mainly in the library of Trinity College, Cambridge, a group of biblical manuscripts where the gloss is arranged elaborately on the page and where the initials show thin coiled foliage, inhabited by small white lions, with heads or small grotesques set in circles.[4] If these indeed come from Becket's *bibliotheca*, then they are presumably of French workmanship. One of the most splendid, however, the XII Prophets (Trinity B. 3. 11) is inscribed as written by Roger of Canterbury, and the artist of this volume certainly decorated also the Bodleian Pentateuch (MS. Auct. E. Infra 7) (Pl. 67 *a* and *b*).

In Eastry's catalogue Becket's donations are followed by those of his companion, biographer, and most intransigent supporter, Herbert of Bosham. We still have, in four splendid volumes, his revision of the Lombard's *Magna Glosatura*,[5] undertaken at

[1] *Materials for the History of Thomas Becket*, R.S. lxvii (1) (1875), 87.

[2] Thus Archdeacon Nicholas in the catalogue inscribed in the Lincoln Bible is stated to have given *hanc bibliothecam in duobus voluminibus*. Giraldus Cambrensis, *Opera*, R.S. xxi (7) (1877), 165.

[3] M. R. James, *Libraries of Canterbury* (1903), 82, 510.

[4] These manuscripts are Trinity B. 3. 11 (12 Prophets); B. 3. 12 (Joshua, Judges, Ruth, Chronicles); B. 3. 29 (Isaiah); B. 3. 30 (Jeremiah); B. 4. 23 (Epistles); B. 5. 5 (Gospels); and Bodley MS. Auct. E. Infra 7 (Pentateuch).

[5] Trinity MSS. B. 5. 4, B. 5. 6, B. 5. 7; Bodley MS. Auct. E. Infra 6. For last see *New Pal. Soc.* 2nd series (1913–30), Pls. 193–4.

Becket's personal command. Herbert was in exile with Becket and returned with him to England, but he was sent back to France before his master's murder. It is clear from references in his prefaces that his work on the Gloss was completed between 1170 and 1176, for the books are dedicated to William, archbishop of Sens, who in the latter year was translated to the see of Rheims. They are splendidly ornamented and here again the white lions swarm: there are extended dogs and nudes, and in the margins figures; at the beginning Becket entrusting the task to Herbert, elsewhere doctors holding scrolls, and occasionally symbolic persons (Pl. 67 c). Herbert refers in some detail to the layout of the page and it seems likely that these are the actual copies (no others are known) produced under his supervision.[1] If that is so, then they were written and decorated in France, though it is possible that Roger of Canterbury or some other English writer may have been working for the exiles. The *Magna Glosatura*, the great text on which much of the supremacy of the University of Paris was to be based, holds a key position in the spread of French intellectual dominance, and it is natural that the style of presentation should be French also.[2] But if the early examples seem to be French in provenance, English scribes and illuminators soon adopted the new manner: cathedral and monastic libraries throughout England were all equipping themselves with these essential texts, and many of them must have been provided by their own local scriptoria.[3] This too becomes a Channel style, whose motifs rapidly appear in unquestionably English books, even if there were

[1] The prefaces are printed by H. Glunz, *Vulgate in England* (1933), 341. For Bosham see also B. Smalley, 'Herbert of Bosham on the Hebraica', *Recherches de Théologie ancienne et médiévale*, xviii (1951), 29.

[2] For a group of French examples see Y. Delaporte, *Les MSS. enluminés de la bibl. de Chartres* (Chartres, 1929), Pls. 6, 7, 8. Much of the Chartres library was destroyed during the war of 1939–45.

[3] Some examples are Hereford O. 4. vii (Ezekiel and Daniel, given by Archdeacon Ralph Foliot (1163–95)), O. 5. vii (St. John), P. 9. iv (Genesis and Exodus); Rochester MSS. Royal 3. C. VIII, 3. C. IX. The latter is dated in a later hand 'c. 1199': the former seems earlier work. Lincoln in its catalogue of c. 1200 has both partially glossed books (*non integer glossatus*) presented by Bishop Alexander (1123–48) and the ordinary Lombard glosses of which MSS. B. 3. 1 and B. 3. 3 are typical examples. For Durham see below, p. 229.

not from the beginning English hands employed on the great editions de luxe in which the new learning was enshrined.

Canterbury indeed must at this time have been a scriptorium of considerable renown, and men trained in it were in demand elsewhere. A scribe responsible for a remarkable book, the great bible which at one time belonged to St. Loup of Troyes and now is MSS. 7–9 in the Bibliothèque Ste-Geneviève,[1] boasts of himself as Canterbury bred. He gives his name, Manerius, and the very English sounding names of his parents, Wigmund and Leobgifu: unfortunately there is no indication where this book was produced. Connected closely with it is another fine bible (Bibl. Nat. MS. lat. 11534–5) from St.-Germain-des-Prés, and a fragment (a magnificent Genesis initial, canon tables, and the initial to St. Matthew: now Bibl. Nat. MS. lat. 8823) which comes from Pontigny. The decoration of neither the Manerius Bible nor MS. 11534–5 is the work of one hand: a team of artists was employed on producing them, and no examples of their work are known in English libraries or of certain English provenance. The probable interpretation of the Manerius colophon would seem to be that he was an Englishman working in France and the controlling craftsman of a considerable group. The great Genesis initials common to all three works have a complexity which recalls on a larger scale some of the 'Bosham' designs; they have too their richness of gold and colour. The historiated scenes continue an English tradition and we find a familiar treatment of Elkanah and his wives. The grotesque initials, where nude satyrs stretch themselves unbecomingly on the sacred page, are a 'Channel' style but certainly one much used in English work. The canon tables have scenes or single figures of remarkable accomplishment, where a new naturalism is beginning to supersede Romanesque conventions, though the 'marvels', fantastic beasts and human figures, are still evident in the top row. The St. Germain volume in several initials and in the tympana of the canon tables is definitely based on the Manerius bible: the scenes are identical, but the poses and

[1] MSS. 8–10. See A. Boinet, 'Les MSS. de la Bibliothèque Ste-Geneviève', *Bulletin de la Société française de Reproductions de MSS. à peintures*, v (Paris, 1921), 21. *New Pal. Soc.* 1st series (1903–12), Pls. 116–18.

gestures much less sure, the figures slighter and feebler. In some of its foliage initials can be seen the small white lions of the 'Bosham' books. The Pontigny fragment is an independent work, very splendid in scale and colour, but definitely of the same school. This remarkable trio of books stands at the parting between two styles and bridges the gap with great magnificence.

VII

THE LATE ROMANESQUE PERIOD

THE reign of Henry II saw England at the widest extent of its continental dominion: and beyond Henry's actual area of rule he had formed close dynastic alliances. The reflection of this wide European activity in the visual arts is a tempting matter for hypotheses. Tempting but elusive, for the channels by which artistic motifs and manners are distributed are rarely documented and the conjunction of an object from one country with some skilled and influential craftsman of another is a matter of many chances. There are, however, certain coincidences of style which must be indicated, even if they may not be used for establishing any clear scheme of the interrelation of artistic diffusion and political events.

Attention has already been drawn to resemblances between English painting and the mosaic work of Sicily. The great decorative schemes of Palermo and Cefalù begin in 1131 with Roger's foundation of the cathedral in the latter town and continue to the completion of the nave of the cathedral of Monreale c. 1190. It was a period during which there were many and close contacts between England and Sicily.[1] Roger's chancellor was a Yorkshireman, Robert of Selby, whose lavish and generous hospitality was extended to visiting Englishmen, such as William of York or John of Salisbury. Thomas Brown returned from the Sicilian curia to hold office in the exchequer of Henry II and obtain his celebrated mention in the *Dialogus de Scaccario*. Herbert of Middlesex held the see of Cosenza from 1169 to 1180, Richard Palmer that of Syracuse from 1165 to 1183 when he became archbishop of Messina. Another Englishman, Walter of the Mill, was tutor to William II of Sicily and archbishop of Palermo from 1169 to 1187, while his brother Bartholomew held the see of Girgenti. Walter was succeeded as royal tutor by the Frenchman, Peter of Blois, who later was invited

[1] E. M. Jamison in *Proc. of the British Academy*, xxiv (1938), 3, and *Journ. of Warburg and Courtauld Institutes*, vi (1943), 20.

to England by Henry II. Scholars such as Adelard of Bath and Mathias, later prior of St. Albans,[1] studied at the University of Salerno: Gervase of Tilbury, who served first under Henry II and then under William II, tells us of an Englishman who sought from King Roger the gift of the bones of Virgil that he might take them back to England.[2] Sicilian parties intensified their divisions by taking different sides in the Becket quarrel. Later, William II intervened with the pope on behalf of Archbishop Baldwin in his quarrel with the monks of Christ Church, and their proctor at Rome wrote warning the monastery that Baldwin's new foundation at Hackington might well prove to Canterbury as dangerous a rival as was Monreale to Palermo. The climax of this long intercourse was the marriage of Henry II's daughter Joan with William II in 1177. The reception of the Sicilian embassy by Richard Toclive, bishop of Winchester, in his cathedral city, where the girl bride awaited them, was an occasion of considerable display, and the queen-elect later departed with a dowry of gold and silver plate. Richard Cœur-de-Lion was to find her, a widow, in Messina when he came to Sicily on his crusading journey, and to take her eastward with him.

These comings and goings of great men and learned scholars need not, however, imply direct contacts in the arts, though much that they saw must have been new and impressive to them and subject of comment when they returned home. The middle ages had a simple means for the distribution of motifs, the model-book. A few pages of such a book, closely related to the Monreale mosaics, exist in the Augustine museum at Freiburg im Breisgau,[3] and there can be little doubt that some such collections of sketches were brought to England and passed round the main centres of English art. Constantinople, then at the height of an artistic revival under Manuel Comnenus, was the prime source and most accomplished executant of stylistic change, and many transmissions

[1] *Gesta abbatum S. Albani*, R.S. xxviii (4 a) (1867), 194.

[2] *Otia imperialia*, Mon. Ger. Hist. xxvii (1885), 392.

[3] O. Demus, *Mosaics of Norman Sicily* (1949), 445. Dr. Demus treats at length the questions of style and dating of the various mosaic cycles and my discussion of the subject is largely based on his book.

may have come from it without any intermediary. Still the world's great mart, it was also on the main crusading highway, a much admired spectacle to the western pilgrim armies. In the crusading kingdom itself Raoul the Englishman, bishop of Bethlehem, was the most trusted adviser of Queen Melisande of Jerusalem and her son, Baldwin III. Melisande's husband, Fulk, was father-in-law to the Empress Matilda and grandfather to Henry II. The most splendid product of the Jerusalem scriptorium, the so-called Psalter of Melisande,[1] has a calendar full of English saints. Eastern connexions are not hard to seek. But Sicily remains for Angevin England the most frequented meeting-place of east and west, and in Sicily the twelfth-century developments of Byzantine art can be traced in surviving monuments more fully even than in Constantinople itself, where few of the great works of this period have escaped destruction.

In the mid-century, in particular in the apse mosaics of Cefalù, can be seen a new emphasis on linear pattern. At Daphni outside Athens the mosaics, set about 1100, are still illusionist: the figures are shaded to give an effect of projecting roundness, and are lively and natural in their poses and expressions. The Greek artists employed at Cefalu, for there was no previous local school, are more interested in the patterning of the drapery: the figures are outlined flatly, the garments hardly attempt to define the bodies beneath: a new liveliness of folds, now crinkled, now circular, a ceaseless play of surface movement, replace earlier more monumental aims. The face of the great Pantocrator in the semi-dome, a work on an unprecedented scale, is built up of linear formulas. We have here the impetus which in England, where linear sense of design was a deep tradition, led to the brilliant fantastication of the Lambeth Bible. Midway between the two, the artist of the Bury Bible has a keen awareness of the contemporary Byzantine achievement. The slightly later works in Palermo, the mosaics of the Palatine chapel and the church of the Martorana, show a greater ease and naturalism in the poses, but also a tendency for the figures to become somewhat elongated, with heads too small for their bodies. In the latest cycles at Monreale (c. 1183–9) there is

[1] B.M. MS. Egerton 1139.

a stress on narrative scenic content and a new urgency in the movements; the figures spring forward on their toes as do the dancing prophets in the Dover Bible.

Mosaic was the medium of the greatest achievements in Sicily. It was undoubtedly mainly the work of imported artists, and it was not a medium attempted in the West. It remains an inaccessible and glorious imperial art: its shining, changing lights must have been all that northern taste found most pleasing, but there was no attempt to rival it or learn this new technique. Of Sicilian illumination comparatively little is known, but there is no indication that it reached an excellence at all comparable to that of the mosaics. It is in the north that these Byzantine trends, of which these Sicilian mosaics are one of the finest manifestations, were absorbed into a native genius which found in book illustration one of its most creative outlets.

Of all his foreign relationships, those of Henry with his namesake Henry the Lion of Saxony were the closest. From the alliance of 1165 and the betrothal of his daughter to the Saxon duke, the latter was a constant visitor in Normandy or England, which provided a refuge for him in both periods of his banishment: his son Otto remained in England as a close follower of Cœur-de-Lion. When Matilda of England came to Brunswick she brought with her gold and silver and much riches,[1] and it is in metal-work, particularly in enamels, that the most striking parallels are found. Henry the Lion had brought many relics from Palestine, and there survives, though now somewhat scattered, a series of arm reliquaries of which two, still in the Welf treasury at Brunswick, bear the inscription *Dux Henricus me fieri iussit.* The apostle's arm reliquary, now in Cleveland museum, has a series of heads of Christ and the apostles, set in circular coils of foliage in a method familiar in the Ezekiel page of the Bury Bible, a painting that strongly suggests some carved altar piece (Pl. 54 b). On the bronze candlestick of the cathedral in Brunswick, there are enamel roundels which with their curving folds recall English illumination

[1] Helmold, *Chronicle* in *Mon. Ger. Hist.* xxi. 95. See for the whole subject G. Swarzenski, 'Aus dem Kunstkreis Heinrichs des Löwen', *Städel-Jahrbuch*, vii–viii (Frankfurt, 1932), 241; O. v. Falke in *Pantheon*, ii (Munich, 1928), 582, and v (1930), 266.

of the third quarter of the century, while the carved dragons of its base (the only original part of the framework) have forms and motifs which are curiously similar to those of English work.[1] Strangest of all is the Oswald casket, surmounted by a (restored) head of the saint, now in the cathedral treasury at Hildesheim. Inset round the casket are eight seated kings, all inscribed with their names, seven of them English, Ethelbert, Ethelwold, Oswald, Edmund, Alfred, Canute, Edward, and one Burgundian, who is the sixth-century king and saint, Sigismund. This is a cycle that must have some close English origin: Ethelwold, who is a king not a bishop, and Ethelbert, inscribed as saint (the murdered king of East Anglia (792)), would hardly be known outside England. These niello figures have the curving lines and ovoid forms, the drapery tightly drawn over the knees, which we shall find in the Puiset Bible and the northern English school.[2] This casket of the relics of a Northumbrian saint, with its row of English rulers, has English patterns and iconography and may well have come from some English workshop. It is tempting to associate it with the somewhat enigmatic figure of Savaric, bishop of Bath (1192–1205), chief negotiator in the affair of Richard's ransom, who seems on his mother's side to have had kinship with the Burgundian counts and who was much concerned with the proposal that Richard should be enfeoffed with the kingdom of Arles.[3]

It would, however, be wrong to push too far these resemblances between Saxon metal-work and English illumination, for it is probable that the markedly cumbersome forms of this phase of English book illustration owed more to enamel work than they gave to it. The figure of Henry of Blois on the plaque already discussed[4] provides many close parallels to works such as Bishop du Puiset's Bible or the Bodleian Bible, MS. Laud. Misc. 752.

[1] Swarzenski instances the long-eared dragons' heads shown on the carved throne of St. John's Cambridge MS. H. 6, f. 2ᵛ, *Städel Jahrbuch*, vii–viii. 356.

[2] See K. Weitzmann, 'Zwei Fuldaer Handschriften des 12. Jahrhunderts', *Marburger Jahrbuch*, viii (1936), 172: he compares the niello portraits with the physician portrait in B.M. MS. Harley 1585, f. 7ᵛ, which appears to be English work *c.* 1180.

[3] A. L. Poole, 'England and Burgundy in the last decade of the Twelfth Century' in *Essays in History presented to R. L. Poole* (Oxford, 1927), 261.

[4] See above, p. 170.

Enamel work, which had the gleaming quality so much admired by twelfth-century connoisseurs, was small in scale and portable, and much of the demand was undoubtedly met from the main centres of its production, Limoges and the towns of the Maas valley. From this latter region came Godefroid de Claire, 'a man second to none in his time for goldsmith's work, who made many reliquaries for the saints in diverse regions'.[1] The course of his travels, before he returned in 1173 after twenty-seven years to die at his monastery in Huy, is not known: certainly he worked at St. Bertin and likely enough came to England. Certainly also the movements of such craftsmen gave a common form to the products of other localities where this branch of the arts was being pursued.

In England, Bury St. Edmunds, St. Albans, Ely, to take three houses, all chronicle their achievements in metal-work, but we can only imagine the great shrines and altar tables from representations of them in miniatures[2] or from analogy with those on the continent, the altar of St. Maurice made by Fridericus of St. Pantaleon at Cologne, a house that had two English abbots, or the great golden altars in which Denmark is still so rich. Even the smaller objects that survive can be termed English only by provenance, with no stylistic and certain differentiation from continental pieces. Of these a group of three ciboria show some striking similarities to the patterns of illumination in their coiling foliage which forms roundels in which the figure scenes are set. These scenes, drawn with great vigour and skill, are arranged typologically, Old Testament prefigurations round the bowl, the New Testament fulfilment on the cover. The series are very similar: the Kennet ciborium[3] shows the Circumcision of Isaac, Isaac bearing logs, the Sacrifice of Abraham, Samson and the gates of Gaza, David slaying the bear, as parallels to the Baptism, Bearing of the Cross, Crucifixion, Marys at the Tomb, Harrowing of Hell, and

[1] See on Godefroid and on the whole question of enamel work, O. v. Falke and H. Frauberger, *Deutsche Schmelzarbeiten* (1904); and K. H. Usener, 'Reiner von Huy und seine künstlerische Nachfolge', *Marburger Jahrbuch*, vii (1933), 77.

[2] See some examples in W. H. St. John Hope, *English Altars from Illuminated MSS.*, Alcuin Club Collections, i (1899).

[3] Lent by Lord Balfour of Burleigh to the Victoria and Albert Museum.

Ascension. The Malmesbury ciborium[1] has a similar though not identical series of types, and the Warwick ciborium,[2] of which the cover is missing, also uses several of the same incidents (Pl. 69 b). The garments show the large ovoid patterns which became such a dominant feature of the last Romanesque phase: the foliage is a pronged acanthus leaf. The deep blues, reds, and greens of the enamel set in the copper gilt frame-work make a splendid harmony of tones. A series of seven plaques with scenes from the lives of St. Peter and St. Paul, now divided between various museums,[3] has some claim to an English provenance: certainly its figures (Pl. 51 c) are in a convention that was completely acclimatized in our scriptoria.

Two bronze bowls in the British Museum engraved with narrative scenes illustrate another branch of the metal-worker's art. One with scenes of the life of St. Thomas the Apostle has finely drawn figures which suggest a style contemporary with or based on that of the Durham St. Cuthbert (University College MS. 165).[4] The second, less skilfully drawn and stylistically somewhat later, possibly the third quarter of the century, shows the birth, labours, and death of Hercules. A similar bowl, which passed into private ownership, was found at the same time and in the same place, the Severn bed between Tewkesbury and Gloucester: it sets out the story of Scylla. The pair thus presents a striking example of the use of mythological subjects and strengthens the probability that many of the initial figures have some classical allusion. The St. Thomas legend was clearly popular with some group of metal-workers, for there is another St. Thomas bowl in the Louvre and two more, stylistically work of the first half of the century, were found at Bethlehem and are now in the museum of the Flagellation at Jerusalem. There is no certainty of their place of origin. The provenance of various other such engraved bowls points to the Mosan area, but as with enamels there is no reason to think that the craft was not practised elsewhere.[5]

[1] Now in the Pierpont Morgan Library, New York.
[2] Victoria and Albert Museum M. 159–1919.
[3] Metropolitan Museum, New York, Victoria and Albert Museum, Lyons, Dijon, Nuremberg. See M. Chamot, *Enamels* (1930), 35, and H. P. Mitchell, 'English Enamels of the Twelfth Century', *Burl. Mag.* xlix (1926), 161.
[4] See above, p. 28. [5] O. M. Dalton in *Archaeol.* lxxii (1922), 134.

Henry himself did little to encourage developments in the arts. In the anecdotal accounts of his reign that we have from writers such as Walter Map and Gerald of Wales or in the letters of Peter of Blois, the picture of his court, despite the literary figures connected with it, is of a somewhat blunt and boisterous society, fond of jests but without subtlety or refinements: gone are the clerical complaints about the long-haired *effeminati* of the times of Rufus and Henry I: a prodigious worker, incessantly mobile even for a medieval king, 'a vehement lover of woods'[1] and the chase, a serious reader, but for instruction rather than pleasure, impatient of religious ceremonial, whispering or doodling (*Picturae aut susurro vacabat*)[2] in his oratory, the second Henry had neither the amenities nor taste of a patron or collector. It is characteristic that it is only in the Pipe Rolls, from 1155 a new and invaluable source of evidence, that we can trace any of his building activities, particularly the work on his palace at Clarendon. Here and there a note of luxury creeps in, such as repairs to the glass windows of the king's house at Westminster.[3] But such references are few: nor are remains extant of any of his palaces, except as foundations for other buildings or as fragmentary pieces of carving. Something of their furnishings, the cross-legged stools with dragon terminals, or the more elaborate arm-chairs, such as that which still exists at Hereford, are familiar to us in illuminations and on seals: we are familiar also with the long couches and their small roll-like pillows; with the water jars and pottery bowls.[4] The accessories were probably scanty enough: ornament consisted in carving, iron-work on the doors, tapestries, embroideries, and wall-paintings. Of these secular decorations nothing now remains and little enough information has come down to us. Alexander Neckham (1157–1217), foster brother of Richard I and at the end of his life abbot of the Augustinian house at Cirencester, inveighs in his *De naturis rerum*[5] against the too great luxury, 'the superfluous adornment'

[1] 'Peter of Blois, Ep. LXVI', Migne, *P.L.* cvii, 198. See A. L. Poole, *Domesday Book to Magna Carta* (1951), 318.

[2] Ralf Niger, *Chronica*, ed. R. Anstruther, Caxton Society (1851), 169.

[3] *Pipe Roll 25 Henry II*, Pipe Roll Soc. xxviii (1907), 125.

[4] See for examples Pls. 6 *c*, 10 *b*, 35, 41, 52, 53, 64 *b*.

[5] R.S. xxxiv (1863), 281. See T. H. Turner, *Domestic Architecture in England* (1851), 15.

of dwelling-places, the many turrets, the smooth and polished plaster of the walls, the carved beams of the ceilings which only serve for spiders' webs. Some of the wall-paintings were topical in their content even to the extent of being cartoons of current events, for Giraldus Cambrensis tells us how in a room at Winchester Henry had a scene painted of an eagle attacked by four eaglets, as a satire on the conduct of his sons.[1] Something of the style in which current events were treated can probably best be seen in Giraldus's own pages, for a copy of his *Togographia Hibernica*,[2] which must date from soon after its completion in 1188, has vigorous marginal drawings of Irish life and of the odd tales which he tells about it (Pl. 31 e). So apt were these little drawings that they were copied in the second half of the following century in a Bodleian manuscript, Laud Misc. 720, and yet again in MS. Ff. 1. 27 in the Cambridge University Library.

As with his grandfather, the first Henry, Henry II's building activities were largely concerned with castles, both in England and in his continental dominions. Much of his expenditure on them can be traced in the Pipe Rolls and now the names begin to recur of his chief engineers: thus Alnoth, employed on the building of Orford in 1165–6, is probably the Alnodus who in 1174 was dismantling the baronial castle at Framlingham and is also found working at Windsor and Westminster, holding between 1153 and 1189 the important office of keeper of the king's houses.[3] Orford, one of Henry's earliest castles, was an experimental venture. The keep, about 63 feet high, is a polygon of eighteen sides flanked by three towers, each rising some 20 feet higher than the main block: in addition there is a small fore building containing the entrance stair with above it the chapel: the main rooms within are circular, with apartments opening off them in the flanking towers. The aim of this curious and unique plan was presumably to avoid the

[1] *De principis instructione* III, c. 26, R.S. xxi (8) (1891), 295.

[2] B.M. MS. Royal 13 B. VIII; there is another late-twelfth-century example with similar drawings in the National Library at Dublin, MS. 700. For Giraldus Cambrensis see J. Conway Davies in *Archaeol. Cambrensis*, xcix (1947), 85, 256.

[3] See C. T. Clay, 'The Keepership of the Old Palace of Westminster', *E.H.R.* lix (1944), 1; J. H. Harvey, 'The Mediaeval Office of Works', *Journ. Brit. Arch. Ass.* vi (1941), 20, and 'The King's chief Carpenters', ibid. xi (1948), 14.

blind corner angles of a rectangular tower, and this is borne out by the placing of arrow slits in the side walls of the projecting towers: incidentally the plan also provided convenient small rooms, thereby allowing of some privacy, and, though only a sea coast garrison-post, Orford in its cooking and sanitary arrangements and careful masonry (local 'London clay' with limestone quoins and some facings of Caen stone inside) sets a comparatively high standard of comfort. Its total cost seems from the Pipe Roll to have been about £1,400.[1] Henry five years later built another polygonal keep, this time an octagon only, at Chilham in Kent: after that in England the polygonal type was abandoned. It is possible that the octagonal keep at Gisors in Normandy, originally built by Henry I but much enlarged by Henry II, may have influenced the English versions. The keep of Conisborough, of excellent ashlar with a beautifully ornamented chapel in its third story and fine pillared fire-places in its two halls (Pl. 20 *b*), was built by Henry's half-brother, Hamelin Plantagenet (d. 1201),[2] who had married Isabel, heiress of the Warenne family. Its plan, a circle with six solid buttress towers projecting 9 feet from the main building, is midway between the polygonal keep and the round keep which became popular at the end of the century. Its construction is not documented and its curious carved capitals, which include water-leaf, suggest a date in the last quarter of the century.

Henry's principal castles retained the rectangular keep. Scarborough was taken into royal possession early in the reign, and almost certainly 'the great and famous keep', 56 feet square and 70 feet high, was built at this time. It still has many of the features of earlier work, the flat pilaster strips and the beaded moulding at the meeting of the corners: the curtain wall of the bailey had semicircular towers of no great projection, mainly solid but with some larger ones which were hollow.[3] Henry was

[1] R. A. Roberts, *The Story of Orford Castle* (Ipswich, 1933).

[2] G. T. Clark, *Military Architecture*, i (1884), 431; A. Hamilton Thompson, *Military Architecture* (1912), 167.

[3] William of Newburgh in his *Historia rerum Anglicarum* (*Chronicles of Stephen etc.*, R.S. lxxxii (1) (1884), 104) has an unusually romantic account of the castle and its site.

at about the same time (1174) carrying out work on the great keep at Richmond recently erected by Conan of Richmond and Brittany (d. 1171), which resembled Scarborough in scale (52 × 45 feet but rising to the great height of 100 feet), in many details, and in being built at the weak point of the defences of a plateau, in fact over the original gateway. Certain new features are to be found in the keep at Newcastle and coincide with the appearance (1174–5) of a new name in the Pipe Rolls, Maurice the *Cementarius*, paid at the high rate of 1s. a day as compared with the 7d. a day paid to Alnoth.[1] A motte existed at Newcastle, but it was not used for Henry's keep, which was placed on the wall of the triangular bailey, and had three stories with the entrance on the third story, reached by a long external staircase running along the south and east walls, protected by two towers joined by an outer wall. Underneath the stair is a fine chapel, whose ornamental detail is so close to that of Bishop Hugh du Puiset's Galilee at Durham as to suggest some interchange of workmen. Between 1181 and 1187 Maurice, now described as *Ingeniator*, appears as working at Dover.[2] Here again there is a great three-storied keep, 98 × 96 feet, and to the top of its turrets 95 feet high. A forebuilding covers the stairway that leads to the main entrance. On the level of the second floor the forebuilding contains a chapel, entered through an arch supported by detached columns whose capitals have 'stiff leaf' foliage curving into volutes and must owe much to the contemporary rebuilding of Canterbury choir. The base mouldings are an advanced version of those used at Newcastle but are even closer to the corona chapel at Canterbury, and the pointed chevrons enriched with smaller chevrons fitting flatly within the main form are exact equivalents of those in the new ambulatory of William the Englishman.[3]

Tower keeps of these proportions could seldom utilize the motte or any artificially raised eminence, which would have been unequal

[1] *Pipe Roll 21 Henry II*, xxii (1897), 184. There are plans and sections of the keep in *Vetusta Monumenta*, v (1835), Pls. x–xviii.

[2] Lieut. Peck, 'Notes on the Keep, Dover Castle', *Journ. Brit. Arch. Ass.* xx (1914), 242; E. R. Macpherson in *Arch. Journ.* lxxxvi (1929), 251. See *Pipe Roll 28 Henry II*, xxxi (1910), 150, and other references under dates.

[3] See below, p. 251.

to their weight without much complicated reinforcing. Henry's engineers, however, did not always forsake the motte system, but in some cases strengthened it by replacing the palisades with stone walls, generally round in plan, thereby following the shape of the mound and avoiding the weakness of rectangular corners. The process of replacement of wood by stone was being actively pursued throughout the kingdom, though but few of these round walls, less lasting and less habitable than the towers, have survived. Of these shell keeps of Henry's reign, Windsor from its future history is perhaps the most notable. Farnham castle is another example built by Bishop Henry of Blois *c.* 1160, and here it was coupled with an interesting development, the removal of the hall and the living quarters from the motte and their erection in stone in the courtyard below. Though the walls of the hall were of stone, the double row of pillars which supported the roof were of wood with wooden scalloped capitals, one of which is still in position. The entrance recalls, with its segmental arch and banded columns, the work at Newcastle and Dover and is probably therefore later than the death of Bishop Henry in 1171.[1] The pillared hall, an example of which survives in such graceful completeness at Oakham in Rutlandshire, had, however, despite the early precedent of Rufus's hall at Westminster, not yet become the normal form, and the dog-tooth decoration, classical acanthus foliage, and figure carving of Oakham (built by Walchelin de Ferrers, d. 1201) place it in the closing years of the century.[2] The great hall built by John at Corfe castle, whose ruins show some of the continuous mouldings and masonry details of Wells, was known as the Gloriat. At this time a place of enforced retreat for royal ladies, John's niece Eleanor of Brittany, the daughters of the king of Scotland, Corfe seems to have combined strength with a certain measure of more modern elegance.

Of the lesser houses of town and country, built purely for residence and with no scheme of defence except strongly bolted doors, we know comparatively little. In the main they were timber structures, though in the country districts there must have been

[1] C. R. Peers in *V.C.H. Surrey*, ii (1905), 599.
[2] C. M. Jamison in *V.C.H Rutland*, ii (1935), 8.

many hovels rudely composed of mud and rubble, with little science of building about them. The wooden frames of the more ambitious dwellings were a subject of constant experiment, but there are no surviving examples of this period by which we can judge their aesthetic effect or the means taken to ornament them. Undoubtedly wood carving entered into it and carved wooden capitals still exist at Farnham, as already noted, and in the bishop's palace at Hereford. Some stone structures seem to date from the twelfth century: they are in general of two stories, a vaulted basement and an upper 'hall'.[1] The Constable's House at Christchurch is one of the more notable remaining examples, with its windows divided by colonnettes and set under elaborately moulded dripstones, but this is a domestic building within the walled circuit and forming part of the general scheme of the castle. The most complete twelfth-century house (c. 1200) is the Manor House at Boothby Pagnell in Lincolnshire, where the upper story, raised on a vaulted ground floor, is divided into a hall and inner chamber or solar. Lincoln is particularly rich in twelfth-century dwelling houses: St. Mary's Guild, largely rebuilt but with some fine pieces of carving; the 'Jew's' House, with unusual interlace carving on its entrance arch; and 'Aaron's' House. 'King John's' House at Southampton and 'Moyse's' Hall at Bury St. Edmunds are other examples, showing that town dwellings, though still small with few divisions into separate apartments, were built with good masonry and some elaboration of detail. The names are traditional, in some cases, such as that of Aaron's House, very recent traditions, but it is probable enough that in the late twelfth and early thirteenth centuries wealthy Jews, who stood outside the feudal society with its castle dwellings, were setting a new standard in ordinary domestic comfort and were also for purposes of security preferring stone to wooden walls.[2]

Of Anglo-Norman woven and stitched wall hangings of this period, only one has come down to us, the celebrated Bayeux tapestry. Stylistically closer to Norman illumination than to

[1] M. Wood in *Arch. Journ.* xcii (1935), 167 and cviii (1951), 165.
[2] H. Rosenau, 'The Relationship of Jew's Court and the Lincoln Synagogue', *Arch. Journ.* xciii (1936), 51.

English, it may yet in execution be English work, for it seems that already England was renowned for its needlework, a craft that in the thirteenth century she was to raise to the level of a major art. William of Poitiers comments on the skill of English seamstresses and their tissues of gold.[1] Edith, the wife of the Confessor, and Margaret of Scotland were both noted for their embroidery, and the chamber of the latter was like 'a heavenly workshop' with the vestments that were being prepared there.[2] In the twelfth century we know by name one celebrated needlewoman, Christina, the anchoress, friend of Abbot Geoffrey of St. Albans. When in 1154 Nicholas Brakespere became pope as Adrian IV, it was a great occasion in St. Albans, for his father had become a monk there and was still living as one of its inmates. The new pope himself had as a boy been brought to the then abbot to be accepted as a novice: but 'having been examined was found insufficient' and rejected.[3] He was known, however, to bear no ill will, rather to profess great devotion to St. Alban and his abbey, and the new abbot, Robert, proceeded to Rome to offer him his congratulations, bringing him costly gifts. Of these the only ones that the pope accepted were 'three mitres and sandals', sewn by Christina, which he took because of the admirable quality of the work.

The patterns in embroidery seem to have followed the familiar formulas employed in painting and carving and no doubt copied in the same medium the eastern fabrics which formed one source of the Romanesque repertory.[4] We have many lists of such vestments: two dalmatics given by Lanfranc to Canterbury were embroidered respectively with golden beasts in circles and with two-headed eagles;[5] at Sherborne two albs were apparelled with lions, griffins, goats, and small birds.[6] Clearly the twelfth-century use of secular or even pagan themes, so noticeable in church

[1] A. Duchesne, *Historiae Normannorum scriptores antiqui* (Paris, 1619), 211.

[2] *Acta sanctorum*, ii (Antwerp, June 1698), 329. On the whole question see A. G. I. Christie, *Eng. Med. Embroidery* (1938) and D. Talbot Rice, *O.H.E.A.* ii (1952), 242.

[3] *Gesta abbatum*, R.S. xxviii (4 *a*) (1867), 126.

[4] G. Robinson and H. Urquhart, 'Seal bags in the Treasury of the Cathedral Church of Canterbury', *Archaeol.* lxxxiv (1934), 163.

[5] J. W. Legg and W. H. St. J. Hope, *Inventories* (1902), 57.

[6] See above, p. 90.

carving, extended also to the splendid garments of the participants in the ceremonies. The Judaizing tendencies, so marked in biblical studies and in the prominence given to Josephus, are shown too in the elaboration of ritual garments, particularly in the use of the great flat brooch known as the *rationale*, which is based on the ephod, and in the custom of sewing small bells along the foot of the copes. A cope given by Conrad to Canterbury had 140 silver bells: one given by Ernulf to Rochester was similarly ornamented.[1] The Peterborough Chronicle of Hugo Candidus gives us some insight into how these vestments were worked, for when Abbot Ernulf wished to have a cope made he gave the work to his 'secretarius' Wictricus and his assistant Reginald, who had made many chasubles and copes, sewn with gold.[2] Some of these embroidery designs used large narrative themes such as the dorsal given to St. Albans by Abbot Richard (1097–1119) in which was figured the passion of the patron saint.[3]

Of these splendid pieces practically nothing survives. Lanfranc's copes were so thickly sewn with gold that they were burned (in 1371–2) in order to fuse and recover the metal.[4] Others no doubt were similarly treated and many more perished with age. Preserved, however, in the cathedral treasury at Sens is a set of vestments which in an inventory of 1446 are described as those of St. Thomas of Canterbury. There seems little reason to doubt this ascription. The embroidery is either foliage or geometric patterns, with two angels on the chasuble and four dragons on the stole. The alb, if the linen as well as the apparels is original, must be one of the few garments in that material surviving from this period. Somewhat more elaborate work is to be seen on the buskins, amice, and stole of Archbishop Hubert Walter (1193–1205), found when his grave was opened in 1890.[5]

Like the *Libri Sancti Thome* listed under his name in the Canter-

[1] J. W. Legg, *Inventories* (1902), 44, 46.

[2] *The Chronicle of Hugh Candidus*, ed. W. T. Mellows (1949), 91.

[3] *Gesta abbatum*, R.S. xxviii (4 *a*) (1867), 70.

[4] J. W. Legg, *Inventories* (1902), 13.

[5] There are magnificent reproductions of these pieces in W. H. St. John Hope, 'On the Tomb of an Archbishop recently opened in the Cathedral Church of Canterbury', *Vetusta Monumenta*, vii, Pt. 1 (1893).

bury catalogue, these vestments at Sens need not be English work. The archbishop as an English patron remains an elusive figure: the splendour of his chancellorship is contrasted with the austerity of his episcopacy: but his years of exile in France are curiously recurrent as a point of diffusion. A monk, John of St. Satyr, writing to Richard of St. Victor, says that he is following Becket to Canterbury and bringing the gift of a book cover of Limoges work with him,[1] the earliest reference to this product in England. The loyal followers of Becket, who went into exile with him, form a group familiar with the continental practice of the arts.

Becket in another respect has a curious prominence in art history. The rapid growth of his cult, proclaimed by Alexander III for the whole church, led to a demand for representations of the main scenes of his life. For these there was no traditional iconographic pattern, and the new saint was thus a stimulus to artistic inventiveness. One of the earliest representations of him is in the mosaics of Monreale, but here he is a conventional figure identifiable only by his inscription. Henry's daughter, Eleanor, wife of Alfonso III of Castile, founded a chapel of St. Thomas in Toledo cathedral, and the oldest surviving series of wall-paintings of the saint's life and martyrdom comes from the Spanish church of S. Maria of Tarrasa near Barcelona; these from their style may well date from the last quarter of the century. From the early years of the thirteenth is the second series, in the cathedral at Brunswick, where Matilda of England was buried with her husband Henry the Lion.[2] In England, by the turn of the century, the iconography at least of the martyrdom seems to have been established and the setting of the scene, the hanging lamp, the figure of the clerk, Grim, behind the altar, the bear on the shield of Fitz-Urse, appear in the Psalter, which is now B.M. MS. Harley 5102, and were copied some fifty years later in the Carrow Psalter, now MS. 34 of Walters Art Gallery in Baltimore.[3] From the early thirteenth century comes

[1] M. Chamot, *Enamels* (1930), 6.
[2] On all these questions see T. Borenius, *St. Thomas Becket in Art* (1932). For Tarrasa see W. W. S. Cook and J. G. Ricart, *Ars Hispaniae*, vi (1950), 91.
[3] The martyrdom is also shown in the Huntingfield Psalter (Pierpont Morgan

too a mitre with St. Thomas's martyrdom on one side and that of St. Stephen on the other, a connexion based on the fact that St. Thomas's feast day on 29 December follows at three days' interval that of the first martyr.[1] But all branches of the visual arts drew on this popular subject: it is shown on a stone font at Lyngsjö in Sweden; on enamelled Limoges caskets, a larger group than any connected with other saints;[2] and above all in the stained glass of Canterbury cathedral.

It might have been expected that of all Henry's alliances his own marriage would have been the most influential in cultural affairs, for the court of Aquitaine was celebrated for its ease and civility. Eleanor, however, though she patronized literature and drama, has few associations with the visual arts.[3] Aquitainian motifs had, as we have already seen in dealing with the Hereford school, found their way to England before the marriage took place, and there is little trace of any increase in English borrowings from south-west France. If a reflection of the new ties is to be sought in our architecture, Rochester cathedral is almost the only surviving building that supplies an example of it. Here at some period in the latter half of the century, possibly following on the fire of 1177, though there is no sign that the west front was damaged by it, a tympanum was inserted above the central door and the earlier Norman arcading was cut through to provide space for it. This tympanum, unfortunately considerably damaged, shows Christ in a mandorla, with on either side two supporting angels, standing, not flying as in the usual English version, and the signs of the evangelists: on the lintel are the small figures of twelve seated apostles (Pl. 68 a). The figures are slender, the drapery finely marked: there is a distinction and quality about the work which makes most of the

MS. 16, c. 1200) and a Psalter Amiens MS. 19, probably the earliest version. See below, pp. 281, 289.

[1] Becket had used a votive mass of St. Stephen at the crisis at Northampton and the link between archbishop and protomartyr may have existed in the minds of his followers during the former's lifetime.

[2] See for an example that belonged to Malmesbury, 'Ein Limousiner Reliquiens-kästchen', *Pantheon*, vi (1930), 412. Another is in the possession of the Society of Antiquaries: see *Notes on the Society's History and Possessions* (1951), 68.

[3] For an estimate of Eleanor's cultural interests see A. Kelly, 'Eleanor of Aquitaine and her Courts of Love', *Speculum*, xii (Cambridge, Mass., 1937), 3.

carving we have been considering appear provincial. The innermost voussoir is formed of a curious pattern of birds bending back their heads, rarely found in this country (Shobdon provides an exception) but a motive common in Aquitaine, as for instance on the front of Notre-Dame-la-Grande at Poitiers, a work completed in the mid-twelfth century.[1] This close French parallel is further borne out at Rochester by the insertion of column figures, Solomon and the Queen of Sheba, on either side of the doorway. These were not part of the original design and it is clear that the columns have had to be adapted for them by cutting away the central ring, which still ornaments the columns of the other orders. They are the only surviving example *in situ* in England of column figures[2] like those used at St. Denis by Suger or at Chartres on the west front, built in the fifties. Similar figures, under elaborate voussoirs which appear to have included bending birds, once existed on the doorway of the old Moot Hall in Colchester, pulled down shortly before 1846.[3]

Near by two village churches show the influence of the Rochester masons: Patrixbourne has on its voussoirs coils of foliage surrounding human heads: a similar motif occurs on the voussoirs of the Rochester west door. At Barfreston the priest's door and the carving of the unusually elaborate east end are close in style to Patrixbourne and include the backward bending birds of Rochester and Aquitaine. The south door is a brilliant piece of work admirably preserved: Christ in Majesty is set in coils of foliage among which appear the heads of a king and queen and below land monsters and mermaids; on the keystone of the arch is the figure of a bishop; the voussoirs have music-playing beasts and scenes of feasting and labour. It is a summary of the world imagined and executed with real freshness of originality (Pl. 68 *b*); some individual genius has

[1] E. S. Prior and A. Gardner (*Figure sculpture in England*, 1908, 198) date Notre Dame without quoting any authority as 'probably not before 1180' and therefore assign the Rochester carving to a period after the fire of 1177, but so late a date for Notre Dame is not now accepted.

[2] The figures at Kilpeck (see above, p. 82), which are carved in a triple tier on the shaft, have something of the nature of an applied column leading to a somewhat awkwardly suspended capital, but are in fact relief carvings on the flat face of the jamb.

[3] 'Proceedings', *Journ. Brit. Arch. Ass.* i (1846), 143. Drawing by A. J. Sprague.

left his mark on it, possibly some Canterbury mason, for there a vigorous prior, Wibert, between 1151 and 1167 was doing much building, particularly the laver house on its circle of open arches (his plans for the waterworks survive in the end pages of Eadwine's Psalter) and the new hall, work with some elaborate decorative detail, though in nothing that survives is the actual Barfreston hand apparent.[1]

If Rochester and its school of carvers may be taken as an example of foreign influence, others of our later Romanesque buildings show a continuance of English traditions and their decoration is closely parallel to contemporary manuscript styles. These buildings largely consist of alterations or additions to the great churches of the first half of the century, the western transept and façade of Ely, the Galilee of Bishop Hugh du Puiset at Durham, the completion of the nave of Peterborough; or of less ambitious country churches, fortunately too rich a surviving heritage to be mentioned in detail. A few selections must serve to illustrate this phase of our art history. One building, however, stands out, about which there can be no option: and were not its own merits sufficient, a sense of piety would prompt its choice, piety towards its inmate and librarian William, the most artistically observant of all our twelfth-century chroniclers, though he did not live to see the work which we must now consider, for the *Historia novella*, the last of his writings, breaks off with the events of 1142.[2] The *Gesta pontificum* to which I have so constantly referred was an earlier work completed by 1125: his *Gesta regum* was of about the same date but revised in the later thirties. Of the former, the *Gesta pontificum*, the author's autograph or at least working copy survives and is now MS. 172 of Magdalen College, Oxford.[3]

[1] It has been suggested that Barfreston, where there is evidence of some of the material being re-used from another site, was built after the monks of Christ Church destroyed Archbishop Baldwin's new foundation at Hackington (1190): but Hackington was begun in 1185 and this seems too late a date. R. C. Hussey, 'Barfreston Church in 1840', *Archaeol. Cantiana*, xvi (1886), 142. Fragments of its elaborate wall-paintings still remain. See also *Journ. Brit. Arch. Ass.* xx (1914), 172, and F. H. Worsfold, *Barfreystone Church* (Canterbury, 1949).

[2] See M. R. James, *Two English Scholars* (1931).

[3] N. R. Ker, 'William of Malmesbury's Handwriting', *E.H.R.* lix (1944), 371.

Malmesbury abbey had been seized by Roger of Salisbury into his own hands and he had built a castle there. On his death in 1143 the monastery regained its independence and it must be some time after that date that rebuilding was undertaken. William, writing in 1125, states, with what must have been pious exaggeration, that the existing church, which was probably tenth century, 'exceeded in size and beauty any other religious edifice in England'.[1] Of the new building, little is known of the east arm though there are indications that it was on an ambulatory plan, as was common throughout the south-west. The interior elevation has nothing in common with the Gloucester–Tewkesbury type: in the transept there is at the second stage a large central arch supported on either side by two smaller and very narrow ones: in the nave, the tribune opening is approximately half that of the lower arcade and is divided into four small arches. The ground arcade is carried on round pillars and has slightly pointed arches on the Cistercian model with a string course carved in a Greek key pattern. The clerestory, which has a wall passage, was remodelled when the nave was vaulted in the early fourteenth century. But it is the external decorative work that makes Malmesbury so outstanding. Arcades of interlacing arches were freely employed: the external wall face of the clerestory is decorated with carved plaques 19½ inches in diameter: the west door, of which only a fragment remains, had figure scenes, probably the Labours of the Months and signs of the zodiac, carved in medallions, and the same decorative motif was used on the south door, where still exists one of the most complex of our iconographical schemes.[2] The outer porch consists of eight orders, continuous arches without any break of capitals or responds or division into columns, a splendid fashion of this period. Five of these orders carry foliage or geometric ornament. The second, fourth, and sixth members have figure subjects set in the oval openings of a trellis-work design (Pl. 69 a).[3]

[1] *Gesta pontificum*, R.S. lii (1870), 361.

[2] H. Brakspear, 'Malmesbury Abbey', *Archaeol.* lxiv (1913), 399. There are important drawings by F. Nash in *Vetusta Monumenta*, v (1835), Pls. I–IX. See also M. R. James, 'Sculptures at Malmesbury', *Proc. of the Cambridge Antiquarian Soc.* x (1904), 136.

[3] A fragment of the lower part of a seated figure in a similar oval, work of high

On either side the lower parts of the arch seem to show a Psycho-machia, though many of the scenes are damaged past recognition: in the semicircles of the arch are three biblical cycles, the Creation to the death of Cain, Noah to Goliath, the Annunciation to Pente-cost. Almost certainly there is a typological relationship between the scenes: thus the story of the Fall is matched by scenes of salva-tion, the Ark, Abraham and the Angels, Moses, the heroism of Samson and David, of which the life of Christ is the fulfilment: and within the main statement there are more detailed comparisons, Moses striking the Rock with the Last Supper, Samson and the gates of Gaza with Christ rising from the Tomb. Battered and blunted as is the detail, the dramatic tension of the poses, the inventive grouping, and the elegance of the damp fold drapery cannot be altogether obscured. The Sacrifice of Isaac has a taut vigour com-pletely differentiated from the sinking lines of the Burial of Christ: the Christ of the Resurrection has a curious aloofness that only a master carver could have given to the scene. Within the porch, the inner door has a Christ in Majesty on the tympanum and close-knit curling foliage on the continuous archway: on the side walls of the porch are two other tympana: on each are six seated apostles with an angel passing above them. These carvings, in high relief and approximately half life-size, are perhaps the most remarkable pieces of English stonework that have come down to us from the twelfth century. The drapery is highly linear with some remains of damp fold patterning: the seated poses are differentiated by the movements of the hands and the angles of the heads: above, the outstretched figure of the angel, below, the triangular 'chevron' spacing between the pairs of legs, mould the design into a unity and make a fitting climax to all the slenderer elaboration of the outer doorway. Carved direct on the ashlar facing, these apostles have something of the breadth and vigour of fresco painting (Pl. 78 b).

The continuous arch, unbroken by impost or capital, of which Malmesbury is the greatest example, was a widely distributed form found in many parts of England and also, though rarely, in Nor-mandy. An early stage of its use may be seen at Southwell, where

quality, was recently found in the course of work at Whitehall: it is a reminder of the extent of our losses and the gaps in our knowledge.

doors and windows have an inner frame of continuous chevron ornament. At another Nottinghamshire church, that of Balderton (Pl. 70 a), the continuous arch is made up of beak heads, a convention used at several other churches such as Earls Barton in Northamptonshire, St. Peter's in the East, Oxford, and, with a splendid lavishness, at the west door of Iffley, the church founded outside Oxford by Robert de St. Remi between 1175 and 1182 and still one of the most perfect of our smaller Romanesque buildings.

It is in fact in its varied treatment of the doorway that Anglo-Norman art realized some of its happiest achievements. So satisfactorily did they frame the entrance to the church that later ages were loath to part with these ingenious and memorable portals. Constantly we find that where a church has been rebuilt, its Norman doorway has been preserved, sometimes even taken down and carefully re-erected as, for instance, at Water Stratford in Buckinghamshire, where a church rebuilt in 1828 still boasts two Norman doorways whose carved capitals and tympana are fine examples of the gradual fusion of Anglo-Saxon, Viking, and Norman motifs. The barest catalogue would run to much length and even then almost inevitably leave some examples unmentioned. Here it is only possible to indicate some of the main features. Many of the doorways have carved tympana, some with figure scenes. Those that survive are generally in small churches, often crude and naïve in workmanship, undocumented, and difficult to date.[1] Aston Eyre in Shropshire, where the carving of Christ's entry into Jerusalem has straight linear drapery, the large heads of the St. Swithun's Psalter, and a wonderfully elongated ass, is a typical specimen of this provincial work of the mid-century. At Quenington in Gloucestershire the small church has preserved two unusually splendid Norman doorways, richly recessed with chevron and beak-head ornament and with tympana which, if worn and probably always somewhat flatly conceived, are remarkable iconographically for an early representation of the Coronation of the Virgin and a very detailed Harrowing of Hell.[2] The Adoration of

[1] See D. Talbot Rice, *O.H.E.A.* ii (1952), 152, for a discussion of this question.
[2] J. Knowles and C. E. Keyser, 'Symbolism in Norman Sculpture at Quenington', *Arch. Journ.* lxii (1905), 147.

the Magi, a subject so popular in France, only occurs in one surviving English tympanum, now fixed on the south wall of Bishopsteignton church in Devonshire, a strange work whose straight hatched garments and fan-shaped skirts have an archaic appearance, though probably of the same mid-century date as the beak heads and foliage on the west door (Pl. 71 b).[1]

Other churches, without any tympanum in the doorway, have a figure set in a niche above the arch. The church of St. Giles at Balderton, already mentioned for its continuous beak heads, has such a niche figure, much damaged but of admirable quality, with thin, closely marked drapery that recalls French examples (Pl. 70 a). In Worcestershire Rouse Lench has a seated Christ, with fluttering drapery, in a round arched niche whose columns have foliage coils and cats' masks; Leigh, a standing Christ, much weathered, probably from the close of the century. Lullington in Somerset has a seated 'Majesty' set between platter medallions resembling the ornament of Malmesbury.[2] Haddiscoe in Norfolk, one of a local group of churches with round towers, has a seated figure whose patterned vestments recall manuscript work. North Newbold in Yorkshire has a Christ in a mandorla, a somewhat flatly carved work. The church of St. Margaret-at-Cliffe, Dover, has an arrangement of thirteen heads, presumably Christ and the apostles, carved in flat relief and set in a triangular pediment.

In the smaller churches without any western towers, the main doorway is generally on the south side: some, however, have a doorway set in the west façade as part of a general scheme. Iffley, though both its north and south doorways have fine carving, is a case in point. The deeply recessed doorway is flanked by a blind niche on either side: the second stage of the elevation, defined by heavy string courses, has a central round window (a restoration of 1860) and above in the gable three windows, parallel to the triple arcade of the door and niches, decorated with continuous chevrons and with the outer order supported on colonnettes carved with spirals (Pl. 70 b). Stewkley in Buckinghamshire, like Iffley a

[1] P. M. Johnston, 'Bishopsteignton Church', *Journ. Brit. Arch. Ass.* xxxiii (1927), 99.
[2] See C. E. Keyser, *Norman Tympana* (1927), frontispiece. These plaques are also found at Kenilworth church and Llandaff cathedral.

singularly complete mid-twelfth-century church with a fine central tower, has a western doorway set between two arched blind niches: above the central door is a window with a continuous chevron arch.[1] The advowsons of both Iffley and Stewkley had been given to the priory of Kenilworth before the end of the century, so that there may be some building connexion between them. Happiest of all perhaps, in its adaptation of a monumental design to a small scale, is the church of St. Laurence at Castle Rising. Here the elaboration is concentrated on the middle register of the western façade, a window set in an arch of deeply undercut lozenge pattern, supported on spiral columns, with on either side three small niches set in an arcade of interlacing arches: below is a fine doorway; above, two blind arches on either side of a round window.

Not only doorways but also chancel arches were magnificently carved. These have survived less frequently, for many were taken down when the eastern arms were enlarged: where they have been spared, protected from weathering, they are often more finely preserved than any outdoor work. That at St. Chad's in Stafford may be taken as an admirable example (Pl. 71 a). The arch has been rebuilt but the mouldings, capitals, and piers are original work. One of these last bears a rare feature, a foundation inscription, *Orm vocatur qui me condidit*, a good Danelaw name and probably the Orm who made a grant to Tutbury in 1141,[2] another church with magnificent carving and a finely planned west façade. In St. Michael's church at Garway in Herefordshire, built by the Knights Templars in the last quarter of the century, there is a remarkable chancel arch where the inner order has each voussoir moulded across the arch so as to present a curiously denticulated effect, which recalls some Islamic examples more than any western practice.[3]

Inside the churches much of the decoration must have been of

[1] *R.C.H.M. Bucks.* ii (1913), 276, and D. L. Powell in *V.C.H. Bucks.* iii (1925), 424.

[2] J. Hewitt, 'Inscription recording the Building of St. Chad's Church, Stafford', *Arch. Journ.* xxxi (1874), 216.

[3] *R.C.H.M. Herefordshire,* i (1931), 69; A. Watkins, 'Garway Church', *Trans. of the Woolhope Natural Field Club* (1918–20), 52.

wood, in particular the screens and the roods that often sur-
mounted them. Not far from Malmesbury, in the church of South
Cerney, is to be seen a rare relic of our Romanesque carving, the
wooden head and foot of a Christ. The head is about half life-size:
the eyes are closed, the lips drawn and sunken: the hair and beard
are shown with highly formalized curls, not unlike the Terence
masks or the St. Mark of the Winchcombe Psalter: it is a work of
considerable feeling and expression, and suggests that wood carv-
ing must have been a developed skill if a small church such as
South Cerney could command such craftsmen. Walled up in the
tower, as though purposely hidden, these two fragments, preserved
from the reformers' bonfires, rediscovered as recently as 1913, are
a reminder of how much has been lost to us.[1]

Among this widely distributed survival of Romanesque carved
ornament, the activity of local groups of masons can sometimes
be clearly traced. The north-west corner of Norfolk, for instance,
seems in the second half of the century to have had a notable
builder's yard. At King's Lynn, Herbert Losinga's church of St.
Margaret has suffered so many catastrophes that little remains of
its twelfth-century work, but the lower stages of the south-west
tower have a late design of interlaced arches and an elegant, closely
ribbed buttress. Near by the church of Castle Rising, already
mentioned, is matched by the keep set within a great circle
of earthworks. Built by William of Albini, who married Adela of
Louvain, widow of Henry I, and who died in 1171, it is a piece of
admirable masonry, the perfected example of the rectangular form,
with flat pilaster ribs, square corner towers, and an interlacing
arcade ornamenting its forebuilding.[2] These interlaced arcades, so
popular in England, reach a fuller development at Castle Acre,
the Cluniac house of which more must be said shortly. It was a
fashion not restricted to stone, for the church at Hindringham,
a small village of north Norfolk, has an oak chest, one of the earliest
that we have, where interlacing arches are carved on the front.[3]
Castle Rising has also a fine font: the round bowl is set in a square

[1] W. R. Lethaby in *Proc. of the Soc. of Antiq.* xxviii (1915–16), 17 (with plates).
[2] H. L. Bradfer Lawrence, *Castle Rising* (King's Lynn, 1929).
[3] F. Roe, *Ancient Church Chests and Chairs* (1929), 93.

block, carved with cats' masks and with developed, closely veined acanthus foliage. It belongs to a group of fonts in this neighbourhood which must come from the same masons' yard: the font at Shernborne, a rectangular block on four short columns, is one of the finest, but that of Toftrees is certainly by the same master (Pl. 74 a), and there are fine examples also at Sculthorpe and South Wootton.[1]

Even more striking and distinctive is a group of fonts found in Cornwall, of which those at Bodmin and Roche are examples, large bowls supported on a central pillar with four free-standing columns forming the square in which the bowl is set and attached to the bowl by great capitals carved as human heads. Their strange fantastic decoration, cut with great mastery, may be thirteenth-century work but represents a Romanesque tradition.[2] Devonshire also had an able and original Romanesque carver, whose work can be seen on the west doorway of Bishopsteignton, the chancel arch of Hawkchurch, and the doorways of Downe St. Mary and of Shebbear.[3] The beak heads at Bishopsteignton, carved over a roll moulding decorated with grapes and ending in a lively bird that eats the fruit, are a pleasant and individual invention (Pl. 71 b).

In the building enterprises of the second half of the century a considerable place must be given to the activities of the Augustinian canons. In the first half they had, despite their many foundations, produced few important churches: now in the seventies and eighties they seem to have enjoyed a belated architectural vigour. The priory church of St. Peter at Dunstable may serve as an example.[4] Founded in 1131–2, the building progressed but slowly and the final consecration of the whole church did not take place till 1213. The two towers of the west front fell some nine years later in a great storm, so that the completed façade, which was probably still in the late Romanesque style, had only a short period

[1] F. Bond, Fonts (1908), 191. E. M. Beloe, 'Fonts baptismaux romans du Comté de Norfolk', Congrès archéologique LXXVᵉ, Session II (1909), 647; J. E. Bale, 'Of the Norman Font in the Church of All Saints, Toftrees', Arch. Journ. xlvii (1890), 160.

[2] F. Bond, ibid. 203.

[3] P. M. Johnston in Journ. Brit. Arch. Ass. xxxiii (1927), 99.

[4] V.C.H. Bedford, iii (1912), 364, and R. W. Paul in Builder, lxxix (1900), 12.

of existence. The arch of the main doorway, however, remains, five orders supported on column shafts set in the angles of the jambs. The voussoirs contain human heads set in foliage interlaces and the capitals have vigorously carved figure subjects framed in elaborate spreading tendrils. In the interior the composite piers rise to the springing of the tribune arch, broken only by the continuation across them of the string course of the tribune base, a not altogether happy innovation. An even greater doorway than Dunstable can be seen at St. Germans church in Cornwall. The old Saxon cathedral, it was transferred by Bishop Bartholomew of Exeter (1161–84) from secular to regular canons, and its rebuilding dates from that event. The porch has seven orders and is 20 feet wide.[1] Another priory was that of St. Frideswide, now the cathedral Church of Christ in Oxford.[2] The building is singularly undocumented, but the east arm must have been completed by 1181, when the relics of St. Frideswide were translated. The main fabric of the building is of late-twelfth-century date, and the carving of the capitals develops from interlacing coils and simple stiff leaf curling volutes in the choir to a more naturalistic foliage in the transepts and naves. The arcade shows the giant order of the Tewkesbury type, with the triforium passage splayed between the round columns. Dunstable and Oxford, with the contemporary work at another Augustinian house, Worksop priory, where the triforium arch cuts the string course of the clerestory and forces the clerestory windows into alinement with the columns, not with the arches of the arcade, show the continuous interest in the designing of the interior elevation.

The Augustinian churches were equalled by the building activity of the Cluniac priories. About their twelfth-century history we are generally ill informed, but from their architectural remains it is clear that new schemes were undertaken in the mid-century at Bermondsey, Castle Acre, Much Wenlock, Monks Horton, Farley, Thetford, St. Andrew's priory, Northampton, and Lewes. These were mostly foundations of an earlier date, and it is not clear why

[1] C. Henderson, *Records of the Church and Priory of St. Germans in Cornwall* (Shipston-on-Stour, 1929).
[2] E. W. Watson, *The Cathedral Church of Christ in Oxford* (1935).

around 1150–60 they were all enlarging their buildings. The progress of Cluny in England, apart from Lewes and Bermondsey, was never marked, and this phase of magnificence stood for a slowly reached maturity. Of St. Saviour at Bermondsey there survive from this period two capitals, probably from the cloister, showing the trefoil scallop of the latest series of Reading capitals, here with animals carved on the corners and a small acanthus frieze upon the abacus.[1] Castle Acre, founded by William II of Warenne as a cell of his father's foundation at Lewes, was being built in the first half of the century: there was a consecration ceremony between 1146 and 1148. The supports of the arcade, engaged columns with spiral or chevron decoration, and the tribune gallery and clerestory passage agree well enough with such a date. Some of the details on the west front, early palmettes and volutes, show that building continued later.[2] Its row upon row of arcading, the alternate rows interlaced, with its play of varying light when the sun strikes it, is not easily forgotten (Pl. 73 b).

Much Wenlock in Shropshire was founded by Roger of Montgomery between 1071 and 1086 and was placed by him under La Charité-sur-Loire, though his original intention appears to have been a Benedictine house such as his somewhat later foundation at Shrewsbury. It was on the site of the abbey of St. Milburga, founded by Leofric of Mercia, and its early architectural history is uncertain.[3] The present ruins of the church are fully developed Gothic of the early thirteenth century and what foundations remain are variously and uncertainly attributed to the church of Leofric or that of Roger. The chapter house, however, retains its three round-headed entrance arches: the capitals are heavily battered, but the voussoirs have their elaborate chevron ornament. Within, the north wall has a triple row of intersecting arcading. Here this peculiarly English motif reaches an almost Baroque exuberance.

[1] R.C.H.M. London, v (1930), 3, Pl. 18; A. R. Martin, 'On the Topography of the Cluniac Abbey of St. Saviour at Bermondsey', Journ. Brit. Arch. Ass. xxxii (1926), 192.

[2] W. H. St. John Hope, 'Castle Acre Priory', Norfolk Arch. Soc. xii (1893), 105, and 'Proceedings', Journ. Brit. Arch. Ass. xl (1935), 55.

[3] D. H. S. Cranage, 'The Monastery of St. Milburga at Much Wenlock, Shropshire', Archaeol. lxxii (1922), 105; W. H. Godfrey, 'English Cloister Lavatories as Independent Structures', Arch. Journ. cvi (supplement, 1952), 91.

The whole surface becomes a shifting pattern of semicircles and the eye follows one line only to be distracted away on to another: it is the negation of the solidity which is generally regarded as the dominating feature of the Norman style (Pl. 72 *a*). The cloisters are almost entirely gone. In the south-west corner of their enclosure stood an octagonal lavatory. Two carved panels of the laver are preserved, one with the figures of two apostles, the other with Christ walking on the Water: the figures, somewhat heavy and large-headed, have a realistic fall of drapery folds which must be from the later part of the century and the foliage decoration is very full and elaborate.

Of these Cluniac houses, St. Andrew's of Northampton was undoubtedly one of the most important. Founded between 1093 and 1100 by Simon of Senlis, whom the Conqueror had created earl of Northampton and married to Maud, Waltheof's daughter, the mother of St. Waldef and in second marriage the wife of David of Scotland, it enjoyed the patronage both of Henry I and the Scottish king.[1] In 1164 it was at this priory that Becket stayed for the Council of Northampton and from it that he made his famous flight. Today nothing remains of it except a few fragments in the local museum: its traces have disappeared even more completely than those of its sister house of Lewes or its northern neighbour, the priory of Lenton at Nottingham. Northamptonshire was a great Cluniac centre: at Daventry, St. Augustine's priory was founded by Hugh of Leicester shortly after St. Andrew's and in imitation of it. Both houses were cells of La Charité-sur-Loire. At Delapré, outside the town of Northampton, Simon of Senlis the Younger founded in the mid-century a convent of Cluniac nuns. In the city itself the advowsons of all the main churches were assigned to St. Andrew's. Two of them, St. Sepulchre and St. Giles, have work of the early twelfth century: at St. Sepulchre the columns and some of the outer wall of its rotunda remain: built *c.* 1111 by the first Earl Simon, this round church, with an aisleless chancel of three bays leading out of it, was undoubtedly intended as a copy of the great rotunda at Jerusalem and contained a model of the tomb chamber such as still survives

[1] J. C. Cox in *V.C.H. Northamptonshire*, ii (1906), 102, and iii (1930), 57.

in one or two continental examples.[1] If here there is no surviving tomb, at Nottingham the font of Lenton priory, which survives in the local parish church, a large rectangular block of stone carved with scenes of the life of Christ, shows in its representation of the Marys and the Angel a strikingly accurate version of the ædicule as restored by the crusaders in the church of the Holy Sepulchre (Pl. 74 *b*).[2]

In Northampton, in addition to St. Sepulchre, St. Giles retains the lower part of its Norman tower. But the chief example of Romanesque art in this town, which must once have been so rich in it, is the church of St. Peter, where, as in St. Sepulchre's, striking use is made of the deep brown colouring of the local ironstone. Here the arcade, continuous throughout nave and chancel, survives, with its strongly marked chevrons, so carved as to give a curious serrated edge to their silhouette, contrasting with the intricate and deeply cut chiselling of the capitals, where dragons and birds move through closely knit coils. There is no documentary evidence for dating the church, but the work is of the style of *c.* 1140–50 and a very admirable example of it.[3]

Amongst our late Romanesque building the west front of Ely has a special place.[4] Its design, a western lantern tower with two aisleless transepts, had been carried out on an even grander scale at Bury St. Edmunds, but there only some pieces of rubble core survive. Tower and western transepts still stand at Kelso, but the nave is destroyed into which they should lead. There are some indications in the restored and unsatisfactory west front of Norwich

[1] The other extant twelfth-century round churches in England are St. Sepulchre, Cambridge, the chapel of Ludlow castle, and the Temple church in London. Further examples are known from excavations or documentary sources. See W. H. St. John Hope in *Archaeol. Cantiana*, xxxiii (1918), 63, and 'The Round Church of the Knights Templars at Temple Bruer, Lincolnshire', *Archaeol.* lxi (1908), 177. At Garway in Herefordshire the foundations of the round nave were exposed in 1927: see above, p. 212.

[2] 'Notes on a font of the Church of the Holy Trinity, Lenton, Notts.', *Journ. Brit. Arch. Ass.* xxxiii (1927), 191.

[3] F. H. Cheetham and A. Hamilton Thompson, *V.C.H. Northamptonshire*, iii (1930), 40; R. M. Serjeantson, *A History of the Church of St. Peter, Northampton* (Northampton, 1904).

[4] G. Webb, *Ely Cathedral* (1950).

that here too a western tower and transept were originally planned.[1] Otherwise we know of no such western arms built in the twelfth century in these islands: and even at Ely the north transept is destroyed and the scheme thereby truncated. The western transept is not a Norman practice. Here again our architecture draws from other sources, probably from an Anglo-Saxon tradition which in its turn had links with the Carolingian churches of the Rhineland and the Low Countries. At Ely the lower stages formed part of the same building stage as the western bays of the nave: the remainder of the tower up to the final fourteenth-century octagon and turrets, the upper stories of the transept, and its polygonal turrets were added under Bishop Geoffrey Ridel (1173–89). A low arcade of trefoil arches marks the break with the earlier stage: above it the windows are pointed and the capitals change from the cushion type of the nave to stiff foliage volutes. The arcading, scale pattern, and decorative mouldings, the interplay between the lines of the transept and the lines of the tower, changing but always satisfactory from different view points, form one of the most distinctive and endlessly fascinating of our twelfth-century achievements. Within, the walls of the transept rise in tiers of arcading in which a row of interlacing arches plays a prominent part.

This multiplication of intersecting arches may be taken as the most characteristically English feature of our final phase of Romanesque building. The arches themselves are often covered with elaborate patterns and in the latest examples a further refinement is introduced of intersecting the mouldings as well as the arches. In the fine chapter house of St. Augustine's, Bristol (now the cathedral), we have another version of the arcading of Wenlock:[2] at Holyrood there is an elaborate intersection of the mouldings, as also in the work of Bishop Arnald (1158–62) at St. Andrews, in the choir of Bolton priory, and in the porch of Bishop's Cleve: finally, in its most refined and decorative form, over refined perhaps and with some loss of effect, in the chapel of St. Mary, or St. Joseph's chapel as it is more commonly called, at Glaston-

[1] A. W. Clapham in *Arch. Journ.* cvi (1949), 85.
[2] R. W. Paul, 'The Plan of the Church and Monastery of St. Augustine, Bristol', *Archaeol.* lxiii (1912), 231. This is another instance of Augustinian building activity.

bury.[1] Here in 1184 occurred a fire which destroyed the ancient wooden church, Glastonbury's most sacred shrine traditionally ascribed to Joseph of Arimathea, the Norman church of Abbot Herlewin (1101–20), and the cloister and monastic buildings of Henry of Blois. Clearly the devastation was quite out of the ordinary scale of disaster. Of Henry's works, in the abbey which he held during his lifetime, only a few carved fragments remain, one a capital almost identical with that from Old Sarum, now preserved at Salisbury,[2] and like it almost certainly an import from abroad. The work of rebuilding was at once undertaken and the king interested himself particularly in it, for when the fire occurred there was no abbot and the monastery, endowed, as Henry's writ puts it, 'by the famous Arthur and many other Christian kings',[3] was in his hands. Adam of Domerham tells us that Ralph Fitz-Stephen, the king's chamberlain sent by him as overseer of the work, 'completed the church of squared stones of the most splendid workmanship, where from the beginning the "Old Church" had stood, sparing nothing to add to its ornament'.[4] This is the chapel, a detached,[5] rectangular building, at the west end of the main church. Inside and out runs the arcade of intersecting arches, originally supported on columns of blue limestone, which have been carried off or have decayed: the capitals are bell shaped and carved with stiff leaf crocket foliage: the arch of the vault above the windows (the vault itself has fallen) is sharply pointed and the wall ribs stilted: the windows are round-arched with a wide variety of chevron and lozenge pattern: the round-arched south door has an outer continuous order of rich foliage pattern: the second order was supported on limestone columns and contained figure subjects in medallions as does the fourth and innermost order. These medallions show the story of the Birth from the Annunciation to the Return from Egypt. The scenes are

[1] R. Willis, The Architectural History of Glastonbury Abbey (Cambridge, 1866); F. B. Bond, An Architectural Handbook of Glastonbury Abbey, 4th ed. (Glastonbury, 1925).

[2] See above, p. 118, and Pl. 43 b. For the Glastonbury capital see R. Warner, History of Abbey of Glastonbury (Bath, 1826), Pl. XIII.

[3] Adam of Domerham, De rebus gestis (1727), 337. [4] Ibid. 335.

[5] Joined in the late thirteenth century to the main building by a Galilee chapel.

cut by a master hand: the figures are well proportioned, the move-
ments natural: though the building is said to have been completed
by Henry's death in 1189, it is hard not to think that this sculpture
is later work. Certainly it was carved in position, for on the north
door similar carving has been begun but left unfinished, as though
by death or departure the master hand was removed and there
was no one to equal his skill. Whatever its date or history, it is in
the full humanism and graceful rhythms of the Gothic style, and
the fierce contortions, patterned drapery, and strange abstractions
of Romanesque art have become things of the past.

Ralph Fitz-Stephen, Adam tells us, also began the great church,
'400 feet long and 80 broad'. But before the work was completed,
'avaricious death snatched away the king', and his successor Richard
was 'diverted by his warlike tasks' from the building of the church.[1]
The work seems to have suffered delays through lack of funds
and the 'invention' of the bones of St. Dunstan only involved the
abbey in a bitter dispute with Canterbury. The 'invention', how-
ever, in 1191 of the bones of King Arthur and Queen Guinevere,
the former of unusual and heroic size, provided an added induce-
ment to the visits and donations of pilgrims. Something of the
splendour of the great church can be seen from the pillars, still
standing, of the eastern arch of the crossing, work that must date
from the last decade of the century. Here the decorative motif is
still elaborate chevron patterns: the capitals are of the crocket type:
groups of triple shafts, which we shall find again at Wells, are a
marked feature. The arches are sharply pointed and in the two
remaining walls of the transepts we have, here in the west country
of its origin, a final development of the giant order, for the ground
arcade and a triforium passage of three trefoil-headed openings
are both included under a lofty wall arch springing from applied
shafts (Pl. 44 b).

Linked by their common cult of King Arthur, whom Geoffrey
of Monmouth had proclaimed to be the nephew of St. David of
Wales, the Pembrokeshire cathedral, first built in 1131 on the
occasion of the papal canonization of its patron, was contemporary
in its enlargement with the rebuilding of Glastonbury and shares

[1] *De rebus gestis*, 335, 341.

many of its ornamental motifs. Its third Norman bishop, Peter de Leia, began in 1180 a church on a more splendid scale.[1] How far it had progressed by his death in 1199 is uncertain, but in 1220 the new tower fell, so that by that date much had been, however insecurely, completed. The building scheme was a most unusual one inasmuch as it began at the west end: presumably the earlier twelfth-century choir was retained while the nave and crossing were built. The nave is composed of six bays with a round-arched arcade supported on round or polygonal columns with engaged pilasters: the capitals are the older scallop, not the Glastonbury crocket, but the ornamentation of the arches shows a wide variety of lozenge and chevron pattern. The ground arches are unusually broad in span, and support in each bay two great window arches, which include two pointed openings of a triforium passage and also a large clerestory passage (Pl. 72 b), so that for a height of about 11 feet the wall is hollow, being about 2 feet wide on either side; from the arrangement of wall shafts, it seems possible that it was intended to cover each bay of the nave with a sexpartite vault, but unlikely that this was actually carried out. There are in fact several indications that the enterprise of the builders somewhat outran their skill, but of the high standard of the decorative carvers that Bishop Peter brought to his remote cathedral there can be no question.

Even further west, beyond the sea, the influence of Glastonbury can be traced. At Waterford the cathedral was being built in the second half of the twelfth century, only to be enlarged by the addition of an aisled choir early in the thirteenth. Here, to judge from a painting made before the choir was demolished in 1773, was to be found the same ground arcade and triple triforium opening enclosed in the main wall arch as can still be seen in the ruins of the great Somerset abbey.[2]

[1] E. W. Lovegrove, 'St. David's Cathedral', *Archaeol. Cambrensis*, lxxvii (1922), 360. Reprinted in *R.C.H.M. Wales and Monmouthshire*, vii (1925), 343, and with some modifications in *Arch. Journ.* lxxxiii (1926), 254.

[2] For Waterford see A. W. Clapham, 'Some Minor Irish Cathedrals', ibid. cvi (supplement, 1952), 16.

VIII

DURHAM AND YORK

THE two great northern cathedrals, Durham and York, were dominated in the second half of the century by the enterprise of two magnificent prelates, Bishop Hugh du Puiset and Archbishop Roger of Pont l'Évêque.

At Durham the completion of the nave in 1133 had ended the construction of the main fabric and, with the exception of the defective building in the eastern apses and in the high vault of the choir, so sound was the work and such—to judge from the demand for its masons—its fame that there was no inclination to rebuild. The chapter-house was partially destroyed in 1799, and no record was made even of the inscriptions on the tombs, crushed under the roof from which the keystone had been removed. It had been completed under Bishop Geoffrey Rufus (1133–40).[1] It was, and in its modern version is, a vaulted room, 79 feet long, ending in a semicircular apse and surrounded by an inner arcade of linked arches, now only known in their restored form, where the design is taken from the arcading of the nave. The ribs of the semi-dome of the apse were supported on applied pilasters carved with human figures, four of which are preserved in the cathedral museum. The figures are much weathered, but have an angular, gaunt impressiveness (Pl. 77 a): a much-damaged pair of standing figures on an angle block suggest that the cloisters also had figure sculpture of the same period. The geometrical and foliage ornament was more finely worked. The ribs of the chapter-house, fragments of which survive, were enriched with elaborate chevrons. The capitals surmounting the pilaster figures were carved with full acanthus leaves with large, sweeping coils. Similar ornament is found on the interior face of the south-west doorway into the cloisters, which with its large dragons blending with the foliage and marked with beaded outlines has a close similarity to the initials in some of Carilef's books. It is the climax of a phase

[1] Symeon of Durham, *Continuatio Prima*, R.S. lxxv (1) (1882), 142.

beginning in the nineties and continuing to the early thirties, that is to the last building stage of the nave. The columns of the doorway are decorated with chevrons, diamonds, and spirals and on the outer order of the arch are roundels, like the cameo roundels of the Canterbury manuscripts, with foliage and beasts (Fig. 16). The north doorway on its interior face has similar carving, and its diamond-shaped medallions have a greater variety of subjects, including a centaur, a motif found again on the chapter-house door, a bearded figure apparently strangling another man, and the popular episode of a small boy being whipped.[1] The outside of the north door and the closed-in arch of the main west door show patterns of multiple chevrons. Another fine example of this northern carving can be seen on the font at Bridekirk in Cumberland, which bears a runic inscription, 'Richard made me', and on which the artist has shown himself at work with a hammer and chisel. These Durham doorways cannot be left without notice of one particular feature, the bronze knocker of the north-west door, a mask with staring eye-holes and thick curled hair, retaining all the potency and mystery of Celtic barbarism under the skilled manipulation of a Romanesque craftsman. The south-west cloister door has its original and splendid iron tracery, a bold lozenge pattern crossed by foliage sprays, a notable example of an art that must have added much to the beauty of Romanesque churches and which can still be admired in some other surviving examples, the solidly wrought geometric designs of Skipwith in Yorkshire or the rectangular patterns at Haddiscoe in Norfolk. From later in the century the south door of Worksop priory, with its thin three-petalled leaves, shows the new transitional elegance being applied here as in other branches of the arts: Abbey Dore has similar scroll-work.[2]

The death of Geoffrey Rufus was followed by a disturbed period of four years, when the holdings of the bishopric were usurped in defiance of the canonically appointed bishop. Eventually William

[1] Cf. Durham MS. Hunter 100, f. 44: reproduced R. A. B. Mynors, *Durham MSS.* (1939), Pl. 37.

[2] E. Yates, 'Notes on Medieval Church Ironwork', *Journ. Brit. Arch. Ass.* iv (1939), 175.

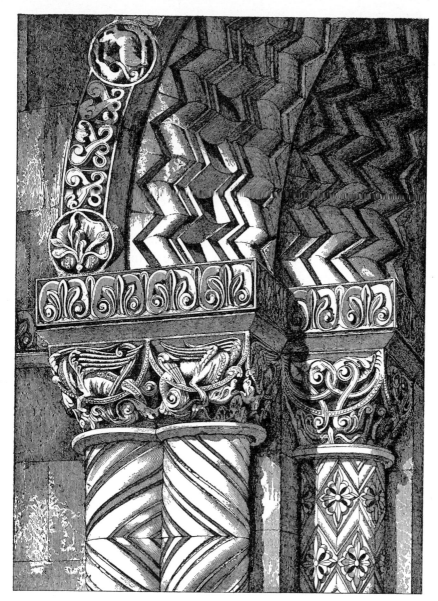

FIG. 16. *Durham cathedral: detail of south-west doorway from cloisters*

of St. Barbara succeeded and ruled uneventfully till 1152. His successor, Hugh du Puiset or Pudsey (1153–95), was elected to Durham while still a young man. An able and ambitious administrator, near kin to the reigning family,[1] he made a false step in 1173 by backing William the Lion against Henry II and had to buy his way back into royal favour. With Richard I he made his notorious bargain, purchasing the sheriffdom of Northumberland and the justiciarship of northern England, and the last years of his life were spent in disputes arising from the transaction. His buildings at the cathedral date from the first and comparatively more peaceful half of his pontificate, for the carvings seem to be an earlier version of the capitals in the chapel of the keep of Newcastle, which can be dated about 1177.[2] He began with a scheme to extend the east end, for which marble columns were brought by sea and a number of master masons consulted: *tot haberet principia quot magistri*.[3] The east end was probably already showing signs of insecurity: some fifty years later the vault above St. Cuthbert's shrine was described as in a dangerous state: also the shrine, the great pilgrim centre, doubtless required room for greater concourses and the increasing cult of the Virgin was popularizing the custom of an eastern Lady chapel. The work, however, whether from too many schemes or not, went ill and was abandoned at an early stage, and the bishop with curious readiness adopted an alternative scheme, that of a Galilee or narthex at the west end, though the narrow space available between the west end and the edge of the cliff made this an awkward site. The Galilee, however, was completed. It is an admirable piece of late Romanesque work (Pl. 75 *b*). All the old Norman solidity has disappeared. The five aisles were divided by arcades on slender twin columns (later, in the fifteenth century, strengthened and made into four-column supports), the arches decorated with

[1] His pedigree gave Stubbs 'a good deal of trouble': his mother Agnes seems to have been a daughter of Adela of Blois: Hugh was therefore nephew to Stephen and second cousin to Henry II. See W. Stubbs, *Historical Introductions to the Rolls Series* (1902), 211.

[2] See W. H. D. Longstaffe, 'Bishop Pudsey's Buildings in the Present County of Durham', *Trans. of the Arch. and Hist. Soc. of Durham and Northumberland*, i (1862), 1. For Newcastle see above, p. 199.

[3] Geoffrey of Coldingham, *Hist. Dunelm: Scriptores Tres*, Surtees Soc. (1839), 11.

deeply indented chevrons, the capitals with water-leaf foliage, the exterior covered with a blind arcade of the familiar interlacing arches, surmounted by a diaper pattern. It has the delicate, fragile elegance of a style's final phase.

As might be expected from the details of Hugh's public career, much of his building was secular. Reginald of Durham gives us the name of his engineer, Richard, 'known throughout all the district':[1] he was employed at Norham to heighten the border keep built by Flambard, and at Durham castle and Bishop Auckland the bishop built great halls to increase the amenities and accommodation of his chief residences. At the former the 'Norman gallery' still retains his interior window arches, thickly covered with chevrons, and the great entrance door, long blocked up and therefore well preserved, has in its use of geometric forms a richness and subtlety of effect that is more akin to the decorative schemes of the High Renaissance than to those of Romanesque art (Fig. 17). Certainly nowhere in England is there a more accomplished doorway arch. All barbaric elements, beak heads, interlaces, inhabited scrolls have gone. This is a severely mathematical scheme without any romantic narrative elements. The exterior arch of the south-east doorway of the cathedral, leading into the cloisters, reflects this style in a simpler, less accumulated form.

Like most buildings of the time, other than the sober Cistercian churches, the Galilee in its interior depended for its effect not only on its closely carved decoration but also on painting. Some fragments of this remain: two figures, a king and bishop, a band of full acanthus leaves and a painted curtain, the last probably later work. The two figures, generally identified as St. Cuthbert and St. Oswald, are noble designs, somewhat stiffly posed but well proportioned, and the strongly marked drapery falls naturalistically with few conventional folds: they must date from the very close of the Romanesque period. This insight into the art of monumental painting is all the more significant because we are able to trace at Durham the development of the manuscript style in some detail. The continuation of the earlier manner of Durham illustration

[1] Reginald of Durham, *Libellus de admirandis beati Cuthberti virtutibus*, Surtees Soc. i (1835), 112.

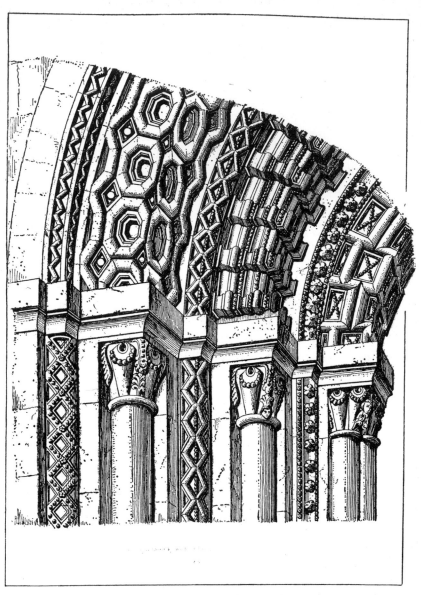

FIG. 17. *Durham castle: detail of doorway*

may be seen in various books of the mid-century, such as a splendid edition of St. Jerome's Commentary on Isaiah (Durham MS. B. II. 8). Here the basis of the decoration is still interlaces and inhabited scrolls. The colours are reds and greens on a peculiarly fine blue background.[1] The figures have something of the elongated stiffness of the Albani style, but recall also the easier movements of the University College Life of St. Cuthbert (Pl. 33 b and 6 c). A St. Jerome on the Psalter (B. II. 7) has fine initials of a somewhat similar type, but with no figure subjects. As at Canterbury so at Durham the second half of the century saw the equipment of the library with the glosses on the bible. Some of these books were given by Master Robert of Edington, and are inscribed with his name. On one of them, a manuscript containing the gloss on Ecclesiasticus, Tobit, Judith, and Esther, is written in a late-twelfth-century hand a list of the *libri magistri Roberti de Aednt' repositi apud sanctum Victorem'.*[2] This must be St. Victor of Paris, where Robert was presumably studying. The list includes a complete glossed bible, but whether they were books purchased by Robert in Paris or books lent him from Durham remains uncertain. None of his volumes equals those of Becket or Bosham in magnificence, but the familiar initials with small white lions occur in some of them. Two of them retain the sides of their original binding, magnificent pieces of work.[3]

Beyond question, however, the great Durham manuscript of this phase is Bishop Puiset's Bible. Contained in four folio volumes it ranks in scale and splendour but not in genius and inspiration with the great books of southern England. There are some fine foliage initials, but the figure drawing is dominated by a pedestrian artist who used broad, sweeping folds, which split the figures into a series of oval patterns. The general result is one of bulky, inflated forms, and there is an ugly trick of bunching the skirts into over-emphatic circles at the knee. The initial I of volume III, folio 109, showing Esther triumphing over the hanging figure of Haman, may be taken as one of the more expert pieces: the naked torso of

[1] *ff.* 10ᵛ and 34 ᵛ are reproduced in R. A. B. Mynors, *Durham MSS.* (1939), Pl. 42.
[2] Ibid. 78. MS. A. iii. 16.
[3] G. D. Hobson in *The Library*, xv (1934–5), 161. MSS. A. iii. 2, A. iii. 17.

the victim shows a curious attempt to transfer the formulas by which the drapery was related to the figure beneath to the figure itself (Pl. 76 a). Some of the initials have thick, curling acanthus and dragons' heads set very strikingly in frames of deep blue or red. The canon tables before the New Testament have highly decorated columns, which recall in some of their detail those of the cathedral. The styles range from those of c. 1160 to that of a feeble hand of the close of the century. There are other books in the Durham library which can still be identified by the bishop's mortuary list and the twelfth-century mark, *Liber Hugonis episcopi*—how fortunate Durham is in its documentation—as presentations by Hugh du Puiset. Among them is a volume of the *Magna Glosatura* on the Pauline epistles (MS. A. II. 19) with some excellent initials: one shows the martyrdom of St. Paul,[1] another St. Paul and Sosthenes, a third St. Paul and Timothy: these figure subjects are close in style but superior to those of the main artist of the bible. A foliage initial has a very fine curled acanthus leaf framed in the circle of the P with small dragons set like cameos on the stem of the letter:[2] another P encircles four long-necked griffins. This careful framing is the complete antithesis of the interlacing, 'gymnastic' letters of the beginning of the century. A new classical restraint has come into vogue. With it has come a new humanism already apparent in the fuller, heavier, less linear bodies of the bible artists. The achievement of a new style was at hand and before the century ended Durham was to show striking competence in it.

Linked to that of du Puiset by many similarities of style is another great bible, now MS. Laud. Misc. 752 in the Bodleian Library. This is a large folio elaborately decorated with historiated initials and with the gospels headed by half-page seated figures of the evangelist. None of the work, which as usual is by various hands, is of first-rate quality. The earliest style is that of an artist using highly conventionalized damp folds and thin, somewhat grotesque heads: it belongs to the type of the Lambeth Bible but is conceived on a small jewel-like scale of rich deep colours, unlike the broad Lambeth designs. Much use is made of long curling

[1] Reproduced R. A. B. Mynors, *Durham MSS.* (1939), Pl. 55 (in colour).
[2] Ibid., Pl. 54.

scrolls. The scene of David playing before the Ark may be taken as an example of its detailed but not entirely successful method. The main artist also employs conventionalized damp folds, but with a much more sweeping type of drapery. He plans boldly in great curves, representing his bloated figures almost as a series of circles, aiming at a solidity which he does not achieve. His Ascent of Elijah (Pl. 60 *b*) strikingly lacks the vigour and dash of the Winchester initial by the Master of the Leaping Figures: and in scenes such as the Murder of Eglon, an unusual subject but one well suited to him, for Eglon 'was a very fat man',[1] Moses and the Burning Bush, or Daniel in the Lions' Den (Pl. 66 *b*), his rotund bodies have an absurdity which is unredeemed by any schematic effect. The opening letter has a series of Creation roundels set in its bar, but carrying the series as far only as the creation of the beasts. On the larger scale of the evangelist portraits, the results, brilliantly coloured on burnished gold, are somewhat happier. Last of all a few figure subjects were added by a mediocre artist, influenced by the new Gothic naturalism. Its purely decorative initials are, as so often, more skilfully drawn. In type resembling those of the Durham Epistles, with the foliage framed in the letter, they show the thin curling stems and white pigmy lions of the 'Bosham' style. There is nothing to indicate the provenance of this lavish but disappointing work. The script seems to be by a continental hand:[2] the paintings come from the same artistic milieu as produced the Puiset Bible and combine the clumsy northern style of figure drawing with ornamental designs and motifs which belong to the Channel style of the glossed texts. Translated into stone, there are striking examples of these inflated forms in the work of a sculptor who carved the lectern, found on the site of Evesham abbey and now in the nearby church at Norton, where a seated abbot, probably St. Egwin, raises his hand in blessing among thick coils of acanthus; and in a similar lectern, with a crouching figure grasping the stems, in the church at Crowle, some few miles farther north.[3]

[1] Reproduced *Bodleian Eng. Rom. Ill.* (1951), Pl. 20 *a*.

[2] I am indebted to Mr. N. Ker for his views as to the script.

[3] Reproduced in A. Gardner, *Eng. Med. Sculpture* (1951), Pl. 146. For Norton see *Archaeol.* xvii (1814), 278, and J. R. Allen in *V.C.H. Worcs.* ii (1906), 195.

Reference has been made above to the original bindings attached to two volumes of Robert of Edington's gift to Durham. These are leather bindings, stretched on boards, with patterns which include figure and animal scenes stamped upon them. This was an art much practised in France and England in the twelfth century, with no clear priority between the two countries.[1] There is a group of three Winchester bindings, which can be securely localized, for one covers the St. Swithun's cartulary (B.M. MS. Add. 15350) and another a register of Winchester property, written about 1150, now belonging to the Society of Antiquaries;[2] the third and best preserved is on a volume of the popular summary of Josephus known as Hegesippus *de excidio Judeorum*.[3] With their large medallions and frequent use of a pear-shaped form, these are the most striking of all the bindings of this period, though they employ comparatively few stamps: they are a further proof of the taste and skill of the Winchester scriptorium under Henry of Blois. Two other English groups are later in the century: one probably of London make, for it includes a register of the Knights Templars (*c.* 1185)[4] and a Petrus Comestor that belonged to St. Mary's, Southwark;[5] the other composed of the bindings on the four volumes of Bishop Puiset's Bible. These fine large covers employ fifty-one stamps in their decoration, and there is no reason to doubt their Durham origin. The remaining three bindings at Durham, which possesses seven out of the eighteen known twelfth-century bindings in England, are, however, more doubtful: two are on biblical volumes in the Edington gift, the third on a glossed psalter given by Bishop Hugh, a book with the familiar small white lion initials. The two Edington volumes are the work of a stamp cutter of genius, an individual hand which is now accepted as French: the Puiset Psalter and with it a glossed Ezekiel in the

[1] G. D. Hobson, *English Binding* (1929), and 'Further notes on Romanesque Binding', *Trans. of Bibliographical Soc.* xv (1934), 161.

[2] *The Society of Antiquaries: Notes on its History and Possessions* (1951), 60.

[3] *Illustrations from 100 MSS. in the Library of H. Yates Thompson*, iv (1914), 1. The manuscript is now in the Dyson Perrins collection at Malvern.

[4] London, Record Office, Misc. Books i. 16. E. 1. 64/16.

[5] B.M. Egerton MS. 272. A third example of this group is the fine binding on Bodley MS. Rawlinson C. 163.

library of Pembroke College, Cambridge (MS. 147), are less nota-
ble achievements, but probably come from the same workshop.
The evidence of binding supports a Parisian origin for the debat-
able 'Bosham' style.

Of other English binding centres we know little or nothing:
certainly it is an art that must have been practised at St. Albans,
probably also at Canterbury. In some excavations at Belvoir
priory, a cell of St. Albans, a bronze book stamp was found, 2 cm.
square, 4 mm. thick, with a tongue 3 cm. long on the back for
insertion in a wooden handle: on the stamp is a stag-like beast.
It is likely enough that here is one of the stamps employed in
the mother abbey, the greatest of our medieval centres of book
production.[1]

As would be expected of such a patron, books were not the only
gifts made by Hugh du Puiset. Geoffrey of Coldingham writes[2]
of the hanging lamps and candelabra for the altar, the golden cross
and chalice, the shrine for the bones of Bede, where it was impos-
sible to tell whether the skill of the workmanship or the beauty
of design (opus an decor) were most to be admired. But, as always,
these splendid, gleaming pieces of metal-work are now only a list
in a chronicle.

Of the figure sculpture of the Durham school only few and
fragmentary pieces have come down to us. In the cathedral museum
there are four scenes of the appearances of the risen Christ: the
heads are broken off and the work is sadly battered: the drapery
has patterns of curving damp folds: the figures are slender and
posed with a very vivid grace which must precede the heavier
Puiset style. If these come, as is sometimes suggested, from the
pulpitum, which is known to have shown the whole story of the
passion, as well as a series of kings and bishops ending respectively
with Henry I and Hugh du Puiset,[3] and if they are representative
of the quality of its carving, then it must indeed have been a splen-
did entrance to the choir. Close to the city, in the churchyard at
Kelloe, there is a carved wheel cross with the somewhat unusual

[1] *Antiq. Journ.* iv (1924), 272.
[2] *Scriptores Tres*, Surtees Soc. ix. (1839), 11.
[3] See *Rites of Durham*, Surtees Soc. cvii (1903), 137.

scenes of Constantine's Dream, St. Helena and the Queen of Sheba (?), and the Finding of the True Cross, set in arches where flat acanthus leaves clasp the columns: damp folds have almost gone and the drapery falls in close, finely carved lines, spreading out fanwise at the feet in a way that is reminiscent of earlier designs.

The other great northern centre and one of which we have as yet seen nothing was that of York. Like Durham it had in the second half of the century a powerful and magnificent prelate. Roger of Pont l'Évêque, archbishop of York from 1154 to 1181, had been archdeacon of Canterbury. He was therefore familiar with Conrad's choir, and the contrast in York, where Thomas of Bayeux's cathedral built in the last decade of the eleventh century had been little altered, must have been marked. It was as far as can be ascertained based on the plan of Lanfranc's cathedral at Canterbury, possibly employing the old Saxon church as choir: it was partially burnt in 1137, but no large-scale rebuilding seems to have been required, and the Cistercian sympathies of two of the intervening archbishops, Thurstan (1119–40) and Henry Murdac, abbot of Fountains (1147–53), were little likely to lend themselves to new and ostentatious schemes. Roger in his political career was an adroit, somewhat time-serving man, opposed to the enthusiasms of Becket, an able financier who built up both the resources of the see and his own private fortune. As at Canterbury, his additions to the cathedral consisted in an enlargement of the choir. The Great Register of the dean and chapter provides examples of the methods taken to finance the building, as, for instance, a grant from William de Percy of the church of Topcliffe in perpetual alms 'for the repairing and building, according to the direction of the Lord Archbishop Roger and his successors and the chapter of York, such parts as they should see fit to repair or build', the chapter to undertake nothing without first obtaining the authority and consent of the archbishop.[1] Of this work the crypt only now survives, but its plan suggests that the main eastern arm above it was rectangular with a short eastern transept and an ambulatory along

[1] J. Browne, *St. Peter's, York*, i (1847), 18; *York Fabric Rolls*, Surtees Soc. xxxv (1858), 142.

the sides of the choir. This follows the plan of the eastern arm of Byland abbey and must be work of the seventies more or less contemporary with it. Some remains of capitals and pier bases, very similar to those of du Puiset's work at Durham, show that water-leaf and other characteristic Cistercian detail were employed by Roger's masons as well as more elaborate Romanesque formulas.[1] The crypt, in plan and ornament, was a novel and arresting conception, of which the general effect is now spoilt by substructures for later building. Some of the great piers, which are composed of huge circular columns with engaged semicircular, or in some cases free-standing, smaller columns, are decorated with spiral bands of chevrons or lozenge ornament: there is the lower portion of a doorway which includes a spiral column and a jamb decorated with alternate circles and triangles. Of the crypt capitals, which are octagonal, two have closely interwoven foliage designs, in low relief, with fan-shaped palmettes and beaded stems: on one of them a row of interlacing arches has been begun on the impost but not completed: the corners of the pier bases are carved with similar leaves; they would be easily matched among foliage initials of the second half of the century: another capital has two rows of fan-shaped leaves, turned towards each other. These foliage designs are interrupted by one where standing bearded figures, with outspread arms and wide dervish-like skirts, form a row divided by thickly cut leaves: this is a strange design, hard to parallel, though similarly dressed figures appear on the much cruder carving of the tympanum at Danby Wiske in the North Riding. The water-leaf appears on responds of the side walls and also on the much weathered arcade which is all that remains of Roger's episcopal palace. In these varied motifs, in the pillars whose girth is set off by the lighter colonnettes surrounding them, our Romanesque art reaches one of its most impressive statements.

There are preserved, in the crypt but of quite uncertain pro-

[1] W. R. Lethaby, 'Archbishop Roger's Cathedral at York', *Arch. Journ.* lxxii (1915), 37; R. Willis, 'The Architectural History of York Cathedral', *Proc. of the Archaeological Institute of Great Britain at York, 1846* (1848); Thomas Stubbs, *De Vitis archiepiscoporum Eboracensium*, ed. J. Raine, R.S. lxxi (2) (1886), 397.

venance, two carved slabs. One is the celebrated York Virgin, a seated figure, unfortunately headless, holding the clothed Child on her lap. This type of Virgin with the Child looking sideways seems to have been a popular formula, which must have had some Byzantine exemplar. The York Virgin is often claimed as Saxon work,[1] and the epigraphy of its inscription is that of the eleventh century, but in a work that is clearly a copy of some Byzantine original, possibly an ivory, this fact is not conclusive evidence. It remains, for all that has been written of it, a mutilated masterpiece, difficult to date. It is cut in a fine slab of local Tadcaster stone, originally 40 inches high: the round damp folds have twelfth-century stylistic connexions: the nearest English parallel is the St. Michael slab at Ely, but there the blue marble stone suggests a foreign origin. The other carving is a much worn scene of hell, with the Torments of the Damned. This also is on a slab of Tadcaster stone, 5 feet 2 inches high and 3 feet 2 inches wide. It was found in 1904 in the deanery garden: the design extends over the sides and top as far as a slight rebate, which suggests that it was set, slightly projecting, in a wall, The carving is bold and somewhat coarse, but the figures have a genuine violence of movement: the ordinary types, such as luxury and avarice, can be seen amongst those suffering punishment. Another fragment, now in the museum of the Yorkshire Philosophical Society, a tympanum 3 feet 3½ inches wide showing, with remarkable realism and horror, the death of a sinner, is almost certainly a product of the same school. It was found in 1817, face downwards, at the bottom of a flight of steps in a building generally considered the crypt of the chapel of the Holy Sepulchre, which Thomas Stubbs, the fourteenth-century historian, describes as built by Roger at the gate of his palace.[2] It is unlikely, however, that this small tympanum with its macabre subject, which on the analogy of Lincoln is most

[1] A. Clapham, 'The York Virgin and its Date', *Arch. Journ.* cv (1948), 6; D. Talbot Rice, *O.H.E.A.* ii (1952), 114.

[2] T. Stubbs, *Lives of the Archbishops*, R.S. lxxi (2) (1886), 398; A. Hamilton Thompson, 'The Chapel of St. Mary and the Holy Angels, otherwise known as St. Sepulchre's Chapel, at York', *Yorks. Arch. Journ.* xxxvi (1944–7), 6. It is tempting to associate the Virgin slab with this chapel, which is said to have been dedicated by Roger to the *Virgo Beata et Intemerata*: R.S. lxxi (3) (1894), 76.

likely the Death of Dives, could have been above a doorway: it would be more normal and fitting on some side arcade of the west front, and in that case could well have had the Doom panel beneath, for the stone is the same, the measurements would allow of it, and the devils, though the detail is more preserved on the tympanum, have their heads similarly enriched with bossed scales. Above all, the brutality of the subject is rendered in both pieces with a furious vehemence which suggests a single personality.[1] In the same museum a fine Romanesque capital shows a man struggling with two dragons, one of the most skilfully planned and executed of our examples of this well-worn theme (Pl. 77 b).

It was not only in carving that Roger's work was notable: two fragments of stained glass still survive which in their colouring and borders recall that of Chartres and St. Denis, and in their drawing have parallelisms to the heavy rounded folds and large leaves of the Puiset Bible: one fragment shows Daniel in the Lions' Den; the other, now reset in the north aisle of the nave, must have been a figure from a Jesse Tree. At Canterbury, in the new Gothic choir of William of Sens, glass of high quality was being put into the windows: at Durham Bishop Hugh also is said to have put in painted glass. Whether or not this glass was English-made cannot be determined. Undoubtedly the influence of Paris and Chartres was strong in this field and glass or workmen may have been sent from France, but certainly in England by the last quarter of the century the demand was well established.[2]

The other great church-building enterprise to which Roger devoted himself and for which he supplied a large part of the money required (£1,000) was at Ripon.[3] Here there was the curiously original arrangement of an aisled choir but an aisleless nave, though one of 40 feet in width. What remains of Roger's work is strikingly unlike the ornate style of the crypt. The transepts and the west bay of the choir still show, above a ground arcade of pointed arches, a triforium and clerestory in each of which a round arch is set between pointed lancets (Pl. 75 a): in the nave

[1] J. Bilson in *Proc. of Soc. Antiq.* xxi (1905–7), 248.
[2] J. A. Knowles, *Essays in the History of the York School of Glass-painting* (1936).
[3] *Memorials of Ripon*, Surtees Soc. lxxiv (1882), i. 97.

the narrow triforium passage passed behind groups of four sharply
pointed, narrow arches, of which the central two were considerably
higher than those at the side: there was little decorative carving,
but the typical water-leaf capital occurs. Two styles were meeting,
Romanesque at its most lavish and the severe plainness of the
Cistercian tradition, and it was with the latter that the future lay.
But not immediately: at Selby, where after many delays the
western doorway was being built, the carving is as decoratively
rich as in the York crypt, chevrons and lozenges above a row of
water-leaf capitals (Pl. 47 *b*), and in the cloisters at the Augustinian
priory of Bridlington, of which a fragmentary arcade exists built
up inside the church, the scallop capitals are worked into folds as
though of some woven fabric, a last refinement of this much used
form (Pl. 47 *a*). A recently found fragment of sculpture,[1] the lower
part of a small stone figure, admirably cut, with ovoid folds that
show it to belong to this period, proves that at Bridlington the
masons were capable of work of the finest quality.

The carvings at York, Selby, and Bridlington are works of
the greatest sophistication. Yorkshire, particularly the North and
East Ridings, is full also of small Romanesque churches, lavishly
decorated with an inventive and skilful fancy but in a more pro-
vincial style. These have survived with curiously little change, for
there has been less rebuilding of village churches than in most
parts of England. The second half of the twelfth century marks
here the gradual recovery from the fearful harrying by the Con-
queror. The activity in church building may be part of the attempt
to replace after nearly a century the results of that destruction. If so,
it came at a fortunate time. This group of pleasant, varied buildings
is a genuine enrichment of English Romanesque art.

In York itself, the doorways of the three churches of St. Law-
rence, St. Margaret, and St. Denis are typical products of a local
style. Of these St. Lawrence may well be considerably the earliest:
its outer voussoirs have a band of palmettes and winged dragons;
on a rudely carved capital the lamb carrying the Cross confronts
a monster. The work at St. Margaret's is more finely cut, with

[1] Now in the Victoria and Albert Museum. See G. Zarnecki, *Later Eng. Rom.
Sculpture* (1953), Pl. 115.

designs set in medallions, and is closely paralleled by a fine series
of voussoirs preserved in the museum of the Yorkshire Philo-
sophical Society (Pl. 39 *b*).

Of these Yorkshire churches, that of Alne, eleven miles north
of York, may be taken as an important example. Here the south
doorway retains much of its original decoration, though some
stones have been replaced by somewhat incongruous restorations.
There is no evidence by which it can be exactly dated, but stylistic-
ally it should belong to the third quarter of the century. The outer
order of the arch contains a remarkable series of carvings from the
bestiary: these are carefully inscribed, Vulpis, Caladrius, and so
forth, and are close parallels to manuscript treatments of the theme.
They are carved with considerable skill and delicacy of detail. On
the second order is a series of medallions, the Agnus Dei, some
of the signs of the zodiac, a man killing a pig, some birds and
beasts: it is a list that might be regarded as conventionally
haphazard, but with the careful programme of the outer order it is
unlikely that this scheme is any less precise, and it presumably has,
in its reference to the seasons and the zodiac, and possibly to the
animal world, some symbolism of the Cross-bearing lamb in
relation to creation as a whole.[1] At Adel, on the outskirts of Leeds,
the decoration is chevron and beak head, the former with very
sharp free-standing dentation: in the gable Christ is carved in relief
between the symbols of the evangelists: a fine devil's head door
knocker, with a typical foliage scroll, survives: the capitals on the
chancel arch show a centaur (saggitarius) fighting a dragon, coiled
beasts and, facing inward to the arch, the Baptism, with the
curious detail of a monster trying to drink up the water: opposite
are the Deposition, from which the same monster slips away
defeated, more coiled beasts, and then, balancing the centaur, a
crusading warrior.[2] There is some documentary evidence that this
completely Romanesque scheme is work of the eighties, and it is

[1] See J. Romilly Allen, 'On the Norman Doorway at Alne', *Journ. Brit. Arch. Ass.*
xlii (1886), 143, and G. C. Druce, 'The Caladrius and its Legend, sculptured upon the
Twelfth Century Doorway of Alne Church, Yorkshire', *Arch. Journ.* lxix (1912), 381.

[2] W. T. Lancaster, 'Adel', *Thoresby Soc. Miscellanea*, iv (1895), 161; 'Adel Church:
its sculptures and their symbolism', *Reports and Papers of Architectural Societies*, xx
(1889), 63; W. H. Draper, *Adel and its Norman Church* (1909).

likely that in the smaller churches there was often a considerable time lag in the adoption of new stylistic fashions. At Fishlake there is a south doorway with a decorative scheme where the historiated scenes take an unusual prominence. Fishlake was the property of the great Cluniac priory of St. Pancras of Lewes, and, though the carving does not suggest other than local hands, its iconography may reflect some more continental scheme: St. Peter and the keys, the essential Cluniac subject, figures here on the right hand of Christ at the keystone of the arch.[1]

The beak-head doorways of Brayton, Bishop Wilton, Fangfoss, Etton, Kirkburn, the curious figure carvings of Bugthorpe, the unfinished zodiac medallions at Ampleforth, and many other buildings of interest must be passed over: one further Yorkshire example must serve to illustrate this remarkable survival of Romanesque village churches. Barton-le-Street was almost entirely rebuilt in 1871, another period when there was much church building and rebuilding in the East Riding. Many of its carved stones are, however, reset in this Romanesque revival structure, and the present north door is largely a reconstruction of the former south one.[2] Barton must have been one of the most richly carved of the smaller churches of England, but it is carving that certainly comes from different periods. Its Adoration of the Magi, if not actually an eleventh-century work, must be a faithful copy of a 'Winchester' drawing. Another fragment shows men hedging, in the Anglo-Saxon tradition that survived in twelfth-century works such as the carving at Steyning or the drawing in MS. Bodley 614.[3] Later, however, the patrons of Barton reacted to newer fashions and much carving of voussoirs, capitals, and corbels was done in the full Romanesque style. Here the normal repertory of grotesques, zodiac symbols, labours is employed, but with some scriptural scenes added. Within the chancel and the nave is reset part of the original outside corbel table, an unusually elaborate

[1] G. Ornsby, 'Fishlake Church and Parish', *Reports and Papers of Architectural Societies*, iv (1857), 91. (Reprinted separately, Lincoln 1858.)

[2] H. E. Ketchley, 'Barton-le-Street', *ibid.* xxix (1907), 280; A. Russell in *V.C.H. Yorkshire North Riding*, i (1914), 475.

[3] See above, pp. 59, 87.

piece of work, where not only the corbels but also the spandrels and soffits are covered with carving.

Close to the cathedral at York work had also been in progress at the abbey of St. Mary. There are in the museum of the Yorkshire Philosophical Society a series of ten statues of prophets and apostles, the fragment of a Virgin, and some much battered voussoirs which seem to have narrated the gospel story.[1] These must belong to a great doorway or doorways, with column figures on the French model. Seven of the statues, approximately life size, were found buried face downwards in the foundations of the late thirteenth-century nave. They are now preserved in the great repository of stone fragments that makes this museum the most important of our medieval sculptural collections. The same artist or his pupils carved in high relief some figures, St. Peter, St. Paul, and Christ rebuking the devil, formerly at Holme-on-the-Wolds, now moved to the church of Etton and much decayed. Some of the museum statues are certainly designed as column figures supporting capitals: they have real plasticity of feeling and a solemn monumentality. Beside their French equivalents they are gauche and heavy work: they have something of the dumpy solidity of the Puiset Bible drawings, which some of their bunched and looped folds recall:[2] they have the hesitancy of a new convention not yet fully grasped, but they have also a classical dignity, which reveals the influences under which they were created, and they represent not unworthily a phase of sculptural development of which no other English examples survive (Pls. 77 c and 78 a).

Associated with this northern revival is a group of manuscripts which by their calendars and litanies must have a northern origin. The psalter now in the Hunterian Museum in Glasgow (MS. U. 3. 2)[3] and sometimes known as the York Psalter has amongst other

[1] E. S. Prior and A. Gardner, *Figure Sculpture* (1912), 213; C. Wellbeloved, *Handbook of Antiquities of Museum of Yorkshire Philosophical Society* (1852), 36; R. Marcousé, *Figure Sculpture in St. Mary's abbey, York* (1951); J. H. Markland in *Vetusta Monumenta*, v (1835).

[2] One of them gathers his draperies into a looped fold behind his arm with the exact gesture used by the statue of St. James on the Portico de la Gloria at Compostela.

[3] Size $11\frac{1}{2} \times 7\frac{1}{2}$ inches. See J. Young and P. H. Aitken, *A Catalogue of the MSS. in the Library of the Hunterian Museum of the University of Glasgow* (Glasgow, 1908), 169;

northern saints Wilfrid (24 April), John of Beverley (7 May), Botolph (17 June), and Oswald (5 August). For St. Cuthbert both his feast and translation are given, suggesting some Durham patronage: for St. Augustine there is his feast on 28 August and its octave, and his translation on 11 October, so that connexion with an Augustinian house seems probable: originally the prayers were designed for a woman, but the masculine singular has been written over them, and later the masculine plural. The first owner must have been some abbess or great lady of northern England. Some of the initials to the psalms are historiated, some have foliage and animals. Several familiar motifs recur, such as the harp-playing goat or the mermaid combing her hair: several artists were at work, one a somewhat old-fashioned stylist, another using damp folds and elegant postures very close to the carved panels at Durham. Some psalms have scenes already accepted by common usage: the anointing of David for Psalm xxvi (xxvii) (Pl. 55 *b*): the slaughter of the priests of Nob by Doeg the Edomite for Psalm li (lii): Wisdom suckling two men at her breast for Psalm lxxi (lxxii), the Psalm of Solomon: others have drawings symbolizing phrases of the text: an armed warrior for Psalm xxxiv (xxxv), 'Take hold of shield and buckler': a man striking at a dragon, 'Rescue me, O my God, out of the hand of the wicked', for Psalm lxx (lxxi): Christ treading on the asp and basilisk for Psalm xc (xci). As there is no entry for St. Thomas of Canterbury, it is reasonable to assume that this book preceded 1173, and this date is acceptable stylistically. The Beatus page is one of the most splendid we have yet seen, and its magnificent full-spiked acanthus and clearly marked coils and figures, set in a frame with angels in the corner medallions, suggest a piece of goldsmith's work, an effect that is increased by the drawing in perspective of the key pattern in the border of the B. Opposite it, however, the drawing of David shows none of this certainty and seems to be by a feebler hand than that responsible for the thirteen, possibly originally fifteen, biblical scenes. These begin with the Fall and Expulsion: then Abraham's Sacrifice, scenes from the Life of Christ, the Death

and *New Pal. Soc.* 1st series (1903–12), Pls. 189–91; O. E. Saunders, *Eng. Ill.* (1928), Pls. 43–45.

and Assumption of the Virgin, and Christ in Majesty between the signs of the evangelists. The group appears to be from one hand: the artist used Romanesque patterned folds and flying drapery of a hard, metallic flatness, blown out by no wind that ever was; his figures are stiff and tubular, but he has much sense of dramatic statement, and his work is full of remarkable and original inventions. Above the Sacrifice of Abraham is the scene of the angel's message (Pl. 80 b), a well-found piece of sentiment where the relationship within the group of the father and child, Abraham's dawning despair and Isaac's confidence, are nicely portrayed. In Christ rescuing Peter from the Waves the surge of the water floods over the inner decorated line of the frame, turning it into a half-submerged column (Pl. 80 c). Two pages are devoted to the Death of the Virgin: the angel brings her a palm, announcing her death: she shows the palm to the apostles: her body is carried up to heaven. Nowhere before in England had this theme been set out so fully, and the scene of the Assumption with its flying angels and shrouded figure has no known parallel (Pl. 80 a). The intensity of visual statement which marks this artist's work was to wait some centuries till it found its echo again in the drawings of Blake.

Closely parallel to it in some of its historiated initials is a psalter now in the Royal Library of Copenhagen.[1] The scale of the two books ($11\frac{1}{2} \times 7\frac{1}{2}$ in.) is the same and the calendars have the same feasts, including the Augustinian commemorations. The Beatus page (Pl. 86) is a bolder version of that in the Glasgow Psalter, from which it takes over many details, the key pattern, the naked figure in the coils, the interlace terminals, but substitutes for the Glasgow conventional cat's mask a terrifying semi-human head. New, too, are the small white dogs, near relatives of the 'Bosham' lions, which invade the tendrils. The lions themselves appear in some of the initials, as do also the extended dogs and naked grotesques (a man with one leg, upside down, pursuing a rabbit) of the Channel style. The full-page scenes, of which there are sixteen, deal with the Birth and Passion stories and are quite distinct from the cycle used in the preceding psalter: they are carried out by

[1] MS. Thott 143 2°. See for a full account of it M. Mackeprang, J. L. Heiberg, and A. Jensen, *Latin MSS. in Danish Collections* (1921), 32, Pls. XLVIII–LX.

two artists, often working together on the same painting, using the curving lines of the Romanesque tradition, faintly outlined damp folds filled with arabesques and patterned gold backgrounds. Once again the dating is uncertain: there is no entry for Becket's feast, though this cannot, in a northern Augustinian house, be considered conclusive proof. Soon after the beginning of the thirteenth century the manuscript was in Scandinavia. The main artist is second only, amongst our Romanesque painters, to the Master of the Bury Bible. He has a sensibility able to create volume by the most economical and subtle use of line. His contours are gently but very surely indicated and his representations of the Virgin have in particular a softness and delicacy rare in twelfth-century art. The Nativity is a lovely example. His assistant had a much coarser touch: in the Betrayal, where they appear to have collaborated, the great curves of the design and the actual figures of Judas and Christ are clearly the master's own: the other figures with their harsher outlines and stiffer poses are by the lesser hand. In the Crucifixion the master is unaided (Pls. 81 *b*, 56 *b*). His scene of the Visitation may be taken as typical of his flowing design and tenderness of expression. It is still a fully Romanesque work, with large ovoid divisions and the familiar patterning on the drapery: the twisting trees, the inset background square, the curved, stiff ends of the women's scarves are all part of the repertory, but it has a new fullness of form and a sense almost of languor (Pl. 81 *a*). In its quality of fancy and of execution the book forestalls Sienese work of the Trecento and fittingly closes the wide and varied range of our twelfth-century achievement. In it Romanesque has lost its rigid, contorted passion and achieved human sympathies for which the Gothic convention was to provide a new mode of expression, but was not to achieve any rendering of greater intensity.

Two other psalters, aesthetically works of much less moment, must receive some briefer notice, for their calendars or litanies[1] associate them with the northern group. One of them, MS. Gough

[1] The calendar is missing in MS. Gough Liturg. 2, but Cuthbert, Hilda, and Oswald occur in the litany. For reproductions from these two psalters see Bodleian Picture Books I, *Eng. Rom. Ill.* (1951), Pls. 23 and 24, and III, *Scenes from the Life of Christ in Eng. MSS.* (1951), Pls. 6, 7, 8, 9, 11, 14, 22.

Liturgical 2 in the Bodleian Library, is a parallel in its new and somewhat clumsy naturalism to the York statues. The initials still have the drapery of the Puiset Bible, and one of them is almost a parody of the latter's Esther figure, but in the introductory New Testament scenes, poorly executed as they are, the ovoid folds are discarded for new rhythms, and an attempt at realistic gestures replaces the vehement movements by which Romanesque emotions were conveyed (Pl. 79 a). The same or largely the same series of scenes is used in yet another psalter (Bodleian MS. Douce 293), whose calendar has a varied range of saints but certainly has some north or east English connexions. This is an interestingly eccentric book, for it is a lavish product executed by a thoroughly incompetent artist. On the whole the standard of our surviving Romanesque illustrated manuscripts is high. This book is a useful reminder that, particularly in smaller centres, work could be grotesquely inadequate. The ornamental initials are well enough if somewhat coarsely carried out. When the artist came to the figure subjects he had no training or ability to deal with them. His colours are bright and crude: his borders, so essential to the setting of the scene, are misunderstood and weakened with sprawling dragons in a confusion of styles, his gilding is applied in unexpected places, the gap, for instance, between the hind legs of the ass in the Flight into Egypt (Pl. 79 b). One is tempted as one turns the pages, not without their own fascination, to wonder whether the late twelfth century had not some fashionable cult of the primitive and whether chance has not preserved for us here the work of a Romanesque Douanier Rousseau.

THE GOTHIC STYLE

'VAE, vae, ecclesia ardet.' It was on the 5th of September, 1174, with a high wind blowing from the south, that a fire broke out in some houses by the gate into the precincts of Canterbury cathedral: sparks were blown on to the church roof and passing by the joints of the lead kindled the beams, but, within, the painted ceiling hid the fact that they were alight and it did not become apparent till they were well blazing. Of no medieval catastrophe have we so detailed a narrative. Gervase of Canterbury had made his profession at Christ Church in 1163: he had been present at Becket's burial: until 1210, the probable year of his death, he was to chronicle the doings of the cathedral priory and in his *Tractatus de combustione et reparatione Cantuariensis ecclesiae*[1] he wrote an account of the destruction of the church, remembering as he wrote how wonderful and awful seemed the glorious choir in that last moment amid the soaring flames; how the monks tore down hangings and metal-work to save them and above all collected the relics of the saints, scattered as the great chests fell from the beam above the altar; how in despair, for there were many who would have died rather than see the church of God perish so miserably, they fixed a temporary altar in the nave and howled rather than sang vespers at it. The Chapter then took counsel how to repair the ruin: artificers (*artifices*) from both France and England were consulted: the particular question in debate was the state of the great columns of the choir and whether or not they could be preserved. The monks hoped that the old framework of the building could be re-used, and they finally entrusted the report on it to a Frenchman, 'on account of his lively ingenuity [*vivacitas ingenii*] and good repute'. William of Sens made his survey, but hesitated to make his final report, namely, that the damage was such that the pillars and all they supported must

[1] Gervase, *De combustione*, R.S. lxxiii (1) (1879), 3; C. Cotton, *Of the Burning and Repair of the Church of Canterbury* (trs. of Gervase), 2nd ed. (Cambridge, 1932).

be removed. In the end, 'patiently though unwillingly', the Chapter consented to the pulling down of the choir. William now busied himself with preparations for the work: stone was brought from beyond the sea, the Caen stone so much used in England; pulleys were set up for unloading it, mortar was prepared; the carvers were provided with 'forms' for the stones that had to be shaped. Gervase gives us an account of the work as it progressed from year to year: we can follow the building seasons, interrupted by winter, cut off early by the unusually heavy autumn rains of 1178, and in his emphasis on certain features, in his comparison of the new building with the old, we have the echo of discussions about the methods and fashions employed. By the end of 1177, the third year of the rebuilding, five pillars had been erected on either side, beginning from the western crossing under the great tower which was still Lanfranc's work (Fig. 5). These pillars, alternately octagonal and round, were of the same thickness as the original pillars but exceeded them by 12 feet in height: the arches supported by them are pointed, but the gallery of the second story has a continuous series of round-headed arches, which Gervase calls the lower triforium, and which, as it lacks any single embracing arch in each bay, is in fact a type of triforium on the French model, not a tribune elevation; above it was *triforium aliud*, that is, the passageway of the clerestory. The pillars of the crossing were reinforced by marble columns, and similar columns were used in the arcade of the triforium gallery; the whole was covered by a vault divided into three bays; 'all which seemed to us who beheld it incomparable and most praiseworthy' (Pl. 82). In the fourth year the two further bays of the choir beyond the eastern crossing were completed and a scaffolding was raised in preparation for the great vault over the crossing itself. It was from this scaffolding, when a beam broke, that William fell, and was so injured that though he was able from his bed to direct the completion of the vaulting of the crossing and a supporting bay of the transepts on either side of it, working somewhat uneasily through a monk who was overseer of the masons, he had to give up the task and return crippled to France. His post was given to another William, an Englishman: he completed in the fifth year the vaulting of the

transepts and turned the roof above the high altar; he began also
the foundations of an eastern chapel, peri-apsidal in form with a
circular chapel, the Trinity chapel or corona, at the eastern point
(Pl. 83 a). This entailed an eastern extension to the crypt, and the
work was not completed, partially through lack of funds, till 1184,
though the choir itself had been brought into use and solemnly
rededicated in 1180.

 This remarkable conjunction of a detailed and intelligent first-
hand account with a building which still survives mainly unaltered
is a most unusual asset in art historical studies. It is all the more
important because the Canterbury choir has features which belong
to the Gothic style as it had been realized in recent buildings in
northern France. It is in fact often quoted as the first example in
England of the new style. This, however, is a point of view that
requires careful examination.[1] Experiments in vaulting had in
England, after their triumphs in the early years of the century,
come to something of a standstill. The nave of Lincoln had been
vaulted in the forties by Bishop Alexander, but between then and
Canterbury we know of no vaulted nave with the possible excep-
tion of Roche abbey in Yorkshire, where the clustered shafts and
the triforium also recall French examples and where the work was
completed at the same time as or shortly before the rebuilding at
Canterbury. The Gothic details of Roche are continued in some
of the later buildings of Roger of Pont l'Évêque such as Ripon,
or in Hugh du Puiset's church of St. Cuthbert at Darlington,
but this northern group seems to have no close contact with
the forms employed at Christ Church. In the south the church of
St. Cross at Winchester, with its vaulted choir, detached Purbeck
columns, and triple groups of shafts, has many French elements and
may, with one or two smaller neighbouring churches, have pre-
ceded the work at the cathedral,[2] but the architectural history of
Henry of Blois' celebrated foundation is very uncertain. The
Hospitallers received charge of it from the founder in 1151, and it

[1] See an important article by J. Bony, 'French influences on the Origins of English
Gothic Architecture', *Journ. of Warburg and Courtauld Institutes*, xii (1949), 1. Dr. Bony's
group of pre-Canterbury Gothic buildings includes several of very uncertain dating,
though this hardly affects his main argument. [2] Ibid. xii. 5.

is to be presumed that building began soon afterwards. There is ample evidence in the structure itself that there were many interruptions, and in fact there was a prolonged dispute between the Hospitallers and Henry's successor, Bishop Richard of Toclive (1174–88).[1] Its rich chevron decoration, interlacing arcades, and massive walls make a somewhat uneasy union with much that looks to new French fashions: it is a transitional building, but one that has failed to evolve a transitional style. Actually at Canterbury itself there had been a striking experiment in vaulting in the treasury built c. 1150 and roofed with an octopartite vault which seems clearly derived from that of Montivilliers (c. 1140) near Le Havre.[2] But the sexpartite vaulting of Canterbury, however the ground was prepared for its reception, is an importation from a line of development that was being worked out in France, at Sens, Senlis, Laon, Notre-Dame, a development very shortly to be abandoned in favour of quadripartite oblong vaults over each bay, made possible by the evolution of a keystone large enough to dispense with a rectangular junction of the rib voussoirs. It is reasonable to assume that this importation was due to William of Sens and the exact part played by him must receive further consideration.

Gervase first refers to him as a very skilful 'artifex' in wood and stone.[3] After his appointment *in curam operis*, however, he consistently calls him *Magister*. There can be no doubt that William, while noted for his own craftsmanship, was exercising many of the functions of an architect: he had a monk under him who was over the masons (*qui cementariis praefuit*): after his accident he directed from his bed 'what should be done first, what afterwards'. We have unfortunately no certain knowledge of early medieval architectural plans: measurements must have been laid down with some exactness, but how far and in what form William of Sens could hand on a prepared and worked-out scheme to William the Englishman still eludes all research on the subject.

[1] J. C. Cox in *V.C.H. Hampshire*, ii (1903), 193, and C. R. Peers, ibid. v (1912), 59.
[2] J. Bilson, 'The Norman School and the Beginnings of Gothic Architecture. Two Octopartite Vaults: Montivilliers and Canterbury', *Arch. Journ.* lxxiv (1917), 1.
[3] M. S. Briggs, *The Architect in History* (Oxford, 1927), 62.

Sens, the city from which William took his name, has in its cathedral one of the earliest examples of a fully developed Gothic building, which was 'almost completed' at the death of Archbishop Hugues de Toucy in 1168.[1] William must have been familiar with the work there. In detail, however, the resemblance between Sens and Canterbury is not close. At Canterbury the arcade is supported by columns alternately round and octagonal, a variation that hardly breaks their sequence and which may have been governed by the desire to repeat the original design, for the destruction of the columns, as we have seen, had been much regretted. At Sens the arcade supports alternate between compound piers and twin columns: on the former engaged shafts in groups of five reach from ground level to the springing of the roof vault, whereas at Canterbury triple columns of Purbeck marble are based on the imposts of the capitals of the octagonal piers and the string course at the base of the triforium passes over all these wall shafts instead of being cut by them as it is at Sens: the emphasis at Canterbury is on horizontal continuity, at Sens on a clear-cut division into double bays. Nor are there at Sens any of the ornate mouldings of Canterbury, with their use of dog-tooth and chevron patterns. Rather is this a practice associated with some churches of Soissons and Picardy: even the colouristic effect of the Purbeck columns against the Caen stone seems to have existed at the church of Notre-Dame at Valenciennes, begun in 1171, where shafts of blue Tournai stone were employed.[2] William's detached shafts round the main pillars of the crossing can be paralleled at Laon, Notre-Dame, and other approximately contemporary French churches, but they were already known in England, in Roger's crypt at York and in the responds of the chancel arch at Iffley, buildings which probably preceded Canterbury. William emerges as an architect closely in touch with contemporary trends, but not dominated by any one particular building.

His successor, William the Englishman, seems also to have been well informed as to building experiments in France: in the Trinity chapel, for instance, he used a true triforium, a wall passage, not

[1] E. Chartaire, *La Cathédrale de Sens* (Paris, 1930).
[2] J. Bony in *Warburg Journ.* xii (1949), 9.

a gallery space above the vault of the aisles. The splendid foliage capitals, where the leaves bend over in curving points forming groups of crockets, have a classical fullness which could be equalled in France but not surpassed. His twin columns recall those of Sens and may be copied from them. Whatever influences were at work, design and craftsmanship reached rare heights of achievement, and the eastern arm of Canterbury has all the unique individuality of a masterpiece. Much of the decoration remains Romanesque in character. The classical acanthus capitals are surmounted by square abaci: windows and ribs have chevron mouldings or dog-tooth carved in the hollows of the rolls, this last refinement of pattern that is the characteristic mark of the architectural transition. Below in William the Englishman's extension of the crypt the silhouette of a new style is more apparent, for here base, column, capital, and abacus are all circular. There is no ornament on the capitals: the vaulting ribs have a plain circular moulding: but the whole has a new intensity of unity through the unbroken circular design and, though as a substructure it requires short and substantial pillars, the high pitched vault, the two slender central columns markedly in contrast with the heavy side arcades, and the clustered ribs springing from them emphasize the upward movement as opposed to the defined horizontal planes of Romanesque, and fore-shadow some of the happiest effects of the thirteenth century.

Canterbury, however, remains isolated, a great architectural achievement in its own right, a brilliant fusion of French and English methods, but something outside the main development of English building. It was in fact a compromise: Gervase tells us how anxious the monks were to preserve as much as possible of their former church, and, if they failed to keep the choir arcade, at least they preserved its outer walls and two of its three apsidal chapels. This gave English William a particular problem in his eastern expansion. Instead of a continuous ambulatory round an apsidal choir, as was the practice in the great French cathedrals, he had to use a bending alinement which gives an individual fascination to the interior vista: beyond the eastern transept he placed a short flight of steps, echoing the steps from the nave to the choir, giv-ing to Canterbury another singular feature in this ascending series

of floor levels: his round chapel at the eastern end seems an invention of his own and one most happily found (Pl. 83 a).[1]

This ground-plan of the eastern arm (Fig. 5) in itself sharply separates Canterbury from the immediately succeeding developments of the new style in England, for these were largely concerned with the rebuilding of the eastern arm in a rectangular form, suppressing the apsidal chapels and utilizing the available space to the full for the provision of a spacious retro-choir. This fashion, a characteristically English one, for the French cathedrals retained the semicircular ambulatory (Laon, this recurrent name, is a notable exception), may have been influenced by the square-ended presbyteries of Cistercian building, or may be a reversion to an older Anglo-Saxon tradition: already in the first half of the century there had been rectangular eastern arms at Southwell, Old Sarum, and possibly Romsey. Now the development begins to fall into two main types, the first where the roof line is carried through at the full height, ending in an eastern front which rises unbroken from the ground: the second where the eastern gable is set back, while beneath it a retro-choir of the same height as the aisles leads into a lady chapel which completes the eastern termination. Either form is in marked contrast to the radiating chapels which constitute the familiar chevet of French Gothic cathedrals. The flying buttress, which in France is another familiar component of the buildings' aspect, is in England used but sparingly and only on the side aisles, as the continuous eastern face gives no possibility for these supports. At Canterbury the choir vault is buttressed by transverse ribs inside the triforium gallery and also by arched supports externally above the choir aisle. At Chichester internal quadrant arches were substituted for the original round transverse arches of the tribune, while, outside, the supporting arches are coped by a straight rib, a true flying buttress taking the thrust of the vault, though neither here nor at Canterbury has the pinnacle yet been devised to weight the point of junction between buttress and arch.

The two types of cathedral eastern arm correspond to a geo-

[1] The exact form of the upper story is uncertain: see C. E. Woodruff and W. Danks, *Memorials of Canterbury* (1912), 100.

graphical division of England roughly formed by a diagonal line from the Solway to the Thames at London:[1] north-east of this the high eastern front prevails; south-west, with the exception of Worcester, Oxford, and Bristol, the two last being built as churches of regular canons, not as cathedrals, there are projecting lady chapels. The latter type, however, has certain varieties of its own. At Chichester the roof level is carried through to the end of the retro-choir and only the lady chapel is at the lower elevation: at Winchester and Wells the retro-choir is a square-ended ambulatory, continuing the elevation of the aisles, a system which, without the lady chapel leading from it, had earlier been used at Byland and probably at Bishop Roger's choir at York. The introduction of the lady chapel is itself another markedly English feature, possibly to be explained by the great part England had taken in the cult of the Virgin, possibly due to the fact that here cathedral dedications to Our Lady were less common than in France and these lady chapels of the south and west are additions to churches dedicated to St. Andrew, St. Swithun, St. Ethelbert, St. Peter, and the Trinity.[2] Whatever the cause of this practice, and there seems to be no contemporary comment on it, the eastern extension at Chichester, with which we must now deal, was built with a small projecting lady chapel of three bays.

The cathedral church of Chichester had been consecrated in 1184.[3] Then, three years after completion, in 1187, the roof caught fire and the damage caused was sufficiently extensive to require a considerable rebuilding scheme. Bishop Seffrid II (1180–1204)

[1] The basic discussion of this question is to be found in E. S. Prior, *Gothic Art in England* (1900), 71 ff. See also H. Felton and J. Harvey, *English Cathedrals* (1950), 15; A. Hamilton Thompson, *Cathedral Churches of England* (1925), 49; G. Webb, *Gothic Architecture* (1951).

[2] Rochester and Wells, St. Andrew; Winchester, St. Swithun; Hereford, St. Ethelbert; Chichester, the Trinity. The dedications were not very closely defined and the Virgin was sometimes associated with the particular local saint. It is to be noted that Worcester, where there was no eastern lady chapel, was dedicated to the Virgin without any associated saint. This point and many others in this chapter will be carried further by Professor P. Brieger in *O.H.E.A.* iv. On the general question see W. Levison, 'Mediaeval Church Dedications in England'. *Trans. of the Architectural and Arch. Soc. of Durham and Northumberland*, x (1946), 57.

[3] R. Willis, *Chichester Cathedral* (1861), 12.

saw the completion of the first work, its destruction, and the rededication of the building in 1199. The nave and choir were now given a quadripartite stone vault, an enterprise no doubt encouraged by the greater security it gave from the devastation of fire. Nowhere in the building does the sexpartite vaulting of Canterbury occur. It was for this vault that the buttressing methods mentioned above were employed. Inside, the nave and choir retain their Romanesque outlines, composite piers supporting a tribune arcade with, above, a clerestory passage and window between two smaller arches. Here it is true there has been some remodelling: the surface damage from fire has been repaired in Caen stone (the roll mouldings of the arches) and Purbeck marble (the string courses); vaulting shafts of Caen stone with Purbeck capitals are applied to the wall face and Purbeck shafts are inserted in the angles of the piers; in the clerestory, while the Norman window of the back wall remains unaltered, the arcade has been rebuilt in Purbeck and Caen stone with pointed arches. There are hints of the new Canterbury fashions, but they are hardly emphatic enough to disturb a design which remains predominantly twelfth century. It is in the retro-choir that the new style is given wider scope; here it was probably desire for space rather than damage from the fire that was in question. The radiating chapels and circular ambulatory were destroyed and a rectangular retro-choir of two bays substituted (Pl. 83 *b*). The two new piers are round columns with four smaller free-standing columns and fine stiff leaf capitals: the pointed arches, which divide the tribune bays, are surmounted by tympana in which some figure carving is inserted, and on the eastern wall this carving suggests a date well advanced in the thirteenth century: below is the opening into the lady chapel. The building of the retro-choir doubtless followed the immediate repairs necessitated by the fire: certainly, after the rededication of 1199, work was still in progress in 1206 when Bishop Simon of Wells received royal authority to fetch marble by sea from Purbeck.[1]

It seems probable from similarities of mouldings and ornaments that some of the Chichester masons were employed also on the

[1] W. H. Godfrey and J. W. Bloe in *V.C.H. Sussex*, iii (1935), 105.

rebuilding of Boxgrove priory:[1] possibly though less probably in the new choir at St. Mary's, Shoreham, where the ornament is more lavishly carried out.[2] The particular interest of New Shoreham, however, lies in the flying buttresses of the choir vault: arch and buttress are both of a somewhat uncouth solidity, as though used uncertainly, but to make doubly safe a heavy pinnacle is placed on the point of junction, a severely functional forerunner to much Gothic crocketed gracefulness.

The extensions of the eastern ends continued. At Winchester the change was introduced under Bishop Godfrey de Lucy (1189–1204), who began the present retro-choir, a deep building of three bays but, unlike Chichester, continuing the elevation of the aisles with the east end of the choir rising above it. Three chapels were placed against the eastern wall, the central being the lady chapel, but they were of equal size and it was not till the end of the fifteenth century that the present projecting chapel was built. Clustered Purbeck columns and capitals with foliage crockets recall some of the detail of Canterbury, though there is a slender and austere elegance about it which contrasts with the more splendid weightiness of the earlier designs. Bases and imposts now have a rounded profile and merge more easily into the upward sweep of the lines: the rounded mouldings have no chevron decoration: the foliage has lost its classical maturity for a less assertive naturalism: for better or worse Early English good taste has arrived, with its faultless sense of line and spacing and its extreme reticence in any ornamental emphasis.

At Winchester the work seems to have been carried to a considerable stage of completion round the original Norman apsidal choir, which remained in use. This may have been one of the reasons, a very practical one, that contributed to the popularity of the square-ended plan. But these extensions, apart from the provision of a lady chapel, seem to be connected with the cult of

[1] J. L. Petit, *Architectural History of Boxgrove Priory* (Chichester, 1861).

[2] E. Sharpe, *Architectural History of St. Mary's Church, New Shoreham* (Chichester, 1861). Some of the ornament at New Shoreham is repeated at Reigate: comparisons have also been made with the decoration at Tynemouth priory: see F. S. W. Simpson, *The Churches of St. Nicholas Old Shoreham and St. Mary de Haura New Shoreham* (Gloucester, n.d.).

particular shrines and to be intended to provide greater facilities for pilgrimage, though the shrine itself was not always placed in the eastern arm. The retro-choir of Rochester, reaching to the full height of the choir and as at Canterbury raised on an extension of the crypt, was begun *c.* 1210, after the murder of a Scottish pilgrim, William of Perth, had provided them with a popular martyr. At Hereford the cathedral authorities, who also were following this new building fashion, employed Giraldus Cambrensis, who was one of their canons, to write a life of their local saint, Ethelbert.[1] At Norwich, though here no extension was built, Thomas of Monmouth finished about 1173 his life of the boy martyr, St. William, that sinister legend which is the first of the Jewish ritual stories.[2] Glastonbury had Arthur and Guinevere (1191); at St. Albans in 1177 the relics of St. Amphibalus, the teacher of St. Alban, were discovered; in 1203 St. Wulfstan was canonized and at Worcester in the second quarter of the thirteenth century a new retro-choir was built. The quest for saints was one of the urgent preoccupations of the closing years of the century.

In the north the new style found an energetic patron in the bishop of Durham.[3] We have already seen something of his work in the cathedral and castle. In the church of the hospital at Sherburn, which had been 'newly built' by 1185, there are round-arched windows and volute capitals. The buildings of the hospital itself with, in the words of the great antiquary, Raine, 'its towers, and parapets, and buttresses, and crypts, with all their accompaniments of old grey, weather-stained, lichen-clothed masonry, and light and shade, and ancient association', were in 1833 'barbarously swept away' to build a modern house for the master. Appropriated to the hospital was the church of Grindon which, now ruined, had been 'newly built' in honour of St. Thomas of Canterbury. The chancel has a round arch and round-headed windows, probably

[1] A. T. Banister, *The Cathedral Church of Hereford* (1924), 109.

[2] A. Jessop and M. R. James, *The Life and Miracles of St. William of Norwich* (Cambridge, 1896).

[3] See W. H. D. Longstaffe, 'Bishop Pudsey's Buildings in the present County of Durham', *Trans. of Architectural and Arch. Soc. of Durham and Northumberland*, i (1863); J. F. Hodgson, 'The Churches of Darlington and Hartlepool', *Arch. Aeliana*, xvii (1895), 145.

earlier work, but the nave has two lancet windows and the finely
built south door has a pointed arch and volute capitals.[1] The last
of his buildings is the church of St. Cuthbert at Darlington. Here
the round arch has been completely abandoned for the pointed:
water-leaf capitals and lozenge ornament are used, and the lancet
window becomes the main feature in the simple but balanced
design (Pl. 84 b).

Apart from du Puiset's buildings, the north is still particularly
rich in churches of this period: at Hexham the new choir, whose
erection is singularly undocumented, seems from some of the
chevron mouldings to belong to the same phase as the work
at Darlington, though its completion is in the fully developed
Early English style of the opening years of the thirteenth century.[2]
Brinkburn, Lanercost, and Hartlepool are other churches where
similar work can still be found. Proudly placed upon its rock above
the Tyne estuary, the priory of Tynemouth is perhaps, weathered
and ruined as it is, still the finest of them all. The Norman church,
with an ambulatory choir, had been completed at some fairly
early date in the century.[3] Some time about 1190, under Prior
Akarius, possibly in rivalry with the magnificent and ill judged
plans for a western extension which the mother abbey, St. Albans,
was then considering, a new eastern arm was begun. Whereas the
Norman choir had been 48 feet in length, this new arm, with the
choir and square-ended retro-choir (the chapel of St. Oswin) was
116 feet. The vaulting seems to have been sexpartite. The tall
lancets of the east end still retain their noble outlines and amongst
the ruins is a great water-leaf capital: the mouldings of the clere-
story range suggest a date c. 1220 for the completion of the work.
Even more than the new eastern arms of the Cistercian abbeys

[1] M. Curtis in *V.C.H. Durham*, iii (1928), 253.

[2] A. B. Hinds in *A History of Northumberland*, iii (1) (1896), 184; C. C. Hodges and
J. Gibson, *Hexham and its Abbey* (1919). There is a magnificent privately printed
publication (1888) with many detailed drawings by C. C. Hodges, *The Abbey of St.
Andrew, Hexham*.

[3] C. C. Hodges, 'Some points in the Architectural History of the Priory Church
at Tynemouth', *Arch. Aeliana*, xix (1922), 105; H. H. E. Craster, *History of Northumber-
land*, viii (1907), 136; W. H. Knowles, 'The Priory Church of St. Mary and St. Oswin,
Tynemouth', *Arch. Journ.* lxvii (1910), 1.

already begun or to be undertaken in the early thirteenth century, Tynemouth (Pl. 73 a)[1] shows the austere beauty of the lancet opening with its narrow, concentrated upward movement, undistracted by ornament, strikingly in contrast with the round Romanesque arcades so firmly placed on their massive columns, so richly decorated with billets and chevrons.

Meanwhile in the west country also, that district which had already shown itself so individual in its architecture, experiments were being made in the new style; of which experiments the west bays of Worcester cathedral are an early and individual example. The Norman cathedral had been begun by Bishop Wulfstan, though the new magnificence of scale was little to his taste and he feared that they were 'neglecting souls to pile up stones'.[2] In 1089 the work was sufficiently advanced for the new buildings, with their accommodation for a greater number of monks, to be brought into use. The old church of St. Oswald was pulled down before Wulfstan's death in 1095. The cathedral suffered from a fire in 1113 and little is known of its history until further destruction is reported through the fall of 'the new tower' in 1175. Of its Romanesque building little remains save the crypt, where from the central pillar of the apse spring seven groined arches, and the numerous and slender columns, with the ingenious vistas through them, give an air of grace and lightness that no other of our subterranean chapels can equal. It has sometimes been argued that this central pillar in the crypt of Worcester is the prototype of later chapter-house designs.[3] Certainly the groined vault of the crypt apse, with the edges of the groins marked out in different stonework, leads on to that of the circular Worcester chapter-house, the first of a long and notable succession, where the groins, supported by semicircular ribs, meet on a central column. This building from its capitals and the mouldings of its inner arcade of intersecting

[1] The ground-plan of the Romanesque round apse and radiating chapels can be seen in the plate inside the later eastern arm.

[2] William of Malmesbury, *Gesta pontificum*, R.S. lii (1870), 283. See R. Willis, 'Worcester Cathedral', *Arch. Journ.* xx (1863), 83, and H. Brakspear in *V.C.H. Worcs.* iv (1924), 394.

[3] R. Willis, 'The Crypt and Chapter House of Worcester Cathedral', *Trans. of R.I.B.A.* (1863), 213.

arches seems to belong to the first half of the twelfth century. In the cloister passageways also there is some Norman work, but apart from foundations and inner cores little of it survives in the cathedral until we come to the two westernmost compartments of the nave. Here we find, as at Malmesbury, round and pointed arches both employed (Fig. 18). The ground arcade has a pointed arch of three orders supported on inset columns: the contrasted stone employed, white and green, already foreshadows the use of Purbeck marble: the great wall rib has triple shafts, a characteristic feature of the western style. The unusual and elaborate second story, a large triforium passage, has a pair of pointed arches each containing three round-headed arches with heavy chevron ornament: above these arches are small tympana with bossed ornamentation, and there are bosses also in the tympanum space of the main arches. The clerestory has a large round-headed window flanked by two pointed arches forming the arcade of its wall passage. Ground and triforium arches have a continuous and rounded outer moulding. The whole effect is markedly ornate and also strangely composite, a meeting rather than an assimilation of two styles. The date of this early and tentative Gothic experiment is nowhere documented, but the term *nova turris* suggests a contrast with an older example, and the most natural interpretation is that it was one of the western towers rather than the central one whose collapse occasioned this rebuilding. These curious bays are a premonition of Gothic some eight or nine years before work was begun at Glastonbury and Wells.[1]

The buildings in the west are too numerous to deal with in detail. At Hereford the scheme of the square eastern end was introduced *c.* 1190 under the wealthy bishop, William de Vere: the great Norman arch which opened from the choir into the apsidal eastern presbytery was retained, but beyond it was built a double aisle, eastern transepts, and a chapel of two projecting bays, later to be extended.[2] The first Gothic choirs of Chester and

[1] For the vexed question of dating at Worcester see W. M. Ede and H. Brakspear, *Worcester Cathedral*, 4th ed. revised (1937), 50, where Sir Harold Brakspear accepts the western tower, as opposed to the central tower for which he had argued in *V.C.H. Worcs.* iv (1924), 394.

[2] G. Marshall, *The Cathedral Church of Hereford* (1951), 52.

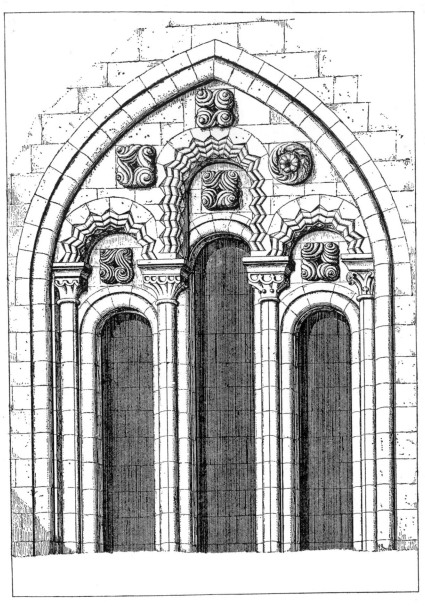

FIG. 18. *Worcester cathedral: detail of west bay of nave*

Lichfield, much of the large parish church of St. Mary's, Shrewsbury (where a wide range of capitals is found), and the eastern extension of Abbey Dore, all belong to this phase. In Ireland the Transitional style was imported by the English conquerors and was used for Christ Church, the new cathedral of Dublin, where the elevation of the nave recalls, in its grouping of triforium and clerestory in one arch, the earlier version of St. David's.[1] At Abbey Dore the eastern of the two walks of the ambulatory still has fragments of its stone screens dividing it up into chapels: the east end of the presbytery rises above this retro-choir and the effect of height in the lancet arches, rising from the string course immediately above the ground arcade, is maintained by setting the windows on high pitched splays. The ruined arcade of Llanthony priory (c. 1180–c. 1210) provides a notable example of arches where the roll moulding is carried continuously from the floor level round the arch head, a western feature used also at Worcester and Glastonbury.[2] At Llandaff, the church begun by the first Norman bishop, Urban (1107–34), whose eastern Romanesque arch, reminiscent of Hereford, still remains, was only reaching completion in the closing years of the century: the nave has a two-storied elevation, where the lancets of the clerestory rise immediately from the string course of the ground arcade: there are triple shafts and a series of notable capitals where the flat vertical leaves of the Cistercian style swell into roundness or sweep almost into crockets, tall slender fronds growing unhampered by the basic shape of the capital that they cover.

Of all the buildings in the west country that have come down to us that of Wells is, however, the most beautiful and the most significant for the future. Reginald Fitz-Jocelin, bishop of Bath from 1174–91, was a son of Jocelin, bishop of Salisbury, born before his father had been admitted to the priesthood. He grew up as one of the king's party in the quarrel with Becket, though his opponents admitted his ability and correctness of life: he was a clear choice for one of the six sees which Henry found himself compelled to fill

[1] A. C. Champneys, *Irish Ecclesiastical Architecture* (1910), 140.
[2] E. W. Lovegrove, 'Llanthony Priory', *Archaeol. Cambrensis*, xcvii (1943), 213, and xcix (1947), 64. For Abbey Dore see *R.C.H.M. Herefordshire*, i (1931), 1.

after the canonization of Becket.[1] The appeal of the Young King against his father's nominations led to Reginald's accompanying the archbishop-elect, Richard of Dover, to Rome: on their return journey he was entrusted with a mission that was to have much influence on English church life, the persuasion of Hugh of Avalon to leave the Grande Chartreuse for the new Carthusian priory of Witham in Reginald's own diocese. On 4 September Richard and Reginald reached Canterbury: the following day, 5 September, was that of the fatal fire which destroyed the glorious choir. Reginald must have returned to his diocese with the impression of that great architectural loss very fresh upon him.

The diocese had a disputed centre. Under Bishop John of Tours (1088–1122) Bath had been the episcopal town from which he took his title, where he built a great Romanesque church and large palace for himself. This church was burnt in 1137, but Bishop Robert (1136–66) was a great builder who restored it and considerably enlarged the monastic buildings. Unlike John of Tours Robert interested himself in Wells also, where he reorganized the Chapter which had been dispersed by his predecessor and undertook the building of a new church of which a consecration, presumably of the eastern arm, took place in 1148. This may have been a rebuilding of the Saxon church: it is unlikely that it was work on a great scale, for when some forty years later Reginald turned his attention to building at Wells, none of the earlier structure appears to have been retained. The surviving charters dealing with funds for the work fall, from the names of the witnesses, in a period after 1184: Reginald died in 1191. In these seven years the new cathedral was begun, and from the first its builders used the Gothic style with an ease and fluency not yet seen in England. The west bays of Worcester, and at Glastonbury St. Joseph's chapel and the eastern arm, still show traces of the Romanesque idiom. In Wells a new decorative sense triumphs. How much was completed by Reginald, how much by his successor, Savaric (1192–1205): whether or not the interdict marked a complete cessation of the work: these are problems to which certain answers are unlikely.

[1] C. M. Church, *Early History of the Church of Wells* (1894); J. Armitage Robinson and J. Bilson in *Arch. Journ.* lxxxv (1928), 1.

The main break in the masonry comes after the sixth bay of the nave, counting from the east. West of that line there is considerable development in ornamental detail: throughout until the great west front is reached there seems to be adherence to an original scheme. In plan the eastern arm was an aisled choir of three bays with a returned aisle across its square east end opening into a Lady chapel, the typical scheme of the period. Its transept arms of three bays each had aisles on both east and west. The vaulting was throughout quadripartite and buttressed by arches under the triforium roof: external flying buttresses were not provided and the outer walls still have only stepped buttresses of comparatively slight projection. The triple columns of the western group are found once again. In the choir and transepts, the bays were clearly divided by vaulting shafts rising from the base of the triforium stage: each bay had two lancet openings set in continuous mouldings. In the nave the bay division is abandoned: the triforium is composed of a continuous row of narrow lancet openings, forming a swiftly moving interchange of light and shadow: the corbelled vaulting shafts start, with a curiously truncated appearance, above the level of the triforium openings (Pl. 84 a). The effect is to produce a long, horizontal line, this favourite and individual tendency of English Gothic, which at Wells is stressed also on the exterior by carrying the string courses round the projecting buttresses. It was only reluctantly that Gothic learned to soar in England.

The greatest glory of Wells is, however, its carving. The type of foliage on frieze and capital was undergoing many and experimental changes. At Canterbury the capitals of William of Sens were classical acanthus, curving over into volutes, with octagonal abaci: nowhere else in England were there as fine examples of the prevalent French mode, though in some of them the lengthened stalks and crinkled, petalled leaves suggest more popular English fashions. At New Shoreham and Reigate the stems are flat and unarticulated and the full Corinthian leaf is simplified into a curved volute: in some cases the abaci are round, though at New Shoreham this is curiously combined with a necking of the old-fashioned rope pattern. In Chichester retro-choir the thin stalks bend over under the weight of their cinque-petalled leaves in work of

miraculously daring undercutting. In the north, Cistercian influence popularized the water-leaf, with its simple outline and inward curling volutes: this was the form that was borrowed by masons for Bishop Roger's work at Ripon and Bishop du Puiset's church at Darlington. At Abbey Dore another Cistercian motif, rows of palmettes, develops into straight-stemmed trefoil leaves, surmounted by an abacus with an irregular wavy line following the three shafts below it: here, as so often in Cistercian art, the simplicity of the decoration leads to a particularly lucid statement of the underlying forms. At St. Frideswide's, Oxford (Pl. 17 b), the development of capital design can be followed with unusual completeness from a simple curved volute through thin-stemmed petalled foliage to a double line of fine petalled leaves, thickly set over the whole face: some of the earlier capitals have as side corbels human heads of unusual dignity and beauty. At Wells the capitals that remain of the original choir are not unlike some of the volute capitals at New Shoreham: unusually tall, as at Llandaff, a single capital with a square or octagonal abacus crowns the triple shafts. Similar capitals were later repeated in the west bays of the nave, a tribute to their admirably effective design. The east piers of the south transept have a more advanced type of foliage, with naturalistic leaves distributed evenly over the whole face of the capital: the west piers have foliage more similar to that of the choir but enriched with grotesques, heads and figures of prophets, and scenes of occupations (Pl. 84 a). One group shows two men stealing grapes and the pursuit and punishment of the thieves by the husbandmen. There is much ingenuity in the placing of the figures under the heavy volutes and in the proportions given to them so that the best effect may be secured when seen from below. The four eastern bays of the nave and their aisles continue the same type of work: the nave triforium has small foliage tympana at the top of its lancet openings and roundels between the points of its arches. Some of these are later work but carry on the style of the capitals. Very similar to them are the fine corbels of the vaulting shafts in the transepts, where figures are added to the foliage: some of these carry scrolls and are accompanied by doves or winged dragons: in the north transept a famous corbel of a lizard gives

a last echo of the coiling dragons of the first half of the century. Many of these carvings are characterized by a triple-petalled leaf, which begins to show itself also in manuscripts of the turn of the century. In the beautiful arcaded porch of the north door the older capitals appear, but in the friezes the new leaf is used. This doorway, which with the transept corbels and some of the nave decoration is the link between the work of Bishop Reginald and the building of the great west front in the second quarter of the thirteenth century, must have been amongst the latest tasks before the façade was begun. Its series of capitals telling the story of the martyrdom of St. Edmund still has the heavy, large-headed figures of the transept carvings, but the time was not far off when a new master was to find another treatment for the great gallery of figures in the west front.

In London the round nave and west door of the Templar's church, much damaged by bombing in 1941, was a building of high quality and reasonably certain date. This church originally consisted of its circular nave with a chancel of small size: it was dedicated in 1185 by the patriarch of Jerusalem, Heraclius. Its piers of four detached Purbeck columns, its fine foliage capitals, its wall arcade of pointed arches, all belong to the new style: the interlacing arcade in the triforium stage and the square bases and abaci look back to earlier traditions. Its west door of seven orders has a fine variety of ornament, ranging from elaborate scallops to grotesque heads amongst foliage.[1]

In the eastern counties the great example of early Gothic was to be the choir of Lincoln, but the new tendencies were evident at other centres also. At Ely the pointed arch appears in the upper stages of the great west tower raised under Bishop Geoffrey Ridel (1174–89). The Galilee is attributed to the episcopate of Eustace (1198–1215), but its advanced detail and naturalistic foliage suggest a date nearer the mid-century.[2] At Peterborough building had gone on continuously on the lines laid down in the earlier part of the century, a consistency of purpose that has produced one of the

[1] R.C.H.M. London, iv (1929), 137. Plans and elevations, G. F. Nash in *Vetusta Monumenta*, v (1835), Pls. xix–xxv.
[2] D. J. Stewart, *Architectural History of Ely Cathedral* (1868), 51.

most complete and satisfying of our Romanesque churches. Under abbot Benedict (1177–94) the west end was reached and the original plan of two western towers at the end of the aisles was modified: the nave was extended for two bays and the west front lengthened by western transepts, in the east walls of which, work of *c.* 1190, lancet windows were used. Benedict's replanning, however, opened the way to further experiment and it was not till the second quarter of the thirteenth century that the great west front as we know it, a Gothic interpretation of a Romanesque scheme, was completed, the third variant from the plan as first designed.[1]

At Lincoln the great cathedral of Remigius, rebuilt by Bishop Alexander the Magnificent, was 'cleft from top to bottom' by an earthquake on Palm Sunday 1185. 'A huge movement of the earth such as from the beginning of the world had not been known in that land.'[2] The see was at the time vacant and had been to all intents vacant for twenty years, being held nominally and without election by Geoffrey, Henry II's illegitimate son, till the learned Walter of Coutances was elected in 1183, only to be transferred to Rouen in the following year. Now, with much unwillingness on his part, Hugh of Avalon, the saintly prior of Witham, was promoted to the see. Hugh was a man, for all his austere piety, of considerable ability and shrewd financial sense. His new bishopric had fallen on evil days and his famous opposition to Richard on the question of knights' service abroad was well justified by the need to husband all its resources.[3] The rebuilding of his ruined minster was naturally one of the most immediate commitments. The ruins were cleared and in 1192 work began. The *fabricae constructor* was Geoffrey de Noiers, whose Norman name was borne by a family long settled in England and need not imply an architect brought from France. A master mason Richard was also in the employment of the cathedral at the close of the century.[4] The plan of the new

[1] C. R. Peers in *V.C.H. Northampton*, ii (1907), 441; G. F. Webb, 'The Sources of the Design of the West Front of Peterborough Cathedral, *Arch. Journ.* cvi (supplement, 1952), 113.

[2] *Gesta Regis Henrici Secundi*, ed. W. Stubbs, R.S. 49 (1) (1867) i. 337.

[3] See H. M. Chew, *Ecclesiastical Tenants-in-chief* (Oxford, 1932), 39, 42.

[4] J. W. F. Hill, *Medieval Lincoln* (1948), 113.

choir has no exact parallel in known buildings: the eastern tran-
septs, each with two apsidal chapels, recall the scheme at Canter-
bury, but the Lincoln eastern chapel was three-sided in shape with
two apsidal chapels opening off the north and south walls (Fig.
19). Of this unusual design nothing now remains, though its plan

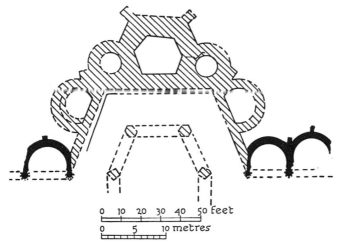

FIG. 19. *Lincoln cathedral: plan of east end of St. Hugh's church*

was traced in excavations carried out in 1886.[1] The choir itself
was much restored after the fall of the central tower in 1237. The
restoration, clumsy work including columns without capitals, is
easily distinguishable from the earlier and finer masonry and,
though it has been much questioned, the curious choir vault,
where between each transverse arch three ribs join the central rib,
forming unequal cells, probably dates from the building phase of
St. Hugh. It has also been argued that the double arcading of the
aisle walls represents an alteration of the original work, but this
beautiful design has a unity which suggests a single inspiration
and its deeply undercut foliage is common to both the inner and
outer arches. The much restored spandrel figures must originally
have been excellent pieces of carving and still retain an elegance
which, if they date from the time of St. Hugh, was an early

[1] Precentor Venables, 'Some Account of the Recent Discovery of the Foundations
of Lincoln Minster as erected by St. Hugh', *Arch. Journ.* xliv (1887), 194. See also
the excellent short history, *Lincoln Minster*, by J. H. Srawley (1947).

demonstration of Gothic refinement. The problems are many and puzzling, but any interpretation of them still leaves it certain that St. Hugh's builders began in the new style, handling it with sympathy and conviction if not always with complete mastery. Purbeck marble was much used; the bases and abaci are round; the capitals have freely curving volutes and the stems and leaves stand out from the surface as though growing with a life of their own. The clustered stone and Purbeck piers with their free-standing shafts and their carved crockets rising along the main column are a particular beauty even of this, the loveliest of our cathedrals (Pl. 40 *b*), the *columnellae quae cinxere columnas* as the author of the metrical life of St. Hugh puts it; and to Giraldus Cambrensis, writing at Lincoln in 1196–9, it is, as to Gervase of Canterbury, the alternation of the marble columns that is the most striking of the 'modern innovations'.[1]

Certain features emerge from the general picture of these building activities of the turn of the century. The undertakings, though numerous, are not on the scale of those which characterize the period around 1100. Few great churches were built or completely rebuilt: Wells and Glastonbury are notable exceptions, but in both cases there were special circumstances, episcopal policy in one, an unusually devastating fire in the other. Mostly it is in the rebuilding of the eastern arm that the new style becomes apparent, while the Norman nave is left unaltered; though it too was to be remodelled at a later period. The Cistercian monasteries, stylistically the forerunners of these new fashions, were amongst the chief exponents of them, and Abbey Dore, Valle Crucis, Beaulieu, Furness, Fountains, Rievaulx, Jervaulx, all undertook new buildings or considerable extensions in the period 1175–1225. Work, once begun, seems to have progressed steadily and not to have been markedly broken by any of the disturbances of the time, though it is a period which includes the heavy exactions for Richard's crusade and ransom, and the interdict under John. Here and there we get echoes of the pressure of events. Geoffrey of Coldingham, telling of Richard's demands on Bishop Hugh du Puiset, notes that

[1] See Giraldus Cambrensis, *Opera* vii, R.S. xxi (1877), lxvi, 97, and *Metrical Life of St. Hugh*, ed. J. F. Dimock (1860), 33.

'amid the vicissitudes of so many tempests, he did not desist from the building of the church of Darlington'.[1] At St. Albans, where Abbot John of Cella (1195–1214) ran into grave financial difficulties over his ambitious project of rebuilding the west front, the monastic chronicler attributes this to lack of forethought and the dishonesty of his master mason, Hugh Goldclif, not to the royal exactions.[2] St. Albans in fact, as happened with many of the cathedral chapters and monasteries, seems to have recovered control of its possessions by paying a fine to the king, and John's confiscation of ecclesiastical property in March 1208, following on the interdict, was not necessarily of any long duration.[3] Even at Worcester, where Bishop Mauger fled the country after proclaiming the interdict, the rebuilding necessitated by the great fire of 1202 was completed in 1218, though John's devotion to the newly canonized St. Wulfstan may, as at Bury where he had a similar devotion to St. Edmund, have induced some special leniency of treatment. At Winchester the work begun by Godfrey de Lucy in 1202 was carried on by John's friend and adviser, Bishop Peter des Roches (1205–38).

Assessment of such problems is faced with one prime difficulty, our comparative ignorance of the cost of building and how it was financed. The fabric rolls of later times are not available for the twelfth century and we are dependent on scattered references in the chronicles and on some building items entered in the Pipe Rolls, mainly for secular constructions. It has been estimated[4] that the building of the Cistercian abbey of Vale Royal cost approximately £1,500 in the three years 1278–80, and costs were probably not notably dissimilar a hundred years earlier. We have already seen some indications of how such sums were raised: Bishop Gilbert Foliot forming a confraternity of donors to the expenses of St. Paul's;[5] grants of land made to the fabric fund at York;

[1] Surtees Soc. (1839), 14. [2] *Gesta abbatum*, R.S. xxviii, 4 *a* (1867), 218.

[3] See on this problem C. R. Cheney, 'King John's Reaction to the Interdict', *Trans. of the Royal Hist. Soc.* xxxi (1949), 129.

[4] D. Knoop and C. P. Jones, *Mediaeval Mason* (1933), 4. The authors calculate £1,500 as equivalent to £48,000 at the time they were writing.

[5] See above, p. 96: when bishop of Hereford, Gilbert had granted his blessing and a form of indulgence to those who visited Leominster on the feast of St. Peter

relics 'invented' to attract greater concourses of pilgrims; more ominously, as in Abbot Simon's time at St. Albans, borrowings from the Jews. Instances from charters and chroniclers could easily be multiplied: John of Cella sent out a clerk 'raised from the dead by the intercession of Saint Alban and Saint Amphibalus' to collect funds for his ill-fated enterprise, while the monks contributed for fifteen years their allowances for wine;[1] at Wells Bishop Reginald with the consent of his archdeacons assigned the income from all vacant churches to the cathedral fabric fund;[2] at Bury Abbot Samson, while he was still sub-sacrist, had made 'a hollow trunk with a hole in the middle on the top, and fastened with an iron bar, and caused it to be set up in the great church near the door outside the choir, where the common folk pass to and fro, so that they might place their alms within for the building of the tower'.[3] But undoubtedly the main factor in twelfth-century finance was the distinction drawn between the funds of bishop or abbot and those of the monastery and the inclusion of the fabric fund in the latter, thereby freeing it from the fiscal obligations to which the former was liable. Grants such as those quoted at York[4] were made *in liberam, puram et perpetuam eleemosinam* and, in the twelfth century, were accepted as quit of all claims for taxation. Whereas William of St. Carilef or Ranulf Flambard appear as genuinely responsible for financing the building of Durham, at Canterbury, where Anselm granted the rents of his manor of Petteham for 'the new work east of the great tower',[5] it is Prior Ernulf or Prior Conrad who plays the leading part. Under the able administration of Prior Wibert (1151–67), Canterbury finance was centralized under a treasurer, with beneath him three obedientiaries, the cellarer, chamberlain, and sacrist. The last was encharged with care of the

and St. Paul, but this was *ad sustentationem* of the inmates. It is possible, however, that it also included building operations, and Gilbert's episcopate (1148–63) probably saw the completion of the west façade. Dugdale, *Monasticon* (1823), iv. 56: see above, p. 75.

[1] *Gesta abbatum*, R.S. xxviii (4 a) (1867), 219.
[2] J. A. Robinson in *Arch. Journ.* lxxxv (1928), 3.
[3] *Chronicle of Jocelin of Brakelond*, ed. H. E. Butler (1949), 10.
[4] See above, p. 234.
[5] *Eadmeri historia*, R.S. lxxxi (1884), 75.

fabric.[1] At St. Albans under Abbot William (1214–35), Richard of Thidenhanger the chamberlain was responsible for the repair of the tower, 'though for reverence sake it was ascribed to the abbot'.[2] Behind the great arches, the vaults, and doorways, lie not only the organization of the masons' yard, but a constantly increasing proficiency in accounting and administration.

[1] R. A. L. Smith, *Canterbury Cathedral Priory* (1943), 14. See also K. Edwards, *The English Secular Cathedrals* (1949).

[2] *Gesta abbatum*, R.S. xxxviii (4 a) (1867), 280.

X

THE CLASSICAL REVIVAL

THE ten years' reign of Cœur de Lion gave little opportunity for royal influence upon taste. As a young man Richard had lived mainly in Aquitaine: as king he spent barely two years in England. His crusading journey may have increased the contacts between East and West and the artistic interactions that accompanied them: here and there we see hints of the process: the charter which he gave in 1191 at Messina to the monks of Christ Church is still wrapped in a piece of silk, wrought with birds and rabbits, which is Sicilian work and similar to some silken fabric taken from the tomb of Henry VI at Palermo,[1] but such interchanges were already frequent and in little need of any particular stimulus. It is fitting that Richard's most celebrated work should be a castle, Château-Gaillard, and that it should be in France, built on the steep hill-side of Les Andelys, guarding the valley of the Seine at the entry into Normandy. Much has been written about Château-Gaillard[2] and its innovations have often been associated with the castle building of Syria, but it is still fundamentally a motte and bailey castle with the keep at the highest, strongest point, round it an inner circle of walls and beyond them the bailey, separated from the hill-side by a rock-cut ditch with a triangular outwork on the farther side. This scheme of defences is in no genuine way concentric: one line of walls does not overlook and support the others: they are rather points of retreat to which the defenders could withdraw if the outer defences were stormed. But in detail they are planned with a new skill: the inner *enceinte* is composed of an elliptical wall, a series of curved faces, so that at every point the glacis at its foot is controlled; the keep has arched machicolations exactly placed to secure as wide a ricochet as possible for missiles

[1] G. Robinson and H. Urquhart in *Archaeol.* lxxxiv (1935), 175.

[2] M. Dieulafoy, 'Le Château Gaillard et l'Architecture militaire au XIIIᵉ siècle', *Mémoires de l'Institut national de France*, xxxvi (Paris, 1898), 325, still remains the most complete account, though its general conclusions are not now accepted.

dropped from them on the battered base of the tower: the whole scheme of fortifications shows a brilliant ingenuity and clearly was given most careful and informed supervision. At the time it was rightly recognized as marking a stage in the development of military science. Apart from such technical accomplishment, it is, even as a ruin, a most impressive piece of architecture, and on the outer *enceinte* the alternate courses of brown and white stone show that the builders were not unheeding of its visual effect.

Nothing of the same date in England can equal Château-Gaillard as a piece of castle building, but an example of new theories of defence can be seen at Framlingham in the castle erected by Roger Bigod II between 1189 and 1213.[1] It was on a great mound, the site of an earlier castle dismantled by Henry II in 1175-7. The new castle was built as a roughly oval curtain wall with twelve projecting rectangular towers and one polygonal at the south-east corner: the wall is some 44 feet high, the towers rise about 20 feet above it. Inside the circuit were the great hall, chapel, and other residential buildings, but no keep. The strength lay in the number and projection of the towers, which covered all the approaches to the wall, but the round tower which characterizes the contemporary work of Philip Augustus in France was nowhere used at Framlingham.

Rouen, the city to which Château-Gaillard was the key, was the second capital of the Angevin kings. Little, however, remains of the buildings of their period. In 1145 Archbishop Hugh (1130-64), the former abbot of Reading, began a large-scale rebuilding of the eleventh-century cathedral. This probably included the choir and the lower stages of the Tour St. Romain, the only surviving part of Hugh's building, gutted by fire in 1944, but still standing. In 1183 Henry the Young King, son of Henry II, was buried in the choir of the cathedral: sixteen years later the heart of Cœur de Lion was, as he had willed, brought to Rouen. The associations of the reigning house were therefore close with the cathedral of their Norman capital, and when in 1200 a great fire 'burned the whole

[1] F. J. E. Raby and P. K. Baillie Reynolds, *Framlingham Castle* (Ministry of Works Guide, 1938); H. A. Evans, *Castles of England and Wales* (1912), 327.

church of Rouen with all its bells, books and ornaments',[1] John at once interested himself in the work of restoration and made a considerable grant on his own behalf.[2] The church of St. Ouen was built early in the twelfth century, but here again fires caused grave destruction and the present building, with the exception of a Romanesque apse in the north transept, is work of the fourteenth and fifteenth centuries. The great stone bridge of the Empress Matilda was replaced by a bridge of boats in the seventeenth century, a suspension bridge in the nineteenth: more recently the army signpost to one of the bailey bridges spanning the river still bore the name 'Pont de Mathilde'. One small building, however, retains both its Angevin associations and its original appearance. The little chapel of St. Julien du Petit-Quevilly belonged to a manor where Henry II in 1160 had built a residence: this in 1183 he converted into a leper hospital for women and the decoration of the chapel seems to belong to this latter date. Hard to find in an outlying suburb of Rouen, the chapel is little known or visited, but in the high quality of its masonry, carving, and painting it is a genuine masterpiece.[3] Its plan is the familiar one of aisleless nave, chancel, and apsidal presbytery: its façade with three windows alined above a central doorway is severely plain; the water-leaf capitals serve to suggest the probable date; inside there is a continuous wall arcade, heavily carved with chevrons and very English in appearance. The chancel is covered with a sexpartite vault in whose triangular compartments are preserved a remarkable series of frescoes. For a time covered with whitewash, they were again brought to light at the end of the nineteenth century, and though the rich colouring is dimmed the beauty of the drawing is still clearly visible. The subjects are a customary series: Annunciation,

[1] M. Aubert, 'Rouen: la Cathédrale', in *Congrès archéologique, LXXXIXe Session* (Paris, 1927), 15.

[2] M. Alluine and A. Loisel, *La Cathédrale de Rouen avant l'incendie de 1200* (Rouen, 1904), 84.

[3] Dr. Coutan, 'La Chapelle St. Julien du Petit-Quevilly', *Congrès archéologique, LXXXIXe Session* (1927), 238; P. Gélis-Didot and H. Laffillée, *La Peinture décorative en France*, 2e Livraison (Paris, 1889). A detail of the roof is reproduced in A. Michel, *Histoire de l'Art*, ii (1906), 403, but is there assigned to the thirteenth century. Dr. H. Swarzenski was the first to suggest its possible English connexions.

Visitation, Nativity, Journey of the Magi, the Magi before Herod, the Adoration, the Magi's Dream, the Flight into Egypt, the Baptism. The types followed are those familiar in works such as the Gough Psalter,[1] and the style fits easily into that of the last quarter of the century in England: the foliage is a large, many-pronged acanthus leaf, and along one of the ribs of the vault runs a band of geometric pattern which recalls some of the borders in the Bury Bible. The paintings are the work of a considerable artist, who was already emancipated from the angular movements and damp folds of the Romanesque manner and who could give a new ease of movement to his figures and suggest their roundness by the subtleties of his outline. The seated Virgin who receives the adoration of the kings is one of the most gracious inventions of this Channel art. By some curious chance of diffusion an artist working under very similar influences decorated the chapter house of the Aragonese monastery of Sigena, founded by Queen Sancia in 1185, where the paintings and decorative motifs constantly recall contemporary English work.[2]

This movement towards a greater naturalism, evident at Le Petit-Quevilly, is nowhere more apparent than at the centre of royal administration, on the Great Seal itself. Here we can see exemplified the reorientation of visual concepts which pervades the representational art of the close of the century. The seals of Henry II show a slender, flat, elongated figure, with triangular folds and curved fluttering drapery, a complete expression of the Romanesque repertory. In the first seal of Richard, the figure is solidly treated, the drapery bends naturally to round the form: there is an attempt, more strongly emphasized in the second version current in the last two years of the reign, to show the arms of the throne in perspective (Pl. 88).[3] The mounted figure of the counter seal has also gained a fresh vigour, though it was not till the seals of Henry III that equine representation was at all

[1] See above, p. 245.

[2] W. W. S. Cook and J. G. Ricart, *Ars Hispaniae*, vi (1950), 123. The paintings have generally been attributed to a later date, but certainly belong to the classicist phase of the close of the twelfth century. They were much damaged by a fire in 1936.

[3] A. B. and A. Wyon, *The Great Seals of England* (1887). W. de G. Birch, *Catalogue of Seals in the Dept. of MSS. in the British Museum*, i (1887).

fully mastered. This stylistic change marks the end of the Roman-esque period, with its emphasis on decorative quality, its acute sense of pattern spread as a web over the forms beneath, without any strict organic relationship to them.

Suddenly from the highest fantastication of tubular, metallic drapery, strained postures, elongated mannerisms, there is a retreat. The garments fall unobtrusively around the bodies; the folds design forms of a new rotundity; the seated figure is placed within the chair; naturalism, a classical, idealized naturalism, humanity noble and serene, becomes the artist's aim. Old formulas are rediscovered and a phase begins which in the climax of its accomplishment was to give us at Chartres, Amiens, and Rheims some of the world's greatest sculpture. Grotesques persist, but ever becoming more humorous and more marginal in the place they occupy: the monsters of the mind are replaced by animals familiar to the artist's eye. A Bodleian Psalter, MS. Auct. D. 2. 8, where the foliage is still formalized, has some initials based on a motif of rabbits, drawn with fair accuracy, a motif that now frequently recurs. In the biblical scenes there is a growing relish for the human implications of the story: details are invented, sentiment invades the theme: not only the figures themselves but their emotions are humanized. A new impulse is at work. As the security of massive walls and pillars, almost defensive in their solidity, is abandoned for a more daring slenderness of construction, so men's minds seem to shake off some of the nightmare images that had exer-cised their skill in carving, and to observe with new confidence and new exactitude the world around them. There is an emergence from obsessions, a concentration on the thing seen. Fresh fields are opened to the arts, though it is only gradually that they are fully entered on.

Of this new style, wall-painting must have been one of the most striking manifestations, and a surviving example, the frescoes of the chapel of the Holy Sepulchre in Winchester cathedral, shows to what splendid accomplishment it could reach. With that disregard for the fashions of yesterday, which was even more foolhardy then than now, they are painted on a thin layer of plaster laid over earlier paintings, probably mid-twelfth century, possibly master-

pieces from the time of Henry of Blois. They themselves seem to be work of *c.* 1220, for though the forms are those of the early classical revival, the poses and expressions have that Gothic emotional intensity which was to be the characteristic feature of works of the mid-century.[1] Sadly wasted, the Descent from the Cross still remains a powerful and impressive masterpiece, and as the eye pieces together the dim fragments of the Entombment there emerges the ghostly presence of a scene worthy comparison with the profound and passionate treatment given to the same subject by the greatest northern painter of the time, the Master of the Ingeburg Psalter. No other frescoes remain to us from the transitional period that can rank with Winchester in quality. Copies of paintings formerly at Winterbourne Dauntsey in Wiltshire show a series of Birth and Passion scenes reminiscent of the psalter MS. Douce 293[2] in their primitive gaucheries and also in the types on which they are based. At Brook in Kent there are the remains of a scheme of medallions similar to those of Le Petit-Quevilly, though the work is much inferior in execution. Both at Winterbourne Dauntsey and Brook, the paintings, though following an older tradition, must from their foliage setting be work of the thirteenth century. The church of St. Clement, Ashampstead, has frescoes of the Nativity which may be slightly earlier. The Visitation is set between two curtains and the figures are thin and elongated as in the Albani Psalter rendering of this subject. Similarly elongated are the personages of the frescoes at Copford in Essex, where the Raising of Jairus's Daughter is moderately well preserved and a striking and beautiful composition, which would seem to be work of *c.* 1180.[3] This unusual subject is characteristic of the growing demand for detailed narrative as opposed to the basic doctrinal emphasis on the Incarnation and Atonement. Jocelin of Brakelond tells us that (*c.* 1180) the choir screen at Bury was covered with painted histories, each with an elegiac couplet setting out its subject.[4] And this zest for story-telling leaves its mark also on a

[1] See on this and the following wall paintings, E. W. Tristram, *Eng. Med. Wall Painting*, ii. *The Thirteenth Century* (1950). [2] See above, p. 245.

[3] E. W. Tristram, *Eng. Med. Wall Painting*, i. *Twelfth Century* (1944), 116.

[4] *Chronicle*, ed. H. E. Butler (1949), 9; M. R. James, 'St. Edmund at Bury', *Cambridge Antiquarian Soc.* xxviii (1895), 131, 202.

group of psalters from the close of the century whose paintings are the most striking example of English experiments in the new naturalistic style.

The psalters in question seem, by the singular cases of the personal pronouns in the prayers, to have been written for individuals, very frequently women, rather than for religious houses. They open with a series of full-page biblical scenes and they generally follow the system, of which the St. Swithun's Psalter had been a notable earlier example, of dividing the page into two compartments, thereby providing fuller scope for detailed narration. If we may judge from surviving works, no other country at this period saw such a lavish output of these books. First place in profuseness of illustration must be given to the psalter which is now MS. Clm. 835 in the Hofbibliothek at Munich.[1] It has the extraordinary number of eighty pages of illustration, mostly arranged two scenes to a page but with some full-page scenes and a few groups of small scenes arranged under arched arcades. It opens with a Tree of Jesse, followed by a long series of Old Testament events, some of them highly unusual subjects. A later fourteenth-century hand has in fact written captions to them, and no doubt incidents such as Phinehas slaying Zimri and Cozbi (Numbers, xxv. 8), or the curious and misinterpreted version of the meeting of Isaac and Rebecca (Genesis, xxiv. 15), in which it should be Rebecca who removes her cloak, were not readily recognized at any period of biblical studies (Pl. 90 a). The scheme used by the artist who illustrated the Book of Ruth is that of a series of small scenes: it is a feeble, sketchy hand but interesting for the extreme detail of its subject-matter, which shows, for instance, the three shrouded bodies of the husbands of Naomi and her daughters, and Naomi suckling Obed her grandson. While Ruth urges her appeal, 'Entreat me not to leave thee', Orpah turns back to the door of her husband's tomb, a characteristic instance of the new sentiment. The enterprising artist has attempted also to show, quite unsuccessfully, the field stretching beyond the gleaners and in the background the water-

[1] See A. Haseloff in *Hist. de l'Art*, ii. Pt, 1, 320. There is a complete set of photographs in the Victoria and Albert Museum. See also G. Leidinger, *Meisterwerke der Buchmalerei* (Munich, 1920), 14, Pl. 19.

pot from which Ruth was allowed to drink (Pl. 90 *b*). The New Testament series has the customary selection of scenes of the Birth, Baptism, Temptation, and Passion, but includes several pages of the Miracles, treated with some repetition as though the artist had insufficiently varied models to guide him. It concludes with some pages illustrating the Benedicite, Te Deum, and Last Judgement. The B of the Beatus page is filled with fine-stemmed foliage coiling into small interlacing circles; within the coils the pronged acanthus appears and small white lions crawl in and out of the tendrils, but, at the corners, stems burgeon beyond the framework with the small trefoil terminals so familiar in early Gothic illumination. The border is still composed of the key pattern used similarly in both the Copenhagen and the York Psalters. Scenes of the life of David are shown in roundels on the frame. The calendar has roundels of the Labours of the Months and the signs of the zodiac. The Labours are represented by an unusual set of incidents, including for April a knight holding a standard while a diminutive horse grazes beside him, and for November hogs feeding in a stylized wood. The calendar itself contains the feasts of many English saints and corresponds fairly closely with known calendars of St. Peter's abbey at Gloucester:[1] in particular it includes St. David, St. Guthlac, and St. Paternus of Llandabarn, all saints with some special Gloucester connexion, the Dedication of St. Michael *in tumba* (Mont St. Michel) on 15 October,[2] and on 28 May the feast of St. Karaunus (St. Chéron) of Chartres who figures in Mont St. Michel liturgies. Abbot Serlo (1072–1104) came from Mont St. Michel to Gloucester, and the dedication and several Mont St. Michel saints figure in Gloucester calendars.

In a work of this scale there were necessarily various artists employed. The opening scenes of the Old Testament are vigorously drawn with strongly marked profiles, occasional ovoid folds, and here and there floral patterns on the draperies, as in the Copenhagen Psalter: the New Testament is largely the work of another

[1] See F. Wormald, *Benedictine Kalendars*, ii (1946), 39.

[2] The correct date is 16 Oct.: the scribe has here slipped and the consecutive feasts of the Dedication, the translation of St. Etheldreda (another Gloucester festival) and St. Luke are all placed a day early.

artist who uses somewhat fuller forms, more naturalistically con-
ceived: throughout, however, there are scenes drawn with tall
slender figures, whose robes fall in straight lines, with small heads
on their long thin necks.[1] It is a hand that is close to, possibly the
same as, that of the illustrator of another psalter, B.M. MS.
Arundel 157, and similar types, with floral tracery on the drapery,
are used along with white lion initials to ornament a large volume
of Gratian's *Decretum* (Corpus Christi College, Cambridge, MS.
10), where the illustration of the various cases, such as the woman
betrothed to two men (Pl. 92 *a*), gave some scope to the artist's
iconographic invention. The Arundel Psalter has twenty-two
pages of scenes from the New Testament, omitting the miracles:
the cycle used is that of the Munich Psalter, and must be based
either on it or on a common prototype. Its Beatus page is a brilliant
piece of decoration. To this same group, though by a skilful artist
who allowed himself some individual variations, belongs also B.M.
MS. Royal 1 D. X.[2] Here the ovoid folds have almost entirely
disappeared, even if the search for realism is still in an early stage
and the gestures are often angular and clumsy: in some scenes,
however, the Washing of the Feet (Pl. 91 *c*) for instance, there is a
new ease of rhythm; the colouring is often subtle, and on each
page, a method employed in several of these psalters, one scene is
shown on a gilt background, the other on one of salmon pink,
grey, or deep blue; in an initial the artist has brought his type of the
Virgin to a very fluent accomplishment (Pl. 91 *b*). This is aesthetic-
ally the most satisfactory of the divided page Gospel books that
can be securely associated with England at this period.[3]

More famous for its associations than for its aesthetic merits is
a psalter now in the library of Leyden University, MS. 76 A.[4]

[1] A striking if somewhat crude example of this style in stone carving is provided by
the effigy of an abbot of Newbo, found near the site of the abbey. Newbo was founded
in 1198, and this monument must date from the early years of the thirteenth century:
see *Antiq. Journ.* xi (1931), 65.

[2] J. A. Herbert in *Walpole Society*, iii (Oxford, 1914), 47.

[3] The small psalter written for Amesbury, Bodleian MS. Liturg. 407, is near in style
to MS. Royal 1 D. X, but does not exactly follow the scheme of its Psalm initials:
for Psalm xlii, where the Royal MS. has the usual scene of the Temptation, MS. Liturg.
407 has Saul casting his spear at David.

[4] L. Delisle, *Douze livres royaux* (1902), 19; H. Omont, *Psautier de S. Louis* (1902).

Its calendar clearly points to the north of England and almost certainly to York: this is confirmed by an obit, in the same hand as that of the calendar, on 7 July: *obitus Henrici regis Angl. patris domini G. Eboracensis Archiepiscopi*. This is Geoffrey Plantagenet, illegitimate son of Henry II, who was archbishop of York from 1191–1212, so that the book falls within that period. In another hand is entered the obit of Alfonso of Castile (d. 1214), the father of Blanche of Castile, wife of Louis VIII, mother of Louis IX, and regent during his minority. A fourteenth-century hand has entered on the Beatus page the famous statement that the book was used by *Monseigneur Saint Louis, ouquel il aprist en s'enfance*. It is clear that the psalter at an early date went to France, where Archbishop Geoffrey spent the last five years of his life: as a relic of the royal saint it was a treasured possession and its later history can be traced in various inventories. Its twenty-three pages of illustration deal with the Creation in a series of roundels, continue with pages divided into two scenes down to Samson, and then present the New Testament scenes in a cycle similar to that of the other psalters. In arrangement and poses there are considerable variations from the Munich Arundel model, though in some scenes, notably The Temptation, the same type has been used. The main artist uses a vigorous, broken stroke, hard outlines to his profiles, and very crude anatomical treatment of the nudes. It is coarse and undistinguished work. The initials have the usual thin coiled foliage with large pronged leaves.[1]

A manuscript now in the Pierpont Morgan collection (MS. 16), the Huntingfield Psalter, with forty introductory pages of paintings, mainly arranged in two scenes, presents some particular problems of its own.[2] Its calendar includes a thirteenth-century obit of Roger of Huntingfield, from whom the psalter takes its name, and this has suggested its association with the Huntingfield foundation of Mendham priory in Suffolk, a cell of Castle Acre. The calendar, however, is not a Cluniac one, and the lady kneeling in the Miserere initial suggests that this too was originally a

[1] The Lesnes Missal in the Victoria and Albert Museum (L. 404) is another example of this rough and somewhat uncouth style of drawing.

[2] M. R. James, *Catalogue of MSS. in the Library of J. Pierpont Morgan* (1906), 32.

private commission. Its choice of subjects and manner of their presentation show points of contact with the psalters already mentioned, particularly in the New Testament scenes: it ends with six pages of martydoms of saints, designed in four compartments to a page and including that of Becket, though his feast does not appear in the calendar. The figure drawing is clumsy; the drapery falls in awkward lines with ungainly crinkles; there would be no difficulty in considering these pages as work contemporary with the Leyden Psalter, on about the same level of achievement. The Beatus page, however, is a new and original design (Pl. 87): the B is filled with a Jesse Tree; the frame is set with round and elliptical medallions which show on the top bar the Coronation of the Virgin, on the bottom the Resurrection of the Dead and the Jaws of Hell. The psalmist himself is relegated to a small circle on the bar of the letter. This use of the Jesse Tree as a Beatus initial was to have distinguished successors, but never again was it to set out so complex a statement. In colour the page is predominantly gold on a reddish-brown background, a departure from the vivid blue of the Beatus backgrounds in the Munich and Arundel psalters, and both this colouring and the intricacy of the design, which are found in some of the smaller initials also, look forward to English work of the mid-thirteenth century. The figure drawing on the Beatus page is, however, by the same hand as that of some of the preceding illustrations, and we have a parallel for this use of the Jesse Tree in an English or Anglo-Norman psalter that includes a list of events ending with the death of Eleanor of Aquitaine in 1204. This book, written presumably in the last half of John's reign, has, possibly after being in the possession of the family of Sir Thomas More, found its resting-place in the Biblioteca Comunale at Imola.[1] It has now no biblical scenes, but some pages have been cut out from the beginning of the book. Its Beatus page has an elabo-rate Jesse Tree, distinct in design from that of the Huntingfield, with scenes from the life of David in round medallions on the bars. The artist was a painter of merit, but it is not easy to assign this book

[1] R. Galli, 'Un prezioso Salterio della Biblioteca Comunale d'Imola', *Accademie e biblioteche d'Italia*, Anno xv (Rome, 1941), 1. There are reproductions in G. Haseloff, *Psalterillustration* (1938).

with any certainty to a particular locality. English saints figure in the calendar which contains the translations of St. Swithun, St. Birinus, and St. Ethelwold: in the Litany, on the other hand, North French saints are more prominent, Remigius, Germanus, Vedast, Wingaloc, Genofeva; on 14 October, the day of Senlac, there is the entry, *Expugnatio Anglie a Francis*. A full-page painting, which precedes the Jesse Tree, shows the genealogy of St. Anne and her sister Esmeria, based on the legend that Anne was three times married, to Joachim, Cleophas, and Salomen, and that Esmeria was the mother of Elizabeth and grandmother of the Baptist. The cult of St. Anne was in the twelfth century by no means fully established, though her feast was kept at Worcester as early as the 1130's and Osbert of Clare wrote a treatise and hymn in her honour.[1] The legend of her 'trinubium' seems to have arisen from the attempt to identify exactly the various Marys mentioned in the Gospels. The most daring of the emendations involved turning the Salome of St. Mark (xv. 40 and xvi. 1) into a man Salomen, and making him the third husband of St. Anne. From this came a controversy which seems to have considerably exercised some English theological circles in the twelfth century. Herbert of Bosham wrote against the Salomites and Maurice, prior of Kirkham, produced two tracts violently attacking their somewhat indefensible position.[2] Like the cult of the Immaculate Conception, this St. Anne controversy seems to have a peculiarly English background. It is found coupled with Eadmer's tract *De Conceptione S. Mariae* in a twelfth-century Anglo-Saxon translation and most of the early Latin accounts are of English or Norman origins. Esmeria, as a name for St. Anne's sister, is also a western form. In the fifteenth century the controversy revived in Germany, and genealogical trees of St. Anne became a common subject of illustration, but of the twelfth-century debate the page in this psalter seems to be the only known pictorial record. The descendants are shown in roundels linked according to descent: from St. Anne comes first the Virgin and Christ; then by her

[1] See A. Wilmart, *Auteurs spirituels et textes dévots du moyen âge latin* (Paris, 1932), 261.
[2] B. Smalley in *Recherches de Théologie ancienne et médiévale*, xviii (1951), 38; M. R. James, 'The Salomites', *Journ. of Theological Studies*, xxxv (1934), 287.

second marriage with Cleophas another Mary, mother of James the Less, Joseph called Barsabas, Jude, and Simon; by her third with Salomen, a third Mary, mother of James and John. The line of Esmeria, as here depicted, is even more remarkable: her children are Elizabeth, mother of the Baptist, and a son Eliud, whose son was Emui, whose son was St. Servatius, bishop of Tongres, here shown in a roundel at the bottom of the page receiving in accordance with his legend his pastoral staff by the direct intervention of an angel. Servatius is known as a bishop of the mid-fourth century. The story of his kinship to Christ seems to receive its earliest mention in a late-ninth-century life of St. Loup of Troyes. At the end of the eleventh century a certain Jocundus Presbyter wrote an enthusiastic defence of his claims. It would be natural for this further controversy to attach itself to that of the Salomites, and this page of the Imola Psalter sets out the story in all its fullness and shows it as a vigorous cult at the end of the twelfth century, a strange aberration of the zest for historical inquiry, a piece of wide credulity that must be set opposite to the shrewd insight of many commentators and chroniclers.[1] Stylistically the psalter has English associations. Its historiated initials belong to the common English pattern of the time: its Jesse Tree, apart from the Huntingfield Psalter, has other parallels in MS. 9 of the Dyson Perrins collection and in MS. III. 3. 21 of Emmanuel College, though these appear to be slightly later works. The accomplished Imola drawings, in particular the admirable Labours of the Months, have an easy treatment of the folds that comes near to a work yet to be dealt with, the great Westminster Psalter.

This type of psalter with its introductory illustrative pages was to enjoy great popularity: the cycle of subjects survives in use well into the thirteenth century, and is repeated in many manuscripts, some of them translating the scenic formulas into a fully Gothic idiom.[2] Beyond question the greatest of them all is the psalter at

[1] For Servatius see Godefridus Henschenius, 'Exegesis de Episcopatu Tungrensi', *Acta Sanctorum Maii*, vii (1688), xxi; Jocundus Presbyter, 'Translatio S. Servatii', *Monumenta Germaniae historica*, xii (1856), 85; Jean Chapeaville, *Gesta pontificum Tungrensium* (Liége, 1612), i. 28.

[2] Examples are St. John's College, Cambridge, MS. D. 6, Bibl. Ste-Geneviève, MS. 1273, Trinity College, Cambridge, MS. B. 11. 4.

Chantilly (MS. 1695), known as the Ingeburg Psalter from the obits of Queen Ingeburg's parents and her faithful friend Eleanor, countess of Vermandois (d. 1213).[1] The calendar includes an entry on 27 July of Philip's victory at Bouvines, the decisive battle which was also the occasion of his reconciliation with his much abused wife. Ingeburg died in 1236, but the psalter must considerably precede this date: it has no obit for Philip Augustus, who died in 1223. Its introductory paintings, twenty-five pages in all, follow the usual cycle, though with some striking variations, such as two scenes devoted to the woman taken in adultery, and four giving the story of Theophilus. They are works which have rarely been surpassed in miniature painting: beside them the paintings we have been considering are feeble indeed. These monumental figures, in their classical serenity and certainty, their wide sweep of movement, are the graphic parallel to the south porch of Chartres and the west porch of Amiens. They have been claimed as English work: the calendar is a French one but includes a few English saints, Cuthbert, Edward King and Martyr, Edmund, Oswald, for whose presence there is no clear explanation. Our MS. Royal 1 D. X foreshadows some of this majestic achievement, but very distantly. A bible in the British Museum (MS. Add. 15452) has sometimes been thought to contain, among its numerous initials, some works by the Ingeburg Master, but these are minutely drawn (the volume is a small quarto) and are hard to compare with the great drawings of the Chantilly Psalter. This bible, however, which clearly belongs to the Channel style of this period, is in itself a beautiful book. The boy Daniel and the Lions, so firmly and freshly conceived, may serve as an example of its quality (Pl. 93 a) and as a link with the Ingeburg achievement.

Of certain English origin and a major work of art is the book already mentioned, the Westminster Psalter, B.M. MS. Royal 2 A. XXII. The scriptorium of Westminster is one about which little is known. We have seen that at the beginning of the century it could produce calligraphy of a bold and striking design,[2] but we

[1] L. Delisle, *Douze livres royaux* (1902), 1; J. Meurgey, *Les principaux MSS. à peintures du Musée Condé à Chantilly* (Paris, 1930), 15. The obits are entered by the same hand as that which wrote the calendar. [2] See above, p. 67.

know nothing of its painting earlier than a psalter (now Bibl. Nat. MS. lat. 10433) which does not include Becket's feast in its calendar and was therefore presumably produced before 1173. This book shows a style of great accomplishment. Both the calendar and the offices of the Virgin establish that it was made for Westminster.[1] Of the two surviving full-page illuminations,[2] the first represents the Christ of Judgement, standing in a mandorla, with at his feet Adam and Eve, on his right hand the Resurrection of the Elect, on his left the Mouth of Hell. Above are three angels holding the Cross, the crown of thorns, and three nails. This leaf is slightly smaller than the others, and the writing on the verso is in a different hand: at first sight its design suggests later work; but the ovoid folds of the angels' robes and the curious shading of the arms and hands are found in the other drawings and, whatever the history of its insertion, this page must be by the artist who painted the whole book. Psalm xxvi (xxvii) (described in the vulgate as a Psalm of David before he was anointed), *Dominus illuminatio mea*, has a full-page initial of the anointing of David, in a roundel, with below Daniel and Jesus, son of Sirach, the author of Ecclesiasticus (Pl. 85 a). This noble and severe design has affinities with contemporary work at St. Albans, but looks ahead to the psalters of the close of the century. Two other initials show a man washing another man's feet, and a majestic Christ Blessing with a small kneeling figure. The quality of this book is developed further in the much better known psalter, now in the British Museum, MS. Royal 2 A. XXII. Its Westminster provenance is clearly established by its calendar, litany, and prayers: its exact date is not certainly indicated, but its initials are composed of fine-stemmed full-leaf acanthus inhabited by small white lions, and in details of costume it has some exact resemblances to the Ingeburg Psalter. Its five full-page miniatures follow a different iconographic type from those that have been discussed, and show the Annunciation, the

[1] V. Leroquais, *Les Livres d'heures MSS. de la Bibl. Nat.* i (Paris, 1928), 311, Pl. I, and *Psautiers MSS. latins*, ii (1940–1), 93. This volume is a psalter and book of hours, an early example of this practice.

[2] There is a third full-page scene, of the Crucifixion, which is by another and later hand.

Visitation, the Virgin and Child, Christ in Majesty, King David harping: brilliantly coloured on thick, highly burnished gold leaf, the figures have a new firmness and solidity: the Virgin holds the Child on her knee and herself sits well back on her throne with a real, if not altogether successful, attempt at recession (Pl. 85 b): nothing so classical had as yet been seen in English art. Something of the same quality can be found in a St. Albans Gospels, now MS. B. 5. 3 of Trinity College, Cambridge, where the seated angel of St. Matthew has an equal certainty of touch and pose and where some of the small medallion figures are drawn with rare skill (Pl. 31 f), and also in the splendid glossed Epistles, now MS. Royal 4 E. IX, with their series of author initials, somewhat mannered in their attitudes but admirably executed (Pl. 93 c). It is, however, in a Durham book, the Life of St. Cuthbert (now B.M. MS. Add. 39943), that the new sense of volume is perhaps most clearly seen.[1] This little book (it is only $5\frac{1}{4} \times 3\frac{7}{8}$ in.), which seems from the known borrowings from it to have set the canon for the representation of the Cuthbert legend, has a monumental simplicity which irresistibly recalls the work of Giotto, and in fact this early artist has some of Giotto's aims: the broad sweep of his cloaks conveys a tactile sense of weight, and his figures are set with care in a defined and localized space even though he still employs the old trick, so notably used by the Bury Bible, of giving depth to his scene by inserting as background a panel of another colour. The figure of St. Bede writing is seated in a chair which is still far from accurately foreshortened, but one has only to compare it with earlier versions of the same author theme to see the change in conception (Pl. 93 b). Laurence of Durham, the chronicler, with his delightful contraption for attaching his desk to his chair, is shown in a manuscript of c. 1160 in a severely profile position (Pl. 53 a):[2] and one of the loveliest of English drawings, from a book of which more must be said later, the Cambridge University Library Bestiary, with its elongated figure and its parallelism to the background plane, belongs for all its subtleties of line to an older con-

[1] See H. Yates Thompson, *Illustrations of 100 MSS.* iv (1914), and W. Forbes-Leith, *The Life of St. Cuthbert* (Edinburgh, 1888).
[2] Durham MS. V. III. 1, f. 22ᵛ.

vention, though probably dating from the last years of the century (Pl. 53 *b*). The St. Cuthbert has of course no calendar to assist in its dating, but its initials, full-pronged acanthus with coiling stalks, firmly confined in their frame, place it within the twelfth-century tradition. Its trefoil arches are more pronounced than any earlier examples and their foliage terminals and the capitals of the columns are transitional in style, and in one case the arch is no longer rounded but is pointed in shape. Its seated Bede finds a striking parallel in the seal of Prior Bertram of Durham, who was in office 1189–1212 (Pl. 93 *d*).

Nothing could be a greater contrast than the other illustrations to a life of a saint which are often assigned to this period. The much praised roll of medallion drawings of the life of St. Guthlac of Crowland (B.M. Harley Roll Y. 6), which may have been designs for reproduction in glass or possibly enamel, show the new flowing treatment of the drapery and slightness of build that characterize the figure from the Cambridge Bestiary, but they have a certain angularity of gesture and the design shows little feeling for the roundel form. In date they are sometimes associated with the translation of the saint's relics to a new shrine in 1196,[1] but they could stylistically be later work, and a certain lack of sensitivity suggests an over-familiar tradition rather than the early days of a fresh invention.

Three more psalters require mention. B.M. Harley 5102 is a psalter without a calendar and provides us with no indication of date or provenance. Some of its initials, where foliage tendrils begin to stretch along the margins, would fit with a somewhat later date than those books which we have been considering: its Beatus page has no small lions in the coils and the acanthus petals are near to new Gothic forms.[2] But the artist of its five pages of illuminations, placed not at the beginning but throughout the book, was working in an older tradition: ovoid folds occur and the whole treatment is still fully Romanesque. The biblical scenes are the Sacrifice of Abraham, Peter walking on the Waves, and Christ appearing to the Apostles—a curious selection. Three half-

[1] G. Warner, *The Guthlac Roll*, Roxburghe Club (1928).
[2] Reproduced O. E. Saunders, *Eng. Ill.* (1928), i. Pl. 35.

pages are given to seated bishops. Two full-page scenes show the martyrdom and burial of Becket, the former by now a popular subject, already depicted in the Huntingfield Psalter and in an Amiens psalter (MS. 19), which is probably the earliest of the three, for in it Becket's feast has been added afterwards to the calendar. Here in the Harley Psalter the martyrdom is somewhat woodenly treated, for it is the work of a dull artist without any model before him. It sets, however, the iconographical tradition.[1] Of far greater importance and quality is the English Psalter, now MS. lat. 8846 in the Bibliothèque Nationale in Paris.[2] It is a triple version of the psalms, the Hebraic, the Latin, and the Gallican, with glosses and interlinear translations. It opens with eight full pages divided into twelve compartments each and dealing with the Creation and Fall; Noah, Abraham, Moses, and David; the Nativity, Temptation, Miracles, and Parables; and a Tree of Jesse. The scenes of the Passion are wanting, but may have been included in the original scheme. It follows in this type of setting the mid-twelfth-century psalter[3] whose pages are divided between the Pierpont Morgan Library, the British Museum, and the Victoria and Albert Museum. The execution of the Paris book is infinitely superior, by a master hand, the themes are more elaborated, details are enlarged upon and invented, but the correspondence is such that clearly one was the model for the other or else they shared some common prototype. Some of the scenes found in each are in themselves unusual enough, such as Herod killing himself with a knife that he has been given to peel an apple, and the strange little picture of the foxes in their holes and the birds of the trees in their nests (Pl. 95). These introductory pages are followed by the triple psalter with large composite illustrations to each psalm (Pl. 94 b). These go back to an even earlier model, namely the Utrecht Psalter, though here it is fairly evident that it is Eadwine of Canterbury's twelfth-century version that is being followed. This then is probably a Canterbury book, but only the first ninety-three folios contain the work of the original artist, and even in this section seven of the scenes, though the drawing is twelfth

[1] See above, p. 204.
[2] H. Omont, *Psautier illustrée* (*XIIIe siècle*) (Paris, n.d.). [3] See above, p. 110.

century, have been painted by the fourteenth-century Catalan artist who completed the illustration.[1] Its figure drawing has traces of the Puiset Bible ovoid folds and also of the straight elongated shapes of MS. Arundel 157. The vigour of the gestures, the swift, spiral movements are the artist's own. In his noble Tree of Jesse the foliage has the full three-pronged acanthus leaf (Pl. 96): his smaller initials have thin stems and somewhat flat small leaves that are very distinctive.

The last of the psalters under review is now MS. 100 of Magdalen College, Oxford. Its very interesting calendar, which includes such unusual feasts as the finding of the body of St. Ives on 24 April, points clearly to Worcester through the prominence given to the three Worcester bishops and saints, Egwin (founder of Evesham), Wulfstan, and Oswald. The translation of Wulfstan (14 June) and the dedication of the cathedral church of Worcester (7 June) have been added to the calendar in a distinctly later hand. The translation to the new shrine and the rededication of the church on 7 June both occurred in 1218, after the repair of the damage done in the fire of 1202. There is therefore a presumption that the original calendar dates from before 1218. The translation of Becket (1220), now partially erased, is also in a later hand, whereas the feast of Becket on 29 December is in the original script. The calendar has foliage initials: the text of the psalter, written in a large bold hand, has coloured initials with streamers of thin foliage work. Of its historiated initials four only remain. Psalm xxvi (*Dominus illuminatio*) has a vigorous scene of David between a lion and a bear with, above, Christ protecting him. Psalm xxxviii (*Dixi custodiam*) shows a man with his finger to his lips as a group of men question him, 'I will take heed to my ways that I sin not with my tongue.' Psalm xcv (*Cantate Domino*) has a charming group of monks singing. Psalm cix (*Dixit Dominus Domino meo*) has, above, the Trinity and, below, Pentecost, a scene that in its rhythms and some of its heads recalls the style of the Psalter MS. Royal 1 D. X. Four other initials have been removed. Throughout, the painting is unusually solid and the lines and shading are brushed

[1] M. Meiss, 'Italian Style in Catalonia', *Journ. of the Walters Art Gallery*, iv (Baltimore, 1941), 73.

in above the main ground paint. When complete it must have been a most accomplished piece of book production.

Worcester, with which this psalter is associated, provides also one of the few surviving pieces of English sculpture, if its mangled state can be called survival, parallel in style to the illuminations we have been discussing. Many of the psalters, in particular MSS. Arundel 157, Royal 1 D. X, and Royal 2 A. XXII, depict Christ in Majesty, seated in a mandorla, with the symbols of the evangelists at the corners.[1] This theme was treated monumentally on the refectory wall at Worcester, a life-size figure of Christ being carved seated in a quatrefoil. At the Reformation it was cut away and the wall plastered over, so that now only a battered outline and some of the more recessed detail remain. There is enough, however, to show the typical drapery, the slightly elongated but rounded forms of this period. It must have been a singularly impressive work. A smaller version of the same subject and of approximately the same date in the church of St. Mary-the-less at Durham is better preserved, but its competent, somewhat dull carving does not make up for the lost masterpiece that can be perceived through the mutilated remnants of the Worcester refectory.[2]

In yet another medium we have some considerable English artistic achievements from the close of the twelfth and the opening of the thirteenth century. The rebuilding of the choir at Canterbury cathedral was not only notable for the introduction of a new architectural style: it was also the occasion for installing a series of stained-glass windows on a scale that had as yet been equalled only by Suger's famous windows at St. Denis, the great landmark in this branch of the arts. Though they survive in fragments only, displaced from their original position and confused by later restorations, the Canterbury windows represent one of the earliest sequences of medieval glass still extant in western Europe. The choir clerestory seems to have contained the first stage of the work: the obvious reason for this would be that the windows there, now

[1] Durham MS. A. IV. 10, f. 1 (reproduced in R. A. B. Mynors, *Durham MSS.*, Pl. 56), is an earlier example where damp fold patterns are still employed.

[2] The Worcester and Durham reliefs are reproduced in E. S. Prior and A. Gardner, *Figure Sculpture* (1912), 248–50.

distributed in various parts of the building, were put in place while the scaffolding was still erected. They therefore would date from about 1178. They represent the ancestry of Christ, single figures seated under canopies, with the exception of Adam who is seen digging. They show the rounded panels of drapery, the skirts caught tightly across the knees, which characterize the end of Romanesque art. They have also the curious elongation of the transitional period, with an inordinate length between knee and shoulder. The Genealogy of Christ was interrupted by the windows of the apse clerestory, which showed scenes of the Birth, Ministry, and Passion: these, which have much in common with the psalter treatment of the same scenes, appear to be later work, with more rounded figures, and may well be c. 1200: the ancestors are continued in the transept clerestory and these again seem to belong to a later stage, with free falling drapery and more elaborate settings: the choir aisles had a series of 'theological' windows of types and anti-types, still drawn in the late Romanesque tradition.[1]

Glass-painting was an art to which we have several references from earlier in the century. It was prohibited by the Cistercians, who laid down that 'windows shall be white and without crosses and pictures':[2] so that the Augustinians of Kirkham, when they were negotiating the handing over of their priory of Kirkham to Rievaulx, stipulated that they should be allowed to remove their painted windows to their proposed new house at Linton.[3] At York, as has already been mentioned, some fragments of glass from Roger of Pont l'Évêque's building still remain. Lincoln has some glass from early in the thirteenth century. Dorchester abbey has a small panel that may be the earliest of all. But without Canterbury we should have no real conception of the English twelfth-century contribution to this craft, which in the thirteenth century was to come to such brilliant fulfilment. There we can still see the patterns and types familiar in illumination, taken no doubt from

[1] B. Rackham, *The Ancient Glass of Canterbury Cathedral* (1949). This splendidly produced book has a very full series of plates. On the problem of restorations in the glass see review by W. Oakeshott in *Antiq. Journ.* xxxi (1951), 86.

[2] *Nomasticon Cisterciense* (ed. 1892), 230, 261.

[3] *Vita Ailredi*, ed. F. M. Powicke (1950), lxxiii.

the same model books, enlarged and translated into the radiant splendour of this most fascinating medium, a meeting-place of the two branches of the visual arts which were most essentially medieval.[1]

If a new naturalistic approach is to be seen in the representation of biblical themes, it is to be expected that it would be all the more apparent in that other great subject of illustration, the bestiary. As it purports to be a work of natural history, it should be here that the new exactness of observation should have the widest scope, and in the case of some of the more familiar beasts and birds, which came within the artist's own experience, there is in fact a greater verisimilitude in the drawings of the close of the century. Ailred of Rievaulx complains in a passage of his *Speculum* that the monks were too prone to beguile themselves by the keeping of pets, 'Cranes and hares, does and bucks, magpies and crows, not indeed for any Antonine and Macharian purpose [a reference to the desert fathers whose food was miraculously brought to them by birds] but for mere womanly delights'.[2] His list exactly represents the most popular models for the miniaturists. Primarily, however, the appeal of the bestiary was an exotic one: it was the strangeness, in some cases the gruesome ferocity, of these semi-legendary beasts that gripped the attention and that was only to be replaced in the thirteenth century by the great illustrated apocalypses, which provided subjects of a similarly strange and even more horrific nature. It is a world of fantasy, and bestiary illustration remains in some ways more stylized than the biblical scenes: the animals are fixed in decorative patterns, with a symbolic, heraldic remoteness from natural life. The exactly paired vultures, the elegantly duplicated goats (Pl. 89), though shading is ably used to round the forms and there is much exact notation of feathers, hoofs, hair, and horns, are posed as admirable pieces of ornament, at some loss to their documentary value. If, however, fact and fancy are somewhat evenly matched, there can be no question but that artistically bestiary illustration is one of the

[1] See on the relations between glass and illumination, Correspondence between L. Grodecki and B. Rackham, *Burl. Mag.* xcii (1950), 294, 357.

[2] Migne, *P.L.* cxcv (1855), 572.

triumphs of English art in this transitional period between Romanesque and Gothic.

During the twelfth century interest in the book is attested by new versions of the texts and new compilations of relevant matter. In the earliest Anglo-Norman versions, such as the Bodleian MS. Laud. Misc. 247, there are already additions from Isidore's *Etymologiae*, additions which are more sober natural history than most of the tales of the Physiologus. By the end of the century the *Aviarium* of Hugh de Fouilloi (d. *c.* 1173) is frequently interpolated. This also is a somewhat more practical work, though the moralizing element is strongly stressed; for even if a more rational approach to the subject-matter is apparent, the bestiaries remain edifying rather than instructive. These strange narratives of eastern creatures pleased in themselves, but it is their domination by the law of allegory, whereby everything, however odd, mirrors theological truth, that is still the last thought. An English author, Peter, prior of Holy Trinity, who died in 1221 but seems to have written his popular work, the *Pantheologus*,[1] *c.* 1190, comes under contribution as a further source of pious interpretation. This, however, is set off in one or two volumes (MS. Bodley 764 and MS. Harley 4751) by extracts from the comments of Giraldus Cambrensis on the barnacle goose and other Irish birds.

As the century drew to a close, the bestiaries change not only in matter but in mode of production. The earlier English examples are comparatively small books with line drawings:[2] these are now replaced by splendid volumes with gilt and painted illustrations by the best artists of the day. It is impossible here to deal with the interrelations of these books, where both text and illustration come in question. One or two examples of their style must serve. The Worksop bestiary (Pierpont Morgan MS. 107) is inscribed as given to the Augustinian priory of Radford or Worksop in 1187. The paintings must at that date have been advanced works showing all the latest naturalism in movement and flow of drapery: they are finely coloured, set against gilt or painted background squares

[1] MSS. Royal 7 C. XIII–XIV and 7 E. VIII.

[2] Such as Bodleian MS. Laud Misc. 247, B.M. Stowe 1067, Corpus Christi College, Cambridge, MS. 22, B.M. MS. Add. 11283.

as in the biblical scenes of the psalters. The bestiary in the State Library of Leningrad, a small volume (15 × 21 cm.) with somewhat crude illustrations, belongs to this same cycle and seems stylistically to be work of the eighties.[1] Slightly later in appearance are the beautiful drawings of the Cambridge University Library MS. Ii. iv. 26, of which the opening pages only are completed by painting.[2] The wonderfully sensitive and elegant author page has been already referred to,[3] but there are many other drawings of equal merit: the restless sleep of the sick man as the caladrius perches on his bed; the bustle and excitement of the crew as they come to anchor by the whale's back, mistaking it for an island. In all of them, the bodies are elongated, the limbs at times curiously twisted, but there is a tense liveliness that no contemporary artist surpassed. Those uncoloured drawings are probably work accidentally unfinished. Two pairs of manuscripts, Bodley MS. Ashmole 1511 and Aberdeen MS. 24[4], and B.M. MS. Harley 4751 and Bodley MS. 764, have the magnificence of complete colouring and burnished gold. In each pair, though the artists are different, the same cycle is closely followed. The first pair has a delicacy of drawing and a general refinement which are particularly marked in the Bodleian version. They open with scenes of the Creation, appropriate to the bestiary as a textbook of natural history, and these pages can be compared with the Christ in Majesty of a book such as the Westminster Psalter. The famous roundel of the unicorn from MS. Harley 4751 shows the three-lobed leaf, which is a Gothic form, replacing the old Romanesque luxuriance. The picture from MS. Bodley 764 of the hyena tearing a dead body from the tomb may be taken as a fitting close to this account of the transitional period (Pl. 92 *b*), for in the background is a church whose round arches and lancet windows show the architectural style contemporary with the illuminations that we have been

[1] A. Konstantinowa, 'Ein Englisches Bestiar des Zwölften Jahrhunderts', *Kunstwissenschaftliche Studien*, iv (Berlin, 1929).

[2] M. R. James, *The Bestiary* (1928). For plates see O. E. Saunders, *Eng. Ill.* (1928), Pls. 49–55.

[3] See above, p. 287.

[4] M. R. James, 'The Bestiary in the University Library', *Aberdeen University Library Bulletin*, xxxvi (1928), 1 (with five plates).

discussing; though in painting the phase is less a transition than a complete style in itself, an early Renaissance which threw over the abstractions of Romanesque but which by the end of the first half of the thirteenth century was already giving way before new mannerisms as decoratively stylized as those that had earlier been abandoned.

CONCLUSION

'ANNO Domini M°CC° quarto decimo, veinqui Phelippe li rois de France en bataille le roi Othon et le conte de Flandres et le conte de Boloigne et plusors autres barons.' Such is the entry under 27 July in the calendar of the Ingeburg Psalter. In 1204 Château-Gaillard, Richard's carefully planned castle, had fallen to the forces of Philip Augustus: three months later Rouen was occupied by the French: at Bouvines in 1214 John's attempt, in alliance with his nephew Otto of Brunswick, to regain his continental possessions was decisively foiled. The union of England and Normandy, now almost a century and a half old, was broken, and though for a time it was to be renewed it was never again to form the dominant empire of north-west Europe. And with Normandy went something of England's pre-eminence in the arts. Individual and accomplished as is much of our Gothic work, it lacks the high finality of Durham or the Bury Bible. In the twelfth century, in architecture and painting, England is a great, at moments supreme, exponent of a European style: in scale her works were indeed in the grand manner and in quality the clear product of genius. The ghost of Cluny, gaining new tangibility with modern researches, may rise in rivalry: the domed Romanesque cathedrals of Spain have their own peculiar memorable merits: Bamberg and Worms have their own grave splendours but they are a later manifestation, a thirteenth-century prolongation of the style that is a peculiarly German feature: in sculpture Provence and Burgundy cannot be challenged on any of our fragmentary remains: but our Norman cathedrals are to the Romanesque style what Chartres, Amiens, and Rheims are to the Gothic, and the genius of painting was abroad in these islands with a force of inspiration that was not to come again till Constable and Turner. It is, however, seldom true to talk of the arts in terms of nationalism. The English centres were the exponents of forms and motifs current also throughout the north of France, and their particular characteristics within the wider framework of the Romanesque style belong to the Angevin empire and owe much

to the contacts and the intercourse which it promoted: then, as the century draws to a close, the cultural supremacy of Paris begins to override political unities. Rouen and Canterbury, St. Albans and St. Bertin, the story of the one is incomplete without that of the other.

The style itself is a great one. A Renaissance building was primarily a definition of space: in Romanesque architecture the interest lay in the distribution between void and solid: piers, tribune arches, wall area were all emphatic and there was no attempt to dispense with their bulkiness: galleries, aisles, transepts were places of deep shadow and uncertain scope: bands of colour, bright points of reflection in the surrounding dimness, broke up still further the clarity of the spatial design. To this dark mysterious richness, the white-walled starkness of Cistercian building provided a contrast, a suggestion of other possibilities and a stimulus to new architectural experiment.

The coming of the Gothic style did not at once transform the concept. In an Early English church the narrow lancets still leave great importance to the wall surface and it was only with reluctance that the round, massive columns were changed for slighter supports. It is the disappearance of the great tribune galleries that marks the decisive change in the internal disposition: instead of a careful proportion between these heavy and repetitive arcades, reassuring despite the dim caverns beyond them, there is a new emphasis on height: the slender pillars give full scope for the display beyond them of the aisle windows, and the clerestory stage becomes a wall of coloured glass rather than a colonnaded passage. But that was a development of later times, outside the scope of this volume.

Compared with architecture wall-painting lacks surviving representation of its achievement. The Canterbury St. Paul has to serve for so many lost contemporaries, and we are inevitably thrown back on manuscript illustration. Here many of the figural scenes can well supply the gap in our knowledge and, as clearly shown by enlargement on the lantern screen, are monumental in conception, but much of the work of the miniaturists was of a more purely decorative nature, small fantastic initials, related no doubt to the ornamental panels painted on the walls but with a

peculiar fitness to the miniature scale of the book. I have spent much time in my survey of the arts on these small but elaborate initials, matters which, in a period where major painting is more represented, might easily be passed over unmentioned: or so at least it might well be argued. To me they seem not merely a makeshift, a second best when the rest is lost to us, but a central and inherent part' of the artistic development of the time. They are inhabited by monsters coming from deep obsessions in their creators' minds. Their lively intensity reveals them as a central preoccupation of the creative imagination. In their superficial similarity there is much variety, where some slight alteration in curve or interlace makes a telling difference. Long familiarity with them breeds an awareness of their quality, and I like to think that I share with their executants my enthusiasm for the subtleties of this minute but vigorous art.

'Omne nitescat opus': it was the gleam of gold that was most admired.[1] When a book is praised it is generally for its jewelled, carved, or enamelled cover: the inscription on the Gospels given to Jumièges by Faricius of Abingdon describes the volume as ornamented with gold and silver and jewels. It is the scribe that signs rather than the painter, and there are few who, like Hugo, describe themselves as *illuminator huius operis*,[2] or who were famed, like Ervenius, the master of Wulfstan of Worcester, for their skill 'in writing and drawing figures [*effingendo*] in colours.'[3] Beyond even architecture it was craftsmanship in the precious metals that was the most esteemed of artistic activities and is now the most unknown. We have but fragmentary data for the century's achievement and we cannot therefore in any completeness identify our own aesthetic pleasures in it with those of our ancestors. But we can still wonder at the excellence of their work which, as tastes change and appreciation is reconditioned, retains validity, through all the processes of time, for an age so different in experience and in assumptions from that which produced it.

[1] J. Evans, *Art in Med. France* (1948), 34. [2] See above, pp. 29, 30.
[3] H. Wharton, *Anglia Sacra*, ii (1691), 244.

BIBLIOGRAPHY

ENGLISH Romanesque art is dealt with incidentally in many works, architectural or topographical, that have a far wider range of subject: each cathedral has a considerable literature of its own: the local archaeological journals have many notes or articles on particular churches: contemporary chronicles scatter their references to building, painting, sculpture, and metal-work at random through their pages. A bibliography that aimed at any completeness would be a lengthy document. In the limited and highly selective list that follows, I have tried to give the most recent books and articles on the main topics and also some of the classics of the subject on which later work has been based. It remains, however, a very personal choice. Some of the more specialized studies of particular works are not included, but full details of them will be found in the relevant footnotes: nor have I attempted to list the many library catalogues, which are the basis of all study of the manuscripts, but which cover wide fields and are the familiar and constant tools of any specialized worker. Those of M. R. James for Trinity, Corpus Christi, and Pembroke colleges, Cambridge, that of G. F. Warner and J. P. Gilson for the Western manuscripts in the Old Royal and Kings collections, and that of F. Madan and H. H. E. Craster for the Bodleian Library are particularly valuable for this period. I have also assumed that, apart from the footnotes, no detailed entries are required for the volumes of the *Royal Commission on Historical Monuments* or for the *Victoria County History*. The topographical card index of the library of the Society of Antiquaries is an essential guide to the periodical literature: for recent years this is supplemented by the *Annual Bibliography of the History of British Art* published by the Courtauld Institute (5 volumes covering 1934 to 1945).

T. D. Atkinson's *Glossary of Terms used in English Architecture* is a serviceable handbook for the by no means stereotyped terminology of the subject.

In the first section I have given some of the more relevant collections of documents and some of the chroniclers whose interest in building and the arts has resulted in frequent citation of them; but incidental references occur in most twelfth-century writers.

Unless otherwise stated, the place of publication is London.

CONTEMPORARY SOURCES

Albani, S., Chronica Monasterii, ed. H. T. Riley (R.S. xxviii, 12 vols., 1863–76); the *Gesta abbatum* is in vol. iv.

Annales Monastici, ed H. R. Luard (R.S. xxxvi, 5 vols., 1864–9): vol. i: *de Margan, Theokesberia et Burton*; vol. ii: *de Wintonia et Waverleia*; vol. iii: *de Dunstaplia et Bermundeseia*; vol. iv: *de Osneia et Wigornia*.

BRAKELOND, JOCELIN OF, *Chronicle*, ed. H. E. Butler (1949).

Bury, Memorials of the Abbey of St. Edmund at, ed. T. Arnold (R.S. xcvi, 3 vols., 1890–6).

Bury St. Edmunds, Feudal Documents from the Abbey of, ed. D. C. Douglas (1932).

DANIEL, WALTER, *Life of Ailred*, ed. F. M. Powicke (1950).

DOMERHAM, ADAM OF, *Historia de rebus gestis Glastoniensibus*, ed. T. Hearne (2 vols., Oxford, 1727).

Dunelmensis, Historiae Scriptores Tres, ed. J. Raine (Surtees Society, ix, 1839).

DURHAM, LAURENCE OF, *Dialogi*, ed. J. Raine (Surtees Society, lxx, 1880).

DURHAM, SYMEON OF, *Opera*, ed. T. Arnold (R.S. lxxv, 2 vols., 1882–5).

EADMER, *Historia Novorum in Anglia et opuscula duo*, ed. M. Rule (R.S. lxxxi, 1884).

Eliensis, Liber, ed. O. J. Stewart (1848).

Ely, Sacrist Rolls of, ed. F. R. Chapman (2 vols., Cambridge, 1907).

Fountains, Memorials of the Abbey of St. Mary of, ed. J. R. Walbran (Surtees Society, xlii, vol. i, 1863).

GERVASE OF CANTERBURY, *Opera*, ed. W. Stubbs (R.S. lxxiii, 2 vols., 1879–80).

GIRALDUS CAMBRENSIS, *Opera*, ed. J. S. Brewer, J. F. Dimock, and G. F. Warner (R.S. xxi, 8 vols., 1861–91).

Hugh of Lincoln, Metrical Life of, ed. J. F. Dimock (Lincoln, 1860).

Hugonis Lincolniensis, Magna Vita, ed. J. F. Dimock (R.S. xxxvii, 1864).

HUGO CANDIDUS, *Chronicle*, ed. W. T. Mellows (1949).

Kyrkestall, Fundacio Abbathie de, ed. E. K. Clark (Thoresby Soc. iv, Miscellanea, 169–208, Leeds 1895).

Lanfranc, The Monastic Constitutions of, ed. D. Knowles (1951).

Malmesbury, William of, *de Antiquitate ecclesiae Glastoniensis*, ed. T. Gale, *Historiae Britannicae Scriptores*, xv (Oxford, 1691).

—— *de Gestis Pontificum Anglorum*, ed. N. E. S. A. Hamilton (R.S. lii, 1870).

—— *de Gestis Regum Anglorum*, ed. W. Stubbs (R.S. xc, 2 vols. 1887–9).

MORTET, V., *Recueil de textes relatifs à l'histoire de l'architecture et à la condition des architectes en France au moyen âge:* vol. i, *XIe et XIIe siècles* (Paris, 1911); vol. ii (with P. Deschamps), *XIIe et XIIIe siècles* (Paris, 1929).

NECKAM, ALEXANDER, *De naturis rerum*, ed. T. Wright (R.S. xxxiv, 1863).

Nomasticon Cisterciense, ed. H. Séjalon (Solesmes, 1892).

Nova Legenda Anglie, ed. C. Horstman (2 vols., Oxford, 1901).

Pipe Roll of 31 Henry I, ed. J. Hunter (1833) (facsimile edition 1929).

Pipe, Great Rolls of the, ed. J. Hunter (I. 2nd, 3rd, and 4th Hy. II; II. 1st Ric. I) (1844).

Pipe, Great Rolls of the, ed. Pipe Roll Society (1883–1949).

Rites of Durham, ed. Canon Fowler (Surtees Society, cvii, 1903).

TORIGNI, ROBERT OF, *Chronica*, ed. L. Delisle (Soc. de l'histoire de Normandie, 2 vols., Rouen, 1872–3).

—— *Tractatus de Immutatione Ordinis Monachorum*, ed. Migne, *P.L.* ccii. 1310.

—— *Historiae Northmannorum* Willelmi Calculi Gemmeticensis Monachi, Lib. viii, Migne, *P.L.* cxlix. 879.

WORCESTER, FLORENCE OF, *Chronicle*, ed. B. Thorpe (Eng. Hist. Soc., 2 vols., 1848–9).

WORCESTER, JOHN OF, *Chronicle*, ed. J. R. H. Weaver (*Anecdota Oxoniensia*, Medieval and Modern Series, 13, 1908).

MODERN WORKS

ADDY, S. O., *The Evolution of the English House*, ed. J. Summerson (1933).

ADHÉMAR, J., *Influences antiques dans l'art du moyen âge français* (1939).

ALARI, A. M., 'Codici miniati inediti dei secoli XI e XII della Bibl. Laurenziana', *La Bibliofilia*, xxxix (1937), 97.

AMEISENOWA, Z., 'Animal-headed Gods, Evangelists, Saints and Righteous Men', *Journ. of the Warburg and Courtauld Institutes*, xii (1949), 21.

ANDRÉ, J. LEWIS, 'Fonts in Sussex Churches', *Sussex Arch. Collections*, xliv (1901), 28.

ANDREWS, F. B., 'The Medieval Builder and his Methods', *Birmingham Arch. Soc., Trans.* xlviii (1922; publ. 1925), 1.

ANFRAY, M., *L'Architecture normande*, Paris (1939).

ARMITAGE, E. S., *The Early Norman Castles of the British Isles* (1912).

ATKINSON, T. D., *Architectural History of the Benedictine Monastery of Saint Etheldreda at Ely*, 2 vols. (Cambridge, 1933).

—— *A Glossary of Terms used in English Architecture*, 7th ed. (1948).

AUBERT, M., *L'Architecture cistercienne en France*, 2 vols., 2nd ed. (Paris, 1947).

AVELING, J. H., *The History of Roche Abbey* (1870).

BAKER, A., 'Lewes Priory and the Early Group of Wall Paintings in Sussex', *Walpole Soc.* xxxi (1942–3; publ. 1946).

BALTRUSAITIS, J., *La Stylistique ornementale dans la sculpture romane* (Paris, 1931).

BENHAM, W., *Old St. Paul's Cathedral* (1902).

BENTHAM, J., *The History and Antiquities of the Conventual and Cathedral Church of Ely, from the Foundation of the Monastery* A.D. *63 to the year 1771* (Cambridge, 1771); 2nd ed. (1812) and supplement by W. Stevenson (Norwich, 1817).

BILLINGS, R. W., *Architectural Illustrations and Description of the Cathedral Church at Durham* (1843).

BILSON, J., 'On the Recent Discoveries at the East End of the Cathedral Church of Durham', *Arch. Journ.* liii (1896), 1.

BILSON, J., 'The Beginning of Gothic Architecture', *Journ. of the Royal Institute of British Architects*, vi (1899), 259, 288, 345.

—— 'The Architecture of the Church of Kirkstall Abbey', *Publ. of the Thoresby Soc.* xvi (1907), 73.

—— 'The Architecture of the Cistercians with Special Reference to some of their Earlier Churches in England', *Arch. Journ.* lxvi (1909), 185.

—— 'Le Chapiteau à godrons en Angleterre', *Congrès archéologique, LXXVᵉ Session* (Paris, 1909), ii. 634.

—— 'Durham Cathedral: The Chronology of its Vaults', *Arch. Journ.* lxxix (1922), 101.

—— 'Notes on the Earlier Architectural History of Wells Cathedral', *Arch. Journ.* lxxxv (1928), 23.

BIRCH, W. DE G., *Catalogue of Seals in the Department of MSS. in the British Museum*, i (1887).

BISHOP, E., and GASQUET, F. A., *The Bosworth Psalter* (1908).

—— *Liturgica Historia*, Oxford (1918).

BISHOP, H. E., and PRIDEAUX, E. K., *The Building of the Cathedral Church of St. Peter in Exeter* (Exeter, 1922).

BLOMEFIELD, F., *An Essay towards a Topographical History of the County of Norfolk*, 5 vols. (1739–75).

BODLEIAN LIBRARY, *English Romanesque Illumination*, Oxford (1951).

BOECKLER, A., *Abendländische Miniaturen bis zum Ausgang der Romanischen Zeit* (Berlin, 1930).

BOINET, A., 'Les MSS. de la Bibliothèque Ste- Geneviève', *Bulletin de la Société française de Reproductions de MSS. à peintures*, v (Paris, 1921), 21.

BOND, F., *Gothic Architecture in England* (1905).

—— *Fonts and Font Covers* (1908).

—— *An Introduction to English Church Architecture*, 2 vols. (Oxford, 1913).

—— *Dedications of English Churches* (Oxford, 1914).

—— 'On the Comparative Value of Documentary and Architectural Evidence in Establishing the Chronology of the English Cathedrals', *Journ. of the Royal Institute of British Architects*, vi (1899), 17.

BONY, J., 'Tewkesbury et Pershore', *Bull. Mon.* xcvi (Paris, 1937), 281, 503.

—— 'La Technique normande du mur épais à l'époque romane', *Bull. mon.* xcviii (1939), 153.

—— 'Gloucester et l'origine des voûtes d'hémicycle gothiques', *Bull. mon.* xcviii (1939), 329.

—— 'French Influences on the Origins of English Gothic Architecture', *Journ. of the Warburg and Courtauld Institutes*, xii (1949), 1.

—— 'Le Projet premier de Durham', *Urbanisme et Architecture* (Paris, 1953).

BORENIUS, T., *St. Thomas Becket in Art* (1932).

BORENIUS, T., and TRISTRAM, E., *English Medieval Painting* (Florence and Paris, 1927).

BRAKSPEAR, H., 'Malmesbury Abbey', *Archaeol.* lxiv (1913), 399.

BRAUN, H., *The English Castle* (1936).

—— *An Introduction to English Mediaeval Architecture* (1951).

BRAYLEY, E. W., and BRITTON, J., *The History of the Ancient Palace and Late Houses of Parliaments at Westminster* (1836).

BRAYLEY, E. W., and NEALE, J. P., *The History and Antiquities of the Abbey Church of St. Peter, Westminster*, 2 vols. (1818).

BRITISH MUSEUM, *Reproductions from Illuminated MSS.*, 4 vols. (1923–8).

—— See J. A. HERBERT, G. WARNER.

BRITTON, J., *Architectural Antiquities*, 5 vols. (1807–26).

—— *Cathedral Antiquities*, 11 vols. (1814–35).

BROOKE, Z. N., *The English Church and the Papacy from the Conquest to the Reign of John* (Cambridge, 1931).

BROWNE, J., *The History of the Metropolitan Church of St. Peter, York*, 2 vols. (London, Oxford, and York, 1847).

BURLINGTON FINE ARTS CLUB, *Catalogue of an Exhibition of Illuminated MSS.* (1908).

—— *Catalogue of an Exhibition of British Medieval Art* (1939).

BURRIDGE, A. W., 'L' Immaculée Conception dans la théologie de l'Angleterre médiévale', *Revue d'histoire ecclésiastique*, xxxii (1936), 570.

Caen, Congrès archéologique tenue à, LXXVIème Session, 2 vols. (Paris, 1909).

CARTER, J., *Some account of the Cathedral Church of Durham with Plates illustrative of the Plans, Elevations and Sections of that Building* (1801).

CAUTLEY, H. M., *Suffolk Churches and their Treasures* (1937).

—— *Norfolk Churches* (Ipswich, 1949).

CHAMOT, M., *English Medieval Enamels* (1930).

CHAMPNEYS, A. C., *Irish Ecclesiastical Architecture* (1910).

CHRISTIE, A. G. I., *English Mediaeval Embroidery* (Oxford, 1938).

CHURCH, C. M., *Chapters in the Early History of the Church of Wells* (1894).

CLAPHAM, A. W., *English Romanesque Architecture before the Conquest* (Oxford, 1930).

—— *English Romanesque Architecture after the Conquest* (Oxford, 1934).

—— *Romanesque Architecture in England*, The British Council (1950).

—— Memorial volume to, *Arch. Journ.* cvi, supplement (1952).

—— 'The Architecture of the Premonstratensians, with Special Reference to their Buildings in England', *Archaeol.* lxxiii (1923), 117.

—— 'Some Minor Irish Cathedrals', in *Medieval Studies in Memory of A. Kingsley Porter*, ed. R. W. Koehler, II (Harvard, 1939).

CLAPHAM, A. W., and GODFREY, W. H., *Some Famous Buildings and their Story* (n.d.).

CLARK, G. T., *Medieval Military Architecture in England*, 2 vols. (1884).

CLARKE, W. H. E., 'The Church of St. David at Kilpeck', *Trans. of the Wool-hope Natural Field Club, 1930–2* (1935), 7.

COLVIN, H. M., *The White Canons in England* (Oxford, 1951).

CONYBEARE, W. J., 'The Carved Capitals of Southwell Minster', *Journ. Brit. Arch. Ass.* xxix (1934), 176.

COOK, G. H., *Portrait of Durham Cathedral* (1948).

—— *Portrait of Canterbury Cathedral* (1949).

—— *Portrait of Lincoln Cathedral* (1950).

COOKE, A. M., 'The Settlement of the Cistercians in England', *E.H.R.* viii (1893), 625.

COX, J. C., *Notes on the Churches of Derbyshire*, 4 vols. (Chesterfield, London, and Derby, 1877).

CROSSLEY, F. H., *English Church Monuments A.D. 1150–1550: an Introduction to the Study of Tombs and Effigies of the Mediaeval Period* (1921).

DALTON, O. M., *Catalogue of the Ivory Carvings of the Christian Era in the British Museum* (1909).

—— 'On Two Medieval Bronze Bowls in the British Museum', *Archaeol.* lxxii (1922), 133.

DART, J., *The History and Antiquities of the Cathedral Church of Canterbury* (1726).

DE BRUYNE, E., *Études d'esthétique médiévale*, 3 vols. (Bruges, 1946).

DELISLE, L., *Rouleaux des Morts*, ed. Soc. de l'Histoire de France (Paris, 1866).

—— *Notice de douze livres royaux du XIII⁰ et du XIV⁰ siècle* (Paris, 1902).

DE MOREAU, E., *Histoire de l'Église en Belgique*, ii (Brussels, 1945).

DEMUS, O., *The Mosaics of Norman Sicily* (1949).

DE WALD, E. T., *The Illustrations of the Utrecht Psalter* (Princeton, 1932).

DICKINSON, J. C., *The Origins of the Austin Canons and their Introduction into England* (1950).

—— 'English Regular Canons and the Continent in the Twelfth Century', *Trans. of the Royal Historical Soc.* 5th series, i (1951), 71.

DIMOCK, A., *The Cathedral Church of Southwell* (1898).

DODWELL, C. R., *The Canterbury School of Illumination* (unpublished thesis, University of Cambridge, 1951).

DRUCE, G. C., 'The Symbolism of the Crocodile', *Arch. Journ.* lxvi (1909), 312.

—— 'The Amphisbaena and its connexions in ecclesiastical art', *Arch. Journ.* lxvii (1910), 285.

—— 'Some Abnormal and Composite Human Forms in English Church Architecture', *Arch. Journ.* lxxii (1915), 135.

—— 'The Legend of the Serra or Saw-fish', *Proc. of the Soc. of Antiq.* xxxi (1918), 20.

DRUCE, G. C., 'The Mediaeval Bestiaries and their Influence on Ecclesiastical Decorative Art', *Journ Brit. Arch. Soc.* xxv (1919), 41, and xxvi (1920), 35.

——'An Account of the Μυρμηκολέων or Ant-lion', *Antiq. Journ.* iii (1923), 347.

DUGDALE, W., *Monasticon Anglicanum*, ed. J. Caley, H. Ellis, and B. Bandinel, 6 vols. in 8 (1817–30).

—— *The History of St. Paul's Cathedral* (1658), ed. H. Ellis (1818).

EDEN, C. H., *Black Tournai Fonts in England* (1909).

ELLIS, J. W., 'The Mediaeval Fonts of the Hundreds of West Derby and Wirral', *Trans. of the Historical Soc. of Lancashire and Cheshire*, liii (1901), 59.

EVANS, H. A., *Castles of England and Wales* (1912).

EVANS, JOAN, *The Romanesque Architecture of the Order of Cluny* (Cambridge, 1938).

—— *Cluniac Art of the Romanesque Period* (Cambridge, 1949).

FAGE, R., 'La Décoration géométrique dans l'école romane de Normandie', *Congrès archéologique*, lxxv (2) (Paris, 1909), 615.

FARLEY, M. A., and WORMALD, F., 'Three Related English Romanesque Manuscripts', *Art Bulletin*, xxii (1940), 157.

FELTON, H., and HARVEY, J., *The English Cathedrals* (1950).

FOCILLON, H., *Moyen âge survivances et réveils* (Valiquette, 1943).

—— *Art d'Occident. Le Moyen Âge roman et gothique* (Paris, 1947).

FORBES-LEITH, W., *Life of St. Cuthbert, with 45 full page illuminations from the Lawson MS.* (Edinburgh, 1888).

FORSTER, R. ARNOLD, *Studies in Church Dedication or England's Patron Saints*, 3 vols. (1899).

FOX, Sir C., *Illustrated Regional Guide to Ancient Monuments: South Wales* (1949).

FRYER, A. C., 'Gloucestershire Fonts', *Trans. of the Bristol and Gloucester Arch. Soc.* xxxii (1909), 301.

GARDNER, A., *English Medieval Sculpture* (Cambridge, 1951).

GARDNER, S., *English Gothic Foliage Sculpture* (Cambridge, 1927).

GLUNZ, H. H., *History of the Vulgate in England from Alcuin to Roger Bacon* (Cambridge, 1933).

GODFREY, W. H., *The Priory of St. Pancras at Lewes* (Lewes, 1927).

GOLDSCHMIDT, A., *Der Albanipsalter in Hildesheim* (Berlin, 1895).

—— *Die Elfenbeinskulpturen aus der romanischen Zeit*, vol. iv, *XI–XIII Jahrhundert* (Berlin, 1926).

—— 'English Influence on Mediaeval Art on the Continent', *Medieval Studies in Memory of A. Kingsley Porter*, ed. R. W. Koehler, II (Harvard, 1939).

GRAHAM, R., *St. Gilbert of Sempringham and the Gilbertines* (1901).
—— *English Ecclesiastical Studies* (1929).
GREENWELL, W., *Durham Cathedral* (Durham, 1904).
GRIGSON, G., MEYER, P., and HÜRLIMANN, M., *English Cathedrals* (1950).
GUNTHER, R. T., *The Herbal of Apuleius Barbarus*, Roxburghe Club (1925).

HABICHT, V. C., *Niedersächsische Kunst in England* (Hanover, 1930).
HARLECH, LORD, *Illustrated Regional Guides to Ancient Monuments under the Ownership or Guardianship of the Ministry of Works: England and North Wales*, 4 vols., 2nd ed. (1949).
HARVEY, A., *The Castles and Walled Towns of England* (1911).
HARVEY, J. H., 'The Medieval Office of Works', *Journ. Brit. Arch. Ass.* vi (1941), 20.
—— 'The King's Chief Carpenters', *Journ. Brit. Arch. Ass.* xi (1948), 13.
HASELOFF, G., *Die Psalterillustration im 13 Jahrhundert* (1938).
HASKINS, C. H., *Studies in the History of Medieval Science* (Harvard University Press, 1924).
—— *The Renaissance of the Twelfth Century* (Harvard University Press, 1927).
—— *Studies in Medieval Culture* (Oxford, 1929).
HENRY, F., *La Sculpture irlandaise pendant les douze premiers siècles de l'ère chrétienne*, 2 vols. (Paris, 1932).
HERBERT, J. A., *Illuminated Manuscripts* (1911).
—— 'A Psalter in the British Museum (Royal MS. 1 D. X) Illuminated in England early in the Thirteenth Century', *Walpole Soc.* iii (Oxford, 1914), 47.
—— *Schools of Illumination from MSS. in the British Museum, II. English 12th and 13th centuries* (1915).
HILL, J. W. F., *Medieval Lincoln* (Cambridge, 1948).
HOBSON, G. D., *English Binding before 1500* (Cambridge, 1929).
HOMBURGER, O., *Der Trivulzio-Kandelaber* (Zürich, 1949).
HOPE, W. H. ST. JOHN, 'The Architectural History of the Cluniac Priory of St. Pancras at Lewes', *Arch. Journ.* xli (1884), 1.
—— 'Notes on the Benedictine Abbey of St. Peter at Gloucester', *Arch. Journ.* liv (1897), 77.
—— 'Fountains Abbey', *Yorkshire Arch. Journ.* xv (1898), 269.
—— 'The Abbey of St. Mary in Furness, Lancashire', *Trans. of the Cumberland and Westmorland Arch. Soc.* xvi (1900), 221.
—— *Rochester Cathedral* (1900).
—— 'The Cluniac Priory at Lewes', *Sussex Arch. Soc. Collections*, xlix (Lewes, 1906), 166.
—— 'Kirkstall Abbey', *Publ. of the Thoresby Soc.* xvi (1907), 1.
—— 'Quire Screens in English Churches', *Archaeol.* lxviii (1917), 43.

HOPE, W. H. ST. JOHN, 'Round Naved Churches in England', *Archaeol. Cantiana*, xxxiii (1918), 63.

HOPE, W. H. ST. JOHN, and BRAKSPEAR, H., 'Jervaulx Abbey', *Yorkshire Arch. Journ.* xxi (1911), 303.

HUMBERT, L. M., *Memorials of the Hospital of St. Cross* (1868).

HURRY, J. B., *Reading Abbey* (1901).

IRVINE, J. T., 'Some Northamptonshire Churches of Norman Age', *Journ. Brit. Arch. Ass.*, N.S. i (1895), 309.

JAMES, M. R., 'On Fine Art as Applied to the Illustration of the Bible in the Ninth and following Centuries', *Proc. of the Cambridge Antiquarian Soc.* vii (1888–91), 31.

—— *On the Abbey of St. Edmund at Bury*, Cambridge Antiquarian Society, xxviii (1895).

—— 'Sculptures at Lincoln Cathedral', *Proc. of the Cambridge Antiquarian Soc.* x (1898–1903), 148.

— *The Ancient Libraries of Canterbury and Dover* (Cambridge, 1903).

—— *Catalogue of MSS. and Early Printed Books in the Library of J. Pierpont Morgan* (1906).

—— *Abbeys* (1926).

—— *The Bestiary* (Cambridge University Library MS. Ii. 4. 26), Roxburghe Club (1928).

—— *Marvels of the East*, Roxburghe Club (1929).

—— *Two Ancient English Scholars, St. Aldhelm and William of Malmesbury* (Glasgow, 1931).

—— *The Canterbury Psalter* (1935).

—— 'Four Leaves of an English Psalter', *Walpole Soc.* xxv (1937), 1.

—— 'Pictor in Carmine', *Archaeol.* xciv (1951), 141.

JAMISON, E. M., 'The Sicilian Norman Kingdom in the Mind of Anglo-Norman Contemporaries', *Proc. of the British Academy*, xxiv (1938), 3.

—— 'Alliance of England and Sicily in the Second Half of the Twelfth Century', *Journ. of the Warburg and Courtauld Institutes*, vi (1943), 20.

JOHNSTON, P. M., 'Studland Church and some Remarks on Norman Corbel-tables, *Journ. Brit. Arch. Ass.* xxiv (1918), 33.

—— 'Romanesque Ornament in England: Its Sources and Evolution', *Journ. Brit. Arch. Ass.* xxx (1924), 91.

JONES, L. WEBBER, and MOREY, C. R., *The Miniatures of the MSS. of Terence*, 2 vols. (Princeton University Press, 1931).

JÓNSDÓTTIR, S., 'The Portal of Kilpeck Church: Its Place in English Romanesque Sculpture', *The Art Bulletin*, xxxii (New York, 1950), 171.

KATZENELLENBOGEN, A., *Allegories of the Virtues and Vices in Mediaeval Art* (1939).

KENDRICK, T. D., *Late Saxon and Viking Art* (1949).

KER, N. R., *Medieval Libraries of Great Britain* (1941).

KEYSER, C. E., *Norman Tympana and Lintels*, 2nd ed. (1927).

—— 'The Norman Doorways in the Counties of Berkshire and Buckinghamshire', *Berks., Bucks. and Oxon. Arch. Journ.* vi (Reading, 1900), 8, 73.

—— 'Notes on a Sculptured Tympanum at Kingswinford Church, Staffordshire, and other Early Representations of St. Michael the Archangel', *Arch. Journ.* lxii (1905), 137.

—— 'Some Norman Capitals from Sonning, Berks., and some Sculptured Stones at Shiplake and Windsor Castle', *Proc. of Soc. of Antiq.* xxviii (1915–16).

KNOOP, D., and JONES, G. P., *The Mediaeval Mason* (Manchester, 1933).

KNOWLES, D., *The Religious Houses of Medieval England* (1940).

—— *The Monastic Order in England 943–1216* (Cambridge, 1941).

—— *The Episcopal Colleagues of Archbishop Thomas Becket* (Cambridge, 1951).

—— 'The Humanism of the Twelfth Century', *Studies* (1941), 3.

KNOWLES, D., and ST. JOSEPH, J. K., *Monastic Sites from the Air* (Cambridge, 1952).

KOEHLER, W., 'Byzantine Art in the West', *Dumbarton Oaks Inaugural Lectures, Dumbarton Oaks Papers* (Harvard University Press, 1941), 63.

KRÜCKE, A., 'Über einige angebliche Darstellungen Gott-Vaters im frühen Mittelalter', *Marburger Jahrbuch für Kunstwissenschaft*, x (1937), 5.

LE COUTEUR, J. D., *English Mediaeval Painted Glass* (1926).

LEGG, J. WICKHAM, and HOPE, W. H. ST. JOHN, *Inventories of Christ Church, Canterbury* (1902).

LETHABY, W. R., *Westminster Abbey Re-examined* (1925).

—— 'The Palace of Westminster in the Eleventh and Twelfth Centuries', *Archaeol.* lx (1906), 131.

—— 'Archbishop Roger's Cathedral at York and its Stained Glass', *Arch. Journ.* lxxii (1915), 37.

—— 'Old St. Paul's', *The Builder*, cxxxviii (1930), 671, 862, 1091; cxxxix (1930), 24, 193, 234, 393, 613, 791, 1005, 1088.

LEWIS, G. R., *Illustrations of Kilpeck Church, Herefordshire* (1842).

—— *Shobdon Church* (1852).

LIVETT, G. M., 'Early-Norman Churches in and near the Medway Valley', *Archaeol. Cantiana*, xx (1893), 137, and xxi (1895), 260.

LLOYD, N., *A History of the English House* (1931).

LONGHURST, M. H., *English Ivories* (1926).

—— *Catalogue of Carvings in Ivory, Victoria and Albert Museum* (1927).

LONGSTAFFE, W. H. D., 'Bishop Pudsey's Buildings in the County of Durham', *Trans. of the Architectural and Archaeol. Soc. of Durham and Northumberland*, i (1862), 1.

LOVEGROVE, E. W., 'The Cathedral Church of St. David's', *Arch. Journ.* lxxxiii (1926), 254.

MacGIBBON, D., and Ross, T., *The Ecclesiastical Architecture of Scotland*, 3 vols. (Edinburgh, 1896–7).

MÂLE, E., *L'Art religieux du XII^e siècle en France* (Paris, 1924).

MARCOUSÉ, R., *Figure Sculpture in St. Mary's Abbey, York* (York, 1951).

MARSHALL, G., *The Cathedral Church of Hereford* (Worcester, 1951).

—— 'Remarks on a Norman Tympanum at Fownhope and others in Herefordshire', *Trans. of the Woolhope Naturalists' Field Club, 1918–20* (Hereford, 1921), 52.

MASSÉ, H. J. and J., *The Cathedral Church of Gloucester* (1898).

—— —— *The Abbey Church of Tewkesbury* (1900).

MESSENT, C. J. W., *The Monastic Remains of Norfolk and Suffolk* (Norwich, 1934).

MICHEL, A., *Histoire de l'art*, II. *Formation, expansion et évolution de l'art gothique* (Paris, 1906).

MILLAR, E. G., *English Illuminated Manuscripts from the 10th to the 13th Century* (Paris and Brussels, 1926).

—— *A Descriptive Catalogue of the Western MSS. in the Library of A. Chester Beatty*, 2 vols. text, 2 vols. plates (1927).

—— 'Les Principaux MSS. à peintures du Lambeth Palace à Londres', *Bulletin de la Société française de Reproductions de MSS. à peintures*, viii (1924).

MITCHELL, H. P., 'Some Enamels of the School of Godefroid de Claire', *Burl. Mag.* xxxiv (1919), 85, 165; xxxv (1919), 34, 92, 217; xxxvi (1920), 18, 128; xxxvii (1920), 11.

—— 'Two Bronzes by Nicholas of Verdun', *Burl. Mag.* xxxviii (1921), 157.

—— 'Two English Ivory Carvings of the Twelfth Century', *Burl. Mag.* xli (1922), 176.

—— 'Flotsam of Later Anglo-Saxon art', *Burl. Mag.* xlii (1923), 63, 162, 303, and xliii (1924), 104.

—— 'English Enamels of the XIIth Century', *Burl. Mag.* xlvii (1925), 163, and xlix (1926), 261.

MOREY, C. R., GREENE, B. DA COSTA, and HASSEN, M. P., *Exhibition of Illuminated MSS. from the Pierpont Morgan Library* (New York, 1934).

MYNORS, R. A. B., *Durham Cathedral Manuscripts to the End of the Twelfth Century* (Oxford, 1939).

NEALE, J. P., and LE KEUX, J., *Views of the Most Interesting Collegiate and Parochial Churches in Great Britain*, 2 vols. (1824–5).

NEW PALAEOGRAPHICAL SOCIETY, *Facsimiles of Ancient Manuscripts, &c.*, 1st series (1903–12), 2nd series (1913–30).

Nørlund, P., *Gyldne Altre* (in Danish with English summary) (Copenhagen, 1926).

Oakeshott, W., *The Artists of the Winchester Bible* (1945).
—— *The Sequence of English Medieval Art* (1950).
Oliver, G., *Lives of the Bishops of Exeter* (Exeter, 1861).
Omont, H., *Miniatures du Psautier de S. Louis* (Leyden, 1902).
—— *Psautier illustrée (XIII^e siècle): Reproduction du MS. lat. 8846 de la Bibliothèque Nationale* (Paris, n.d.).
Oursel, C., *La Miniature du XII^e siècle à l'Abbaye de Cîteaux* (Dijon, 1926).

Pächt, O., 'Hugo Pictor', *The Bodleian Library Record*, iii (Oxford, 1950), 96.
Painter, S., 'English Castles in the early Middle Ages', *Speculum*, x (Cambridge, Mass., 1935), 321.
Palaeographical Society, *Facsimiles of Manuscripts, &c.*, vols. i and ii (1873–83); 2nd series (1884–94). *See also* New Palaeographical Society.
Panofsky, E., and Saxl, F., 'Classical Mythology in Mediaeval Art', *Metropolitan Museum Studies*, iii, Pt. 2 (New York, 1931), 228.
Pantin, W. A., *Durham Cathedral* (1948).
Parker, J. H., 'On the English Origin of Gothic Architecture', *Archaeol.* xliii (1871), 73.
Pinder, W., *Einleitende Voruntersuchung zu einer Rythmik Romanischer Innenräume in der Normandie* (Strassburg, 1903).
Pollen, J. H., *Ancient and Modern Gold and Silver Smiths' Work in the South Kensington Museum* (1878).
Poole, A. L., *From Domesday Book to Magna Carta 1087–1216* (Oxford, 1951).
Potter, J., *Remains of Ancient Monastic Architecture in England* (1847).
Prior, E. S., *A History of Gothic Art in England* (1900).
—— *The Cathedral Builders in England* (1905).
Prior, E. S., and Gardner, A., *An Account of Medieval Figure Sculpture in England* (Cambridge, 1912).
—— —— *Eight Chapters on English Mediaeval Art* (Cambridge, 1922).

Rackham, B., *The Ancient Glass of Canterbury Cathedral* (1949).
Read, H., *English Stained Glass* (London and New York, 1926).
Rice, D. Talbot, *English Art 871–1100*, *O.H.E.A.* ii (1951).
Richards, R. *Old Cheshire Churches* (1947).
Robertson, W. A. Scott, 'The Crypt of Canterbury Cathedral', *Archaeol. Cantiana*, xiii (1880), 17, 500.
Robinson, G., and Urquhart, H., 'Seal Bags in the Treasury of the Cathedral Church of Canterbury', *Archaeol.* lxxxiv (1934), 163.
Robinson, J. Armitage, *Gilbert Crispin, Abbot of Westminster* (Cambridge, 1911).

ROBINSON, J. ARMITAGE, 'Documentary Evidence relating to the Building of the Cathedral Church of Wells', *Arch. Journ.* lxxxv (1928), 1.

ROHDE, E. S., *The Old English Herbals* (1922).

ROLLAND, PAUL, 'La Technique normande du mur évidé et l'architecture scaldienne', *Revue belge d'Arch. et d'Hist. de l'Art*, x (1940), 169.

ROST, H., *Die Bibel im Mittelalter* (Augsburg, 1939).

ROTH, D., 'Norman Survivals in London', *Journ. of Royal Institute of British Architects*, xlii (1935), 863.

Rouen, Congrès archéologique tenue à, LXXXIX^{ième} Session (Paris, 1927).

RUPRICH-ROBERT, V., *L'Architecture normande aux XI^e et XII^e siècles en Normandie et en Angleterre*, 2 vols. (Paris, 1884).

SALMON, J., 'Beakhead Ornament in Norman Architecture', *Yorkshire Arch. Journ.* xxxvi (1944–7), 349.

SALZMAN, L. F., *Building in England down to 1540* (Oxford, 1952).

SAUNDERS, O. E., *English Illumination*, 2 vols. (Florence and Paris, 1928).

—— *A History of English Art in the Middle Ages* (Oxford, 1932).

SAXL, F., and WITTKOWER, R., *British Art and the Mediterranean* (Oxford, 1947).

SEDDING, E. H., *Norman Architecture in Cornwall* (1909).

SEYMOUR, CHARLES, *Notre-Dame of Noyon in the Twelfth Century: A Study in the early development of Gothic Architecture* (Yale, 1939).

SEZNEC, J., *La Survivance des Dieux antiques* (1940).

SHARPE, E., *Architectural Parallels* (1848).

—— *The Ornamentation of the Transitional Period of British Architecture* (1871).

SMALLEY, B., *The Study of the Bible in the Middle Ages* (Oxford U.P., 1941; revised ed., Blackwell, Oxford, 1952).

SMITH, G. LE BLANC, 'Derbyshire Fonts', *Derbyshire Arch. Journ.* xxv (1903), 217.

SMITH, R. A. L., *Canterbury Cathedral Priory* (Cambridge, 1943).

—— *Collected Papers* (1947).

SRAWLEY, J. H., *The Story of Lincoln Minster* (1947).

STENTON, F. M., *Norman London* (Historical Association Leaflets, 93–94) (1934).

STETTINER, R., *Die illustrierten Prudentiushandschriften*, 2 vols. (1895–1905).

STOTHARD, C. A., *The Monumental Effigies of Great Britain* (1817).

STRANGE, E. F., *The Cathedral Church of Worcester* (1900).

STUBBS, W., *Historical Introductions to the Rolls Series*, ed. A. Hassall (1902).

SWARZENSKI, G., 'Aus dem Kunstkreis Heinrichs des Löwen', *Städel-Jahrbuch*, vii–viii (Frankfurt, 1932), 241.

TANNER, T., *Notitia Monastica or an Account of all the Abbies, Priories and Houses of Friers, formerly in England and Wales*, ed. J. Nasmith (Cambridge, 1787).

THIELE, G., *Der Illustrierte Lateinische Aesop* (Leyden, 1905).

THOMPSON, A. HAMILTON, *Military Architecture in England during the Middle Ages* (Oxford, 1912).

—— *English Monasteries* (Cambridge, 1923).

—— *The Cathedral Churches of England* (1925).

—— *The Building of York Minster* (1927).

—— 'The Cathedral Church of the Blessed Virgin Mary, Southwell', *Trans. of the Thoroton Soc.* xv (Nottingham, 1911), 15.

—— 'Mediaeval Building Documents and what we learn from them', *The National Ancient Monuments Review*, i (1928), 30.

THOMPSON, E. MAUNDE, *English Illuminated Manuscripts* (1895).

THOMPSON, H. YATES, *Illustrations from 100 MSS. in the Library of H. Yates Thompson*, Vol. IV. *Sixteen MSS. of English Origin* (1914).

TIKKANEN, J. J., *Die Psalterillustration im Mittelalter* (Helsingfors, 1900).

TOY, S., *Castles* (1939).

—— 'Corfe Castle: Its History, Construction and Present Condition', *Archaeol.* lxxix (1929), 85.

TRISTRAM, E. W., *English Medieval Wall Painting: I. The Twelfth Century* (1944); II. *The Thirteenth Century*, 2 vols. (1950).

TURNER, T. HUDSON, *Some account of Domestic Architecture in England from the Conquest to the End of the Thirteenth Century* (Oxford, 1851).

VALLERY-RADOT, J., *Églises romanes* (Paris, 1931).

VICTORIA AND ALBERT MUSEUM, *Catalogue of an Exhibition of English Mediaeval Art* (1930).

VON FALKE, O., and FRAUBERGER, H., *Deutsche Schmelzarbeiten des Mittelalters* (Frankfurt, 1904).

WALTERS ART GALLERY, *Illuminated Books of the Middle Ages and Renaissance* (Baltimore, 1949).

WARNER, G., *Illuminated Manuscripts in the British Museum* (1903).

—— *The Guthlac Roll*, Roxburghe Club (1928).

WATSON, A., *The Early Iconography of the Tree of Jesse* (1934).

WATSON, E. W., *The Cathedral Church of Christ in Oxford* (1935).

WEBB, E. A., *The Records of St. Bartholomew's Priory and of the Church and Parish of St. Bartholomew the Great, West Smithfield*, 2 vols. (1921).

WEBB, G., *Ely Cathedral* (1951).

—— *Gothic Architecture in England*, The British Council (1951).

WEBSTER, J. C., *The Labors of the Months in Antique and Mediaeval Art* (Northwestern University Studies, Evanston and Chicago, 1938).

WILLIAMS, L. F. RUSHBROOK, *History of the Abbey of St. Alban* (1917).

WILLIS, R., *The Architectural History of Canterbury Cathedral* (1845).

WILLIS, R., 'The Architectural History of Winchester Cathedral', *Proc. of the Arch. Institute at Winchester, 1845* (1846), 1.

—— 'The Architectural History of York Cathedral', *Proc. of the Arch. Institute at York, 1846* (1848).

—— *The Architectural History of Chichester Cathedral* (Chichester, 1861).

—— 'The Architectural History of the Cathedral and Monastery at Worcester', *Arch. Journ.* xx (1863), 83, 254, 301.

—— *The Architectural History of Glastonbury Abbey* (Cambridge, 1866).

WOOD, M., 'Norman Domestic Architecture', *Arch. Journ.* xcii (1935), 167.

WOODRUFF, C. E., and DANKS, W., *Memorials of the Cathedral and Priory of Christ in Canterbury* (1912).

WOODRUFF, H., 'The Illustrated MSS. of Prudentius', *Art Studies*, vii (Harvard University Press, 1929), 33.

WORMALD, F., *English Kalendars before 1100*, Henry Bradshaw Society, lxxii (1934).

—— *English Benedictine Kalendars after 1100*, 2 vols., Henry Bradshaw Society, lxxvii (1939), and lxxxi (1946).

—— *English Drawings of the Tenth and Eleventh Centuries* (Faber & Faber, 1952).

—— 'A Romanesque Drawing at Oxford', *Antiq. Journ.* xxii (1942), 17.

—— 'The Development of English Illumination in the Twelfth Century', *Journ. Brit. Arch. Ass.* viii (1943), 31.

—— 'The Survival of Anglo-Saxon Illumination after the Norman Conquest', *Proc. of the British Academy*, xxx (1944), 127.

—— 'Decorative Initials in English Manuscripts from 900 to 1000', *Archaeol.* xci (1945), 107.

WRIGHT, T., *A History of Domestic Manners and Sentiments in England* (1862).

WYON, A. B., and A., *The Great Seals of England* (1887).

YATES, E., 'Notes on Mediaeval Church Ironwork', *Journ. Brit. Arch. Ass.* iv (1939), 175.

ZARNECKI, G., *English Romanesque Sculpture 1066–1140* (1951).

—— *Later English Romanesque Sculpture 1140–1210* (1953).

—— 'The Coronation of the Virgin', *Journ. of the Warburg and Courtauld Institutes*, xiii (1950), 1.

—— 'Regional Schools of English Sculpture in the Twelfth Century' (unpublished thesis, University of London, 1951).

INDEX

References in **black** type are to plates.

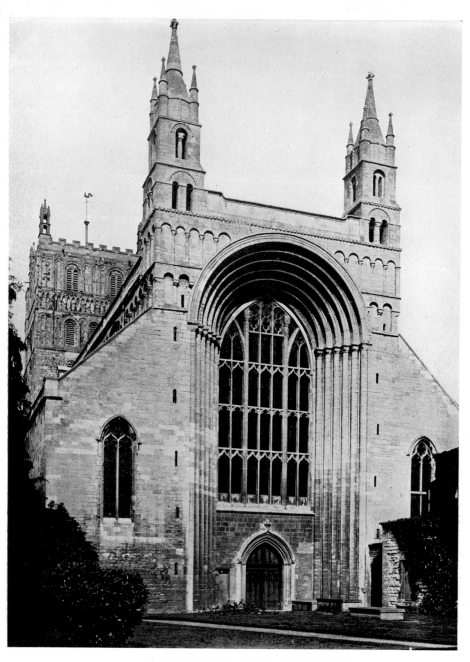

I. TEWKESBURY ABBEY: WEST FRONT

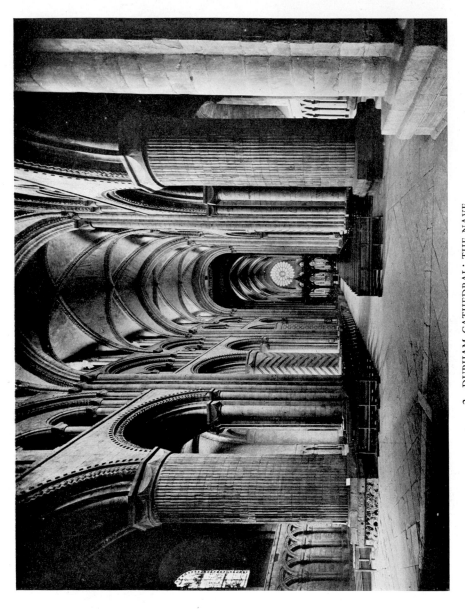

2. DURHAM CATHEDRAL: THE NAVE

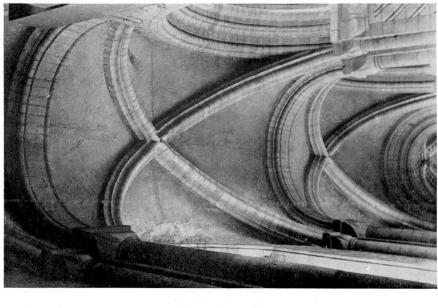

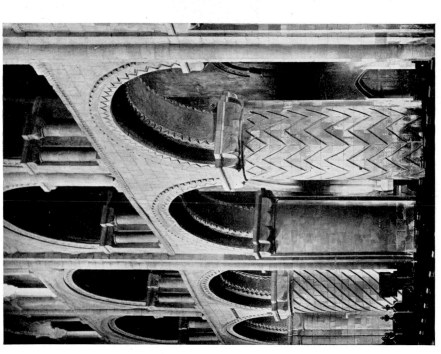

3. *a.* WALTHAM ABBEY: THE NAVE
b. DURHAM CATHEDRAL: VAULT IN NORTH AISLE OF CHOIR

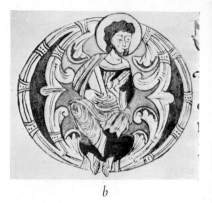

a

b

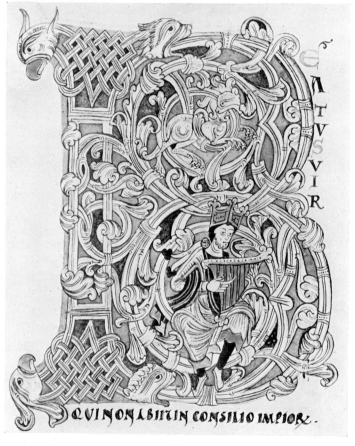

c

4. *a*. DETAIL OF INITIAL. Bayeux MS. 57

 b. HABAKKUK: INITIAL FROM CARILEF BIBLE

 c. BEATUS INITIAL: FROM CARILEF BIBLE

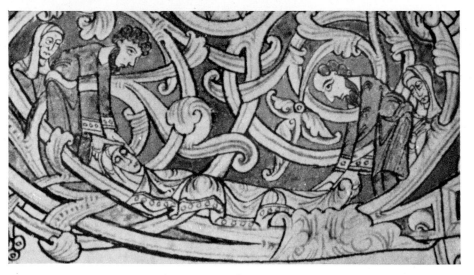

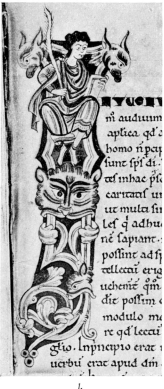

5. *a.* THE BURIAL OF PAULA. Bodl. MS. Bodley 717

 b. INITIAL. Bodl. MS. Bodley 301

 c. INITIAL. Bayeux MS. 57

a

b

c

6. *a*. A MEDICAL CONSULTATION. Durham MS. Hunter 100
 b. ST. BENIGNE. B.M. MS. Arundel 91
 c. A MIRACLE OF ST. CUTHBERT. Oxford, University College MS. 165

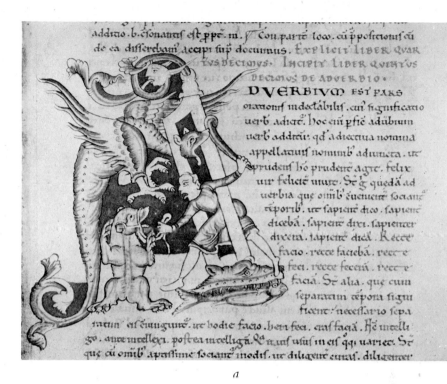

a

b *c*

7. *a.* INITIAL. Vat. Rossiana MS. 500
 b. INITIAL. B.M. MS. Royal 12 E. XX
 c. INITIAL. Cambridge, Trinity College MS. O. 4. 7

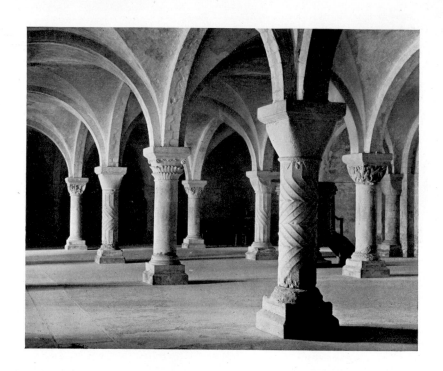

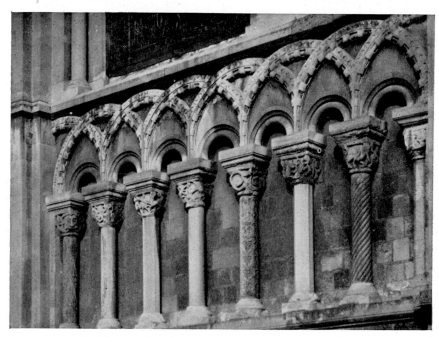

8. CANTERBURY CATHEDRAL

a. THE CRYPT; *b.* ARCADE, NORTH TRANSEPT

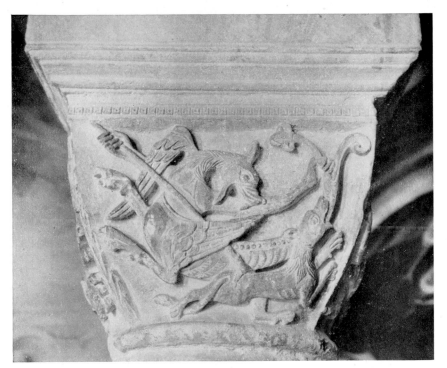

a

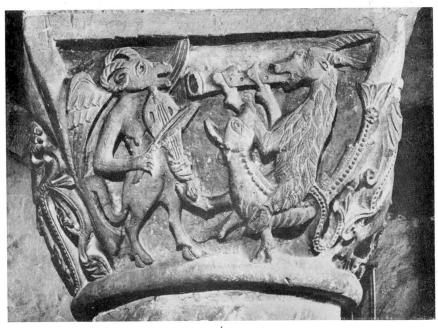

b

9. CANTERBURY CATHEDRAL: CAPITALS IN CRYPT

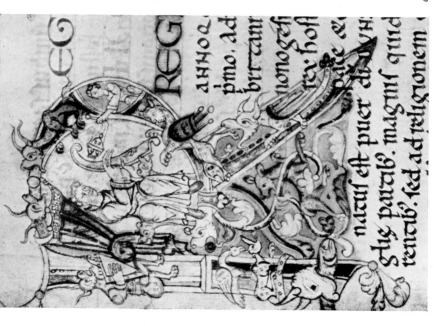

10. *a.* INITIAL: ST. DUNSTAN. B.M. MS. Arundel 16

 b. INITIAL: CHRIST PREACHING REPENTANCE. Lincoln Cathedral MS. A. 3. 17

 c. ST. WITHBURGA. Cambridge, C.C.C. MS. 393

11. *a.* INITIAL. Cambridge, Trinity College, MS. R. 3. 30

b. DETAIL OF INITIAL. B.M. MS. Harley 624

c. DETAIL OF FULL-PAGE DRAWING. Laurentian MS. Pluto XII. 17

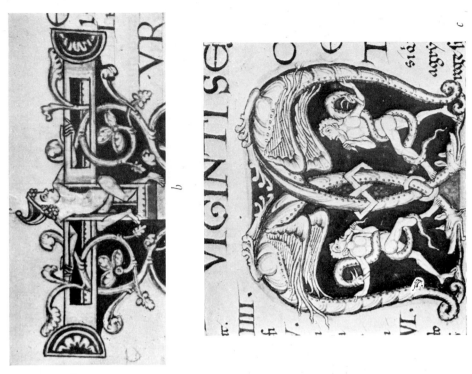

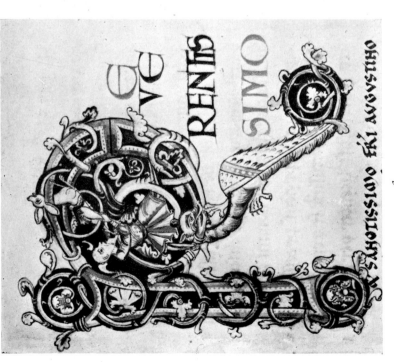

12. *a.* INITIAL. B.M. MS. Cleopatra E. 1
b and *c.* INITIALS. Cambridge, St. John's College, MS. A. 8

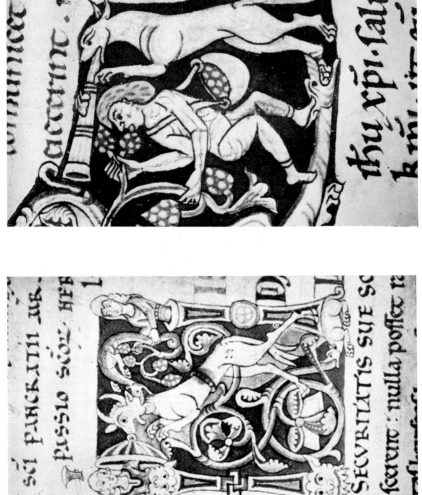

13. *a*. INITIAL. B.M. MS. Harley 624
b. DETAIL FROM INITIAL. B.M. MS. Claudius E. V

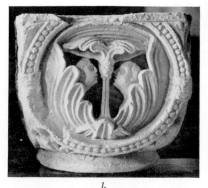

a

b

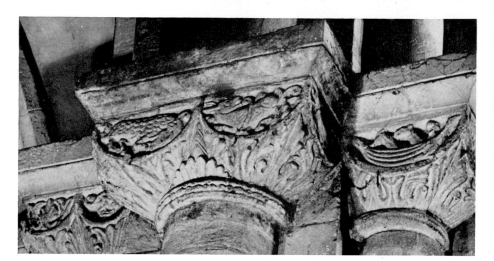

c

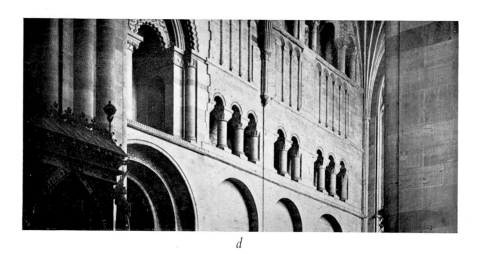

d

14. CAPITALS. *a.* CANTERBURY CRYPT; *b.* HYDE ABBEY; *c.* ROMSEY ABBEY;
d. HEREFORD CATHEDRAL: TRIFORIUM IN SOUTH TRANSEPT

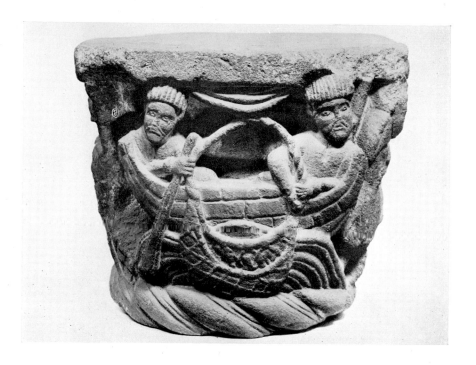

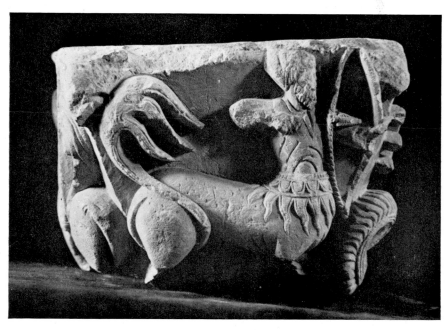

15. *a.* LEWES PRIORY: CAPITAL. THE MIRACULOUS DRAUGHT
 b. WINCHESTER CATHEDRAL: CAPITAL. THE CENTAUR

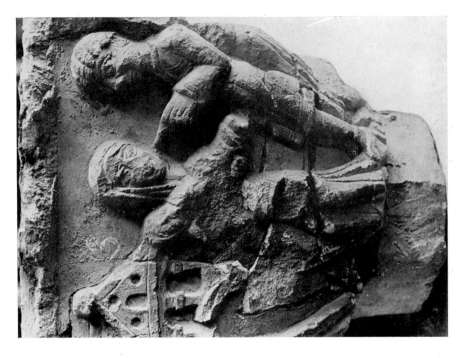

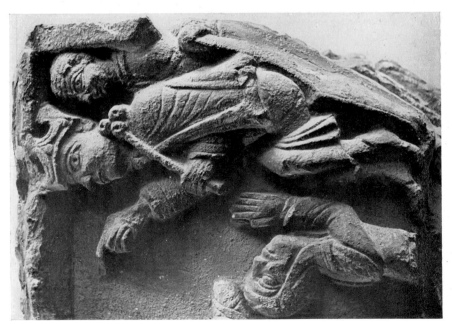

16. WESTMINSTER ABBEY: CAPITAL: THE JUDGEMENT OF SOLOMON

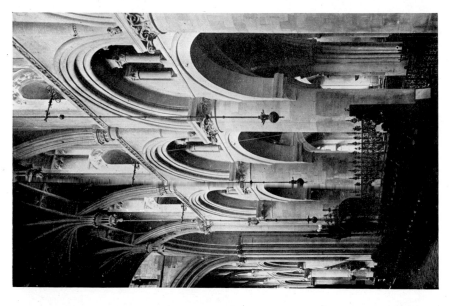

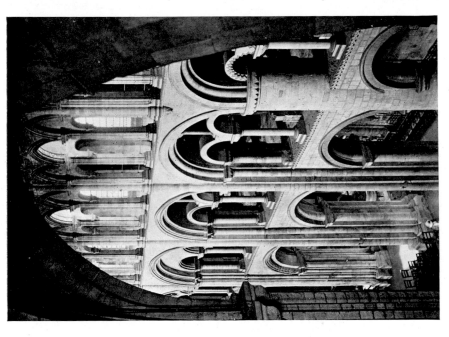

17. *a.* ROMSEY ABBEY: THE NAVE
b. OXFORD CATHEDRAL: THE CHOIR

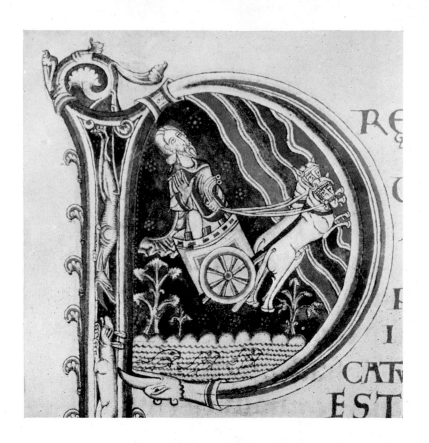

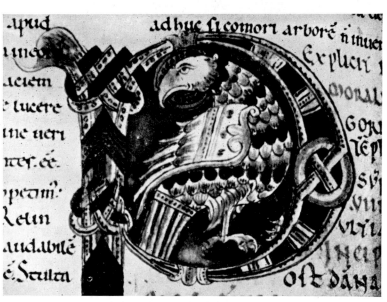

18. *a.* THE CHARIOT OF ELIJAH. B.M. MS. Royal 1 C. VII
 b. THE EAGLE OF ST. JOHN. B.M. MS. Royal 6 C. VI

19. *a.* INITIAL. B.M. MS. Royal 1 C. VII
b. INITIAL. Walters Art Gallery MS. 18

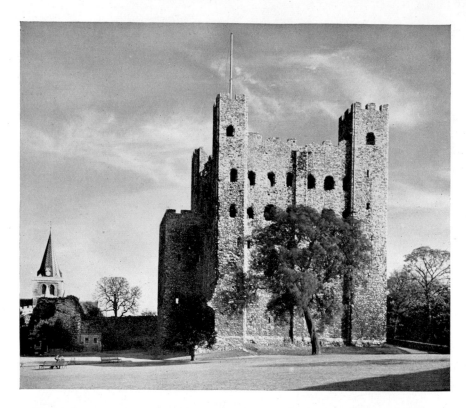

20. *a.* ROCHESTER CASTLE
 b. CONISBOROUGH CASTLE: INTERIOR

a b

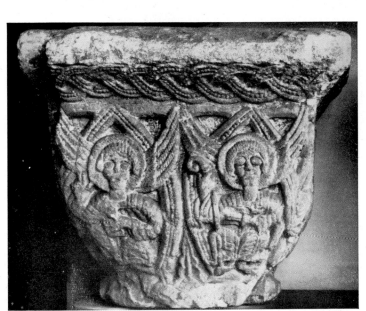

c

21. CARVINGS FROM READING ABBEY
a. CAPITAL: READING MUSEUM
b. THE PELICAN: VICTORIA AND ALBERT MUSEUM
c. THE ANGEL CAPITAL. READING MUSEUM

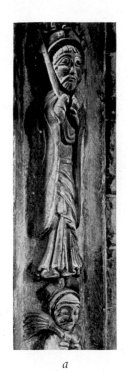

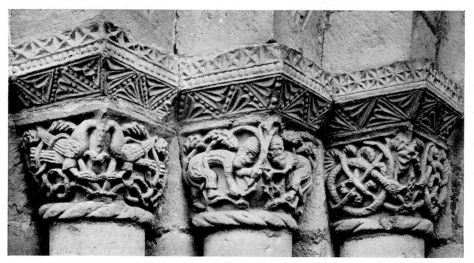

c

22. *a.* KILPECK: FIGURES ON CHANCEL ARCH
b. INITIAL TO HOSEA. Hereford MS. P. 4. iii
c. LEOMINSTER: CAPITALS OF WEST DOOR

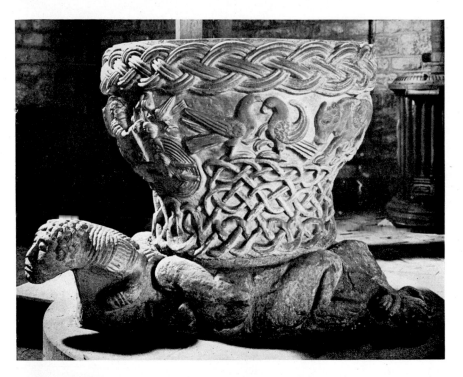

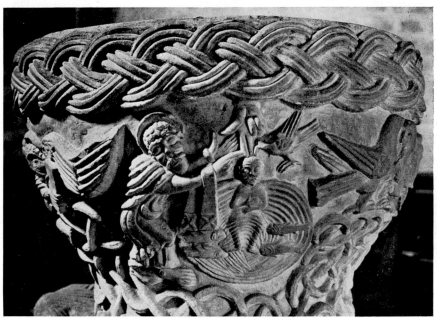

23. CASTLE FROME

a. THE FONT; *b.* DETAIL FROM FONT: THE BAPTISM

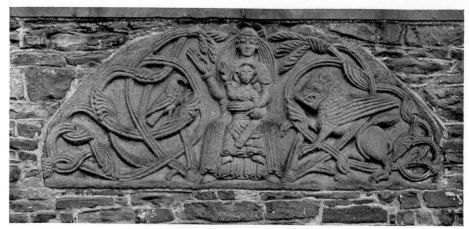

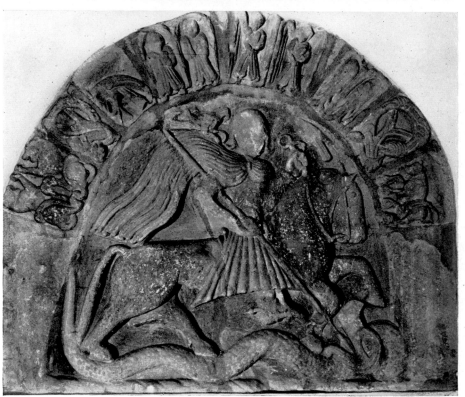

24. *a.* FOWNHOPE: TYMPANUM
b. BRINSOP: TYMPANUM. ST. GEORGE

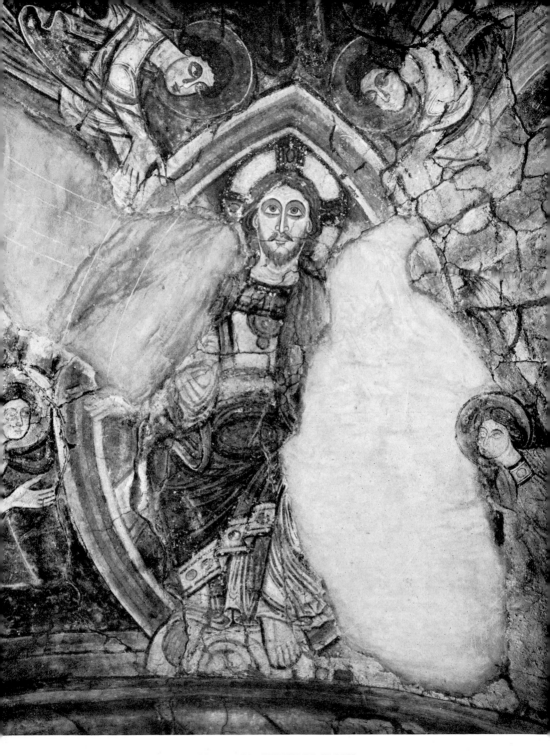

25. CANTERBURY: CHRIST IN GLORY

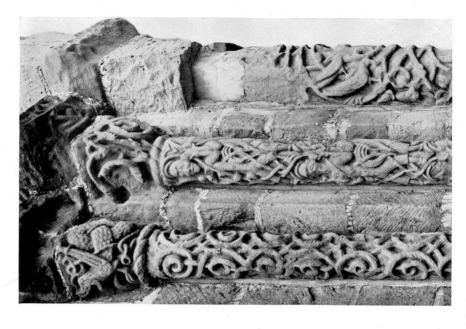

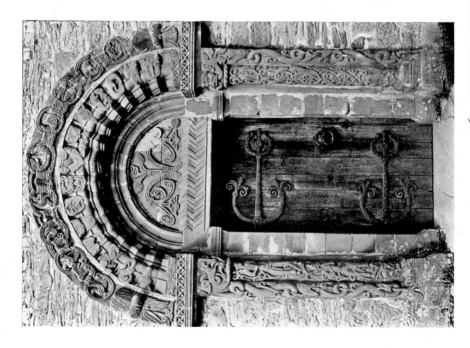

26. *a*. KILPECK: SOUTH DOOR
b. SHOBDON: DETAIL OF CHANCEL ARCH

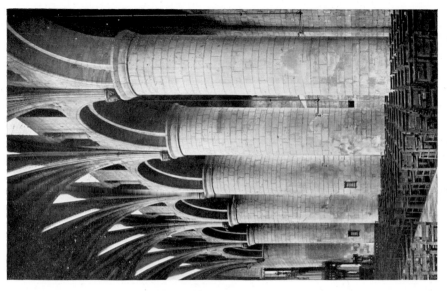

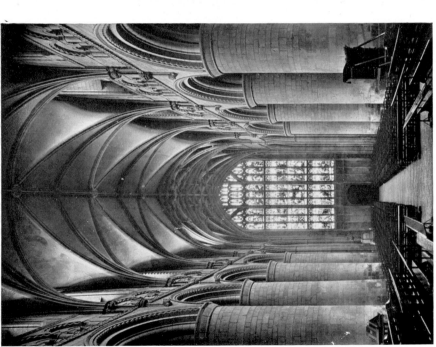

27. _a._ GLOUCESTER CATHEDRAL: THE NAVE

b. TEWKESBURY ABBEY: THE NAVE

a *b*

c

28. *a*. THE GIANT GOATS. B.M. MS. Tiberius B. V
 b. THE GIANT GOATS. Bodl. MS. Bodley 614
 c. DETAIL OF INITIAL. Bodl. MS. Auct. E. Infra 1

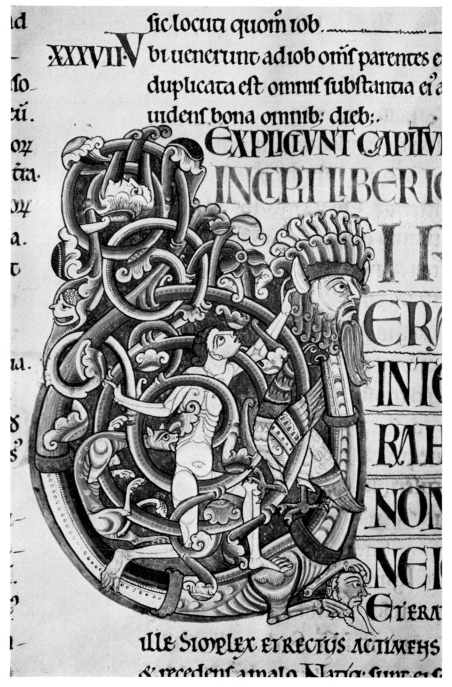

sic locuta quoīm iob.

XXXVII. Vbi uenerunt ad iob omīs parentes e

duplicata est omnīs substantia eīa

uidenf bona omnib; dieb;.

EXPLICIVNT CAPITV

INCIPT LIBERIC

IF

ERA

INT

RAB

NON

NE

ET ERA

ille Simplex et rectus ac timehs

& recedens a malo Nati; sunt e

29. INITIAL TO JOB. Bodl. MS. Auct. E. Infra 1

a

b

c

30. *a.* DETAIL OF THE GLOUCESTER CANDLESTICK
b. INITIAL: VIRGO. B.M. MS. Vitellius C. XII
c. IVORY FROM ST. ALBANS

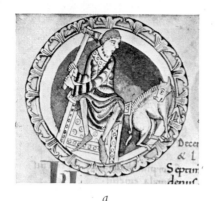

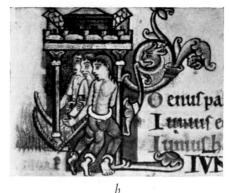

a

b

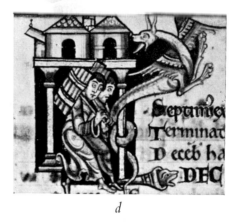

c

d

e

f

31. *a.* ST. ALBANS PSALTER: DECEMBER
 b. SHAFTESBURY PSALTER: JUNE
 c. GLASGOW PSALTER: AUGUST
 d. SHAFTESBURY PSALTER: DECEMBER
 e. GIRALDUS CAMBRENSIS: HAWKING. B.M. MS. Royal 13 B. VIII
 f. DETAIL. Cambridge, Trinity College, MS. B. 5. 3

32. a. INITIAL. Trinity Hall MS. 4
b. INITIAL. B.M. MS. Royal 13 D. VII

33. *a*. INITIAL. Oxford, Christ Church, MS. 95
b. INITIAL. Durham MS. B. II. 8

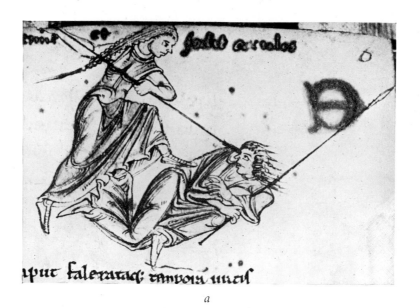

a

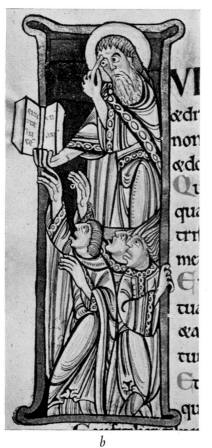

b

c

34. *a.* PSYCHOMACHIA. B.M. MS. Titus D. XVI
b. and *c.* ST. ALBANS PSALTER: INITIALS

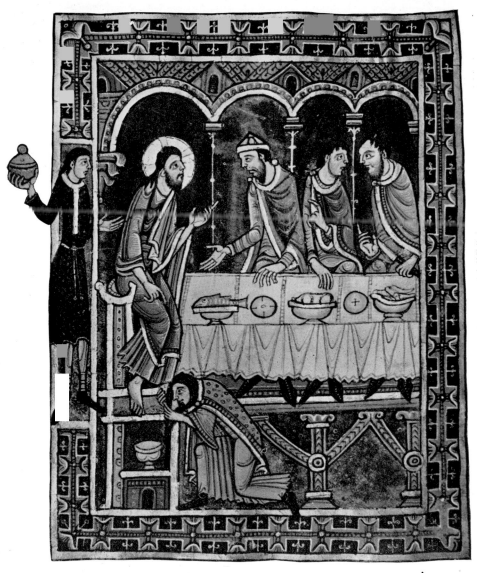

35. ST. ALBANS PSALTER: ST. MARY MAGDALEN ANOINTS CHRIST'S FEET

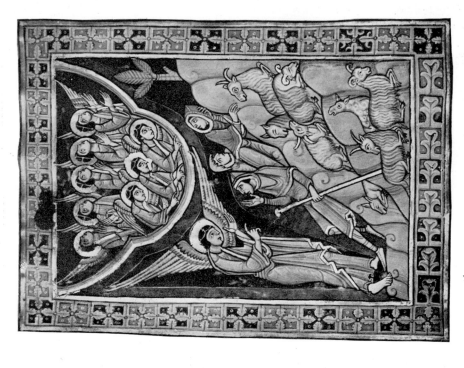

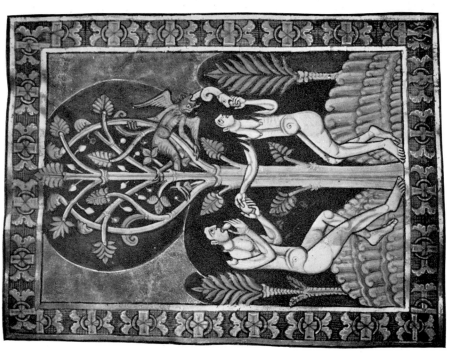

a. THE TEMPTATION OF EVE

b. THE ANGELS AND THE SHEPHERDS

36. ST. ALBANS PSALTER

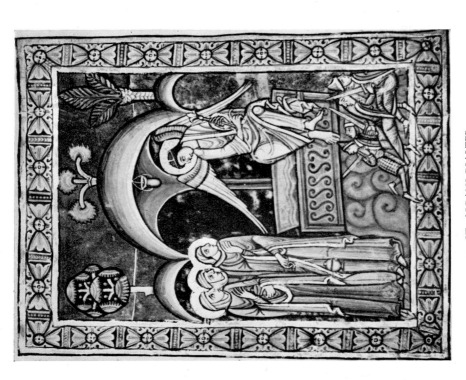

a. ST. ALBANS PSALTER

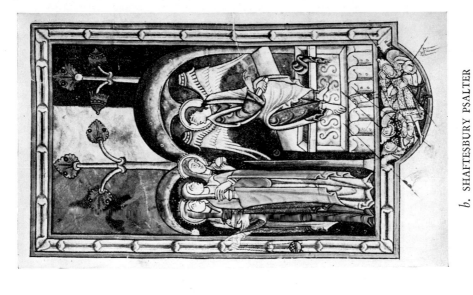

b. SHAFTESBURY PSALTER

37. THE MARYS AT THE SEPULCHRE

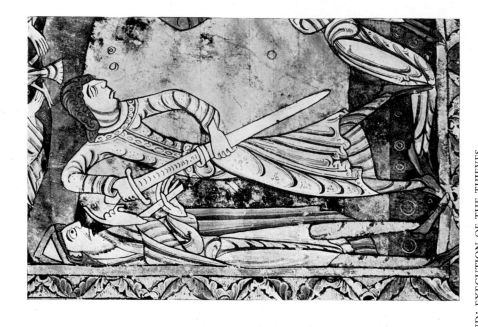

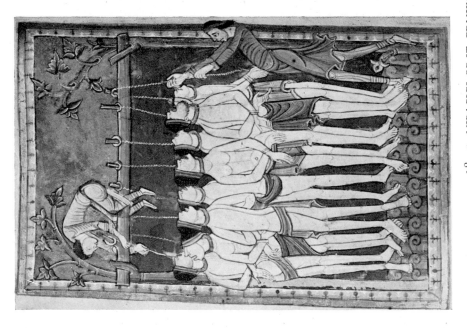

38. *a.* MIRACLES OF ST. EDMUND: EXECUTION OF THE THIEVES

b. ST. ALBANS PSALTER: THE EXECUTIONER

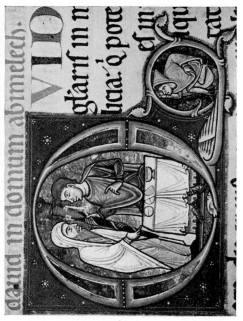

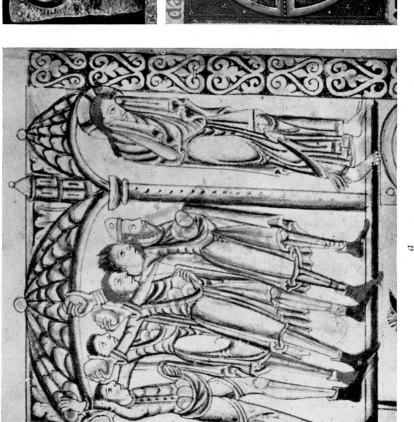

39. *a.* STONING OF CHRIST. Pembroke College Gospels

 b. VOUSSOIRS. Yorkshire Museum

 c. AHIMELECH AND DAVID. Cambridge, St. John's College, Ms. C. 18

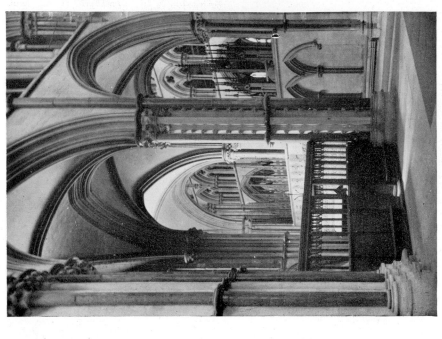

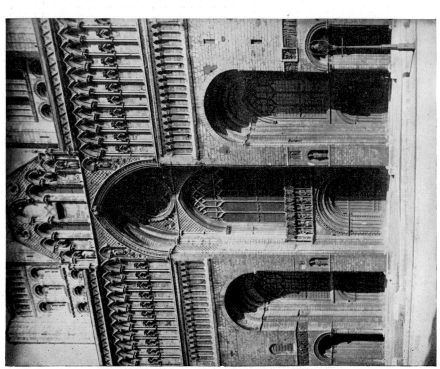

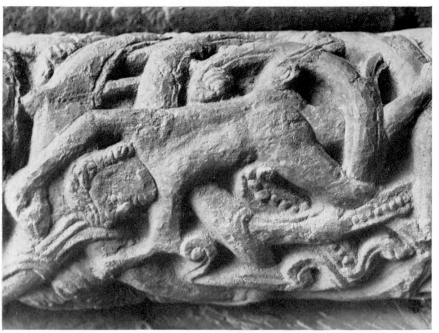

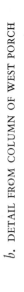

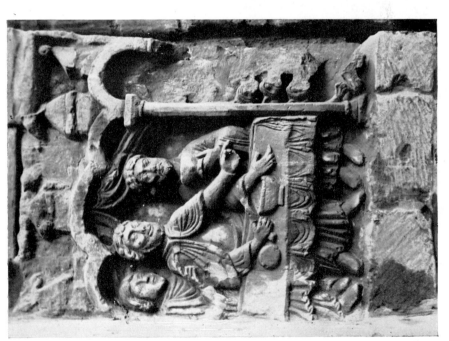

a. THE FEAST OF DIVES

b. DETAIL FROM COLUMN OF WEST PORCH

41. LINCOLN CATHEDRAL

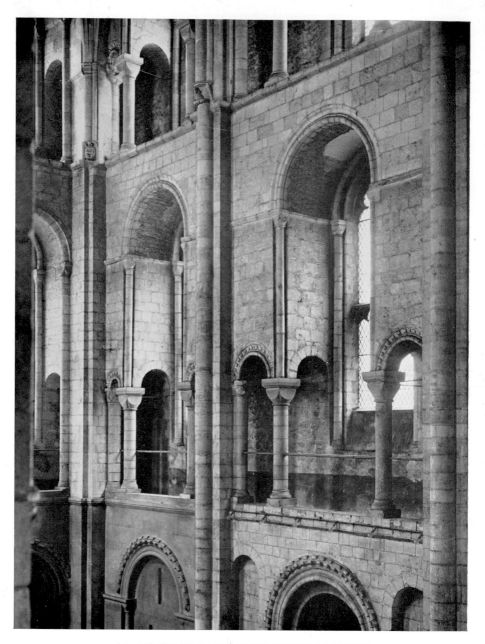

42. NORWICH CATHEDRAL: NORTH TRANSEPT

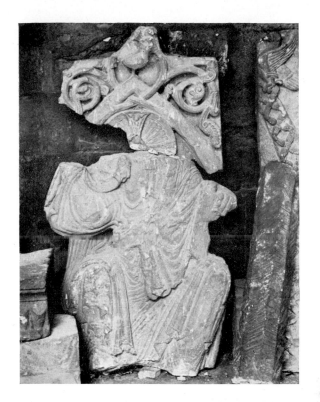

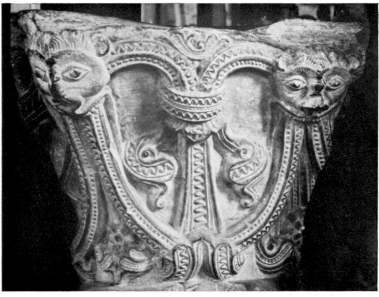

43. *a.* LINCOLN CATHEDRAL: FIGURE OF CHRIST
 b. CAPITAL FROM OLD SARUM

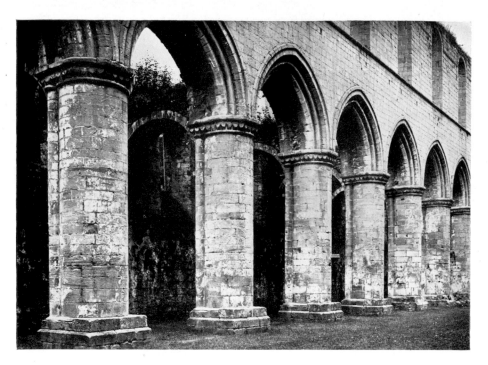

44. *a*. FOUNTAINS ABBEY: THE NAVE
b. GLASTONBURY ABBEY: THE CROSSING

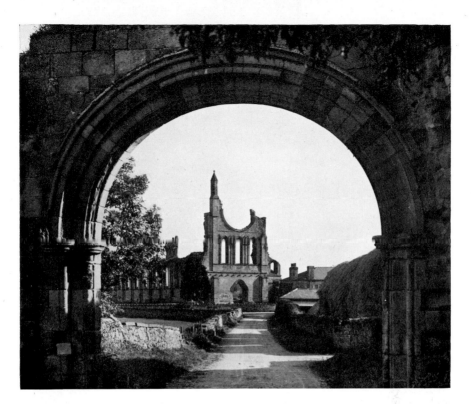

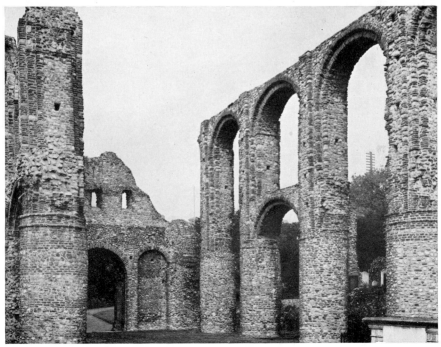

45. *a.* BYLAND ABBEY: WEST FRONT
b. ST. BOTOLPH'S PRIORY: INTERIOR

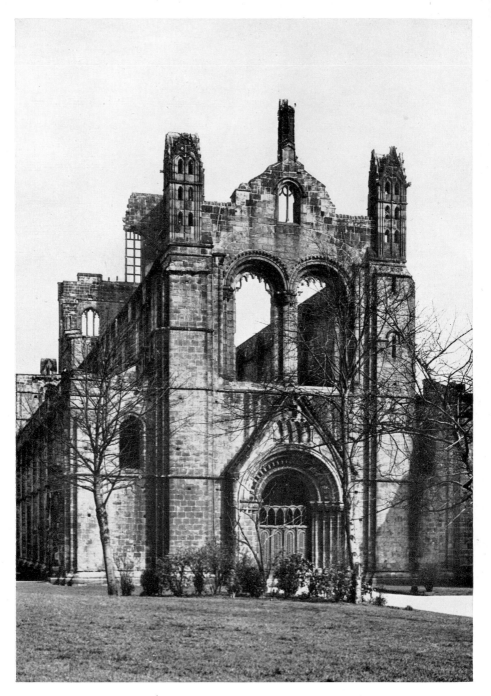

46. KIRKSTALL ABBEY: WEST FRONT

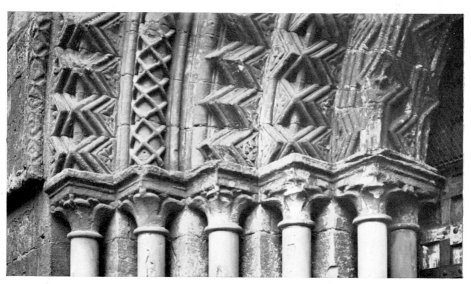

47. *a.* BRIDLINGTON PRIORY: CAPITALS
 b. SELBY ABBEY: WEST PORCH, DETAIL

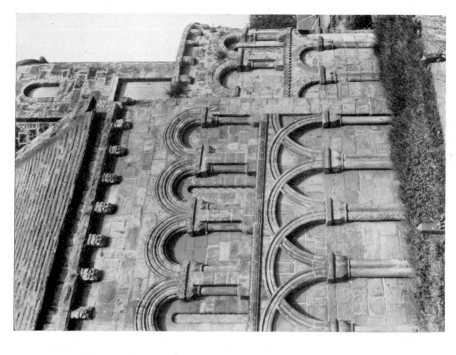

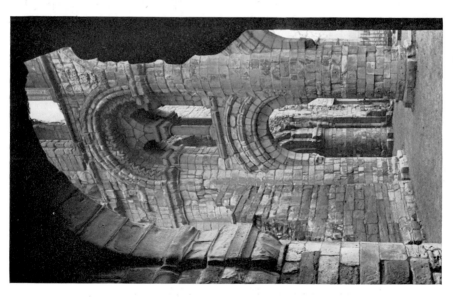

48. *a.* JEDBURGH ABBEY: THE NAVE

b. LEUCHARS: THE APSE

49. *a.* ADORATION OF THE KINGS. Cambridge, Pembroke College, MS. 16
 b. ST. MARK. Dublin, Trinity College, MS. 53

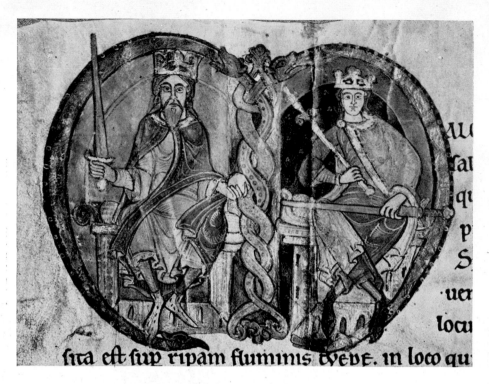

sita est sup ripam fluminis tyeve. in loco qu

50. *a*. INITIAL: DAVID I AND MALCOLM IV. Kelso Charter
b. THE CHARGE TO PETER. Bodl. MS. Auct. D. 2. 6

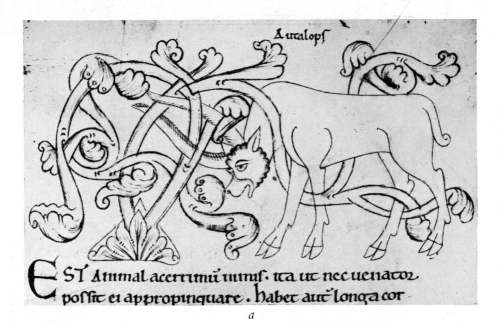

51. *a.* ANTELOPE FROM THE BESTIARY. Bodl. MS. Laud Misc. 247

 b. WINCHESTER BIBLE: KING ANTIOCHUS

 c. ENAMEL: A DISPUTANT

52. *a.* EADWINE: CANTERBURY PSALTER
b. ST. AUGUSTINE, Laurentian MS. Pluto XII. 17

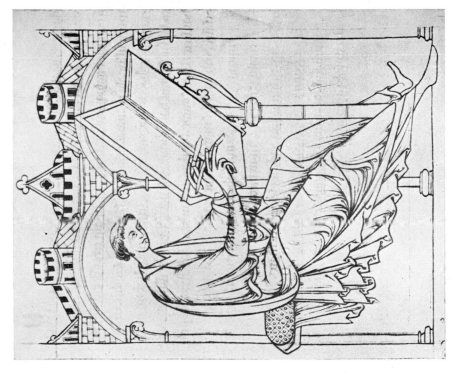

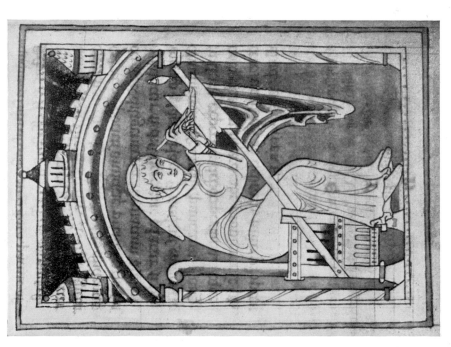

53. *a.* LAURENCE OF DURHAM. Durham MS. V. III
 b. ISIDORE. Cambridge University Library, MS. Ii. V. 26

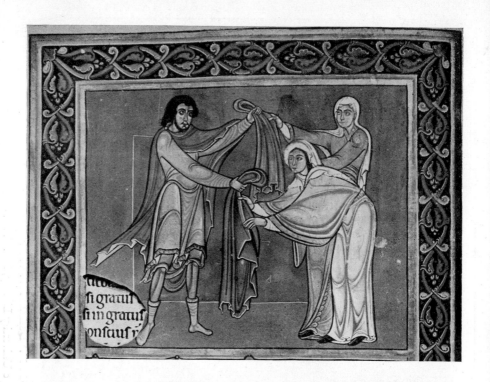

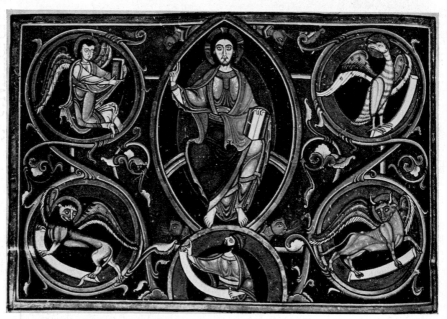

54. THE BURY BIBLE
a. ELKANAH AND HIS WIVES
b. THE VISION OF EZEKIEL

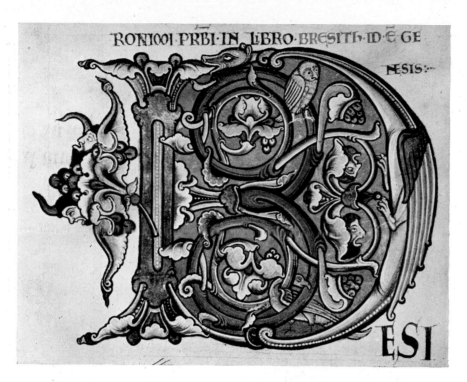

55. *a.* THE BURY BIBLE: INITIAL
 b. GLASGOW PSALTER: ANOINTING OF DAVID

56. *a.* SHERBORNE CARTULARY: ST. JOHN. B.M. MS. Add. 46487; *b.* COPENHAGEN PSALTER: VIRGIN OF THE CRUCIFIXION;
c. DOVER BIBLE: ST. MATTHEW

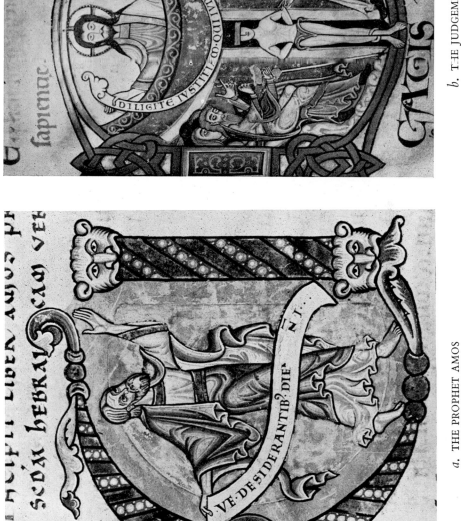

a. THE PROPHET AMOS

b. T·IE JUDGEMENT SCENE

57. DOVER BIBLE

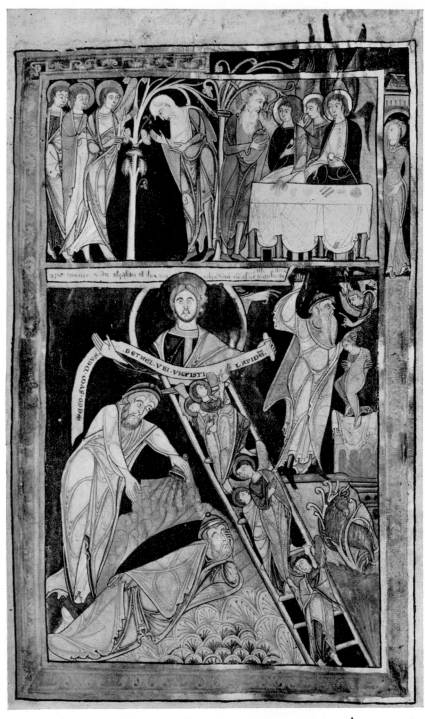

58. LAMBETH BIBLE: ABRAHAM AND THE ANGELS; ABRAHAM'S SACRIFICE;
JACOB'S DREAM

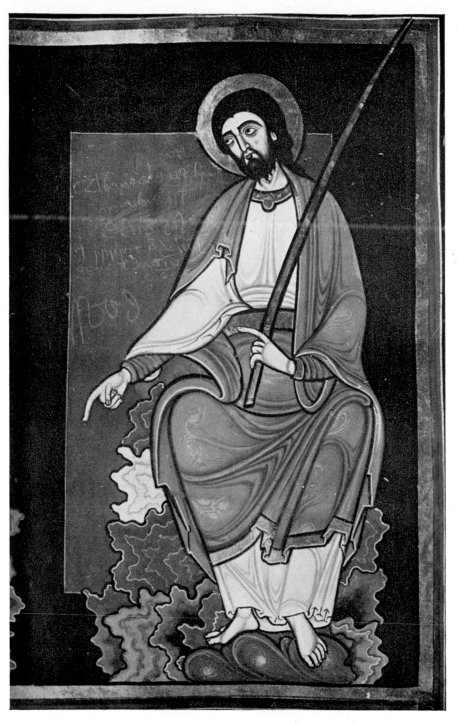

59. BURY BIBLE: AARON

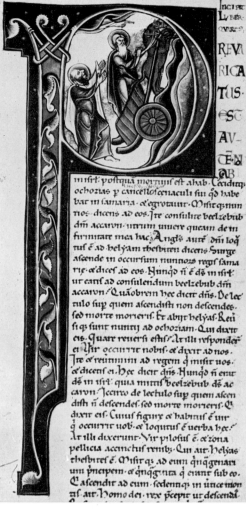

a. DOVER BIBLE *b*. BODL. MS. LAUD MISC. 752

60. THE CHARIOT OF ELIJAH

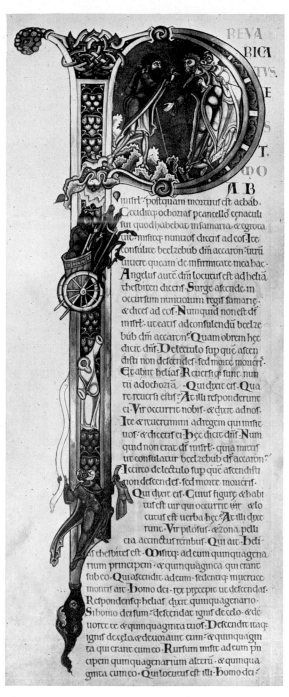

REVA
RICA
TVS
E
S
T.
QVO
AB

nifr̄ · poſtquam moruuſ eſt achāb · Cecidit̄q̄ ochoziaſ p̄cancellō cēnaculi ſui quod habebac inſamaria · & egroca uic · miſit̄q̄ nuncioſ dicenſ ad coſ · Ice conſulice beelzebub dm̄ accaron · utr̄u uiuere queam de inſirmicate mea hac · Angeluſ auc̄ dn̄i locutuſ eſt ad heliā cheſbicen dicenſ · Surge aſcende in occurſum nunciorum regiſ ſamarię · & diceſ ad coſ · Numquid non eſt dſ miſr̄t · uc eaciſ ad conſulendū beelze bub dm̄ accaron · Quam obrem hēc dicic dn̄ſ · De lectulo ſup̄ quē aſcen diſti non deſcendeſ · ſed morce morieriſ · Ec abiit heliaſ · Reuerſīq̄ ſunt nun cii ad ochoziā · Qui dixic eiſ · Qua re reuerſi eſtiſ · Ac illi reſponderunt ei · Vir occurric nobiſ · & dixic ad noſ · Ice & reuertimini ad regem qui miſic uoſ · & diceciſ ei · Hēc dicic dn̄ſ · Num quid non erac dſ iniſr̄l · quia micciſ uc conſulacur beelzebub dſ accaron · Iccirco de lectulo ſup̄ quē aſcendiſti non deſcendeſ · ſed morce morieriſ · Qui dixic eiſ · Cuiuſ figurē & habi tuſ eſt uir qui occurric uir̄ & lo cutuſ eſt uerba hēc · Ac illi dixe runc · Vir piloſuſ · & zona pelli cia accinctuſ rēnibuſ · Qui aic · Heli aſ cheſbiceſ eſt · Miſit̄q̄ ad eum quinquagena rium principem · & quinquaginca qui erant ſub eo · Qui aſcendic ad eum · ſedencīq̄ in uercice moncıſ aic · Homo dei · rex precepic uc deſcendaſ · Reſpondenſ̄q̄ heliaſ dixic quinquagenario · Si homo dei ſum · deſcendac igniſ de celo · & de uorec ce · & quinquaginca tuoſ · Deſcendic icāq̄ igniſ de celo · & deuorauic eum · & quinquagin ca qui erant cum eo · Rurſum miſic ad eum p̄in cıpem quinquagenarium alcerū · & quinqua ginca cum eo · Qui locutuſ eſt illi · Homo dei

61. THE CHARIOT OF ELIJAH: WINCHESTER BIBLE

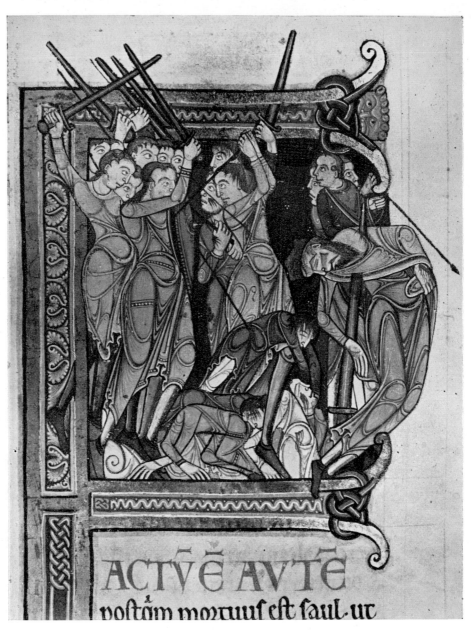

62. LAMBETH BIBLE: THE DEATH OF SAUL

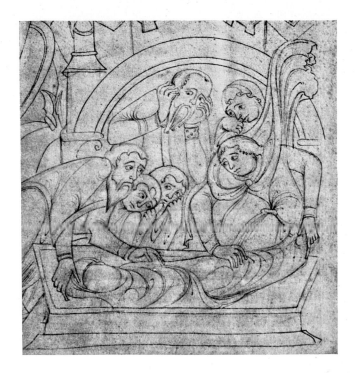

Amabo ut illuc transeas ubi illa est. CHR fo.
Ubi borias. cito hunc deduc ad militem;

ANTI PHO ADOLESCENS.

63. *a.* WINCHESTER BIBLE: BURIAL OF JUDAS MACCABAEUS
 b. SCENE FROM TERENCE. Bodl. MS. Auct. F. 2. 13

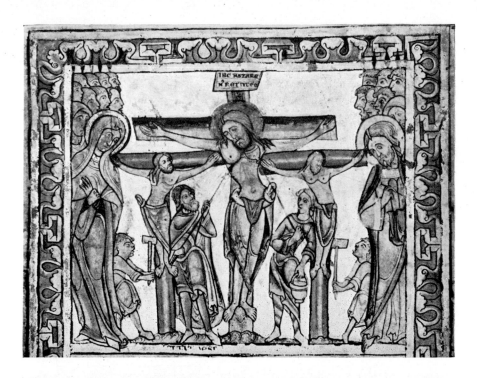

64. ST. SWITHUN'S PSALTER

a. THE CRUCIFIXION

b. THE SERVANTS AT THE MARRIAGE OF CANA

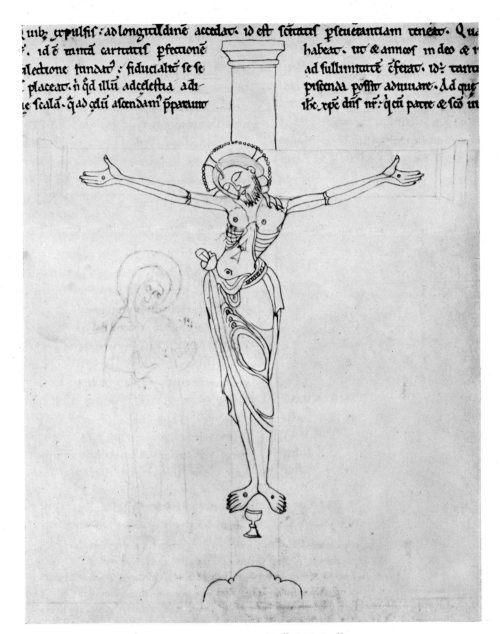

65. THE CRUCIFIXION. Bodl. MS. Bodley 297

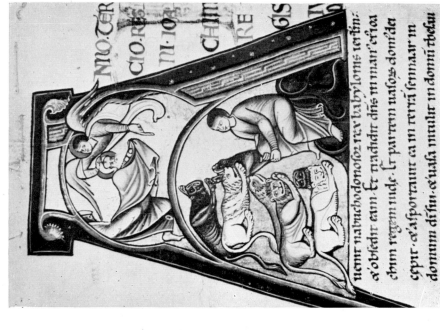

66. *a.* INITIAL. Bodl. MS. Auct. E. Infra 1
b. INITIAL. DANIEL IN THE LIONS' DEN. Bodl. MS. Laud Misc. 752

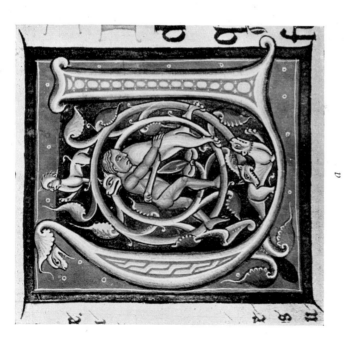

67. *a.* INITIAL. Cambridge, Trinity College, MS. B. 3. 11; *b.* INITIAL. Bodl. MS. Auct. E. Infra 7; *c.* INITIAL. Cambridge, Trinity College, MS. B. 5. 4

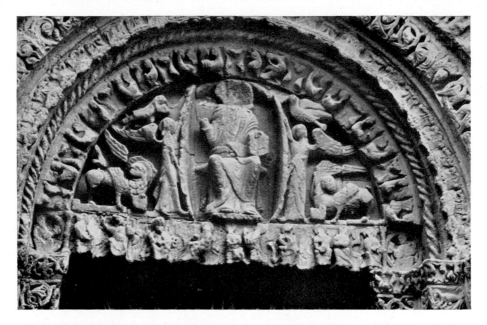

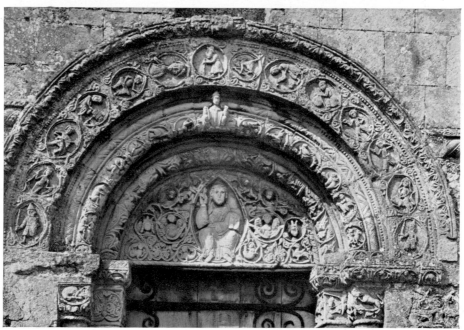

68. *a.* ROCHESTER CATHEDRAL: TYMPANUM OF WEST DOOR
 b. BARFRESTON: SOUTH DOORWAY

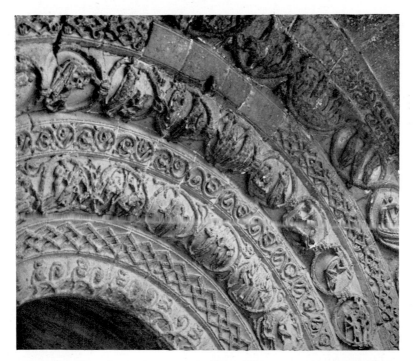

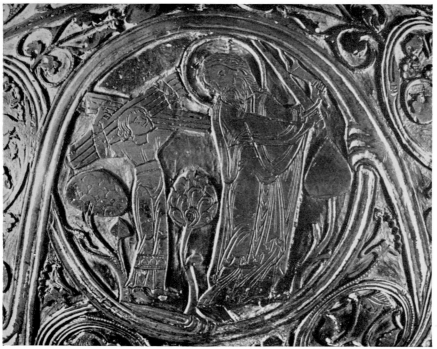

69. *a*. MALMESBURY ABBEY: DETAIL OF SOUTH PORCH
b. THE WARWICK CIBORIUM: DETAIL

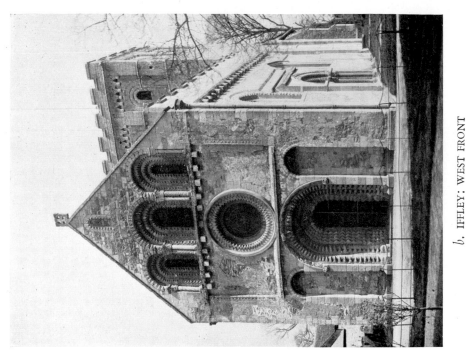

b. IFFLEY: WEST FRONT

70. a. BALDERTON: NORTH DOOR

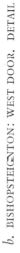

b. BISHOPSTEIGNTON: WEST DOOR. DETAIL

71. a. ST. CHAD'S, STAFFORD: CHANCEL ARCH. DETAIL

72. *a.* WENLOCK PRIORY: CHAPTER HOUSE
b. ST. DAVID'S CATHEDRAL: THE NAVE

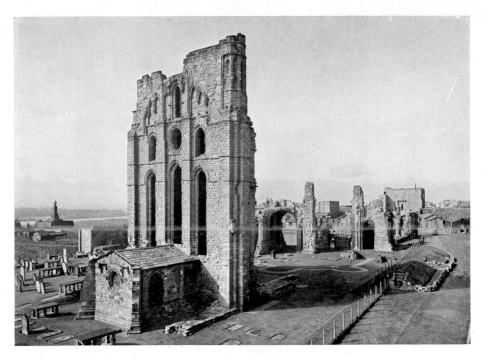

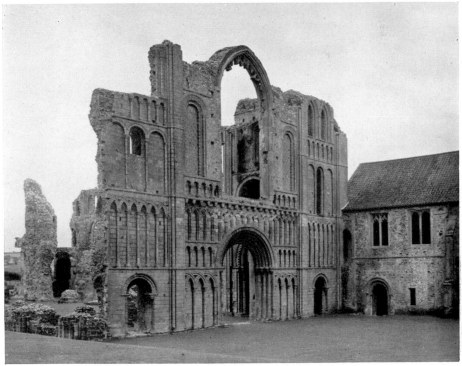

73. *a.* TYNEMOUTH PRIORY FROM THE NORTH-EAST
b. CASTLE ACRE PRIORY: WEST FRONT

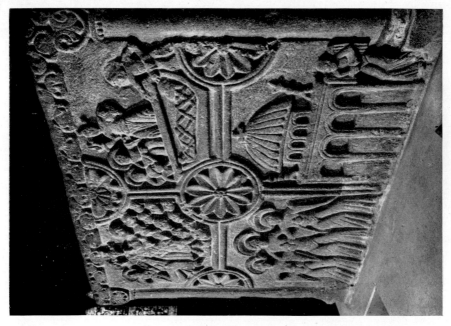

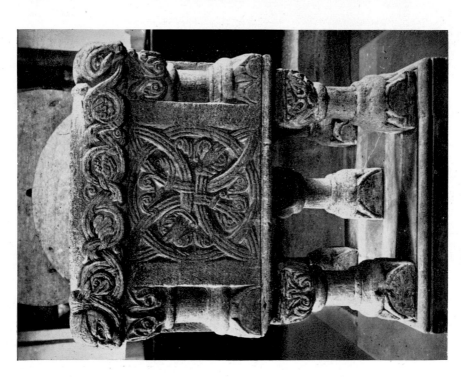

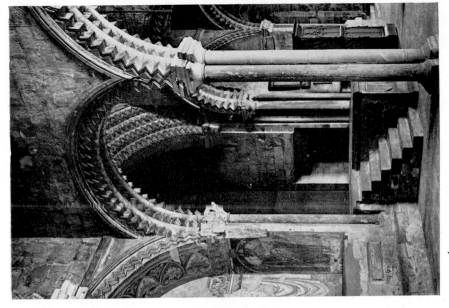

b. DURHAM CATHEDRAL: THE GALILEE

75. a. RIPON CATHEDRAL: THE CHOIR

76. *a.* PUISET BIBLE: ESTHER AND HAMAN

b. INITIAL TO GENESIS. Bodl. MS. Auct. E. Infra 1

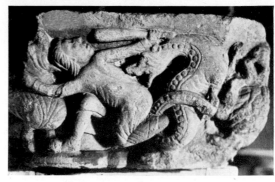

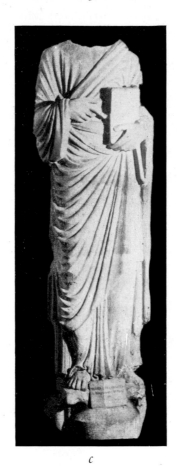

77. *a*. PILASTER FIGURE. DURHAM CATHEDRAL
 b. CAPITAL. YORKSHIRE MUSEUM
 c. COLUMN FIGURE. YORKSHIRE MUSEUM

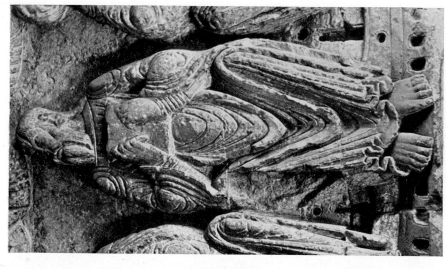

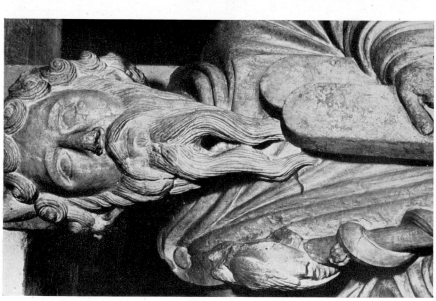

78. *a*. HEAD OF MOSES. YORKSHIRE MUSEUM
b. AN APOSTLE. MALMESBURY

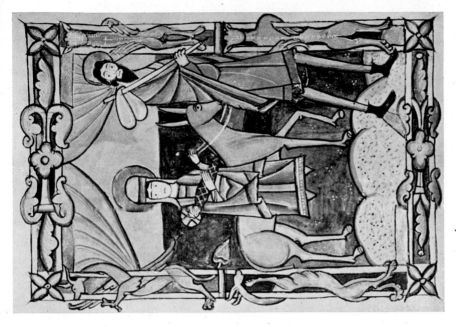

79. THE FLIGHT INTO EGYPT

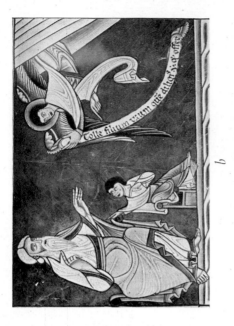

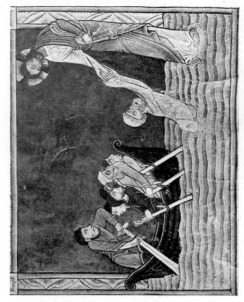

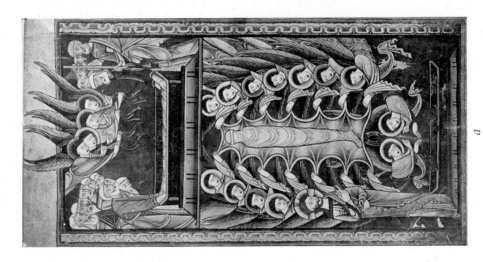

80. THE GLASGOW PSALTER

a. THE ASSUMPTION; *b.* ABRAHAM AND ISAAC; *c.* CHRIST AND PETER

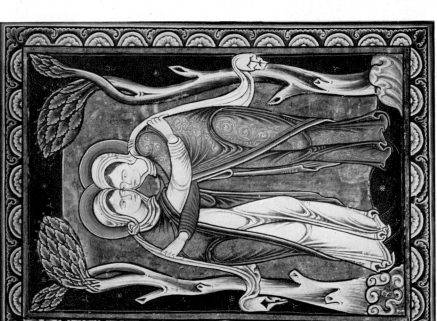

a. THE VISITATION

b. THE BETRAYAL

81. THE COPENHAGEN PSALTER

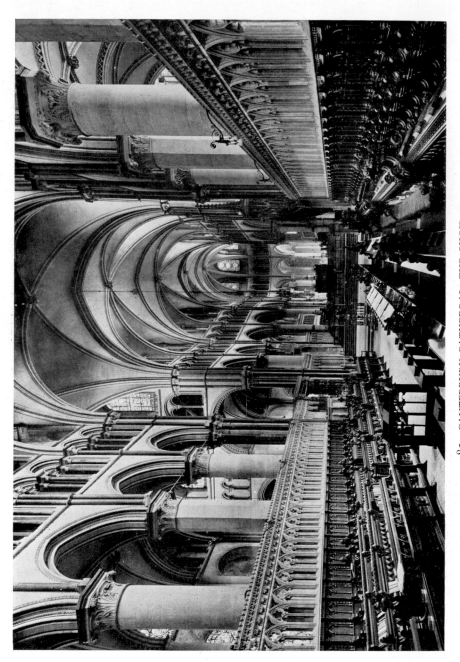

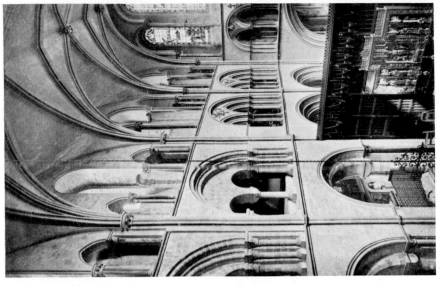

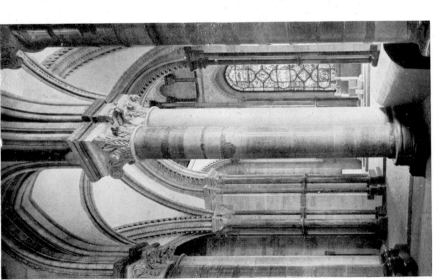

83. *a*. CANTERBURY CATHEDRAL: TRINITY CHAPEL

b. CHICHESTER CATHEDRAL: CHOIR AND RETRO-CHOIR

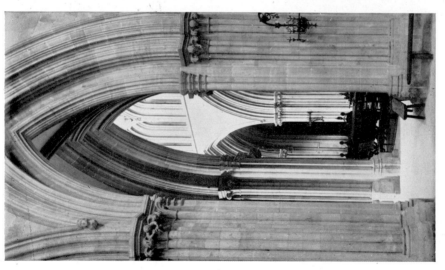

84. *a*. WELLS CATHEDRAL: NAVE FROM SOUTH TRANSEPT
b, ST. CUTHBERT'S, DARLINGTON; SOUTH TRANSEPT

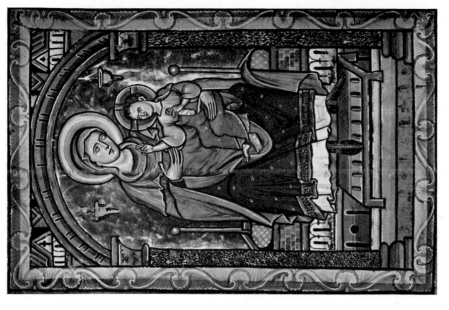

85. *a*. THE ANOINTING OF DAVID. Bibl. Nat. MS. lat. 10433

b. VIRGIN AND CHILD. B.M. MS. Royal 2 A. XXII

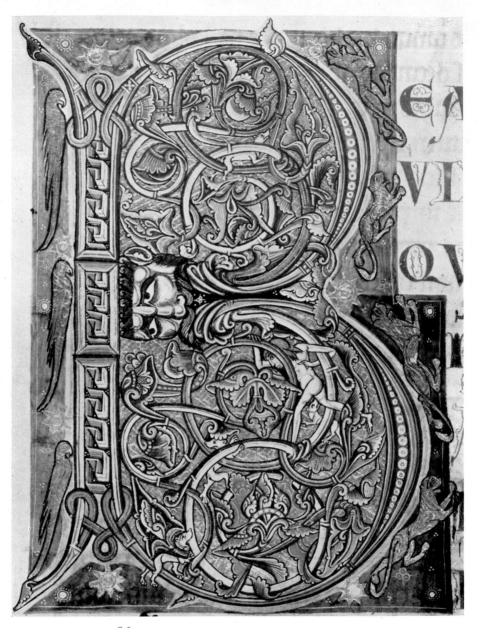

86. COPENHAGEN PSALTER: BEATUS INITIAL

87. HUNTINGFIELD PSALTER: BEATUS INITIAL

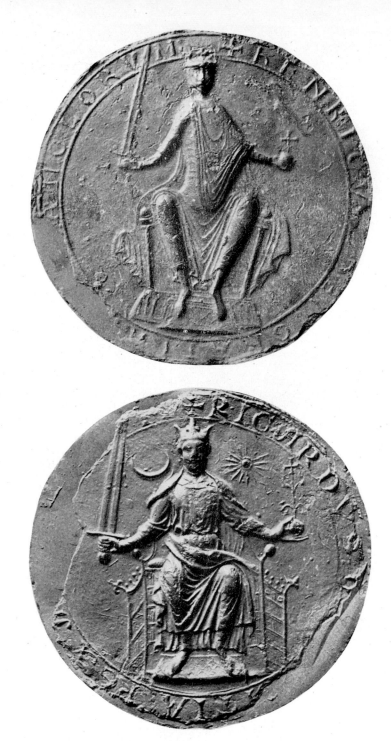

88. *a.* GREAT SEAL OF HENRY II
b. GREAT SEAL OF RICHARD I

89. BESTIARY ILLUSTRATIONS
a. VULTURES. Bodl. MS. Ashmole 1511
b. GOATS. Aberdeen University Library, MS. 24

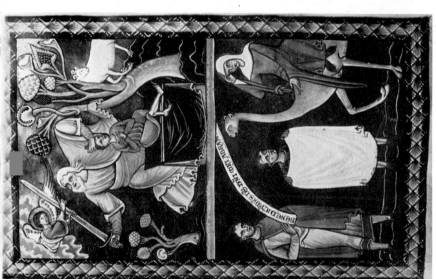

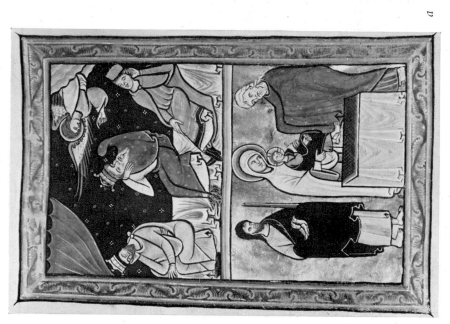

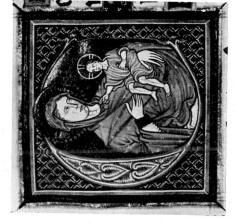

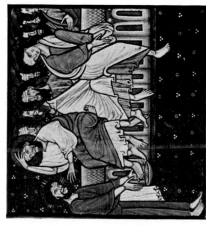

91. *a*. THE MAGI AND THE PRESENTATION. B.M. MS. Arundel 157
 b. VIRGIN AND CHILD. B.M. MS. Royal 1 D. X
 c. THE WASHING OF THE FEET. B.M. MS. Royal 1 E. X

92. *a.* WOMAN WITH TWO BETROTHED. Cambridge, C.C.C. MS. 10
b. THE HYENA: Bodl. MS. Bodley 764

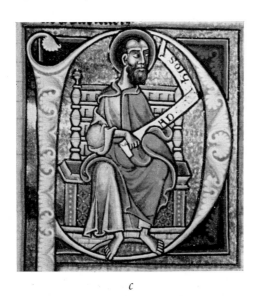

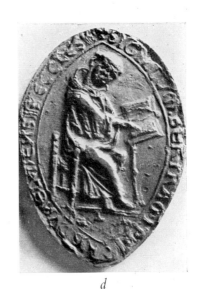

93. *a*. DANIEL. B.M. MS. Add. 15452
 b. BEDE. B.M. MS. Add. 39943
 c. ST. PAUL. B.M. MS. Royal 4 E. IX
 d. SEAL OF BERTRAM, PRIOR OF DURHAM

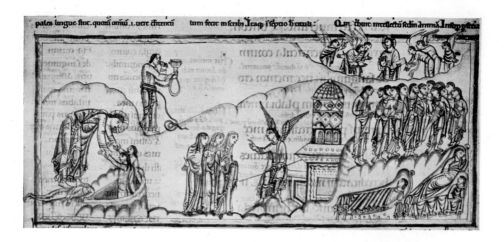

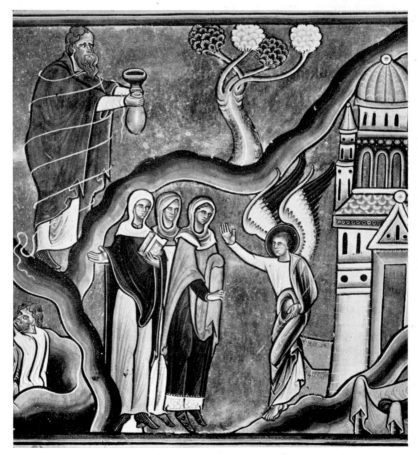

94. *a.* CANTERBURY PSALTER: PSALM XV
 b. PSALTER: PSALM XV (DETAIL). Bibl. Nat. MS. lat. 8846

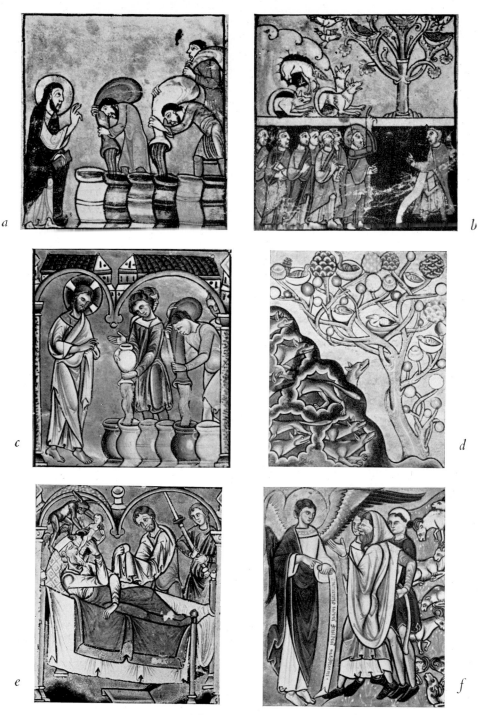

95. *a.* THE MIRACLE OF CANA; *b.* THE FOXES AND BIRDS. B.M. MS. Add. 37472.
c. THE MIRACLE OF CANA; *d.* THE FOXES AND BIRDS;
e. THE DEATH OF HEROD; *f.* THE ANGEL AND THE SHEPHERDS.
Bibl. Nat. MS. lat. 8846

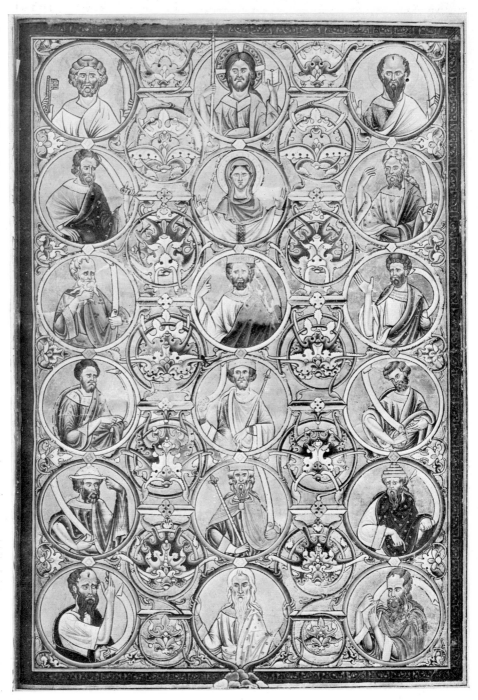

96. THE TREE OF JESSE. Bibl. Nat. MS. lat. 8846